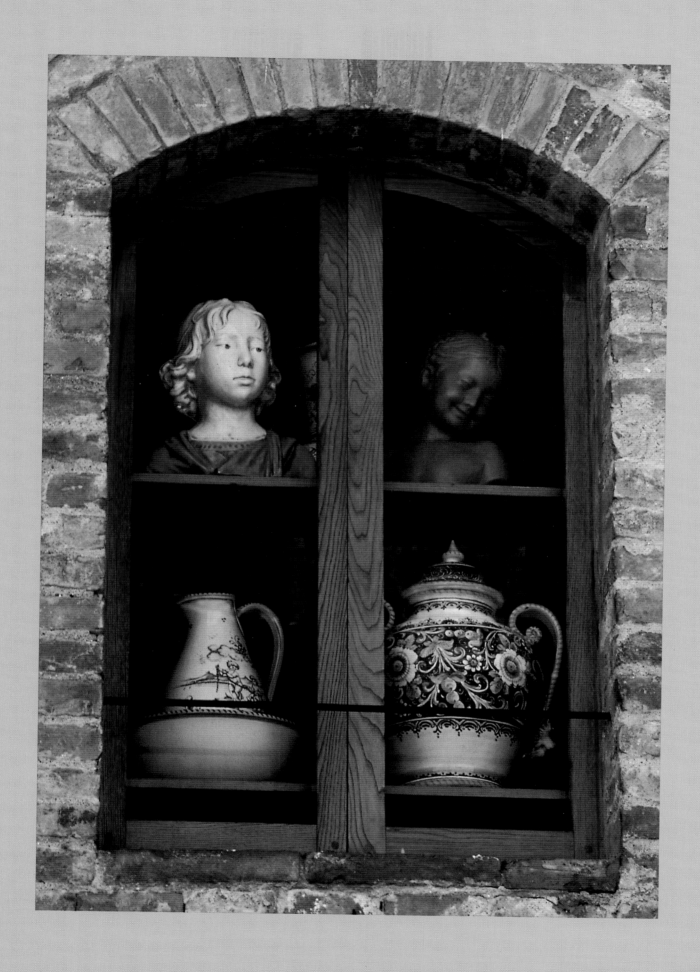

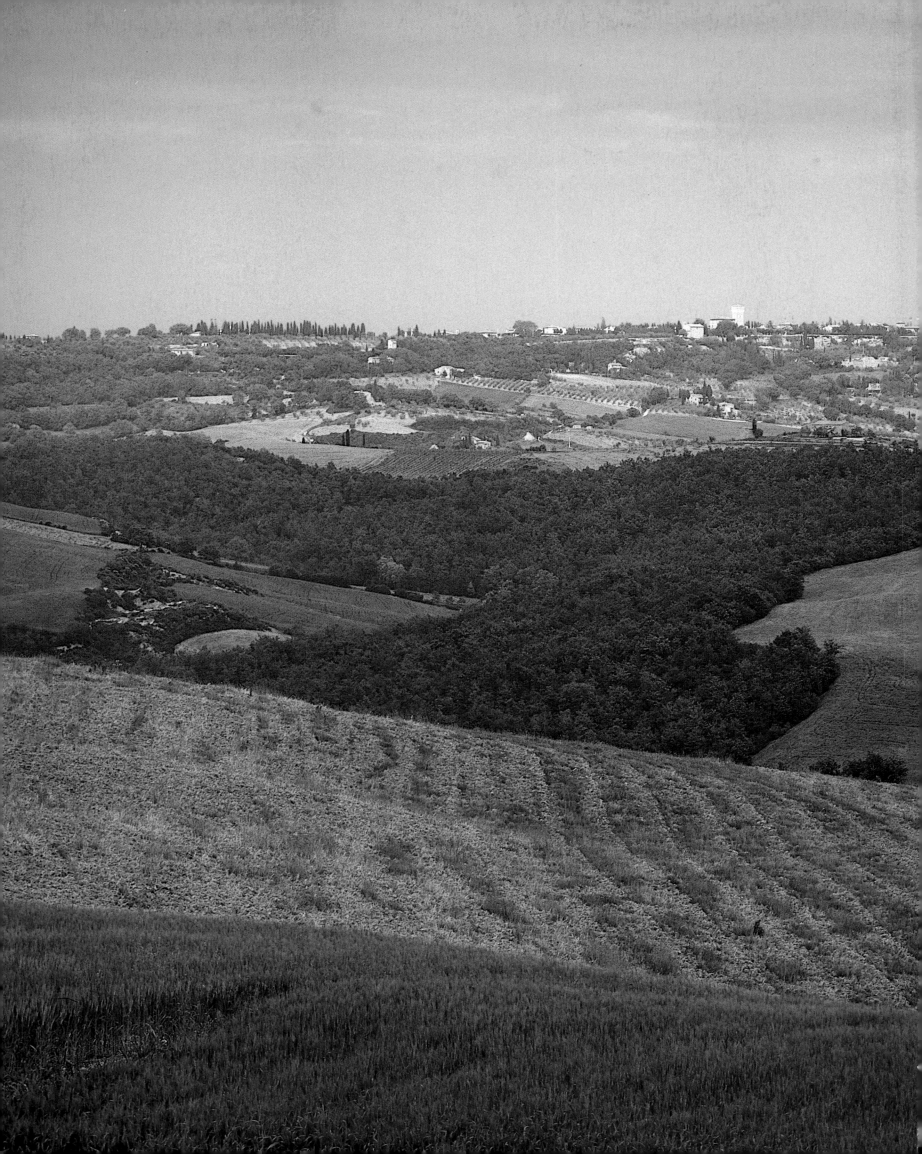

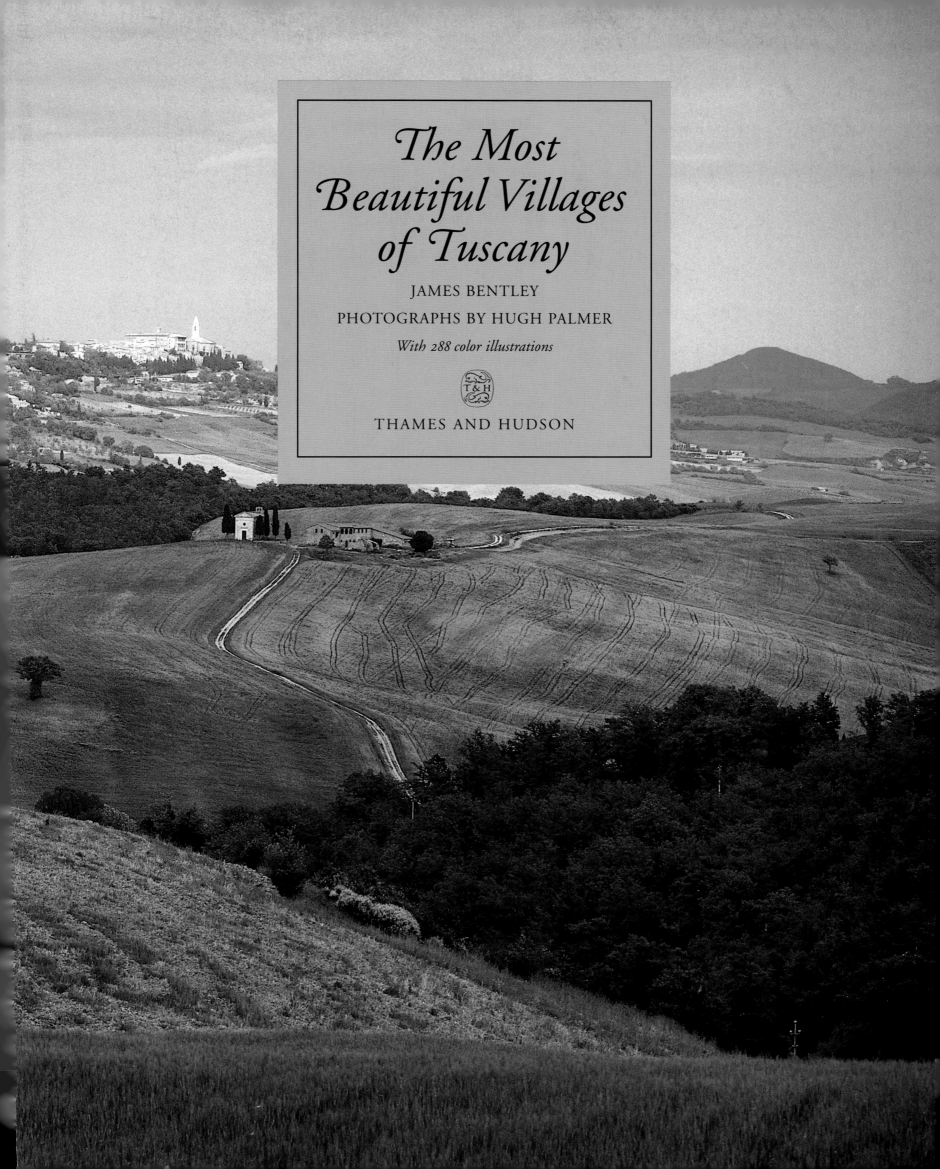

The Most Beautiful Villages of Tuscany

JAMES BENTLEY

PHOTOGRAPHS BY HUGH PALMER

With 288 color illustrations

T & H

THAMES AND HUDSON

HALF TITLE
Tuscan still-life: a display in the window of a potter's studio in San Gimignano.

TITLE PAGE
A magnificent Tuscan panorama: the heavily cultivated landscape south of Siena, looking towards the architectural treasures of Pienza.

Author's Acknowledgments

I am deeply grateful for the kindness of Crystal Holidays of Crystal House, Arlington Road, Surbiton, Surrey KT6 6BW, for making available to me one of their superb villas at Borgo delle More, Aquaviva, just outside Montepulciano, while I was working on this book. I must also express my gratitude to the Italian State Tourist Board, 1 Princes Street, London WIR 8AY, and in particular to its public Relations Director, Signor Eugenio Magnani.

JB

Photographer's Acknowledgments

Many people made my trips to Tuscany a great pleasure with their help and kindness. I am particularly grateful to Janet Hales, my navigationally unchallenged sister, Mark, Heather, Flora, Felix, Anna-Theresa, Ignatius and William Roberts at Badia a Passignano, and Claudio Martinelli at Montefegatesi. The pictures in the book are dedicated with love, as always, to my wife Hoonie.

HP

Reproduction on page 113 Photo Scala.

First published in hardcover in the United States of America in 1995 by Thames and Hudson Inc., 500 Fifth Avenue, New York, New York 10110
Reprinted 1999

Library of Congress Catalog Card Number 95-60274
ISBN 0-500-01664-X

Printed and bound in Singapore

Contents

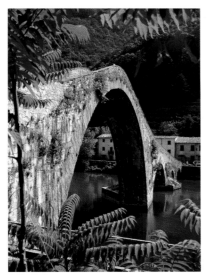

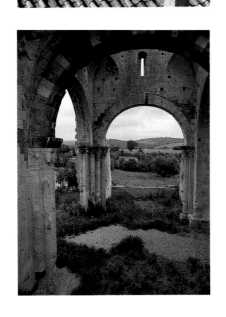

Introduction

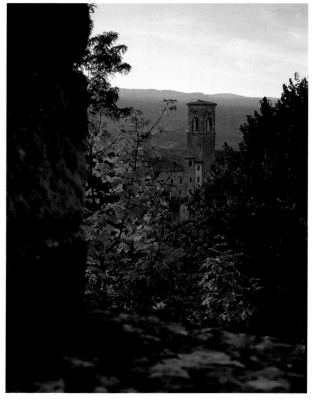

Tuscan twilight: the shadows lengthen around Poppi.

Opposite

*T*he towers of San Gimignano, the città delle belle
torre, *loom on the horizon to dominate a typically
Tuscan landscape of vineyards and cypresses.*

Although our vision of Tuscany often seems to have been
created by the artists of the Renaissance, this dream of the
land and its villages and towns is in fact a reality. Visit
Tuscany, especially travelling from north to south through the region
of Chianti, and you will discover still intact the pine trees, poplars
and hill towns, the rich cities and sleepy, beguiling *quattrocento* vil-
lages of the painters.

The architects, too, joined the artists in the enrichment of the
villages. In part, they were creating those same views that their painter
contemporaries were depicting. Monte San Savino, for instance, was
especially fortunate that Andrea Contucci was born in nearby
Poggiolo in 1460. His skills as an architect and sculptor brought him
noteworthy commissions in Florence, in Rome and as far away as
Portugal. Yet, he not only chose to live in the village, but also took its
name and built some of its finest monuments. To Andrea Sansovino,
then, it owes above all its magnificent Loggia dei Mercanti, with its
Corinthian arcades, which the architect designed in the second
decade of the sixteenth century.

Add to such architectural elements olive groves, cypresses,
rolling woodlands and, of course, the great towns of Pisa, Florence,
Arezzo, Lucca, Volterra and Siena. Add also a cuisine based entirely
on indigenous produce – the famous olive oil of Lucca, the unbe-
lievable variety of meats, the great red wines – and you have another
essential element in the classical image of Tuscany.

Yet Tuscany is immeasurably more enticing than this idyllic
vision. First, it extends geographically far beyond the region of
Chianti, so beloved of Northern visitors, and the six great towns. The
Apennines stretch along its northern and eastern limits. Its south-
western boundary is the Tyrrhenian Sea, where the coast is lined with
exquisite villages. Latium is its southern border, while to the east it
reaches Umbria and the Marches. Above Florence the countryside
known as the Mugello is more rugged, and that section of the Alps
which abuts on to Massa and Carrara, called by the Tuscans the Alpi
Apuane, is even wilder. Near Carrara, Monte Altissimo still supplies
the same pure white marble that Michelangelo used for the façade of
the Florentine church of San Lorenzo, yet another commission from
the great patrons, the Medici.

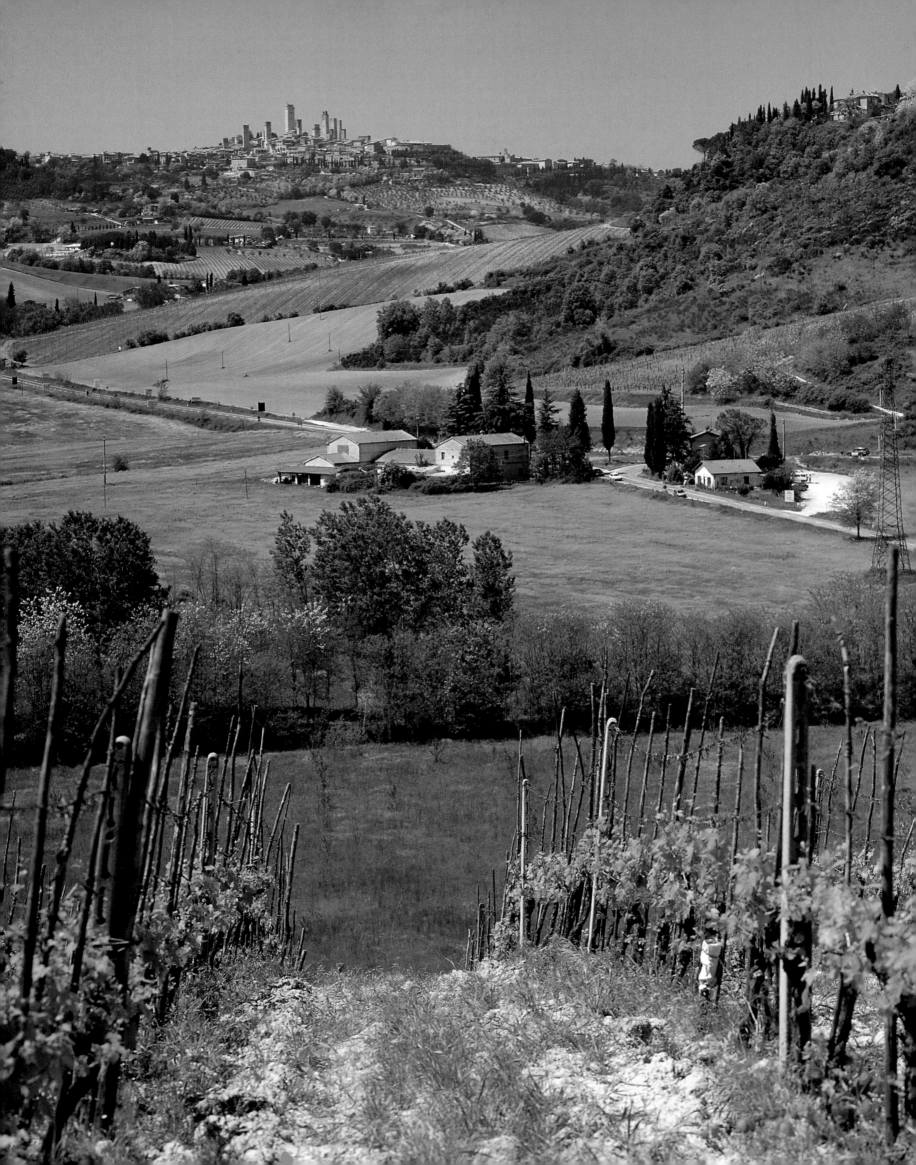

*T*uscan villages are full of sudden glimpses of wider vistas beyond; here the ancient roofs and houses of Castelnuovo di Garfagnana (above) provide a picture beautifully framed by the solid walls of the village's twelfth-century rocca. Even outside the villages and small towns, the Tuscan countryside is covered with hamlets and tiny clusters of buildings: this campanile, lavishly equipped with three bells, is tucked away in the steep hills between Stia and Camaldoli (opposite).

The greatest lovers of the landscape of Tuscany have been quick to perceive the complexity of particular regions. So, in 1818, Shelley celebrated the valley of the Arno (a valley that has scarcely changed almost two centuries later), looking out over 'first the hills of olive and vine, then the chestnut woods, and then the blue and misty pine forests, which invest the aerial Apennines, that fade in the distance.'

A captivating mixture of chestnuts, acacias, scrub oak and broom clothes the slopes of many of Tuscany's hills and mountains, while those of the interior are thickly wooded, especially majestic Monte Amiata, which rises 1738 metres above sea-level and is the highest peak south of the river Arno, sheltering crumbling villages from harsh winds. Around Volterra cornfields replace woodlands, the land still supporting a few sparse trees and riven with deep clefts (known as *balze*), where the soil has been eroded.

The region is dotted with lakes and spas, including the tiny village of Casciana Terme, set amid olive groves, its classical baths approached by tree-lined streets and Art Nouveau houses. Tuscany's valleys are threaded with rivers, which flow through such exquisite villages as Castelnuovo di Garfagnana, at the confluence of the Serchio and the Secca. Some of these river valleys proved so hospitable – particularly, for instance, that of the Orcia – that a succession of villages grew alongside them, notably the beautiful Castiglione d'Orcia and hilltop San Quirico d'Orcia.

Defence against aggressors was always a priority over scenic beauty for the Tuscan villages. Those who controlled the cities of the region longed to increase their power and fortunes. Florence and her satellites rivalled Siena and hers, and their rivalry often broke into open warfare. Strife between the Emperors and the Popes developed into a notorious struggle between the Ghibellines, who supported the Emperor, and the Guelphs, who supported the Pope. The villages and small towns of Tuscany, especially those along key routes such as the river valleys, were prized possessions in these struggles for ascendancy. Such towns and villages were necessarily fortified. Defensive hilltop sites were favoured. (The high ground also allowed the citizens to escape from malaria.) In consequence, again and again a Tuscan village is dominated by its *rocca*, or castle, today often ruined, but once of considerable strategic and defensive value.

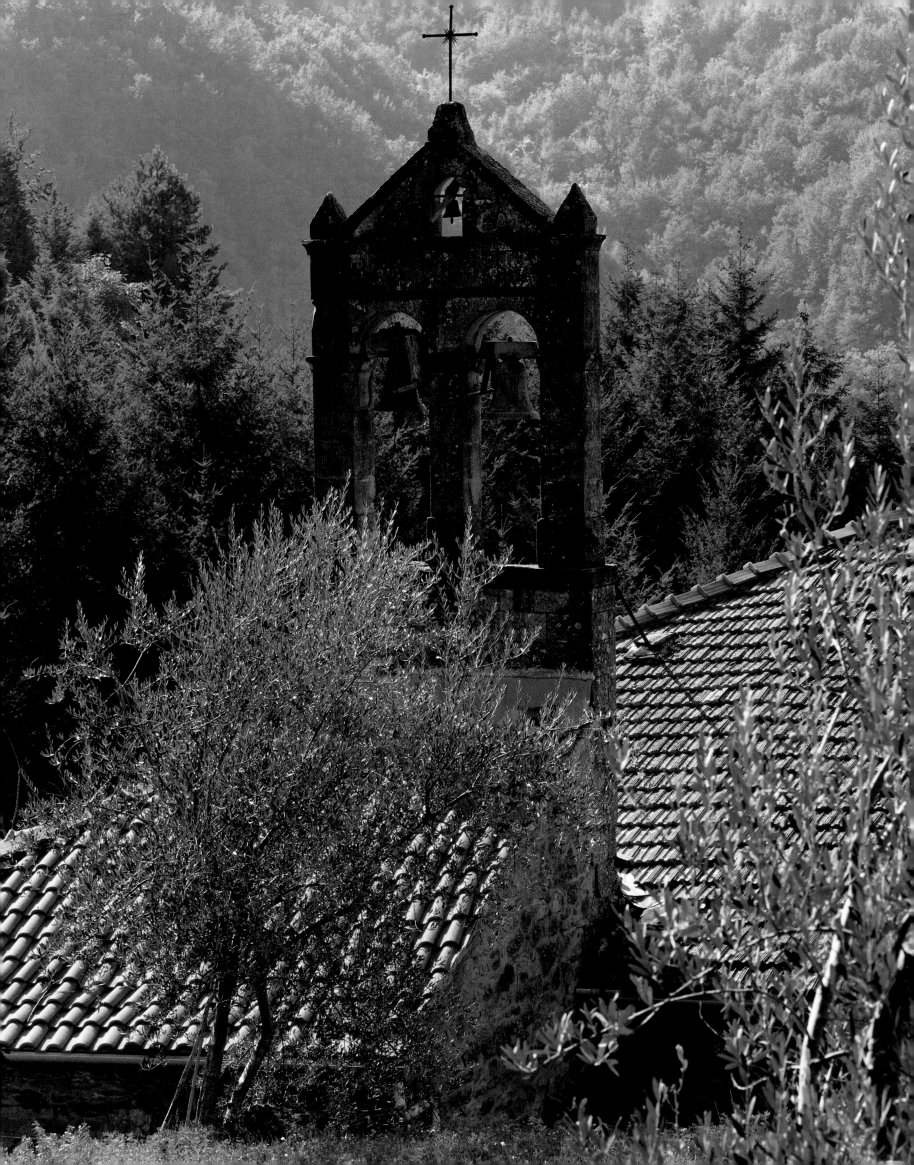

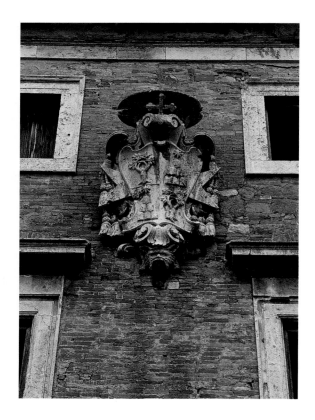

Nowhere in Europe can such small communities as the villages and country towns of Tuscany boast so much architectural treasure. The magnificently sculpted coat of arms of a Chigi cardinal decorates the façade of the Palazzo Pretorio in Casole d'Elsa (above)*, while a magnificent Renaissance doorway leads to the equally impressive interior of Antonio da Sangallo's Palazzo Comunale in Monte San Savino* (opposite)*.*

Etruria, the country of the Etruscans from which Tuscany takes its name, was taken over in 351 B.C. by the Romans, who utilized the skills of the people they had conquered and lived in their settlements. They did not destroy Etruscan civilization, which in our own era has been increasingly rediscovered by archaeologists and revealed as one of astounding artistic achievements. The Romans brought their own skills to the province, too, one of which was road-building; the Cassian Way, among the finest roads in the world, was constructed around 220 B.C. with the practical purpose of controlling Etruria. It connects Rome with Florence and Fiesole; it passes through Viterbo and the plains of Tuscia; touching the shores of Lake Bolsena, its goes by Siena before winding through the valleys between Lazio and San Quirico d'Orcia, a splendid village whose fortunes have been greatly enhanced by the presence of the road.

The Christian era saw the building of another route to run parallel to the Via Cassia. The Via Francigena was designed for pilgrims, and brought many to enrich Tuscany. In consequence, the monasteries of small villages can surprise the visitor with, for example, exquisite Irish reliquaries. In the early Christian era missionaries founded many such monasteries, alongside which grew some of the most beautiful villages we enjoy today.

Meanwhile, the Lombards united the region politically, basing their power on the city of Lucca. Charlemagne, conquering much of northern Italy in the eighth century, obliged the region to become a frontier state, its defence for the most part in the hands of the state counts of Lucca. Soon these counts would claim sovereignty over much of present-day Tuscany. Their success, however, was limited. Many Tuscan villages and towns set themselves up as free communes in opposition to their would-be lords. By playing off the Ghibellines against the Guelphs, they often managed to achieve a remarkable degree of freedom. During these later eras, however, Tuscan towns and cities were frequently also riven internally, with such feudal families as the Malaspina and the Aldobrandeschi struggling for power. Some of their palaces and fortresses remain in what are now peaceful villages. Yet experiments in republicanism and peaceful self-government also took place, a legacy visible today in Tuscan villages and towns in the form of the palace of a *podestà*, or chief magistrate.

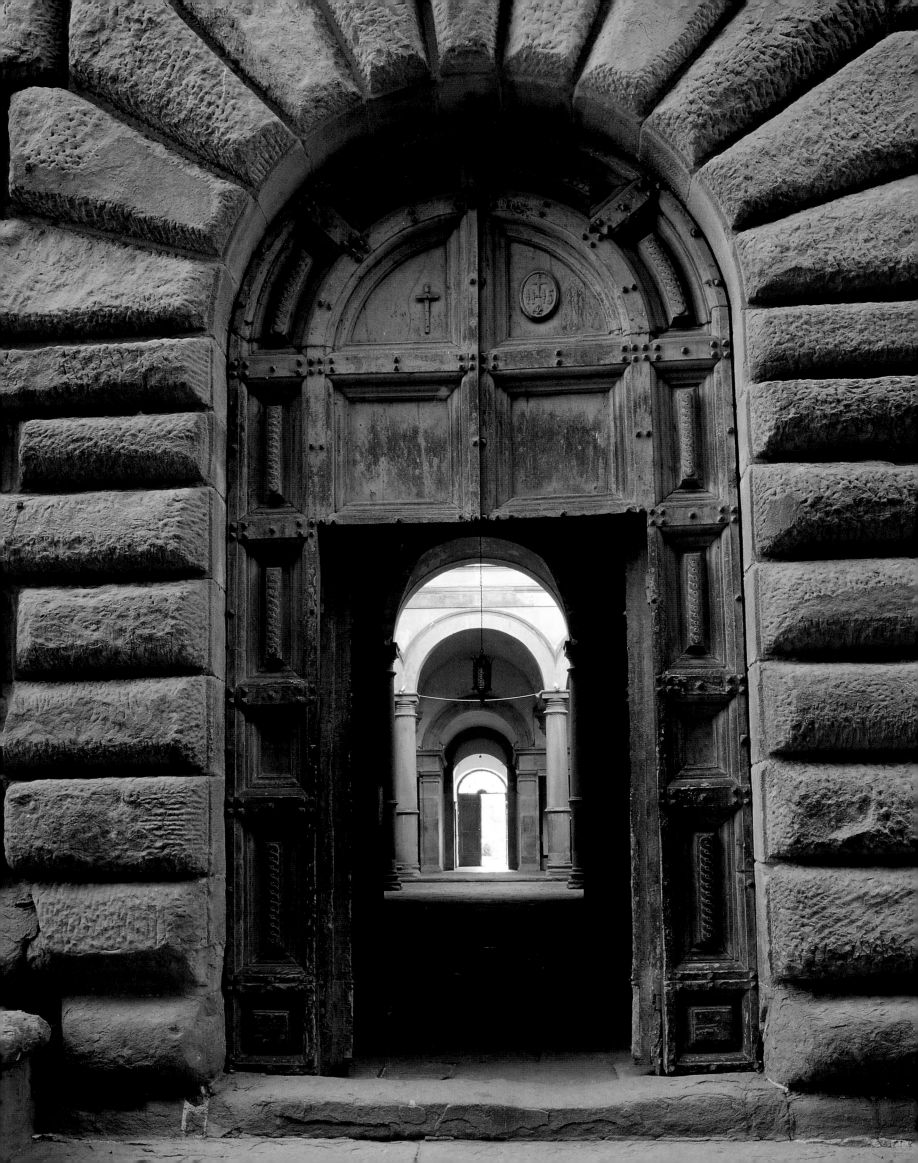

As the cities of Siena, Pisa, Lucca, Pistoia and Florence vied for overall supremacy in the province, however, the villages and small towns began to lose their independence, but they often benefited from the architects and artists patronized by their new rulers. So the great Florentine architect, Filippo Brunelleschi, who built the dome of Florence cathedral, also fortified Vicopisano after the Florentines took it in 1407. The Sienese master, Duccio di Buoninsegna, painted a Madonna and Child for the Collegiate church of Casole d'Elsa. Similarly, visitors to Montalcino are surprised to discover that Italy's greatest Gothic sculptor, the Pisan Giovanni Pisano, was responsible for the finest portal of the Collegiate church there.

The triumph of the Florentines was consolidated only in 1559, when their forces defeated the republic of Siena and Cosimo I de' Medici was declared Grand Duke. As well as asserting political supremacy, Cosimo and his Medici successors did not delay making their architectural and artistic mark on these lands. When the last Medici Grand Duke died without heir in 1737, Tuscany passed into the hands of Francis of Lorraine. His marriage to Maria Theresa brought Tuscany under the sway of the Habsburgs until they were ousted by Napoleon.

Although the Renaissance marked the finest villages and towns of Tuscany more than any other era, this should not disguise the richness bequeathed by other periods. The region's name, after all, derives from the Etruscans, and while their remains are very evident in its villages, Romanesque and medieval Gothic buildings often grace the tiniest settlement. As we approach our own era, Tuscany has embraced the Mannerist, the Baroque and the Rococo, styles by no means confined to the region's great cities.

<center>* * *</center>

Tuscany's varied countryside has created an equally varied cuisine, especially outside the large cities, in the small towns and villages. For instance, Tuscans relish a freshly baked bread, seasoned with salt and garlic, and moistened with local olive oil, a dish known in different localities as *fettunta*, *bruschetta* or *panunto*. In humble village restaurants, olive oil also flavours Tuscan vegetable soups (such as *ribollita*, made from beans and cabbage), and is often poured over *pecorino*

Typical of northern Tuscan hill villages, the roofs of Castiglione di Garfagnana rise above the variegated foliage of surrounding woods (opposite). *The very building materials of Tuscany seem part of the landscape: here the wonderfully textured terracotta of the roofs of Uzzano lends warmth and colour to the valley of the Pescia* (above).

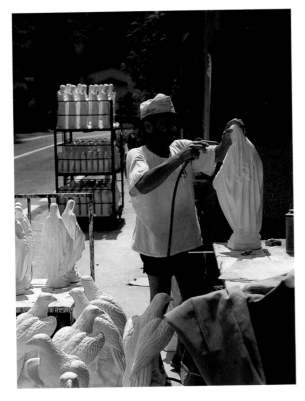

*T*raditional religious ceramic figures are a local speciality in Bagni di Lucca (top). Still promoting local ceramics, the tourist shops of San Gimignano cater for more secular tastes (above).

cheese (of which there are around a hundred varieties). It also heightens the succulence of *fagioli*, the haricot beans that feature seductively on almost every country menu. Inevitably the restaurants of the great cities offer dishes that bear their name, but one suspects that, for example, *baccala' alla fiorentina* (salted cod, fried and served with fennel, tomato and garlic sauce) originated not in Florence but in the countryside around it. Similarly, a steak grilled over a wood fire and today known as *bistecca alla fiorentina* is carved from the breed of cattle known as Chianina. The villages around Florence also serve tripe, stewed in a meat sauce and garnished with cheese, tomatoes and onions, which is termed *trippa alla fiorentina*.

Other cities have arrogated to themselves ownership of Tuscan village recipes. Red wine, tomatoes and spices add flavour to the fish dishes of the region of Livorno, now universally called *cacciucci alla livornese*. A similarly delicate fish dish from the Livorno region, today known as *tonno alla livornese*, consists of tuna fish cooked in a garlic and tomato sauce, which is also served in this region with red mullet (*triglie*). Baby eels are nowadays often served under the name *ciechi alla pisani*. But dishes such as these were created not in Pisa or Livorno but by village housewives whose menfolk had caught the fish and grown the ingredients.

The authentic home of all these dishes is the Tuscan village. And though the overweening cities may have claimed their recipes, many of the villages celebrated in this book still have their traditional gastronomic specialities. Tuscan cakes, for instance, include the powerful cinnamon- and honey-flavoured *panforte* of San Gimignano, which is crammed with almonds, hazelnuts and candied fruits.

Equally varied is Tuscan wine. Fittingly, Italy's major wine showcase, the Enoteca Italiana, is housed in Siena's Medici fortress. Many a variety is the proud speciality of an individual village or town, its vineyards stretching away outside its walls. So San Gimignano boasts that its Vernaccia di San Gimignano, reputed since the thirteenth century, was the first Italian wine to have gained the coveted cachet Denominazione di Origine Controllata.

Chianti is produced in five of Tuscany's provinces (along with a less well-known dry white named Val d'Arbia) and quintessential Tuscan wine villages such as Radda in Chianti and Castellina in

Chianti derive some of their attraction from its renown. Many other fine wines of the region are intimately connected with specific villages. They include the rich-red, violet-scented Carmignano, grown near Artimino, and the ruby-red Brunello di Montalcino, whose colour turns to garnet as it ages. Further east of Montalcino, the vineyards beyond San Quirico d'Orcia produce the grapes which create Vino Nobile di Montepulciano, a red wine whose origins go back to the fourteenth century. In the Chiana valley, stretching southwards from the province of Arezzo to that of Siena, white grapes produce the straw-yellow, greeny Bianco Vergine Valdichiana.

Name a Tuscan village and you often name a Tuscan wine. Consider the lie of the land, and you begin to understand the wine's character, for it is not only the grapes but also the diverse soils of Tuscany which add their especial flavour to the wines grown beside these villages. Bianco di Pitigliano, for instance, derives from grapes nurtured on a strip of volcanic land stretching from Lake Bolsena towards the hilltop village of Pitigliano. It differs markedly from Bianco di Pisano di San Torpè, even though the basic grape variety (*trebbiano toscano*) is the same. This same grape is also used in the making of Candia dei Colli Apuani, but here the flavour is distinctive, in part because of the hilly terrains of the province of Massa which support the vines. Created in Scansano (a medieval agricultural village in the province of Grosetto), the red and white Morellino di Scansano likewise derives some of its character from the contours and the climate of the hills between the rivers Ombrone and Albegna. Other provinces pride themselves on their wines, gathered in from the villages surrounding the great cities. So around Pisa many vintners produce red, white and rosé Val di Cornia. The Lucchesia, a lush green part of the province of Lucca, produces its very individual reds and whites. Around the medieval village of Montecarlo in the same province is produced a distinctive red and white variety.

* * *

So this book is about a more secret Tuscany than that of the great cities. As D. H. Lawrence noted in the nineteen-twenties: 'Tuscany manages to remain so remote, and secretly smiling to itself in its many sleeves, . . . there are so many hills popping up, and they take

*T*uscany in gastronomic profile: a San Gimignano butcher scrutinizes the head of a wild boar (top); in Radda in Chianti a vineyard proclaims its production of the region's most famous wine, symbolized by the black rooster (above).

Sign of Tuscany's rich and colourful past; this well-head (above) at Pitigliano is decorated with a bear, emblem of the powerful and warlike Orsini family. It is indeed hard to believe that this region was the scene of so much strife and dissent in the late Middle Ages and the Renaissance period when we regard the supremely peaceful and intensely cultivated landscape of Tuscany, like the vineyards near San Gimignano (opposite).

no notice of one another. There are so many little deep valleys with streams that seem to go their own little way entirely, regardless of river and sea. There are thousands and millions of utterly secluded little nooks, though the land has been under cultivation these thousands of years. But the intensive culture of vine and olive and wheat, by the ceaseless industry of naked human hands and winter-shod feet, and slow stepping, soft-eyed oxen does not devastate a country, does not denude it, does not lay it bare, does not uncover its nakedness, does not drive away either Pan or his children. The streams run and rattle over wild rocks of secret places, and murmur through blackthorn thickets where the nightingales sing altogether, unruffled and undaunted.'

Any account of Tuscany which simply concentrated on the major towns and cities would exclude the artisans, farmers, craftsmen and their families, whose skills have been honed over centuries. Their inheritance is abundant. Quintessential Tuscany expresses itself in a complex yet harmonious village like Pitigliano, which tops a volcanic hill, boasts Etruscan tombs, derives its water from a fifteenth-century aqueduct, surrounds a palace built by the Orsini family, creates its own wine and worships either in the Renaissance Santa Maria or, in the midst of its medieval quarter, in a Baroque church.

AUTHOR'S NOTE

The villages and small towns which are the subject of this book are divided into three groups: the hinterland of Florence and Lucca, the central area around Siena and Arezzo, and the south. The order of place is roughly north to south, with diversions east and west, reflecting the most frequent route taken by visitors to Tuscany.

Although a number of the places described here could be considered more extensive in area and population than the word 'village' suggests, this nevertheless seems to be the most accurate way of conveying the tightly-built, individual character of what are, in a number of cases, small towns. At the height of Tuscany's power in the late Middle Ages and the Renaissance period, its communities grew, prospered and acquired artistic and architectural treasure. But even as they grew, they retained a quality of intimacy which has remained to this day – hence the title of this book.

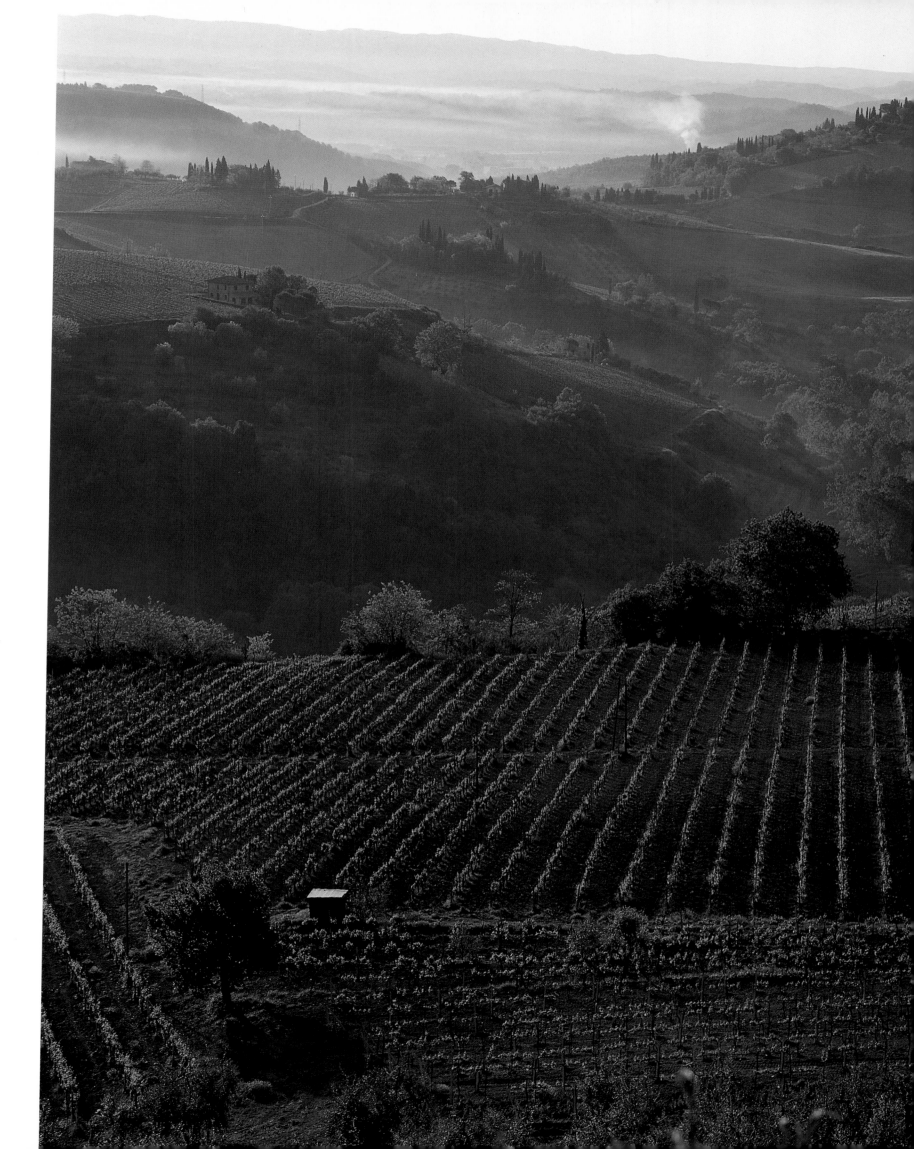

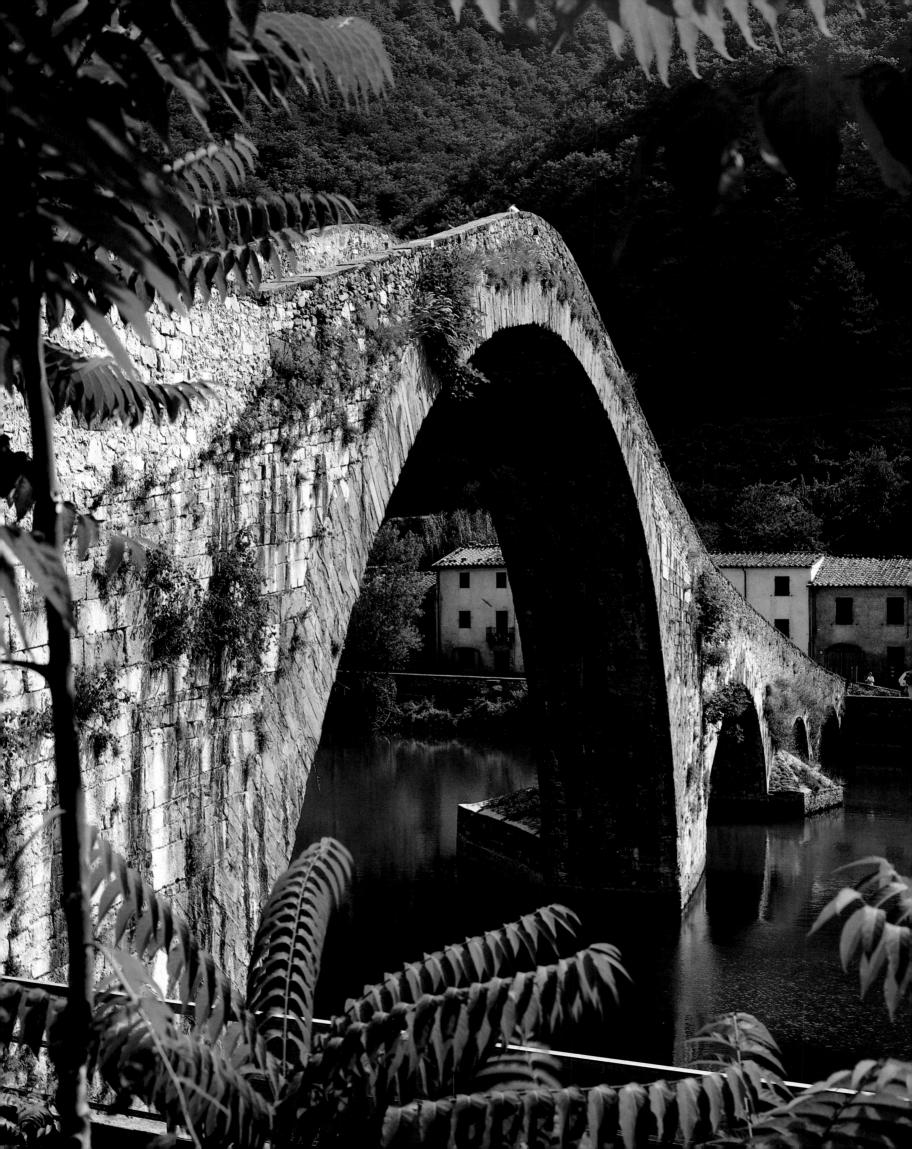

Around Florence and Lucca

Bagni di Lucca

Castelnuovo di Garfagnana

Castiglione di Garfagnana · Cutigliano

Uzzano · Collodi · Vicopisano · Artimino

Scarperia · Vicchio · Stia · Poppi

Camaldoli

Opposite
The delightfully irregular Ponte della Maddalena, a beautifully preserved medieval bridge, spans the river Serchio at Bargo a Mozzano, on the route to the area of northern Tuscany known as the Garfagnana.

A view of Florence, the most influential city of Tuscany, in an eighteenth-century engraving.

'WE TOOK UP OUR QUARTERS at the Pension Suisse,' wrote George Eliot's husband of their visit to Tuscany in 1860, 'and on the first evening we took the most agreeable drive to be had round Florence – the drive to Fiesole. It is in this view that the eye takes in the greatest extent of the green billowy hills; besprinkled with white houses looking almost like flocks of sheep; the great silent uninhabited mountains lie chiefly behind; the plain of the Arno stretches far to the right.'

Inevitably, Florence and its superb environs dominate any visitor's memory of Tuscany. The city boasts many great public buildings, its Duomo and churches, its markets, statues and galleries. Outside, the landscape is one of vineyards, olive groves and cypresses. Yet virtually everything that Florence has to offer can be found, in miniature so to speak, in the villages that surround it and stretch as far west as Lucca and Pisa and thence north to La Spezia. Artimino and Collodi, for instance, offer villas as splendid as any surrounding the capital of the province.

The region known as the Mugello lies north-east of Florence, part of its territory included in the National Park of Monte Fasterone. Less accessible than many other parts of Tuscany, even a trifle hostile, though the valleys are cultivated and vineyards are plentiful, this is a region of walking routes and nature paths. Here, too, are the villages of Vicchio (birthplace of both Giotto and Fra' Angelico) and Scarperia, a Florentine outpost designed to protect its northern flanks from invaders.

A quite different countryside awaits the visitor in the part of Tuscany east of Florence which is known as the Casentino. Here grow superb forests and, set among them, remote monastic foundations, such as the one associated with the exquisite village of Camaldoli, as well as the first home of the Vallombrosan order (founded at Vallombrosa in 1040 and today surrounded by firs, beeches and pines) and the monastic foundation at La Verna, where St. Francis is said to have received the stigmata in 1224. Such monasteries patronized the greatest religious artists. The Della Robbia family, for instance, carried out commissions from the monks of Camaldoli.

Lucca likewise lies at the centre of a remarkable landscape, with its own particular qualities. To the south rises Monte Pisano, with the village of Vicopisano on its sunny side, close by the spas of Uliveto

Terme and Casciano Terme. North of the city the river Serchia and its tributaries, the Secca and the Lima, flow through the region known as the Garfagnana. Over the centuries their waters have cut their way through the mountains that dominate this wild area, whose villages are graced by often startlingly beautiful architecture. At the northernmost part of Tuscany the region still seems more Alpine than Apennine, belonging more to the ancient Lombards than to the modern Tuscans. Much fought over, this is a landscape dotted with fortresses, many of which, like the mighty example at Fosdinovo, were built by the Malaspina family.

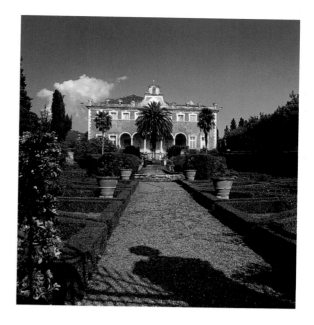

As well as boasting richly endowed villages and small towns, Tuscany is notable for its wealth of elegant villas and larger houses, often very close to or integrated with the local community; the Villa Malaspina, for instance, stands just outside the village of Fosdinovo.

The western part of the Apuan Alps natural park adjoins this part of Tuscany. Founded in 1985 and extending over fifty-four thousand hectares, its highest peak (Monte Pisanino) rises to 1946 metres above sea level. Here are deer and mountain goats and wild boar. Beeches and chestnuts clothe the landscape. Marble is quarried, some of it from ancient, some from modern quarries. This is Tuscany's favourite region for mountaineering and walking, with many marked trails and climbing routes as well as shelters and refuges.

Tuscany's most important winter ski resort lies, however, to the east, at Abetone in the province of Pistoia, north of the village of Cutigliano. The rugged landscape there is as fine as any in the whole of Tuscany. The Pistoian hills are green in summer and snow-bedecked in winter. Much of the area is covered by a forest of silver firs, larches, beeches, maples, birches and pines. The natural park of Migliarino, San Rossore and Massaiuccoli near Pisa covers twenty-one thousand hectares and encompasses a number of beautiful lakes. It includes the coast between Livorno and Viareggio, and the San Rossore estate, which belongs to the President of Italy and has a park open to the public. Here ancient marshes and pine forests nurture roe, deer, wild boar, and other game, as well as providing nesting places for such endangered species of bird as the marsh harrier.

There are also gentler vistas. The mountains around Volterra change colour dramatically with the seasons. Between the Apuan Alps and the sea are market gardens and olive groves. Flower nurseries and vineyards dot the fields on the borders of Pistoia and Lucca, where the vines produce a relatively unknown but attractive wine named Bianco della Val di Nievole. From the province of Livorno comes Biancho i Bolgheri, while the province of Pisa offers Chianti delle Colline Pisane, Il Bianco di San Torpè and Il Montescudaio.

Tuscany also has its wilder side; there we look north towards the high peaks of the Apuan Alps, between Massa on the coast and Castelnuovo di Garfagnana.

22

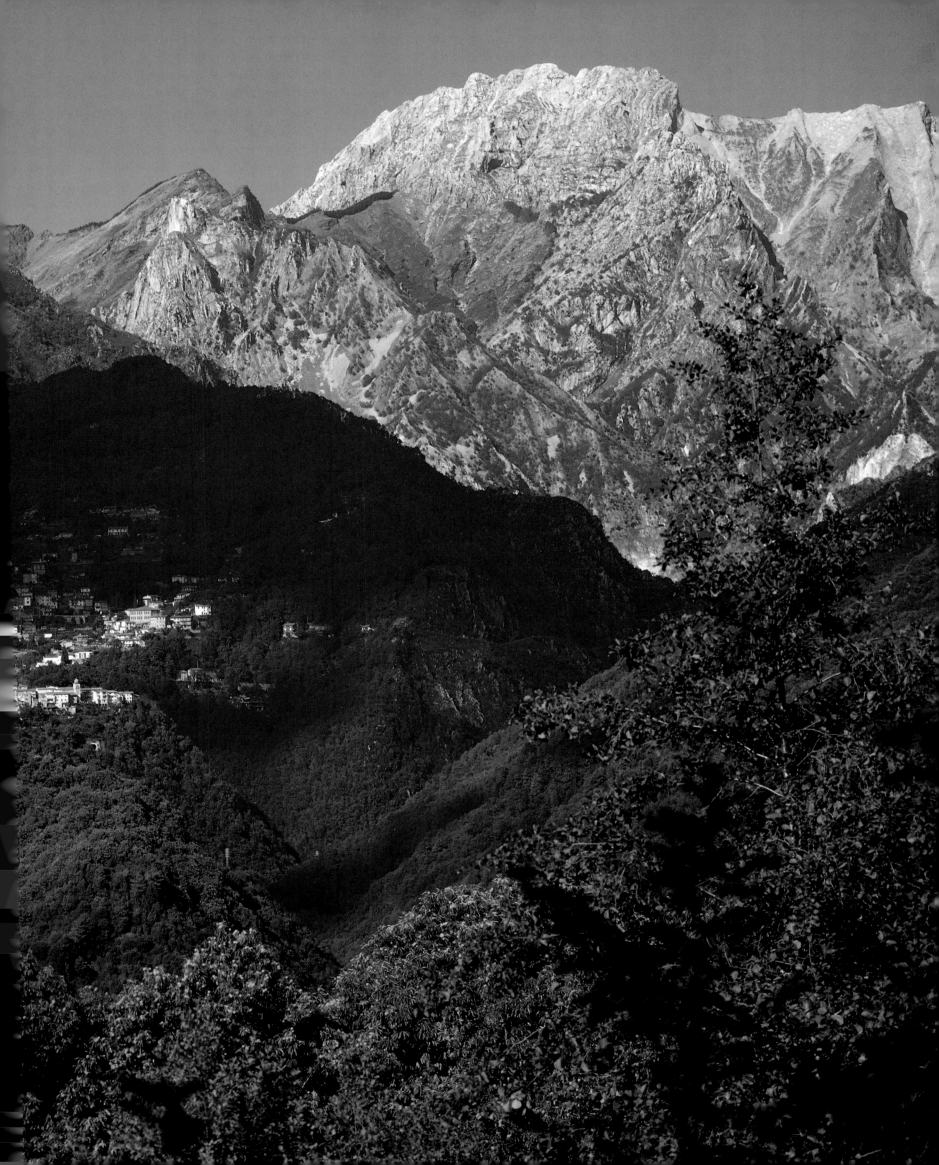

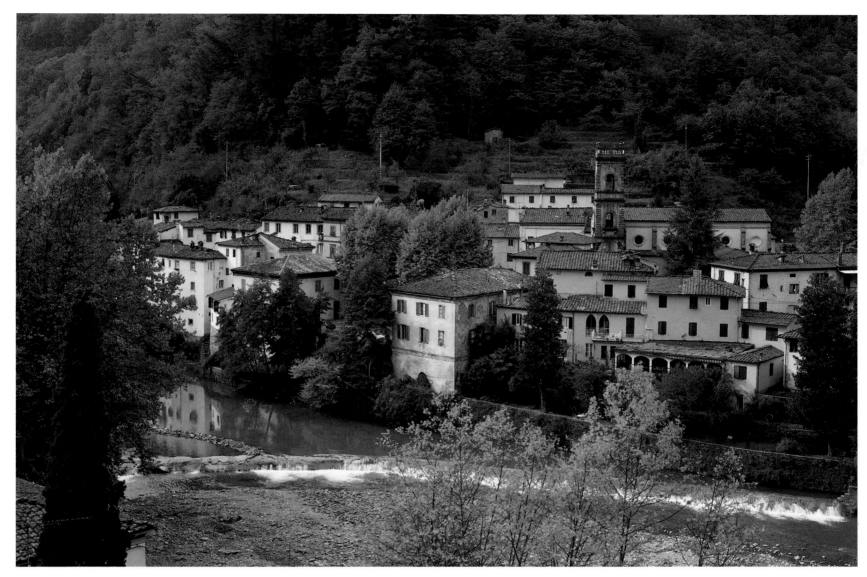

TUSCANY's hills are riddled with springs, and the reputation of their curative value goes back to Roman times. Bagni di Lucca earned a testimonial from a grateful Emperor Frederick I in 1245, but it was not until the sister of Napoleon ordered a good road to be built in 1805 that it became a boom spa town.

Its setting could hardly be more romantic. Surrounded by thickly wooded hills, it threads its way along the banks of the river Lima, a *torrente* that lives up to its name for once, rushing melodiously over a flat bed of rocks. The oldest bathing establishment of the town hangs high above the main bridge, Ponte a Serraglio, which gives its name to the centre. The vast and grandiose Bagni Caldi are now an atmospheric ruin, but beneath, burrowed into the rock from which the hot springs rise, an up-to-date hydro still draws adherents to its *grotto al vapore*.

Upstream from the bridge is La Villa, focus of the main development in the last century. It is named after the Villa Ada, a stylish sixteenth-century affair with a distinctive tower. Shelley rented a villa in the wooded hills around Bagni di Lucca shortly before his fatal return to the coast. Many other luminaries, including Heine, Byron and Montaigne, were regular visitors to the town. From the eighteen-thirties there developed a thriving community of British expatriates, who left many monuments to themselves, including an Anglican church in 'Gothic Alhambra' style, which stands in the Viale Evangelina Wipple. Mrs. Wipple and many of her fellow doyennes ended up in the half-ruined Cimitero Inglese, although not all are as obscure: the cult novelist of the Edwardian era, Ouida, is buried here.

In its heyday Bagni di Lucca had a Neo-classical theatre and a choice of splendid baths. One of them, Ospedale Demidoff, is set off by a fetching Tempietto. Also on offer were a smart Foreigners' Club (Il Circolo di Forestieri) and a thriving Casino. This was built in 1838 and the game of roulette was invented at its tables. The place has had a less worldly air since its decline from the height of fashion, but that is certainly in its favour. The gently decaying evidence of past grandeur blends very pleasingly with the sleepy charm of the town. The sense of history and times gone by make Bagni di Lucca an excellent starting point for an exploration of this northern region of Tuscany.

Bagni di Lucca

Once a fashionable spa town in the nineteenth century, Bagni di Lucca retains a grace and elegance not usually associated with so small a place. Substantial houses (above) *line the river Lima, here seen from the Bagna Bernabo. Looking south* (opposite), *Bagni di Lucca sits snugly among its plane trees.*

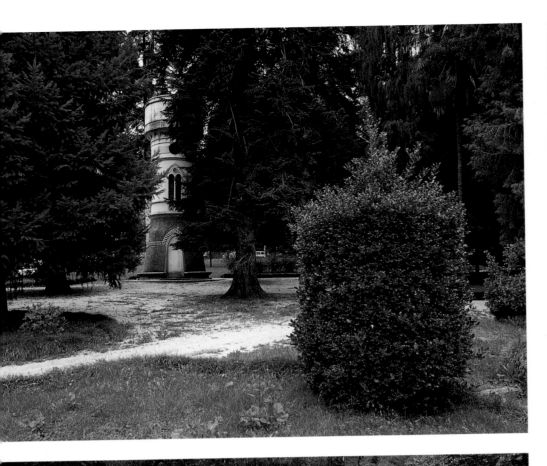

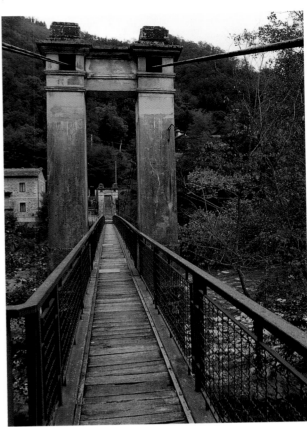

*R*eminders of the golden age of Bagni di Lucca (clockwise): a Gothic water-tower, the suspension bridge, the tomb of Edwardian novelist Ouida, and the Neo-classical Tempietto Demidoff.

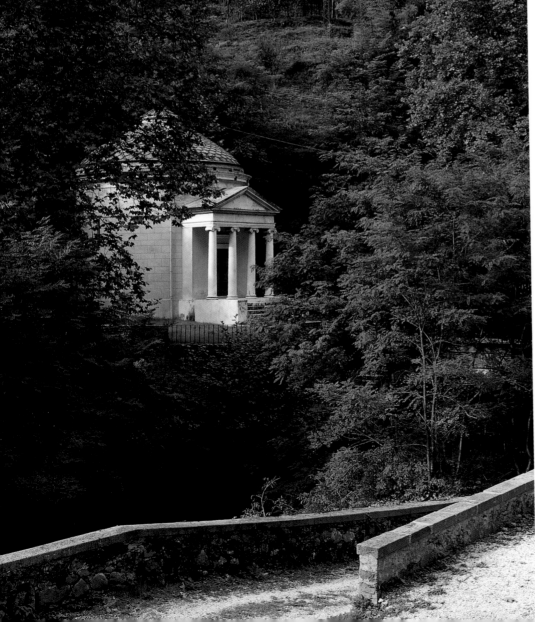

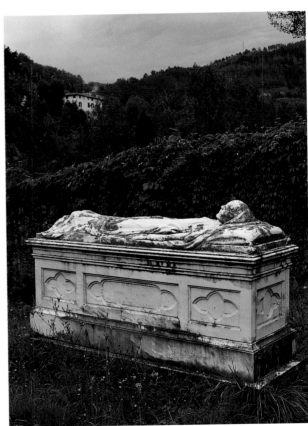

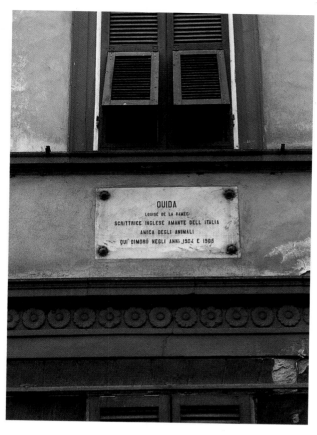

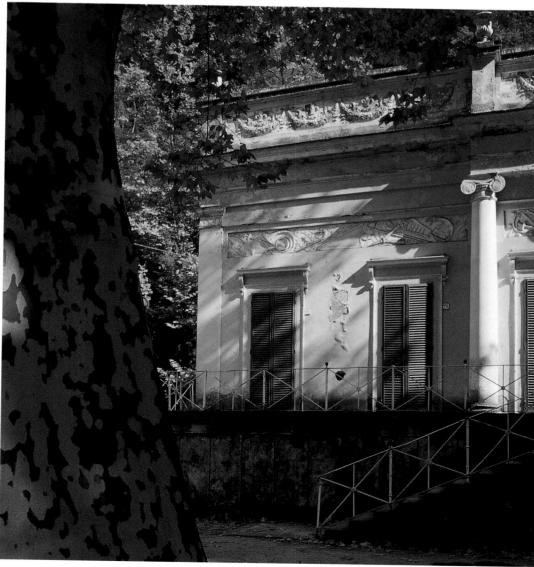

The exquisite detailing of Bagni di Lucca (clockwise): Gothic decoration on Giuseppe Pardini's English Church, Ouida's home, the Casino of 1844, and the park leading to the Bagni Caldi.

In the hills above Bagni di Lucca lies the tiny picturesque village of Montefegatesi, surrounded by a thick forest of chestnut trees.

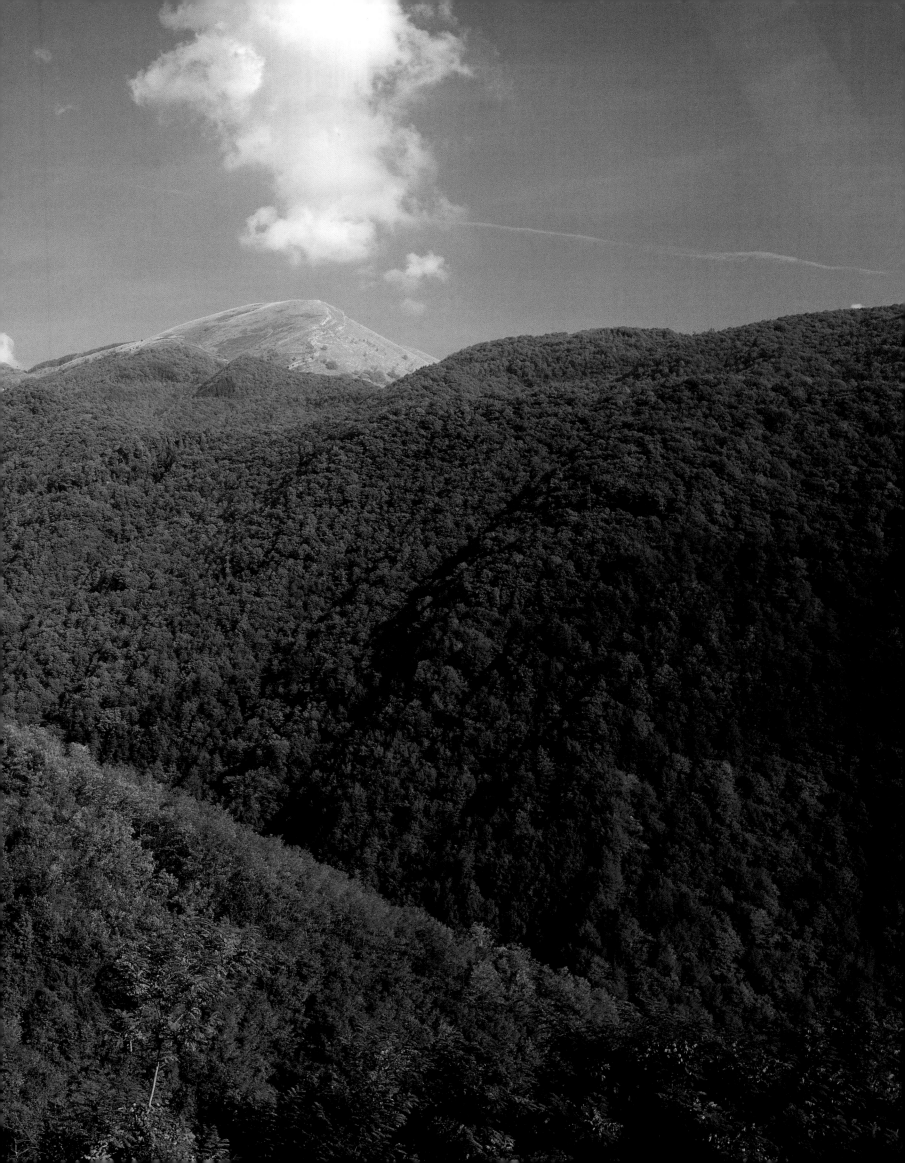

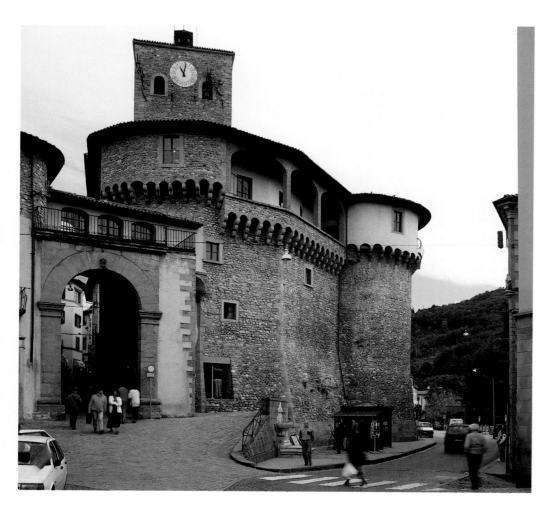

Castelnuovo di Garfagnana

AT Castelnuovo di Garfagnana the twelfth-century fortress, which dominates this picture-book village and is known as the 'Rocca Ariostesca', served as the home of two Tuscan poets: Ludovico Ariosto, who lived there from 1522 to 1525, and Fulvio Testi, from 1630 to 1642. Both were from the celebrated Este family and both were governors of the town, which rests in the green Serchio valley where that river meets the Secca.

Castelnuovo di Garfagnana boasts an early six-teenth-century Renaissance cathedral (excellently restored after damage during the Second World War) in which is housed a fifteenth-century crucifix and an early sixteenth-century reredos, attributed to Domenico Ghirlandaio. Don't miss, in the sacristy, a Madonna with Saints James and Andrew by Giovanni Antonio Sogliani.

To the north of the village stands a convent founded by Alfonso II d'Este, who gave his name to nearby Monte Alfonso, died in 1644 and is buried inside the convent church. A seventeenth-century painting here depicts St. Francis receiving the stigmata.

Each Thursday the villagers flock to their local market, where you can buy the specialities of the region, particularly terra-cotta and plaster figurines, as well as honey, cheese and (in season) walnuts.

A reminder of Tuscany's troubled, warring past: the mighty rocca *and gateway (above) built to protect the entry to this mountain village. Within its protected perimeter lies the heart of Castelnuovo di Garfagnana (opposite), where the houses of its oldest quarter jostle each other in engaging confusion.*

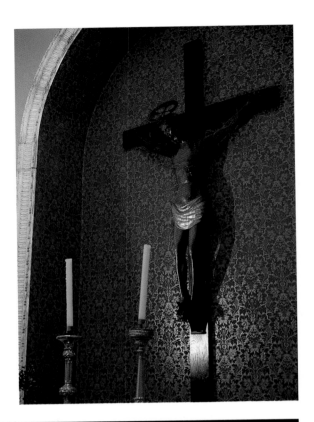

*T*he riches of Castelnuovo di
 Garfagnana (this page,
clockwise): *a fourteenth-century
'Black Christ'; Madonna and the
Two Saints* by Ridolfo Ghirlandaio
*in the Duomo; a Della Robbia
terracotta altarpiece; one of the many
fine Renaissance houses.*

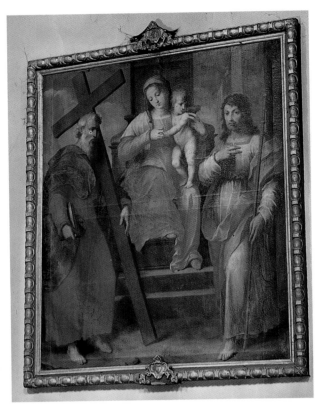

*T*raditional Tuscan street life (opposite) *makes the
 centre of Castelnuovo an animated place* (below),
while elegant town houses rise outside its walls (above).

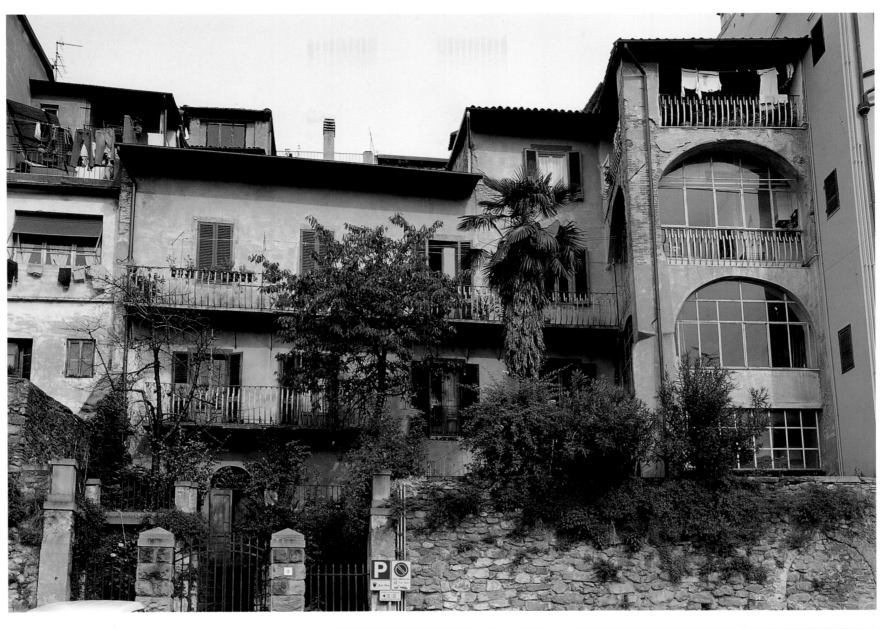

Castiglione di Garfagnana

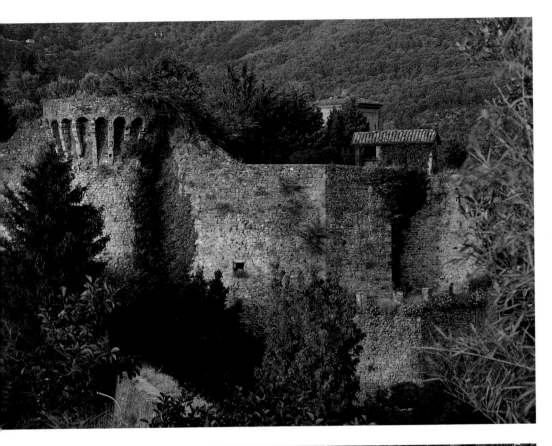

THIS VILLAGE of just over 2000 inhabitants sits beguilingly on the slopes of the Apuan Alps. Still surrounded by the fortifications and the late fourteenth-century *rocca* erected by its former Luccan rulers, it yields superb panoramic vistas of the surrounding countryside, particularly entrancing in summer, when asphodels, blue gentians, white jonquils and scarlet peonies bloom in the forested hills below the mountain peaks.

The early fifteenth-century church of San Michele houses exquisite works of religious art, notably a sixteenth-century marble tabernacle on the high altar, an impressive fifteenth-century wooden crucifix, a fifteenth-century silver thurible in the shape of a medieval castle (kept in the sacristy) and the sole work definitively attributed to Giuliano di Simone of Lucca, a Madonna and Child of 1389. The village boasts two other fine churches: San Pietro, built in the thirteenth century, notable for the painted wooden statues in the choir, and the Romanesque San Francesco.

This is winter sports and trekking country, with mountain footpaths laid out by the Italian Alpine Club. A few kilometres to the south, at San Pellegrino in Alpe, there is a twelfth-century hospice, now transformed into a museum devoted to the life of the local peasantry over the centuries. Local traditions live on, particularly in the frugal yet satisfying cuisine of the region: *polenta* (a mush of corn meal) with stewed rabbit; another different variety of *polenta*, made out of chestnut flour and served either with sausages or pork bones; then bean soups and ricotta cheese.

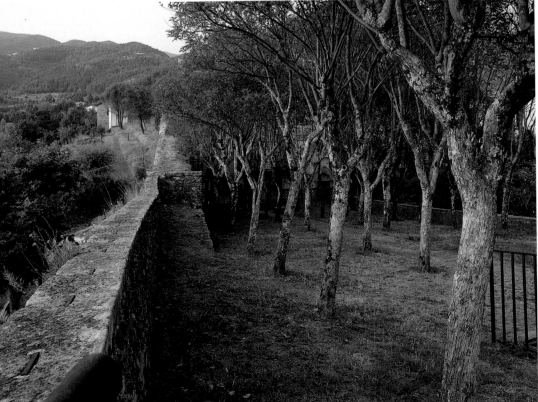

Like many a Tuscan village concerned with its defence, Castiglione is dominated by its rocca (above), *built by the lords of Lucca in 1371. Fourteenth-century fortifications extend around the west end of the village* (below), *and this panoramic view* (opposite) *shows how the whole surrounding landscape is dominated by the siting of Castiglione.*

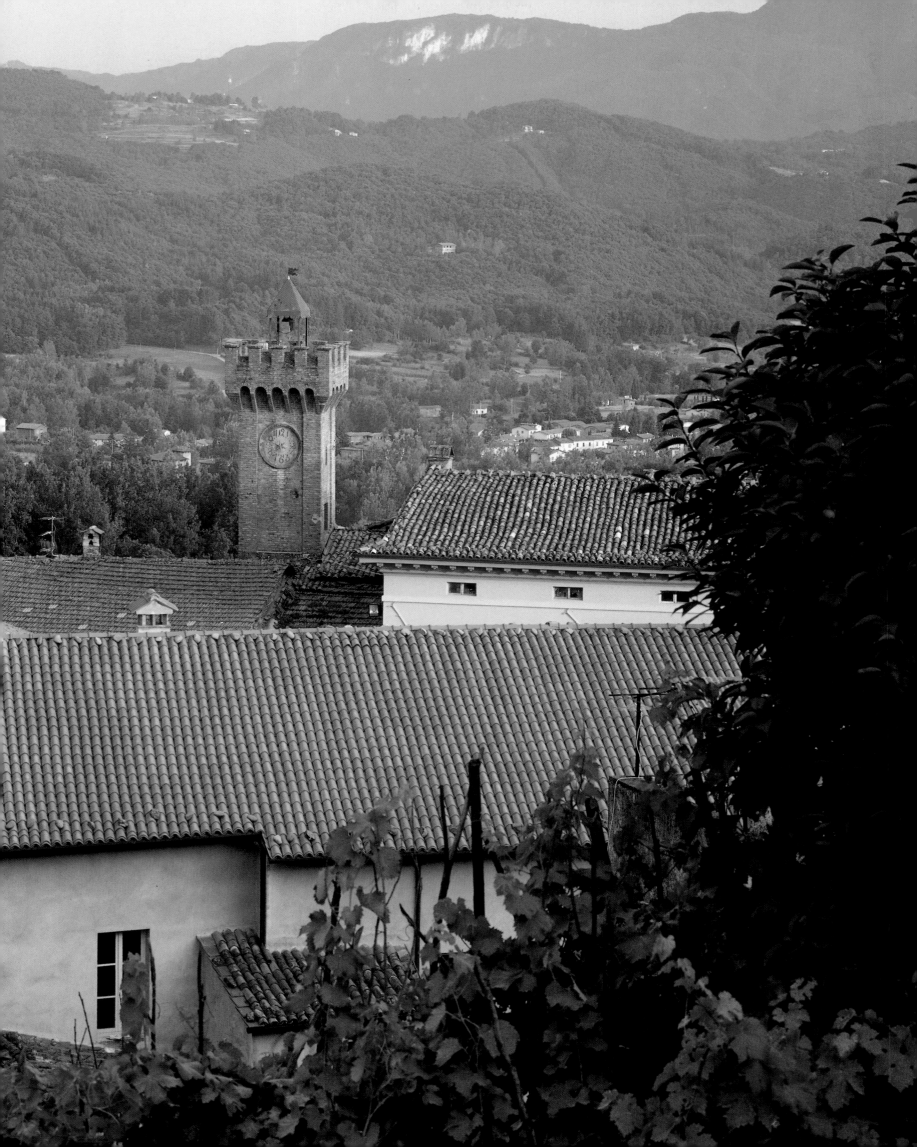

*C*astiglione, in common with many villages and towns of the region, boasts visual delights, both grand and intimate, from the Romanesque façade and bell tower of San Francesco (above, left *and* right) to a flower-bedecked terrace beneath a terracotta roof. One of the village's great treasures is this Madonna and Child (opposite), *painted in 1389 by Giuliano di Simone and his only signed work.*

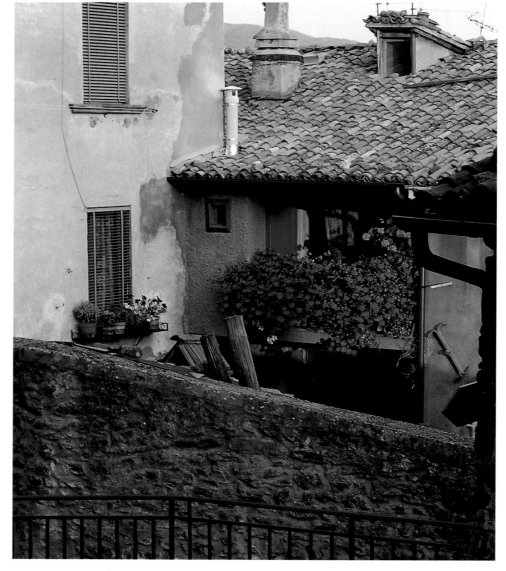

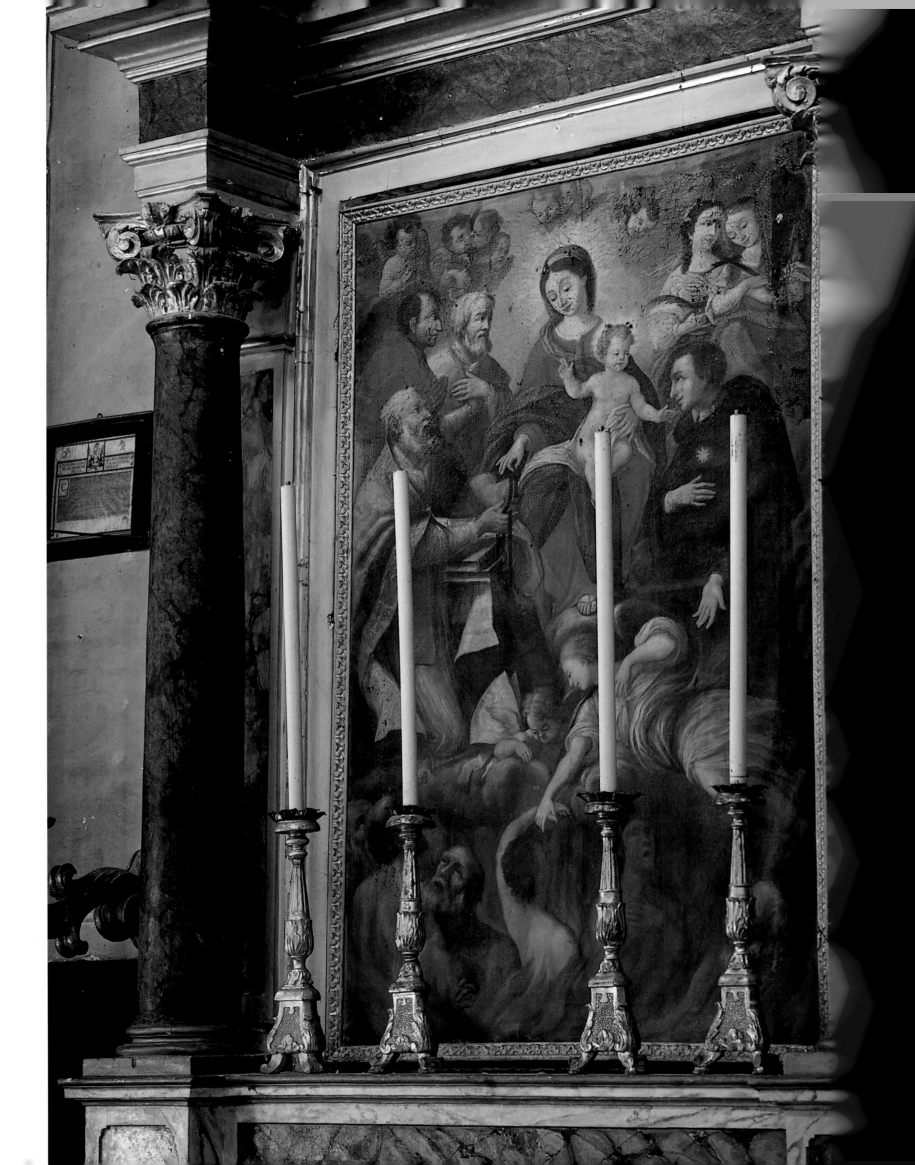

*T*he deep valley of the river Lima is overlooked by numerous north Tuscan hill villages; here, the tiny community of Lucchio hangs precariously above the deep gorge of the river.

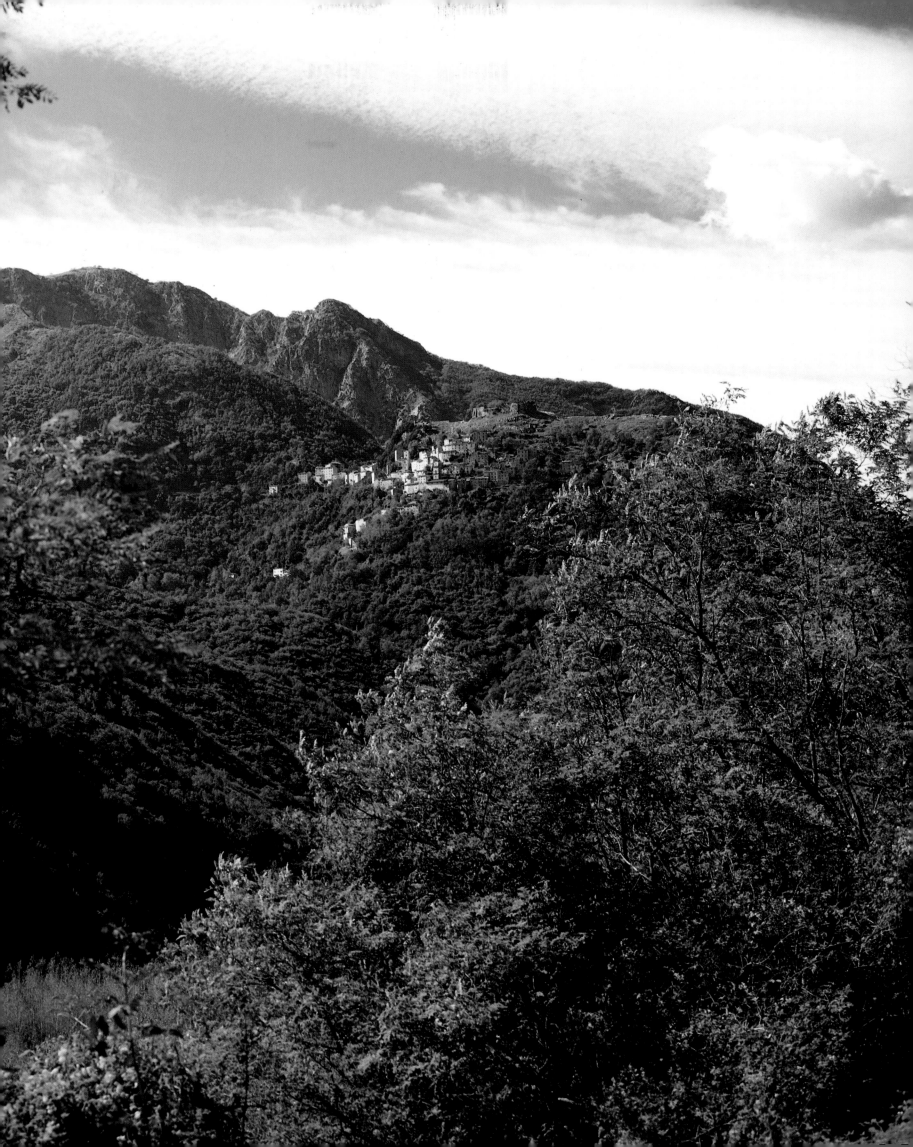

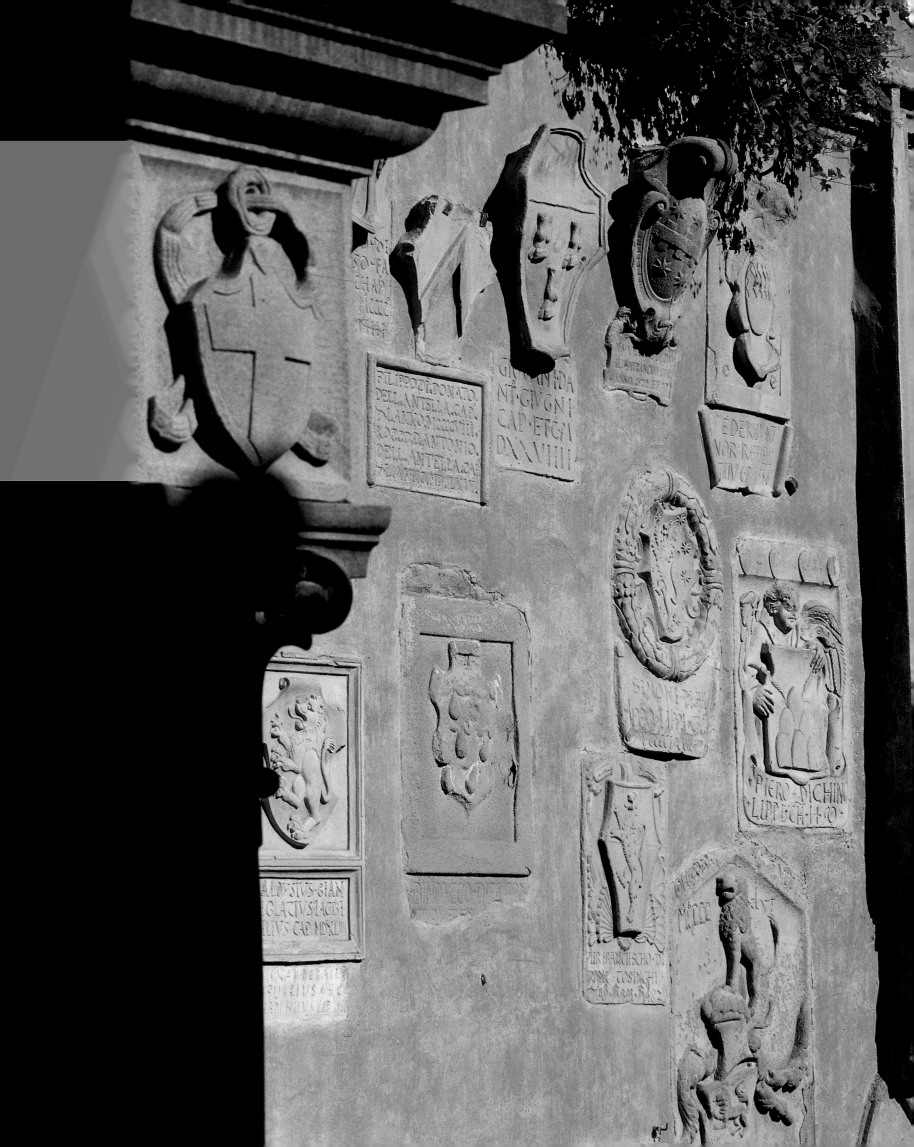

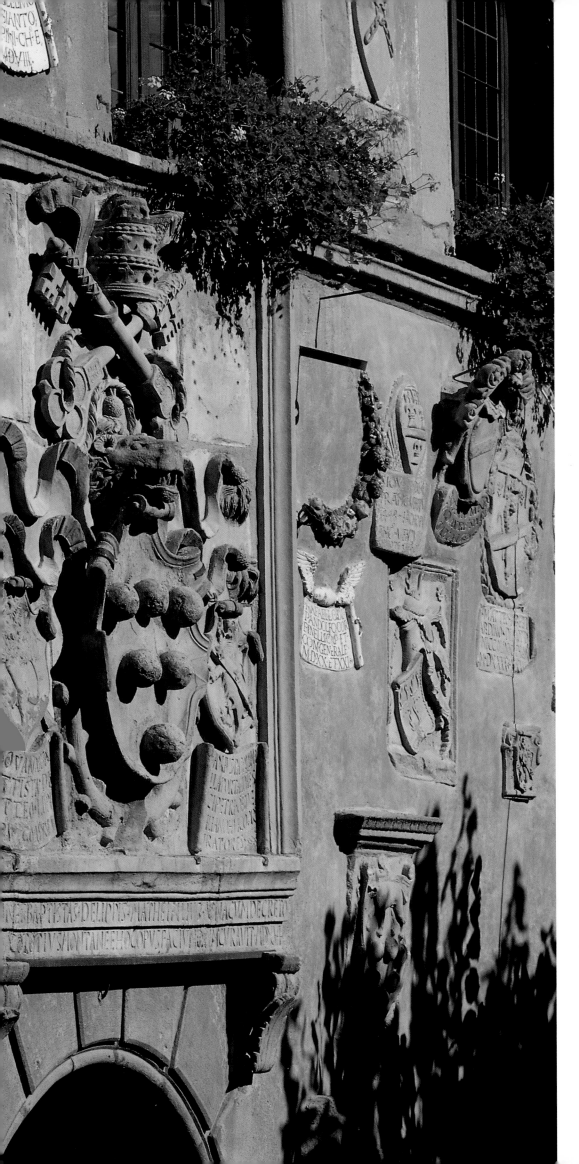

Cutigliano

SIX HUNDRED and seventy metres above sea level, Cutigliano is both a summer holiday resort and an Apennine centre for winter sports, with ski lifts, cross-country ski routes and a three-kilometre-long funicular railway which climbs first to the ski resort of Doganaccia, whence a second funicular takes you a kilometre higher to Croce Arcana. Sheltered by the Cúccola, overlooking the valley of the Lima and surrounded by dense forests, Cutigliano is a base for entrancing walks, particularly up the Cúccola, which rises to 1042 metres above sea level and offers delightful panoramas of the surrounding countryside.

At its heart, Cutigliano is a fascinating medieval village. Here the architectural treats include the fourteenth-century Palazzo Pretorio which was built by the seven major communes of the Pistoian mountains in the fourteenth century and rebuilt in the sixteenth. Its façade is enlivened with the carved coats of arms of the medieval rulers of these communities.

Cutigliano's parish church rises at the extremity of the village. Several minor Tuscan masters have bequeathed works of art to this church, including Giovanni da San Giovanni, Masaccio's brother, whose *Circumcision of Jesus*, painted in 1620, decorates the left wall of the sanctuary, Sebastiano Vini, who in the fifteenth century painted a miracle of St. Bartholomew (he is curing a madman) for the high altar, and the seventeenth-century Nicodemo Ferrucci whose *Birth of the Virgin* graces an altar in the left aisle.

At the centre of the village stands a second church, the Chiesa della Compagnia, inside which is a masterpiece by the Della Robbia family: an altarpiece in enamelled terracotta depicting the Madonna and Child between Saints Anthony and Bernardino of Siena.

These imposing escutcheons on the façade of Cutigliano's fourteenth-century Palazzo Pretorio include the distinctive arms of a Medici Pope.

*F*amed for its mountain spring (below), *Cutigliano*
also boasts pleasantly shaded streets, many fine
houses and a majestic church (above *and* opposite).

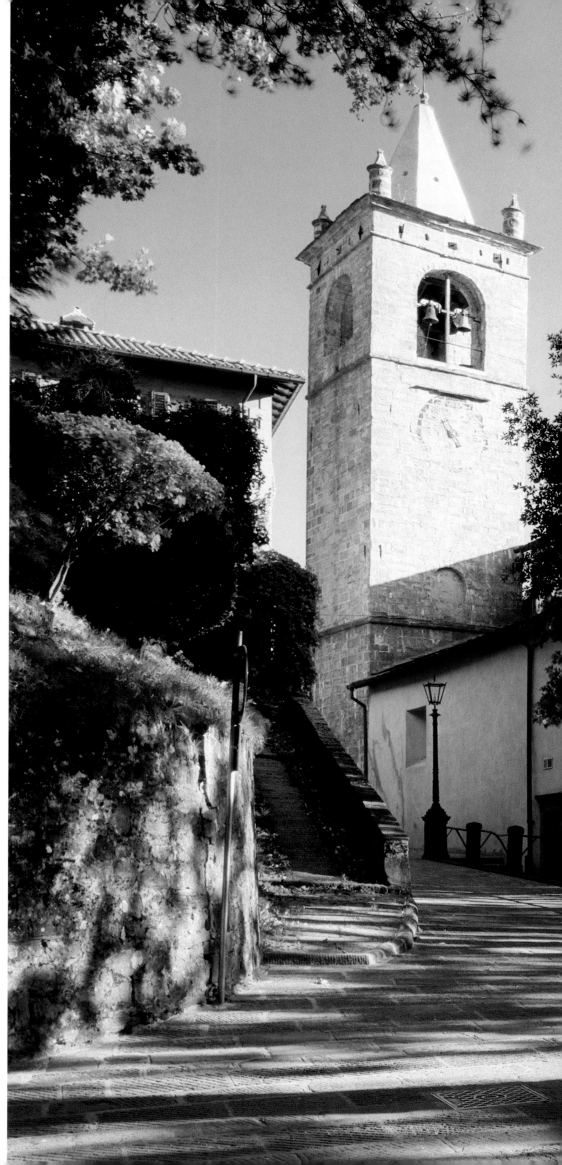

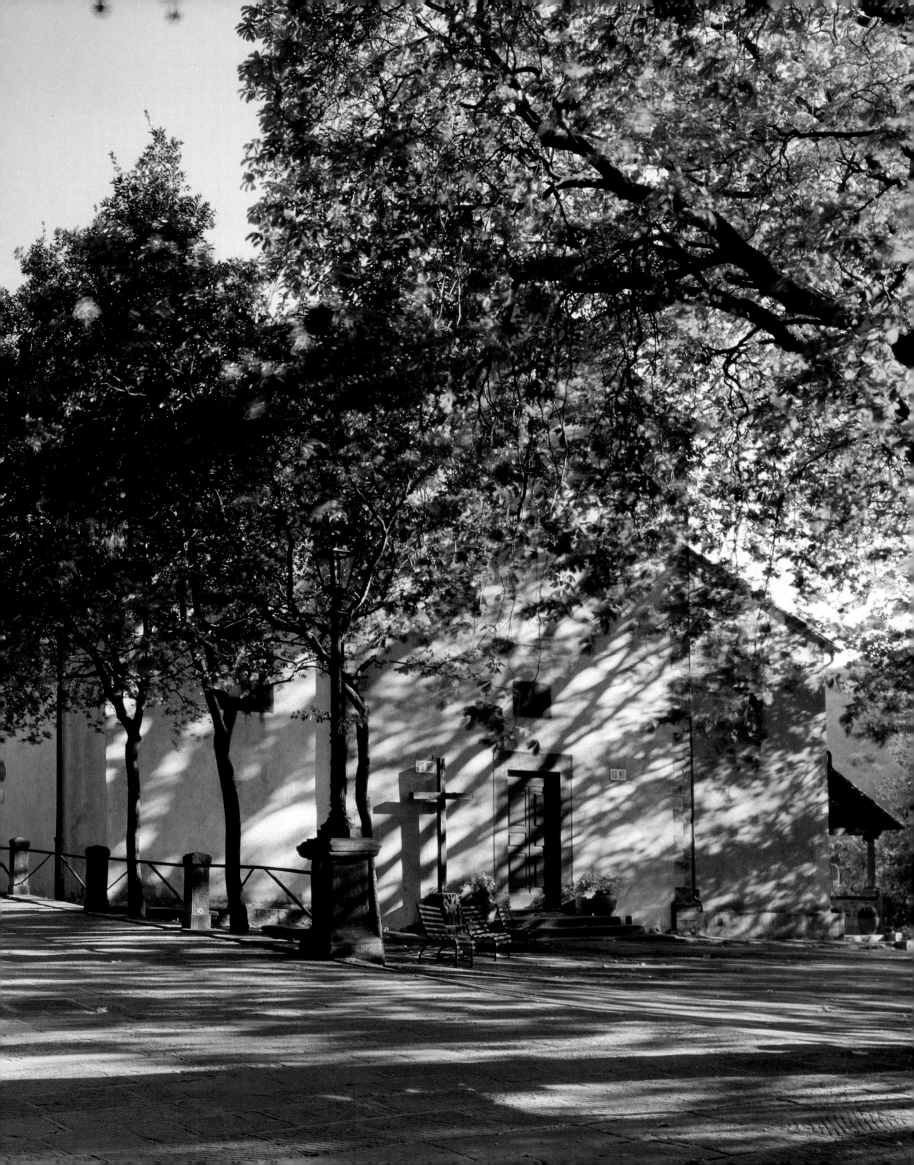

Uzzano

THIS tiny village, with its ancient stone houses, enjoys a breathtaking panoramic site, with richly floral gardens and extensive orchards. The surrounding countryside, watered by the river Pescia, is dotted with greenhouses, all dedicated to producing flowers for the markets of Pescia, the major town of the region. Uzzano itself, however, is flanked by groves of olives. A couple of kilometres higher are yet finer panoramas: of Monte Amiata and Monte Cimone, of the surrounding valleys, and a vista reaching as far as the island of Elba.

A narrow archway gives entrance to the village and to the Piazza Umberto, which looks over the Pescia plain and in which stands the powerful Palazzo del Capitano del Popolo, with its charming ground-floor loggia. Begun in the fourteenth century and many times rebuilt, the palace has been carefully restored in our own century. Further into the village stands the parish church of Saints Jacopo and Martino, its façade charmingly decorated, its belfry enormous. Originally a thirteenth-century Romanesque building, its apse was added in the sixteenth.

This parish church shelters a painted terracotta statue of St. Anthony Abbot, created by artists in the workshop of Luca della Robbia. Other unexpected treasures in this church are a thirteenth-century stoup for holy water, some fifteenth-century frescoes and a sixteenth-century font cover, carved in wood. This church also reveals how talented even minor Tuscan artists were. Among their works, noteworthy paintings here are Alessio Gemignani's *Betrothal of the Blessed Virgin Mary*, created by this Pistoian master in the seventeenth century, an Annunciation by Giovanni Battista Naldini, who worked in Florence in the sixteenth century, and a portrait of St. Francis of Assisi, which is probably by the sixteenth- and seventeenth-century Pisan artist, Ludovico Cigoli.

The winding road to Uzzano shows how the village is precisely sited to ensure its own defence. Above the cluster of its houses rises the tower of the church of SS. Jacopo e Martino.

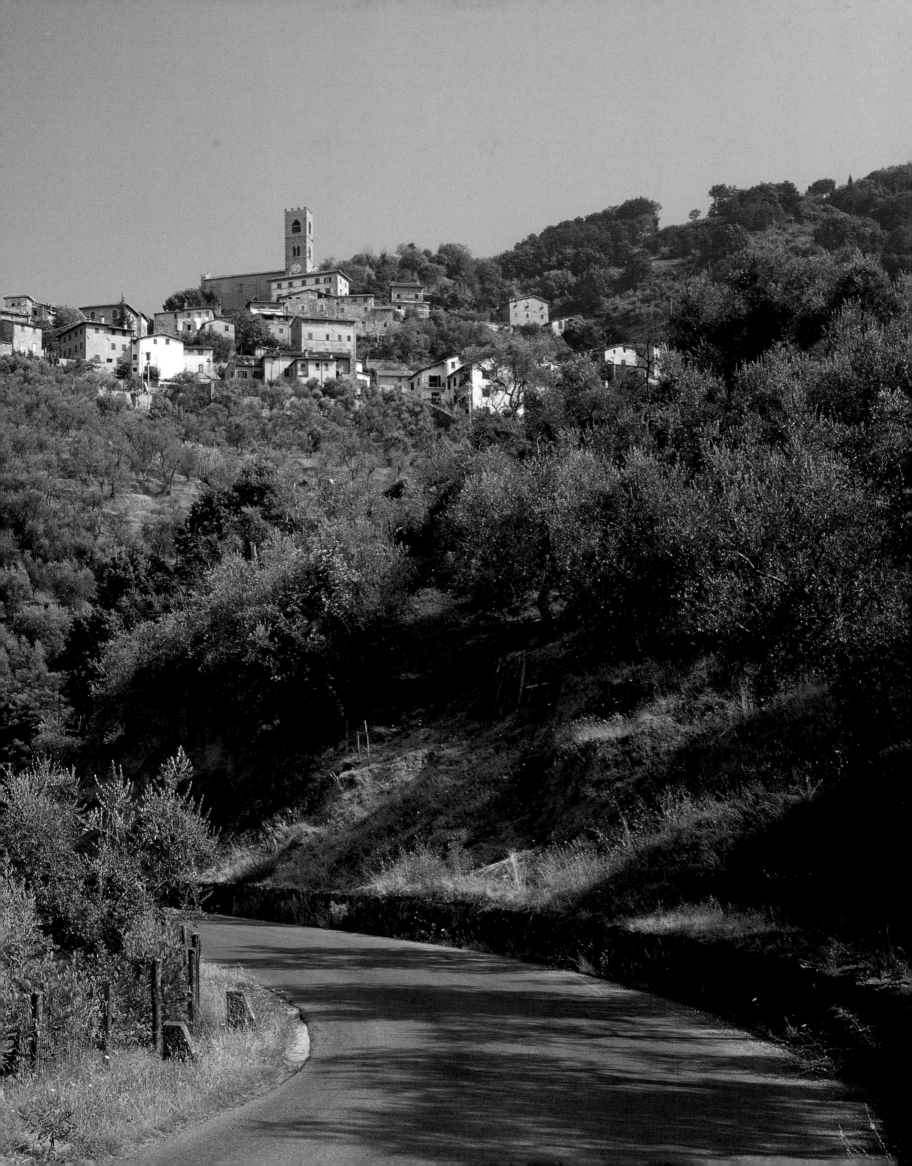

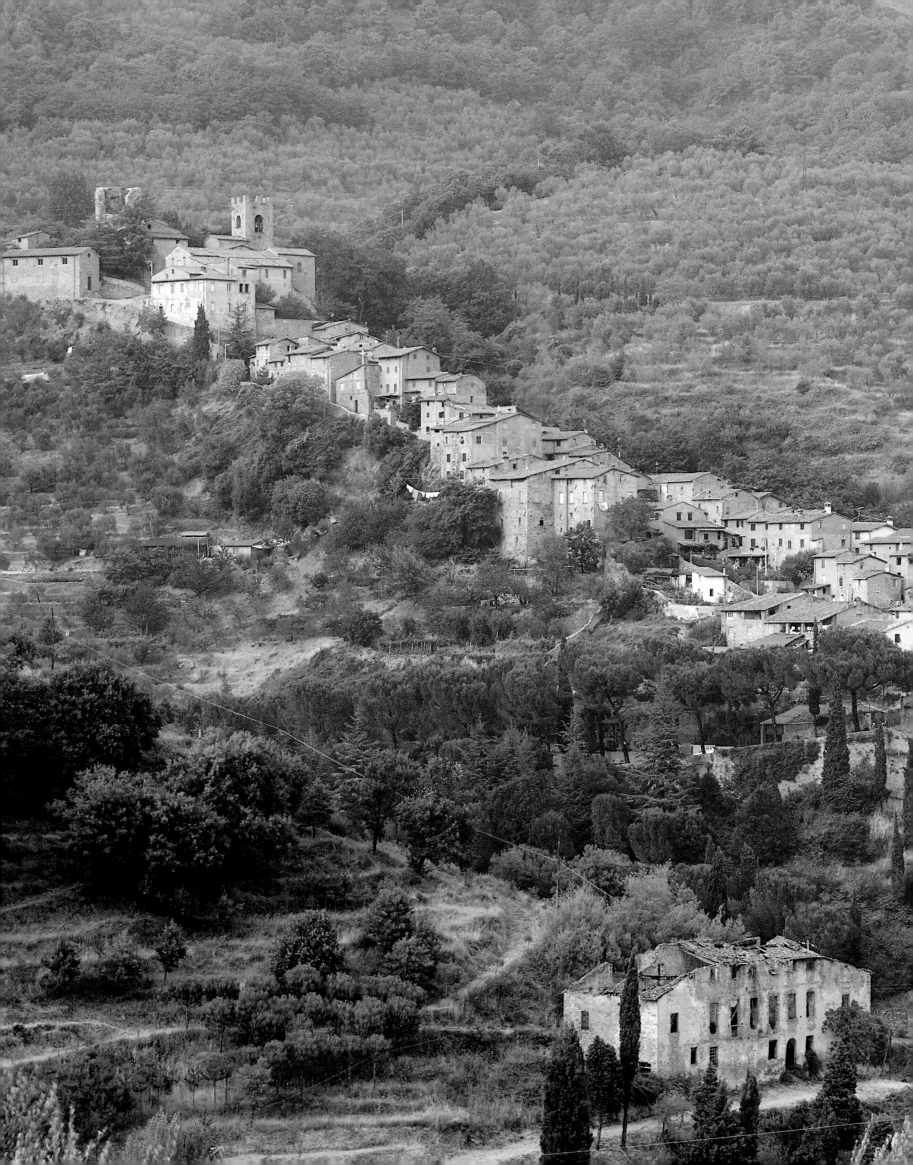

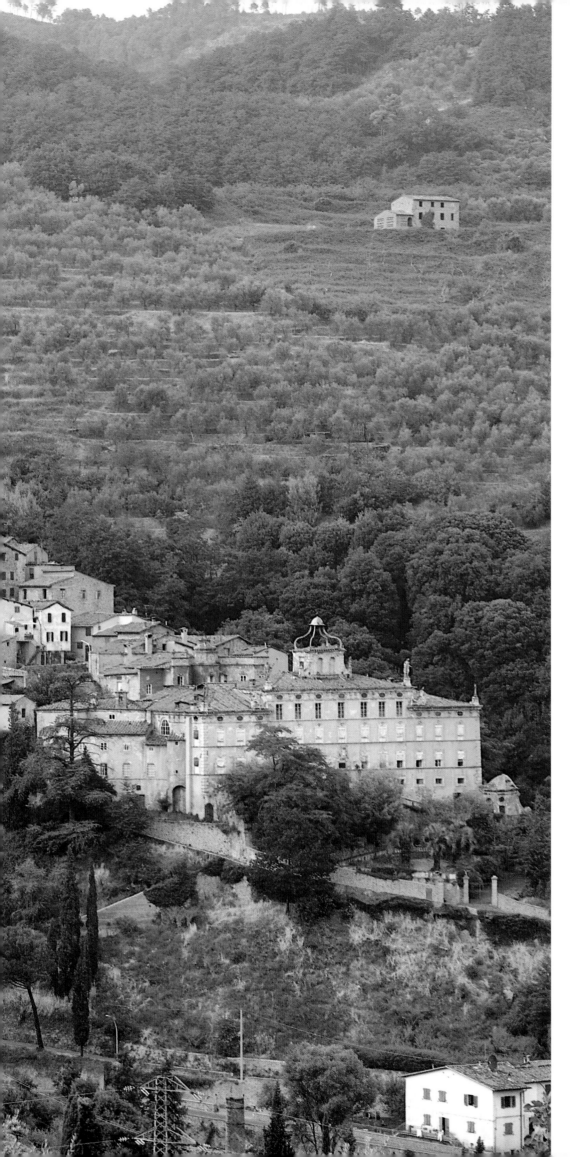

Collodi

A TRANQUIL, ancient village, Collodi is notable for its two, very different parks. The first park belongs to the superb villa, built between 1633 and 1662 in the Luccan Baroque style for the Garzoni family, to replace their twelfth-century castle. In 1786 the Baroque garden was reshaped by Ottaviano Diodati, with steep staircase terraces, a labyrinth of hedges, yews, topiary, statues and particularly fine fountains. Box hedges surround the open-air theatre, while cypresses shade the eighteenth-century baths. The massive villa dominates the village and boasts a splendid staircase, stucco-work, frescoes and paintings from the workshop of the Carracci family.

The second park, across the river, was created in the nineteen-fifties in memory of Carlo Lorenzini, who wrote under the pen-name Carlo Collodi. Lorenzini spent much of his childhood at the Villa Garzoni, where his mother was born and which his uncle administered. His best-loved character is Pinocchio, whose adventures first appeared in 1881, and Collodi's Parco di Pinocchio contains statues commemorating the long-nosed puppet as well as other characters from the author's stories.

South of this theme park is the Paese dei Balocchi. Here a menacing fish with fearsome teeth and a huge pink tongue rises from an ornamental pool. Known as Il Grande Pescecane, it recalls Pinocchio's most famous adventure.

At Collodi you can still trace the walls which once surrounded the castle. Beyond the villa, climb the steep streets of the village, at whose medieval heart stands the church of San Bartolomeo, begun in the thirteenth century, many times altered and housing fifteenth-century frescoes and terracotta statues.

The terracotta rooftops and weathered walls spill dramatically down the hillside from the church of San Bartolomeo to the Villa Garzoni and its garden.

Stepped streets (right) *meander among the houses of the steeply rising village, from the splendid façade of the Villa Garzoni, seen in this view from the Parco di Pinocchio* (above). *The garden of the villa* (opposite) *makes wonderfully dramatic use of the sloping site with a series of Baroque staircases and accompanying statuary.*

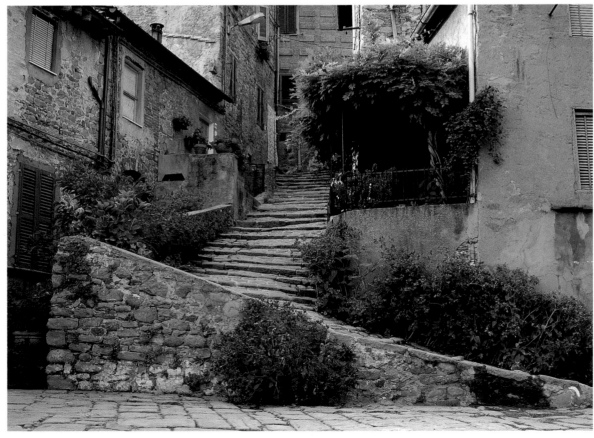

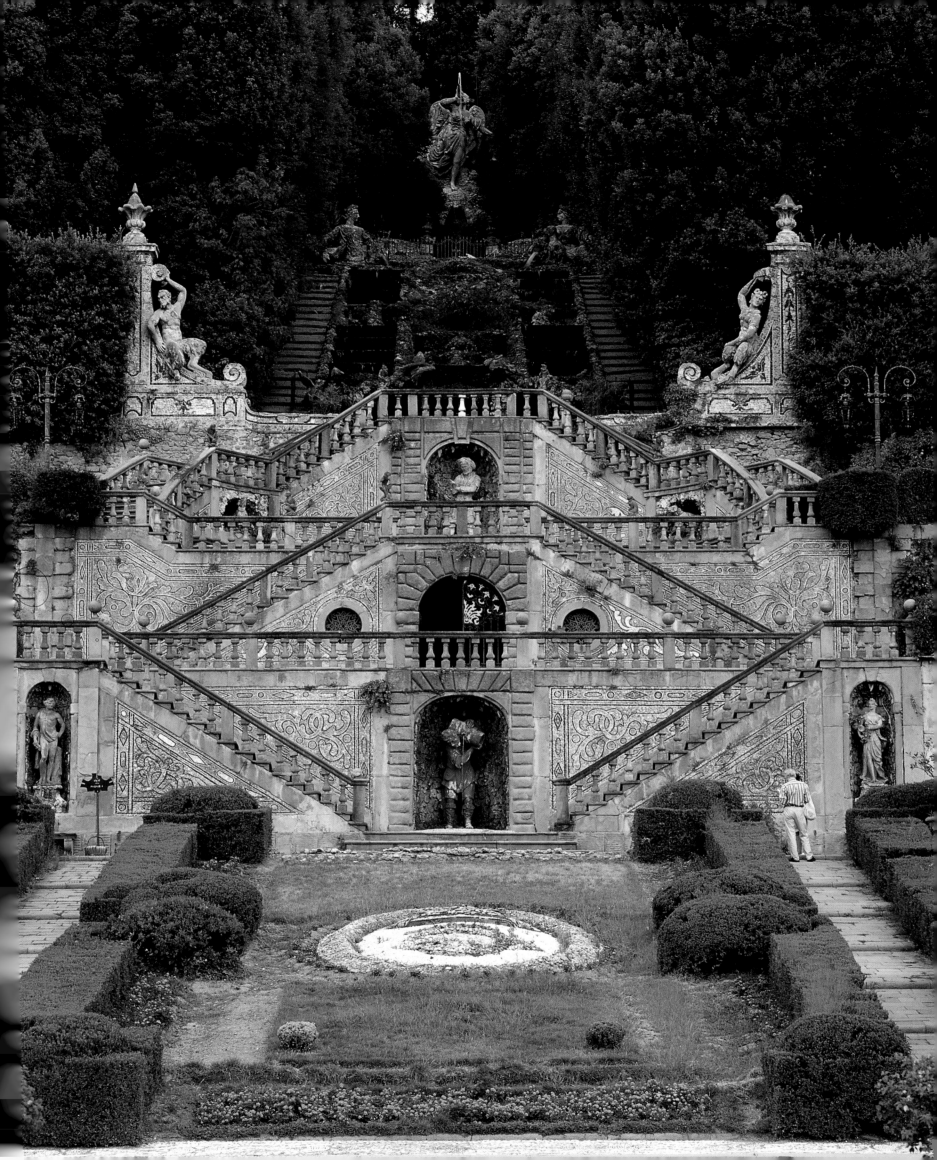

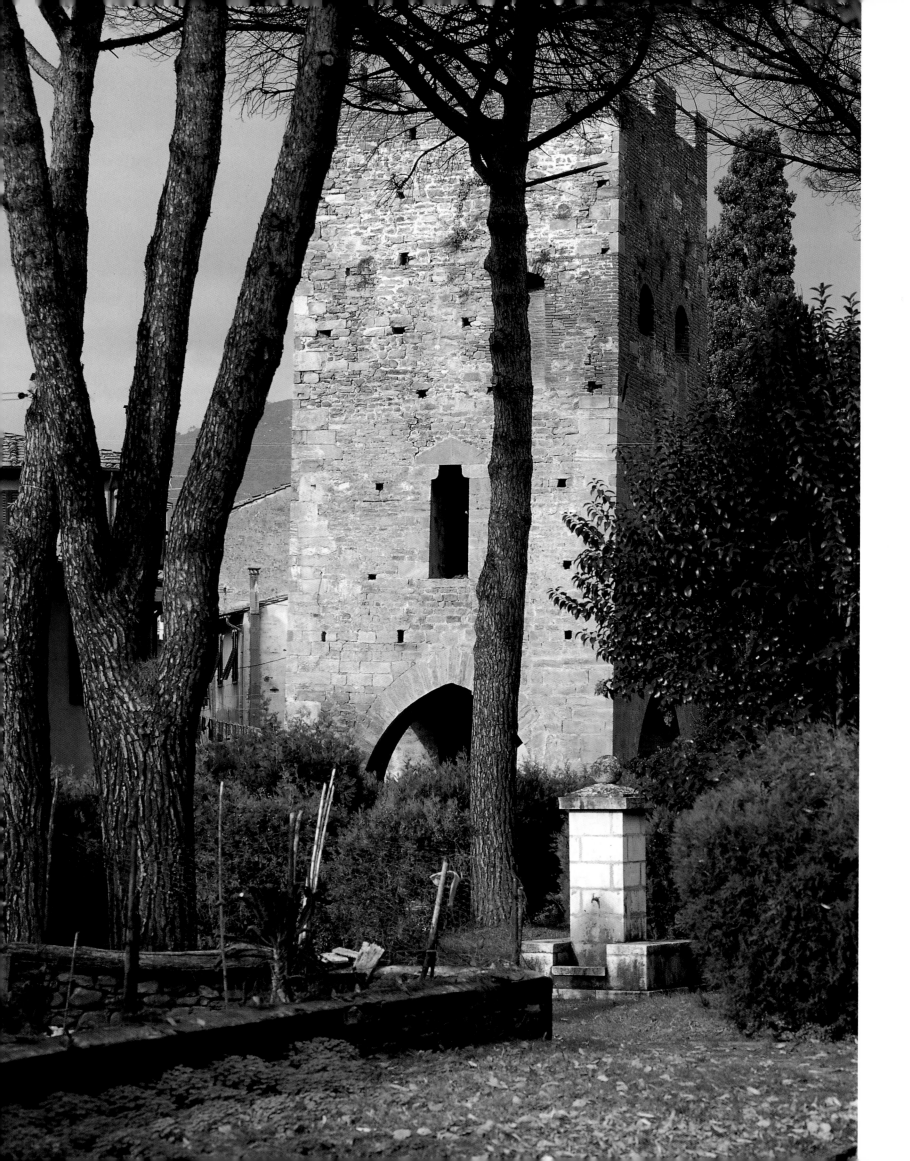

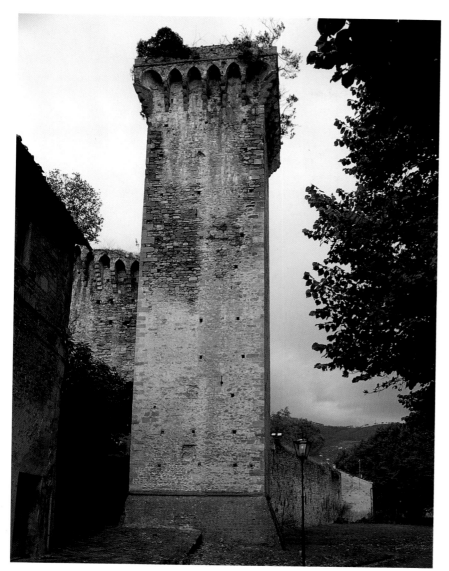

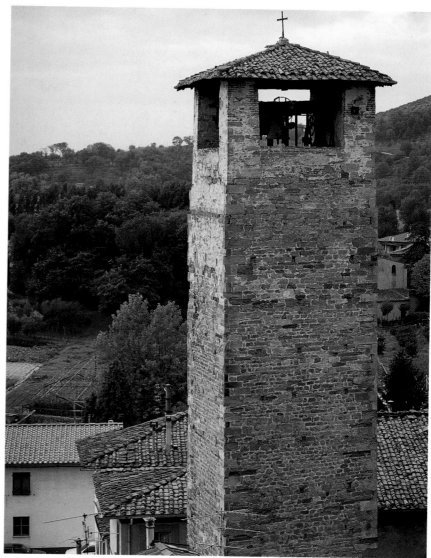

Vicopisano

*T*his village is dominated by the substantial towers which were an essential part of its fortifications: the Torre delle Quattro Porte (opposite), the Torre Brunelleschi (above left), and the Torre Orologio (above right).

ORIGINALLY built on the banks of the Arno, the village is now served by a canal which the Medici Grand Dukes Cosimo I and Francesco I constructed when they diverted the river. Vicopisano benefited from their care and from the waters of Lake Bientina by becoming a centre of agriculture, specializing in the cultivation of rice.

The village rises on a hill at the foot of Monte Pisano and still retains fortifications designed by the great Florentine architect Filippo Brunelleschi at the beginning of the fifteenth century. Among the towers which further buttress these defences, one built in 1406 is named after Brunelleschi; an even finer one, the Torre delle Quattro Porte, rises above a vault and, as its name suggests, incorporates four archways. Above the village looms the tower of its ancient fortress, rebuilt by Brunelleschi after the Florentines took possession of the village in 1407.

The town hall of Vicopisano boasts two medieval towers, while beyond rises the Palazzo Pretorio, one of the finest secular buildings in this province. Begun in the fourteenth century and enlarged in the fifteenth, its façade is enlivened by coats of arms in stone and terracotta. The Via Lante has more fourteenth-century towers and a fourteenth-century house; the Piazza Fra' Domenico Cavalca is named after the Domenican ascetic and writer who was born here in 1270.

Vicopisano's parish church stands just outside the village. Built in the Pisan Romanesque style in the twelfth century, its exquisite façade has three doorways, pilasters and a double mullioned window. Inside, decorated columns divide the church into three naves; it houses a late fourteenth-century statue of St. John the Baptist, sculpted by Nino Pisano, and a fifteenth-century font, as well as twelfth-century figures, carved in wood and representing the deposition of Jesus.

The secular and ecclesiastical delights and details of a Tuscan village (this page, clockwise): washing on the Via Lante, the medieval church, a typically brilliant small garden overlooked by a Madonna, and the return from the market to the Vicolo del' Ario quarter. A statue of St. John the Baptist surmounts a fifteenth-century font in the church (opposite); in the background is a twelfth- or thirteenth-century carving of the Deposition.

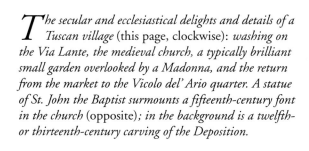

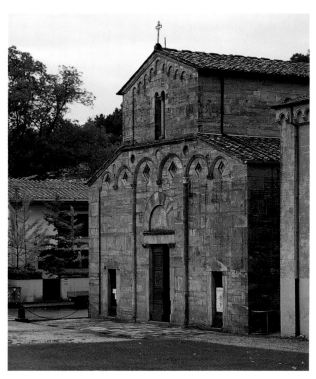

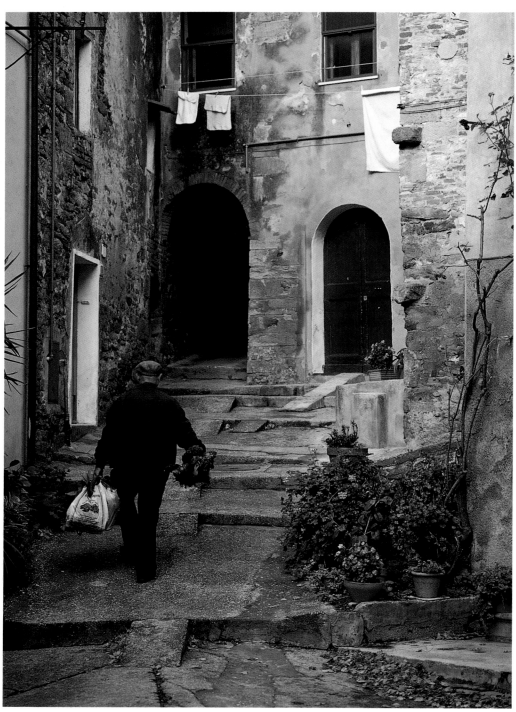

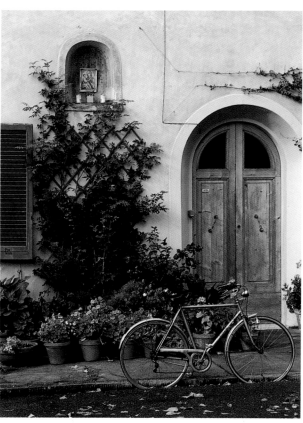

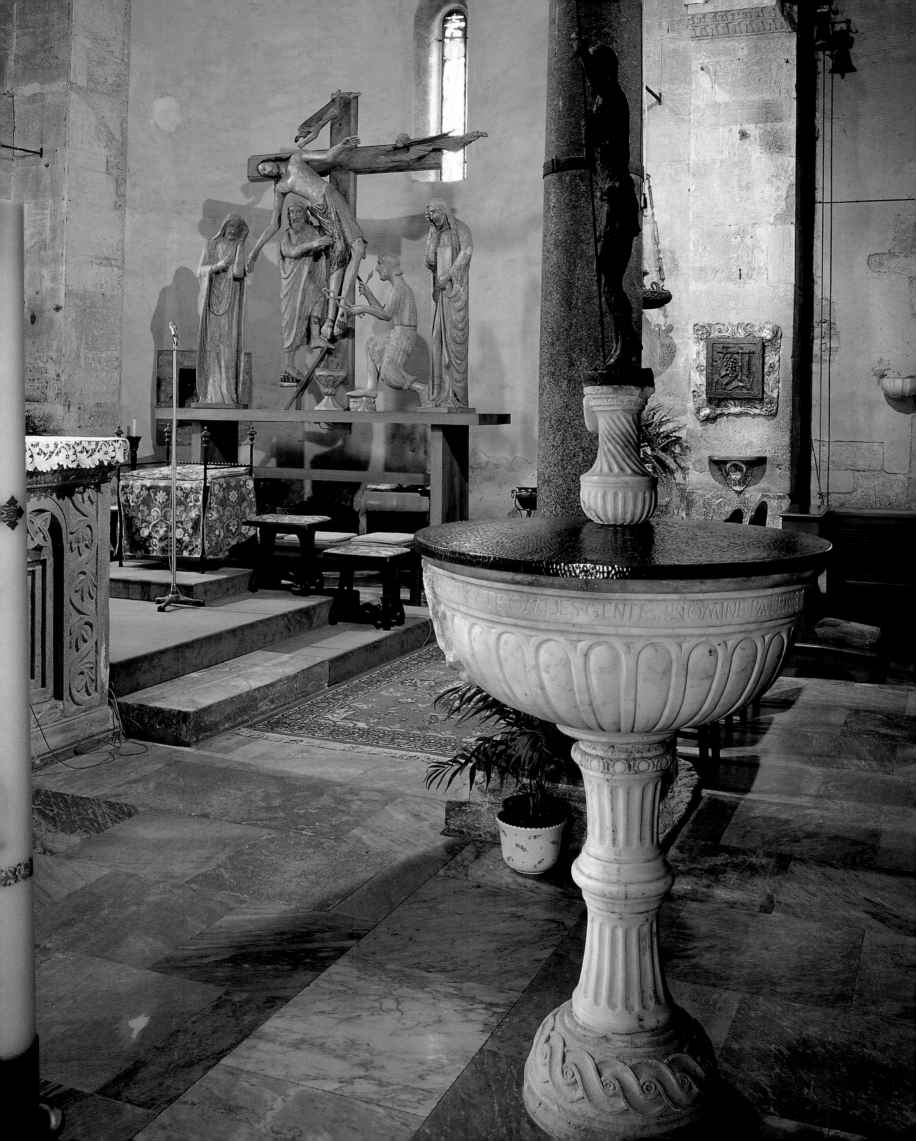

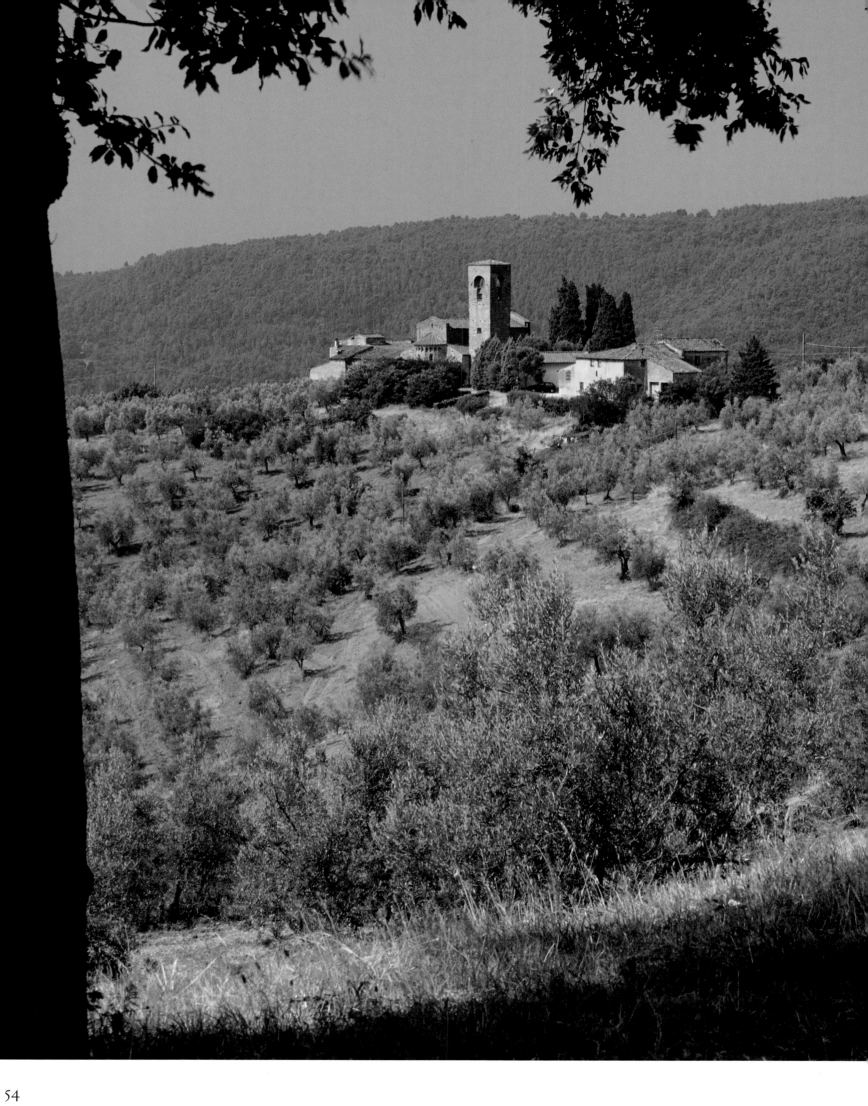

Artimino

T HE ETRUSCANS were the first inhabitants of this site and this walled medieval village has a church built in part from stones brought from their cemetery of Pian di Rossello. This was rediscovered in 1970 and has been newly excavated. Rebuilt in the late twelfth century, the church, dedicated to San Leonardo, was founded by Countess Matilda in 1107.

Artimino affords splendid views of the neighbouring countryside, whose vineyards produce excellent wines. Just above the village, on a plateau of Monte Albano, is a lovely Medici villa, built at the end of the sixteenth century by Bernardo Buontalenti as a hunting lodge for Grand Duke Ferdinando de' Medici I and known from its roofline as the 'Villa of a Hundred Chimneys'.

Another Etruscan burial ground, the Tumulus of Montefortini, has been discovered three kilometres from Artimino, where excavations have revealed two chamber tombs. And after another four kilometres you reach Poggio a Caiano, with another superb villa, this one built in 1480 for Lorenzo il Magnifico by Giuliano da Sangallo. Surrounded by a colonnade, it boasts an Ionic portico whose tympanum carries the Medici coat of arms as well as a coloured frieze created by Andrea del Sansovino around 1490. The villa has its own theatre, designed in the seventeenth century, as well as a billiard room. Here the Medici's love of antiquity and their self-esteem is brilliantly displayed in sixteenth-century frescoes by Francesco Franciabigio and Andrea del Sarto which depict events in Roman history complementing incidents in the lives of Cosimo il Vecchio and Lorenzo il Magnifico.

A rchetypal Tuscany: olive groves surround the village of Artimino, its tightly grouped houses dominated by the campanile.

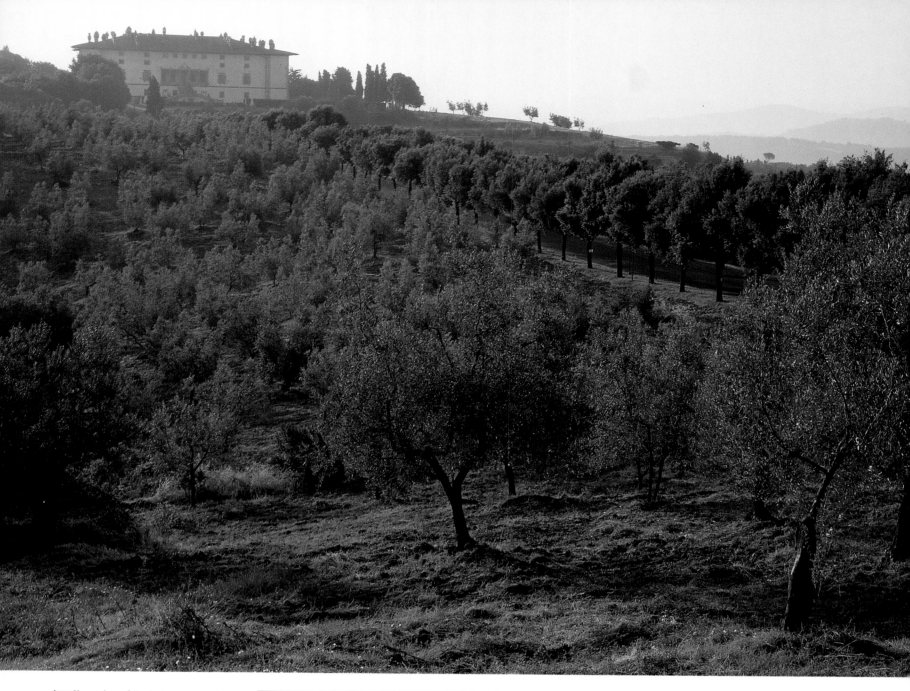

The sights of Artimino: grounds of the 'Villa of a Hundred Chimneys' (above); the clover-leaf apse of the church (right); the village's twelfth-century bell-tower (far right). The interplay of light and shade against an azure sky is a constant theme of the Tuscan village (opposite); here, Artimino's church reposes under the guardianship of towering cypresses.

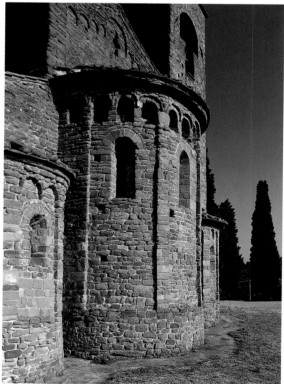

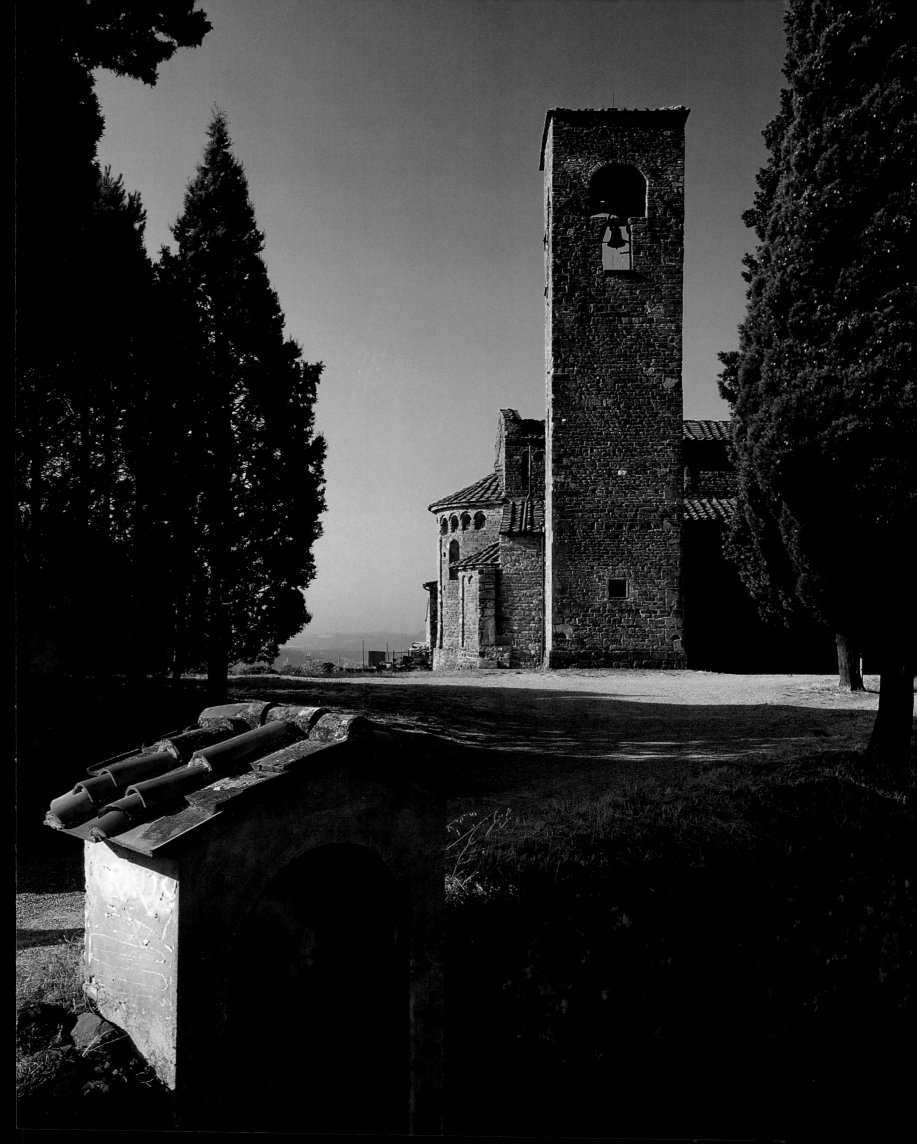

Scarperia

THE VIA ROMA, which bisects Scarperia, was the main route from Florence to Bologna, indicating the former strategic importance of this fortified village. The Florentines founded it in 1306 as a defence against invaders from the north. In that same year they commissioned Arnolfo di Cambio to build their magnificent Palazzo dei Vicari, with its impressively high tower. Later generations added their coats of arms, the finest created in enamelled terracotta by the Della Robbia family. More armorial sculpture can be found in the atrium, while the interior, with its extensive courtyard and staircase, is decorated with frescoes, including one of St. Christopher painted in 1412, and another, of the Madonna and Child with Four Saints, executed by Ridolfo Ghirlandaio in 1554.

Opposite this palace the church of St. Philip and St. James dates from the fourteenth century, its campanile a frothy nineteenth-century Gothic addition. This church is crammed with artistic gems, including a fine Madonna and Child by the fifteenth-century Florentine sculptor Benedetto da Maiano and a little sixteenth-century crucifix by Jacopo Sansovino. In the same piazza stands the oratory of the Madonna di Piazza, inside which is a Gothic tabernacle with an early fourteenth-century painting of the Madonna and Child by Jacopo del Casentino. Another oratory, of the Madonna del Terremoti, has a fresco of the Madonna and Child from the workshop of Filippo Lippi.

In later ages Scarperia became famous for its cutlery and wrought iron, which is still renowned. Lovers of the Romanesque will seek out the tenth-century parish church of St. Agatha, three kilometres west of Scarperia, whose baptistry has marble intarsia panels dating from 1175 as well as a tabernacle by Giovanni della Robbia. The church stands close by a Romanesque bridge and a water mill.

The strife of the Tuscan Middle Ages is reflected in the architecture of many a village and small town; Arnolfo di Cambio built the magnificent Palazzo dei Vicari in the fourteenth century (above and opposite), while the grandees of the Renaissance period added their coats of arms to its façade. A less aggressive, more tranquil note is struck by this wrought-iron balcony (right).

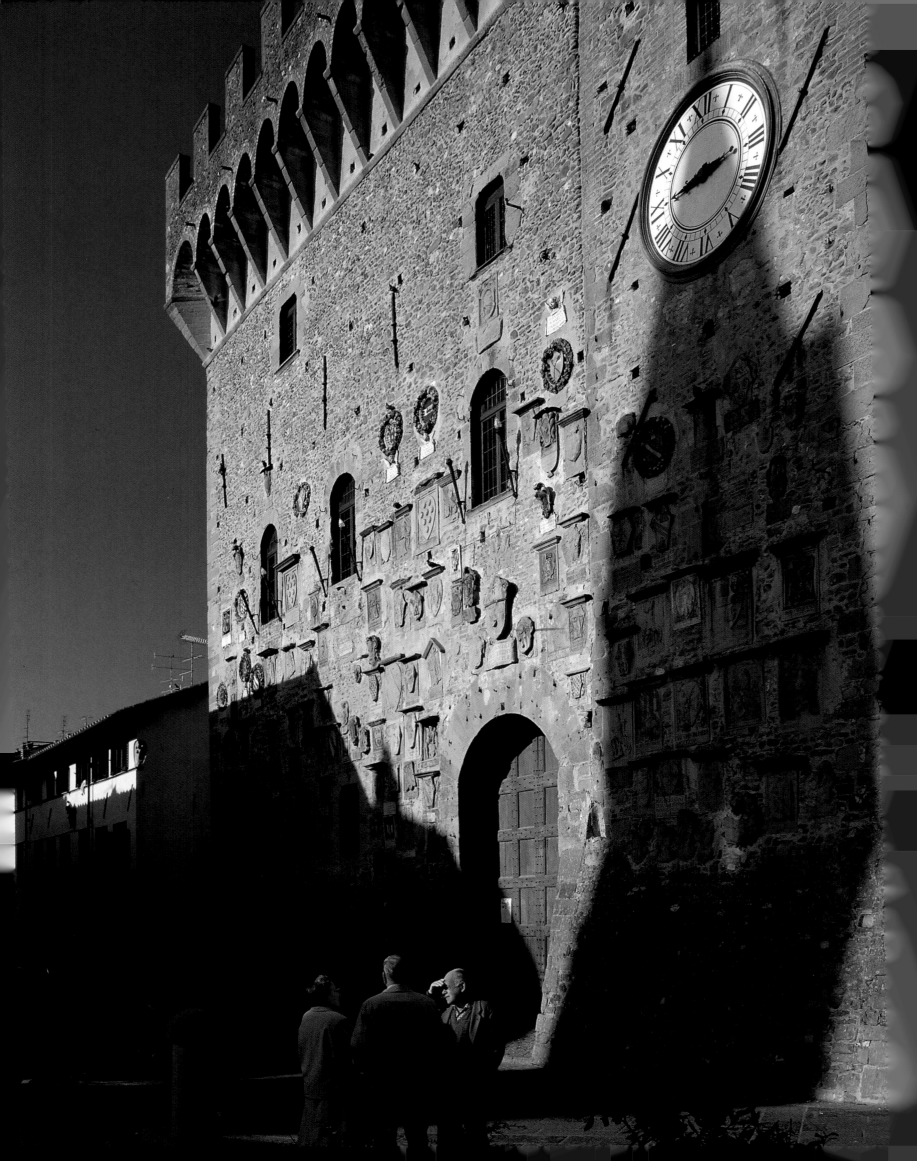

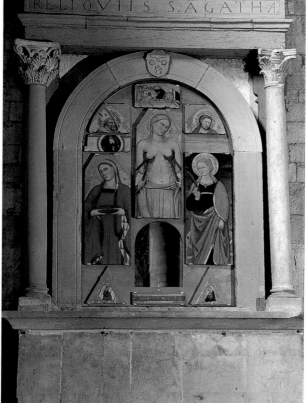

*R*eligious art in Scarperia (this page, clockwise): *the Gothic tabernacle in the church of the Madonna di Piazza; a crucifix by Sansovino; a fourteenth-century painting of St. Agatha, virgin and martyr, flanked by Saints Catherine and Lucy, by Giovanni del Biondo for the church of St. Agatha, just west of Scarperia; a tondo of the Madonna by Benedetto da Maiano in the church of St. Philip and St. James. The font of the church of St. Agatha* (opposite) *is surrounded by intricate panels dating from 1175.*

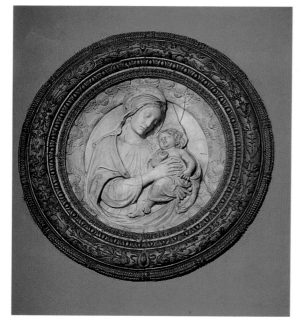

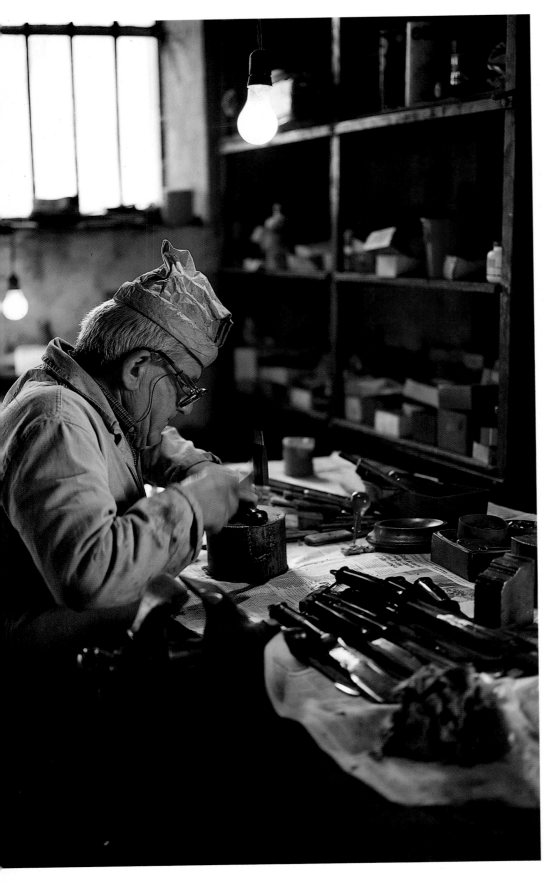

*T*raditional crafts still flourish in many Tuscan
villages; Scarperia is especially notable for its cutlery
and metalware, much of it made in small workshops
(this page *and* opposite).

Vicchio

Vicchio is a place of famous names and elegant dwellings: these steps (below left) lead directly to the house once occupied by Benvenuto Cellini, while the statue of Giotto dominates the Piazza Giotto (opposite above). The impressive architecture of Vicchio is amply demonstrated in the fine loggia of the Piazza della Vittoria (below right) and in the intricate, graceful detailing of the ironwork which adorns many of the houses (opposite, below left and right).

Gioᴛᴛo, Giovanni da Fiesole (who became famous as Fra' Angelico) and his brother Benedetto were all born in this village, which is approached by a bridge across the river Sieve. A plaque on a house in the Corso del Popolo also records that Benvenuto Cellini lived here from 1559 till his death in 1571, while in the Piazza Giotto at the heart of the village is a bronze monument of 1901 by Italo Vagnetti to the memory of Giotto.

Though nowadays its citizens' livelihood derives from agriculture and a healthy trade in confectionery, shoes and handbags, Vicchio has retained its artistic credentials. Brought from churches throughout the region, works of art are today displayed in the Museo Civico Beato Angelico (among the finest a terracotta by Andrea della Robbia depicting St. John the Baptist and a thirteenth-century marble stoup with a bas-relief of St. Francis of Assisi receiving the stigmata).

Giotto's birthplace (just outside Vicchio at Vespignano) is now a gallery with photographs of his most important works and documents about his life. Above the village rises the church of San Martino, inside which is a tabernacle by Mino da Fiesole and a Madonna and Child created by Paolo Schiavo in the fifteenth century. Schiavo also contributed a fresco to the Cappellina delle Bruna, which stands isolated outside the village, surrounded by magnificently tall, guardian-like cypresses.

As for Vicchio itself, its partially intact walls of 1324 enclose the Piazza della Vittoria, with its Neo-classical loggia and its polygonal Torre dei Cerchia. The parish church of San Giovanni Batista, rebuilt in 1830, dominates the Piazza Giotto. In the Corso del Popolo the Oratory of the Arciconfraternita della Misericordia houses a Madonna and Child from the Della Robbia workshop and a dead Christ by the Florentine artist Clemente Susini. And for those who need a respite from such treats, the village is equipped with an artificial lake for water sports.

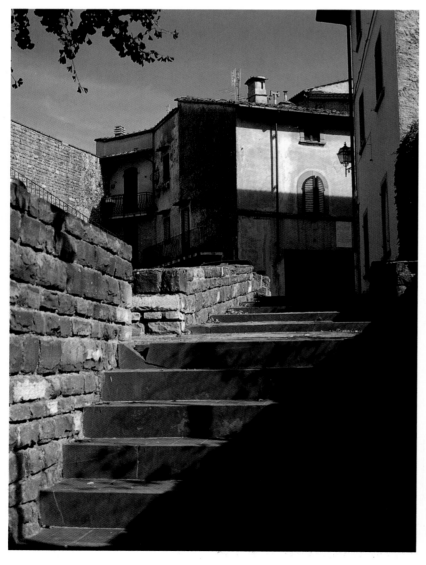

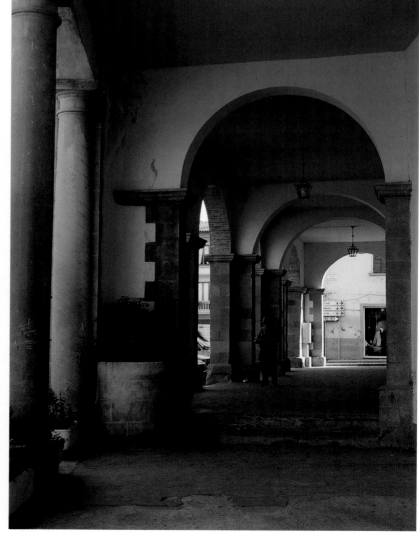

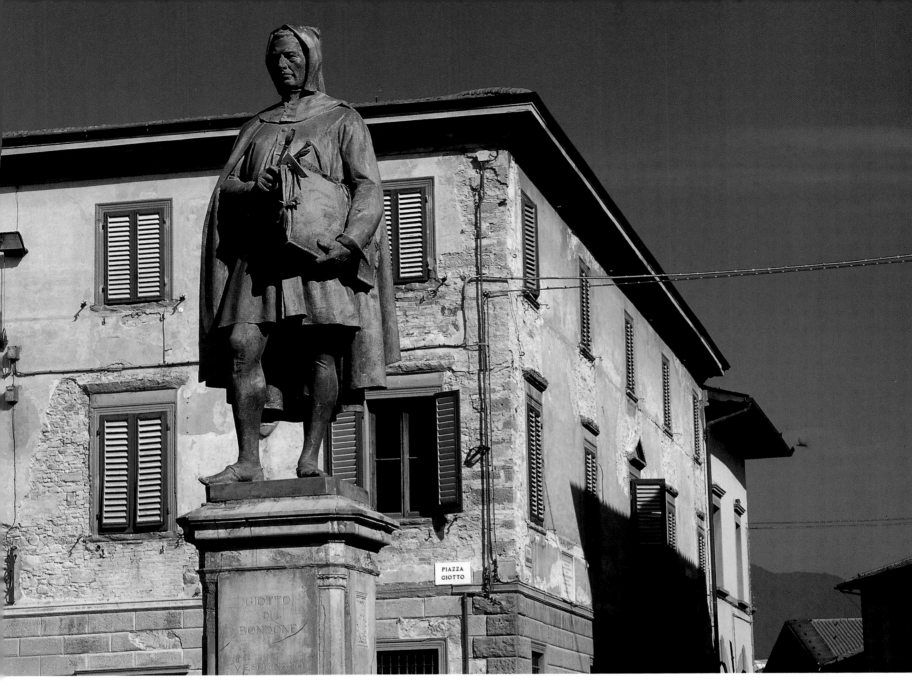

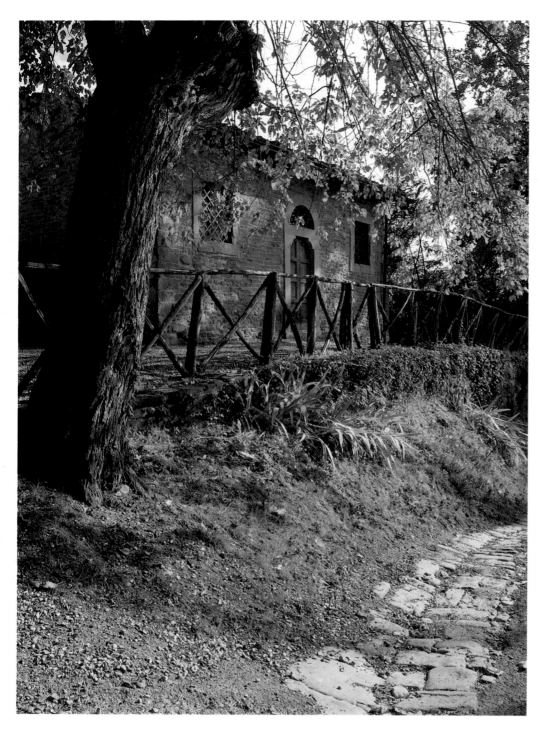

*J*ust outside Vicchio is the hamlet of Vespignano, the
birthplace of Giotto (above); another interesting
building close by is the Capellina delle Bruna
(opposite), *which contains a fresco by the fifteenth-
century painter, Paolo Schiavo.*

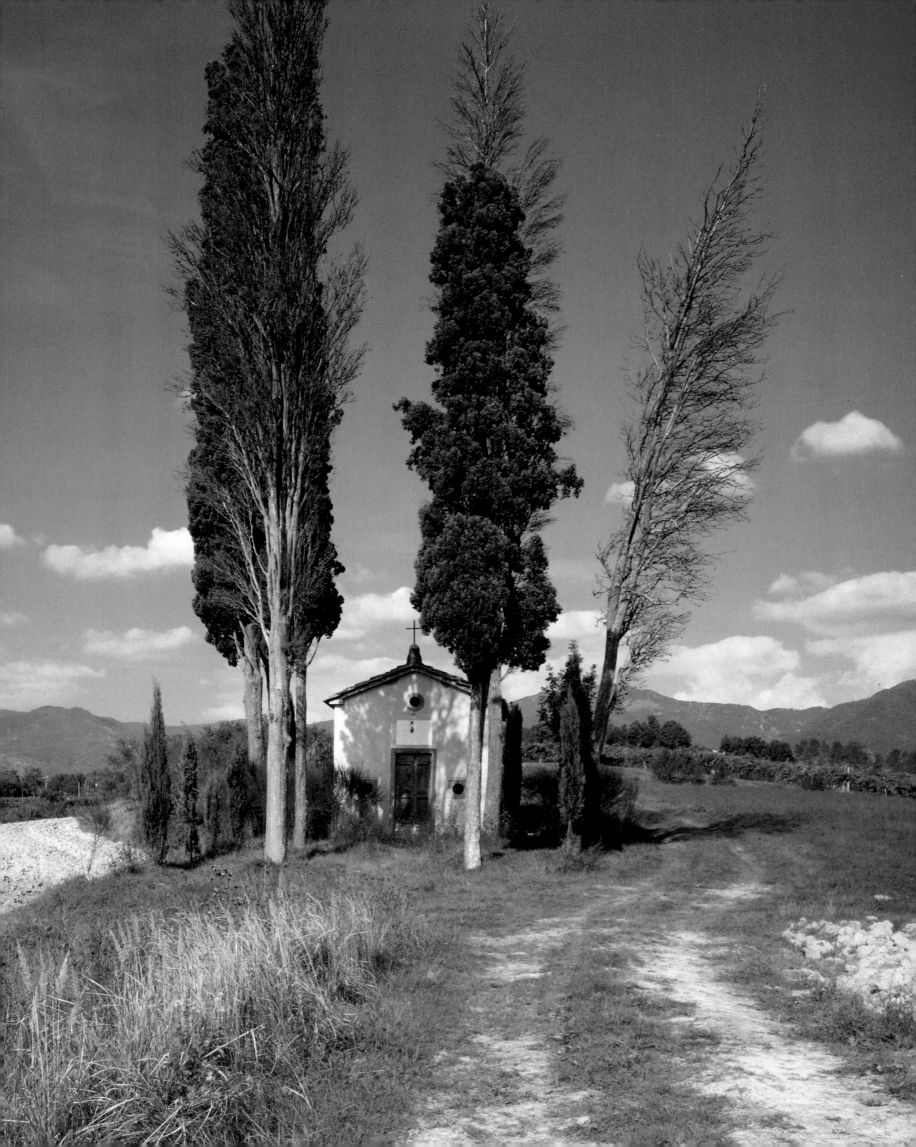

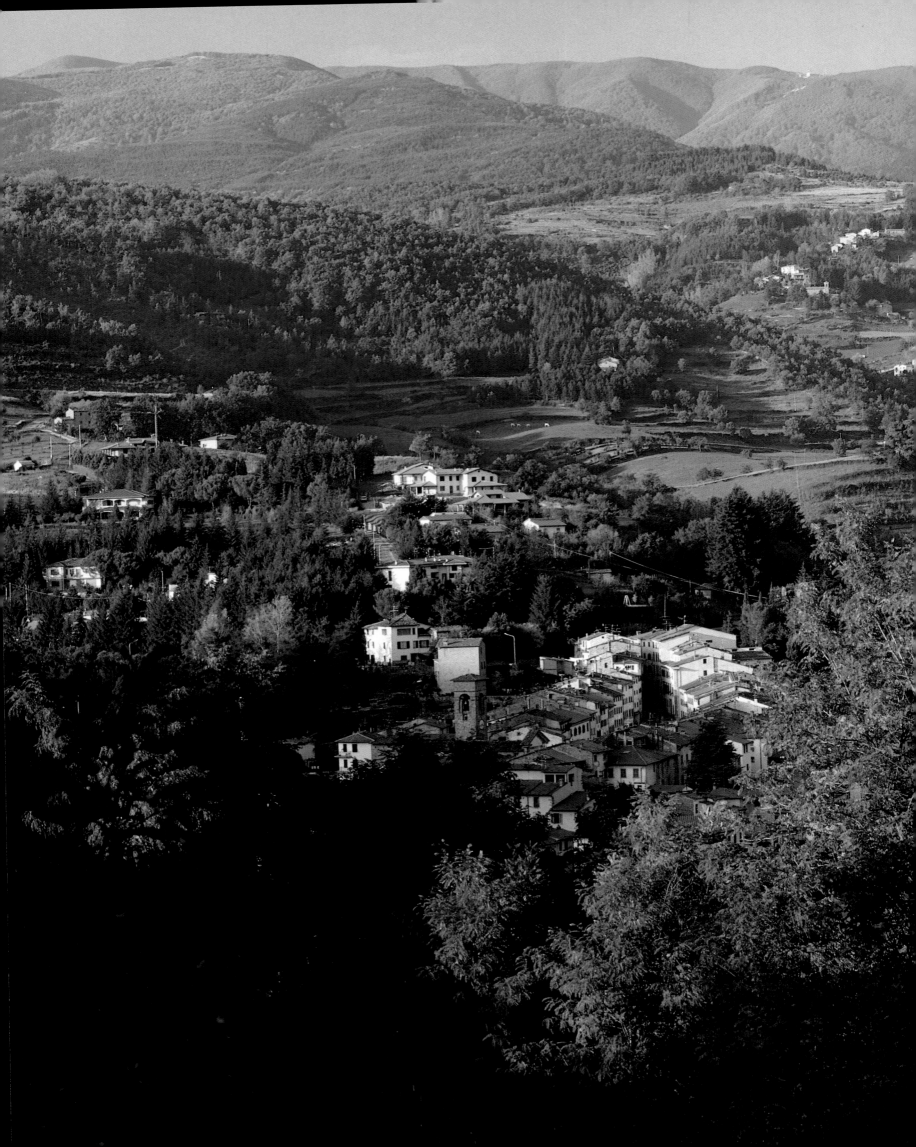

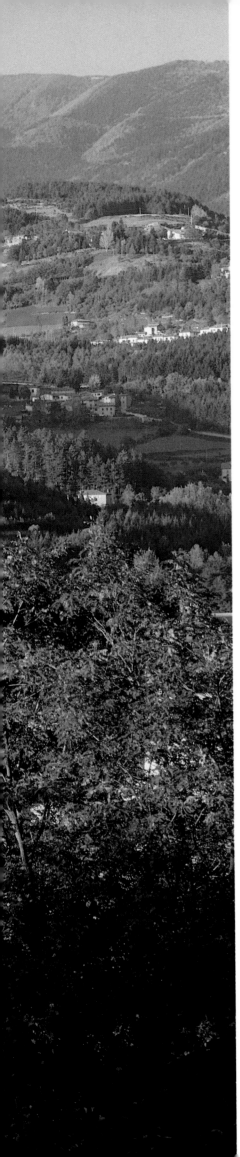

Stia

STIA is entrancingly situated at the foot of Monte Falterona where the river Staggia flows into the Arno. The water is peculiarly suitable for the processing of wool, and the village remains renowned for its woollen garments as well as for its wrought iron. Water for the inhabitants used to be drawn from the well – enlivened with decorations of snakes and lions – in the curiously sloping, arcaded Piazza Tanucci, which is shaded by the Romanesque church of Santa Maria Assunta. Supported on columns with intricately sculpted capitals, its interior ends in an apse with an ambulatory and a fourteenth-century crucifix.

The Della Robbia family created a fanciful tabernacle to house the Blessed Sacrament in this church, and in 1437 Andrea della Robbia was responsible for a captivating Madonna and Child in a chapel near the high altar. The church also has an Annunciation of 1414 by Bicci di Lorenzo. Its campanile is medieval. Next to Santa Maria Assunta is an archway with a modern but nevertheless delightful fresco of St. Francis of Assisi, by Pietro Annigoni.

Cross the river and you find the church of the Madonna del Ponte. The altarpiece is again from the workshop of the Della Robbia family, this one created in terracotta in 1531 and depicting the Madonna and Child with Saints Roch and Sebastian. This side of the river also boasts Stia's town hall and theatre, as well as the castle of the Ghibelline Guidi family (who were lords of Stia), which was built just outside the village at Porciano in the twelfth century and retains a formidable square tower. Here Dante stayed in 1311. A second fortress, the Castello di Palagio, well restored in 1911 (though in an exaggeratedly medieval fashion), has refreshing gardens and hosts summer exhibitions.

Outside and inside Stia: the village stands seemingly tranquil on a superb site at the foot of Monte Falterona (left), but once inside, the visitor will find its winding streets and shaded squares full of vitality.

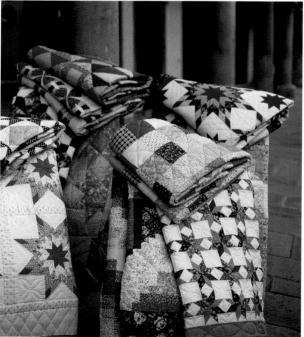

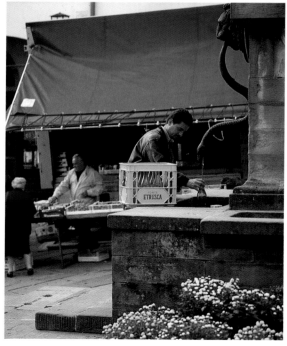

*M*arket day in Stia (this page *and* opposite); *the town is especially famous for its woollen goods and patchwork quilts; the most intense centre of trade is the gracefully sloping Piazza Tanucci, embellished with a magnificent fountain.*

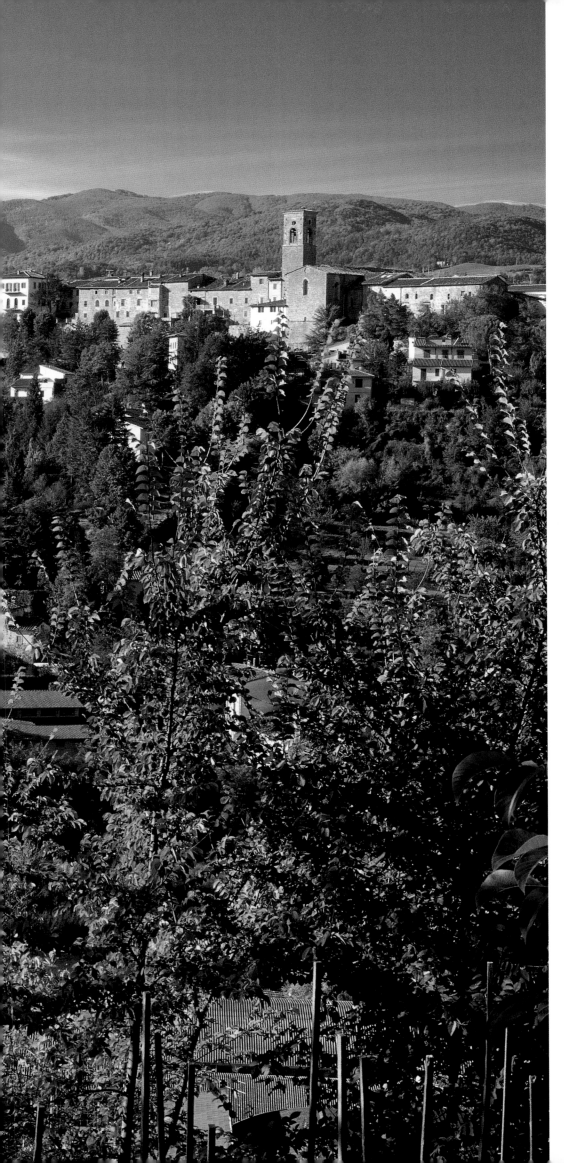

Poppi

I N the upper valley of the Arno, the castle of the
Counts Guidi at Poppi displays all the feudal power
of this family which dominated the Casentino in the
Middle Ages. Moated and surrounded by battlemented
walls, its tower, virtually blank and windowless, is
approached from the south through a garland of gentle
hills and terraces. The tower rises on top of a hill in
front of a square, three-storeyed castle whose windows
grow more graceful as they rise but remain distrustful
and hostile near the ground. The present building,
replacing an earlier one, dates from 1261 (augmented
and extended in 1274 and 1291), and because it resem-
bles the Palazzo della Signoria in Florence some have
concluded that amongst its architects was Arnolfo di
Cambio.

A few stone coats-of-arms grace the walls, but the
most interesting figure is a warrior, perhaps the fear-
some Simone da Battifolle, who in the late thirteenth-
century abandoned the Ghibellines, with whom the
family was traditionally allied, and joined the Guelphs.
In 1289 these relentlessly feuding families fought a
furious battle in which Dante participated, just outside
the village, commemorated by a column on the plain of
Campaldino where the Stia and Pontassieve roads meet.

Inside, the palace grows more hospitable. The
courtyard is decorated with the coats of arms of its
Florentine governors and has an elegant external stair-
case. Taddeo Gaddi painted the frescoes in its chapel.
Giovanni della Robbia was commissioned to produce
fine majolica work. The hall on the first floor is deco-
rated with Florentine paintings and frescoes. The
library contains 850 illuminated manuscripts, 780
incunabuli and many other rare books.

Built in the twelfth century, Poppi's Romanesque
church of San Fedele, the largest in the Casentino, has
a three-aisled crypt and several distinguished works of
art, the finest being a thirteenth-century panel painting
of the Madonna and Child.

*The village of Poppi seems to be entirely in the thrall
of secular power in the form of its castle, which
dominates the village and the church of San Fedele.*

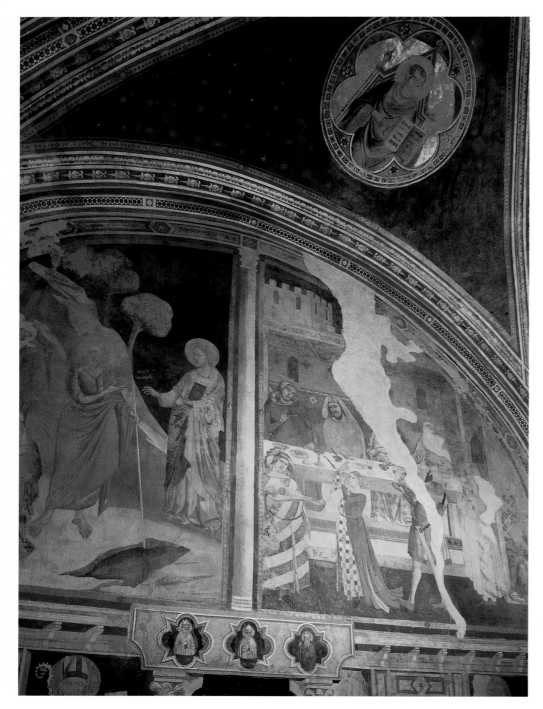

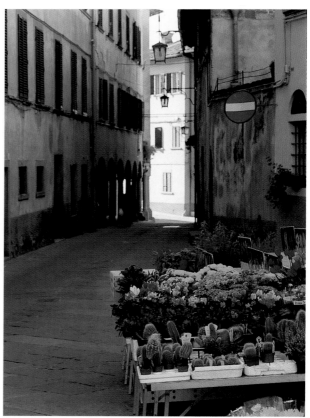

Rich detail in Poppi: early fourteenth-century frescoes by Taddeo Gaddi in the Palazzo Pretorio (above); a 1477 relief of the lion of Florence by Jacopo di Baldassare Torriani (right).

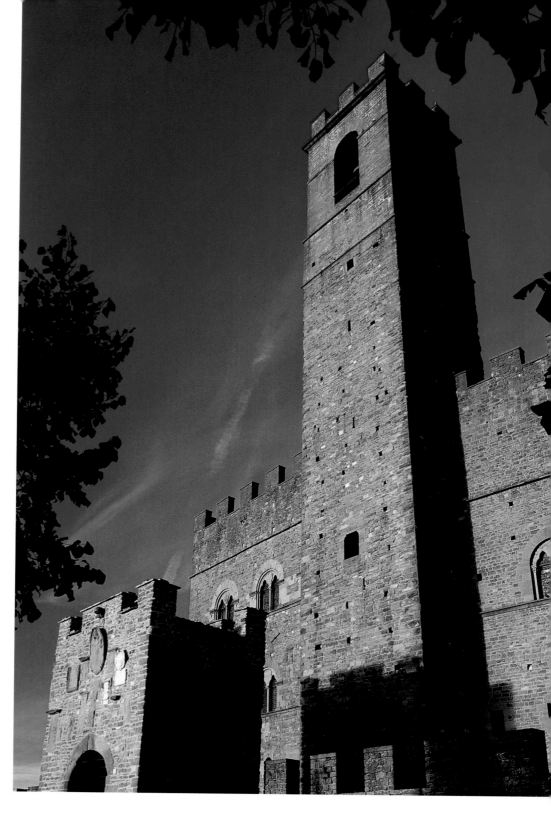

*S*hady porticoes and narrow streets alternate with sunlit squares in Poppi, as the village looks up to its castle for protection (this page *and* opposite, above *and* below right).

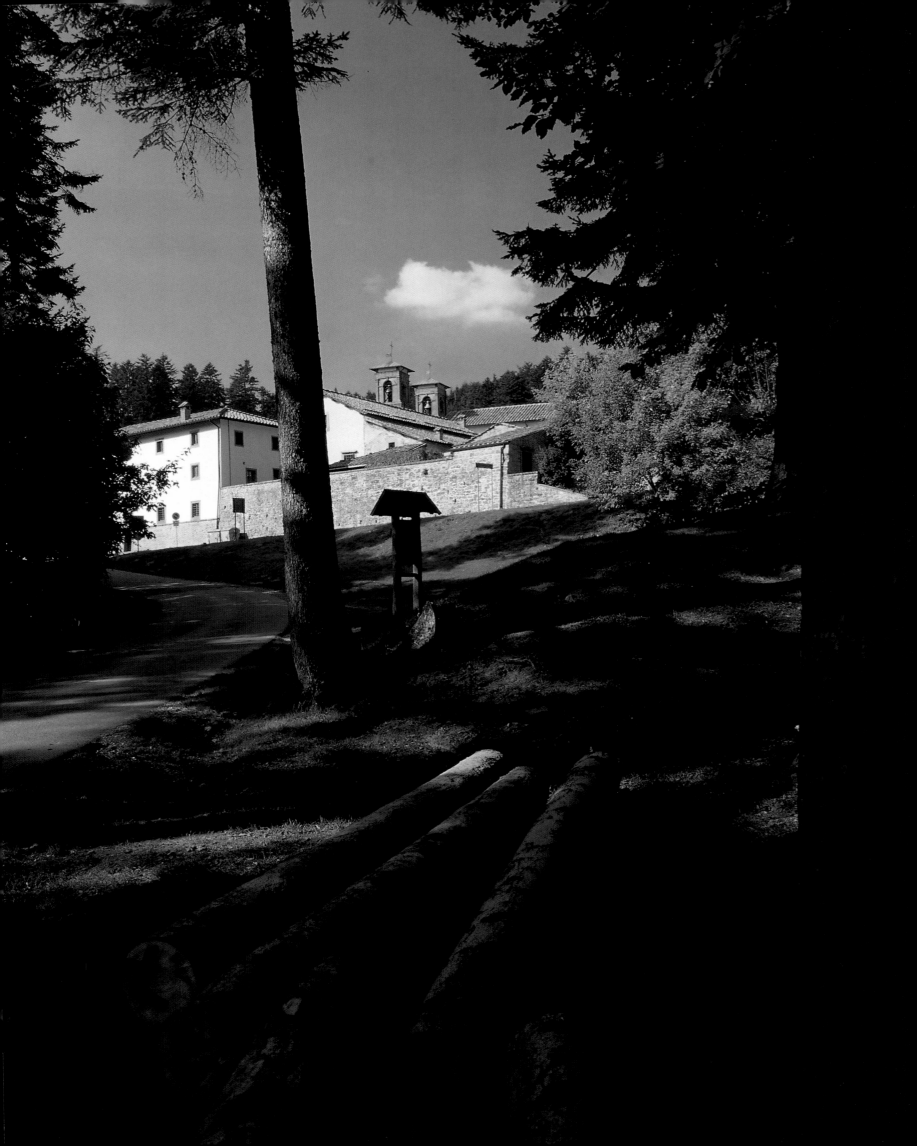

Camaldoli

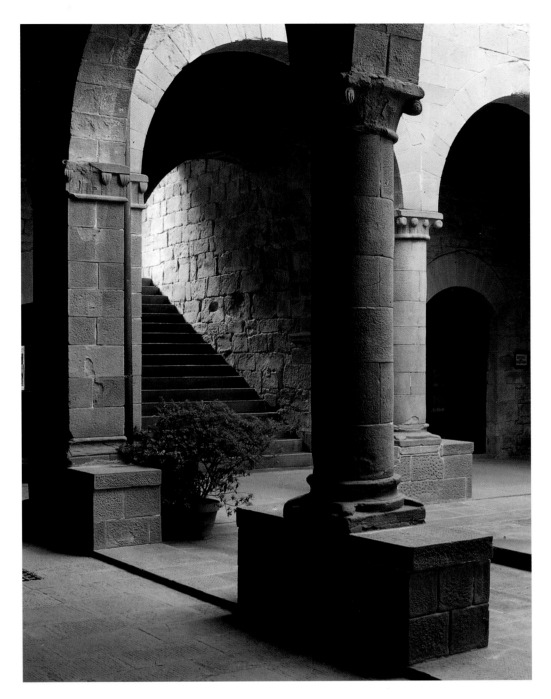

Remote and in a wilder setting than is usual in Tuscany, Camaldoli is set 1104 metres above sea level in the Apennines and the upper Casentino forest. The village is approached through pines, spruce, acacias, horse chestnuts, larch, sycamore, elms, beeches, limes and laburnums. As you climb up towards the village there is the occasional spectacular drop on one side of the road. Ferns, broom and cyclamen add even greater variety to the vegetation. It was in this solitary forest that St. Romuald founded a monastery in 1012.

Romuald, a scion of the dukes of Ravenna, initially had lived an entirely solitary life in a cell in the marsh of Classis, but monks at a nearby monastery elected him their abbot. Inspired now to combine the ideals of a hermit with those of the monastic life, he set about founding monasteries devoted to silent prayer, conversion of the people and daily toil, both mental and manual. The land on which his Tuscan foundation stands was given to him by Count Maldolo d'Arezzo, hence its name, a contraction of Campo Maldoli.

Romuald's foundation consisted of a mere five monastic cells and a little oratory. His oratory, consecrated in 1027, was enlarged and rebuilt over the centuries, notably in 1658 and after a fire in 1693, and today seems astonishingly lavish for such a tiny community. A couple of towers rise from its rich Baroque façade, which carries statues of the Saviour, flanked by Saints Romuald and Benedict. The interior is equally lavish, crammed with carvings, paintings and frescoes, beginning with a fifteenth-century Madonna and Child by Mino da Fiesole in the vestibule. Here, too, is the rich monastic library and a chapter house with intricate intarsia work. Opposite is Romuald's own, humble cell, with his little bed and a reproduction of his millstone, while beyond is the monastic village: twenty minuscule houses, each one housing a single monk and boasting a tiny garden.

The monastic village of Camaldoli lies peacefully in the Casentino forest (opposite). Since its enlargement in the seventeenth century, the foundation is now notable for the lavishness of its architecture: here, the cloisters of the lower monastery (above) and the approach to the cell of St. Romuald (left), the founder of the monastery.

Overleaf *The interior of the monastic church is graced with a superb Della Robbia altarpiece, while the magnificence of its exterior may be judged from this view of its twin towers.*

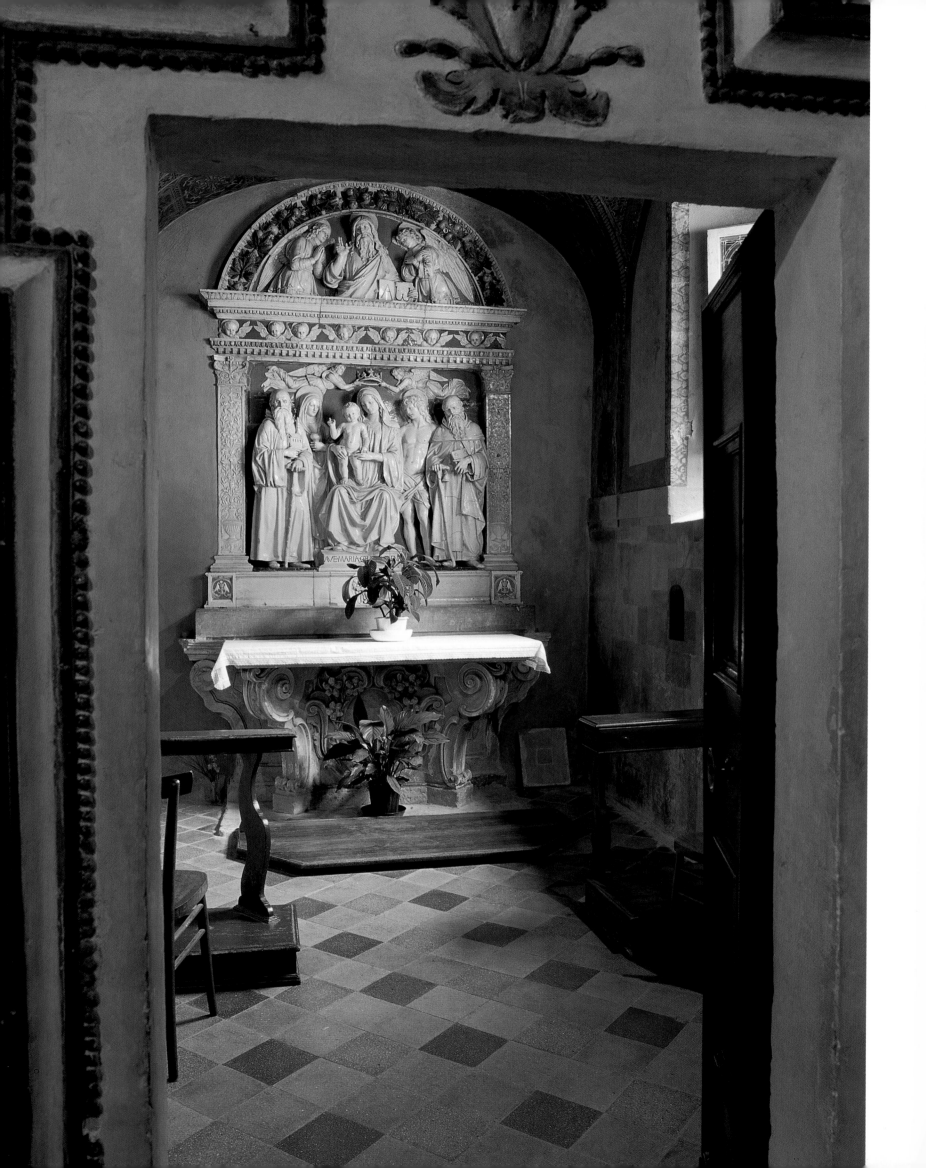

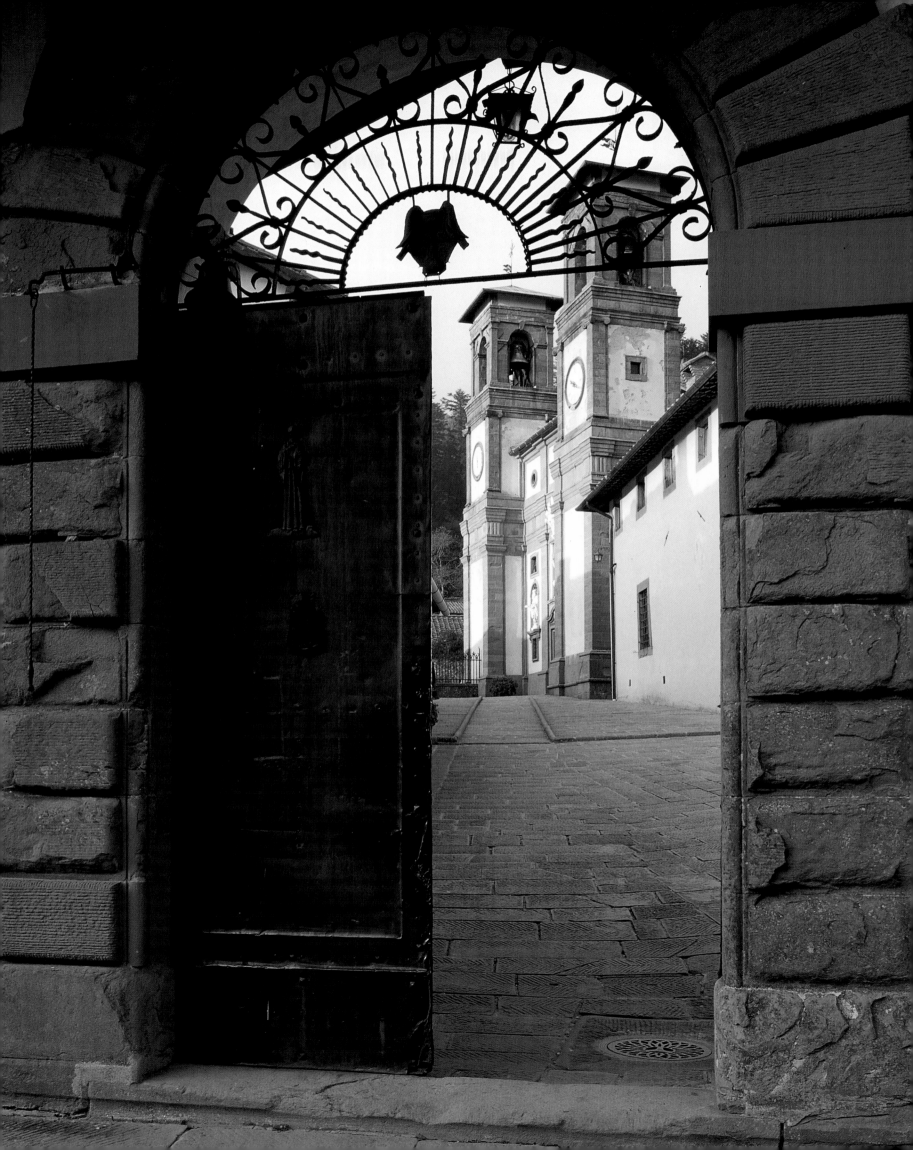

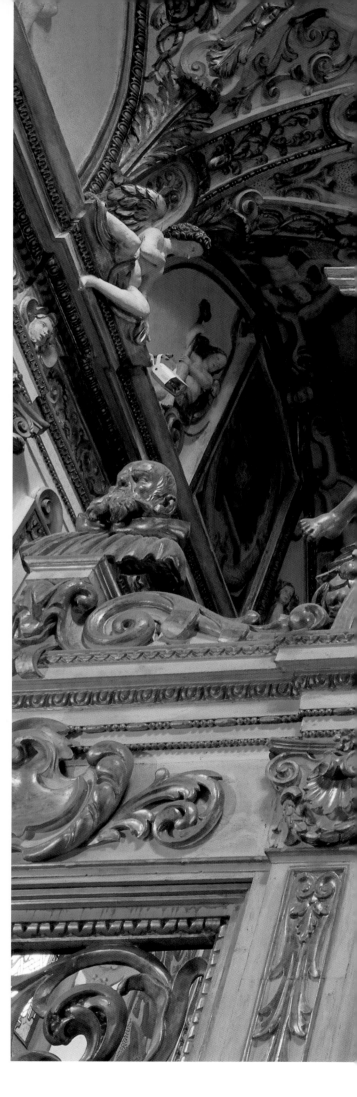

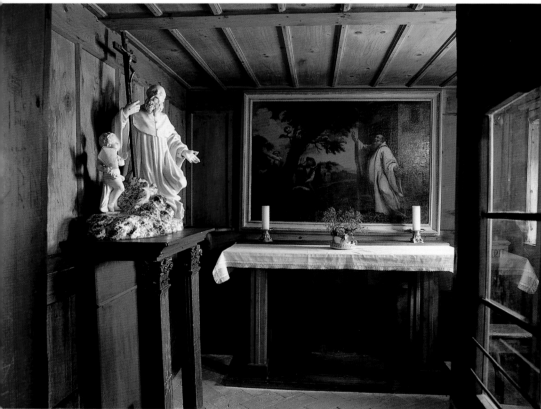

The note of architectural magnificence is continued in the Baroque detailing of Camaldoli's church (right). However, other chords are struck by the simplicity of the monks' houses (top) and in this painting (above) by A. Mussino (1934) of St. Romuald appearing to his followers, now in the monastery church.

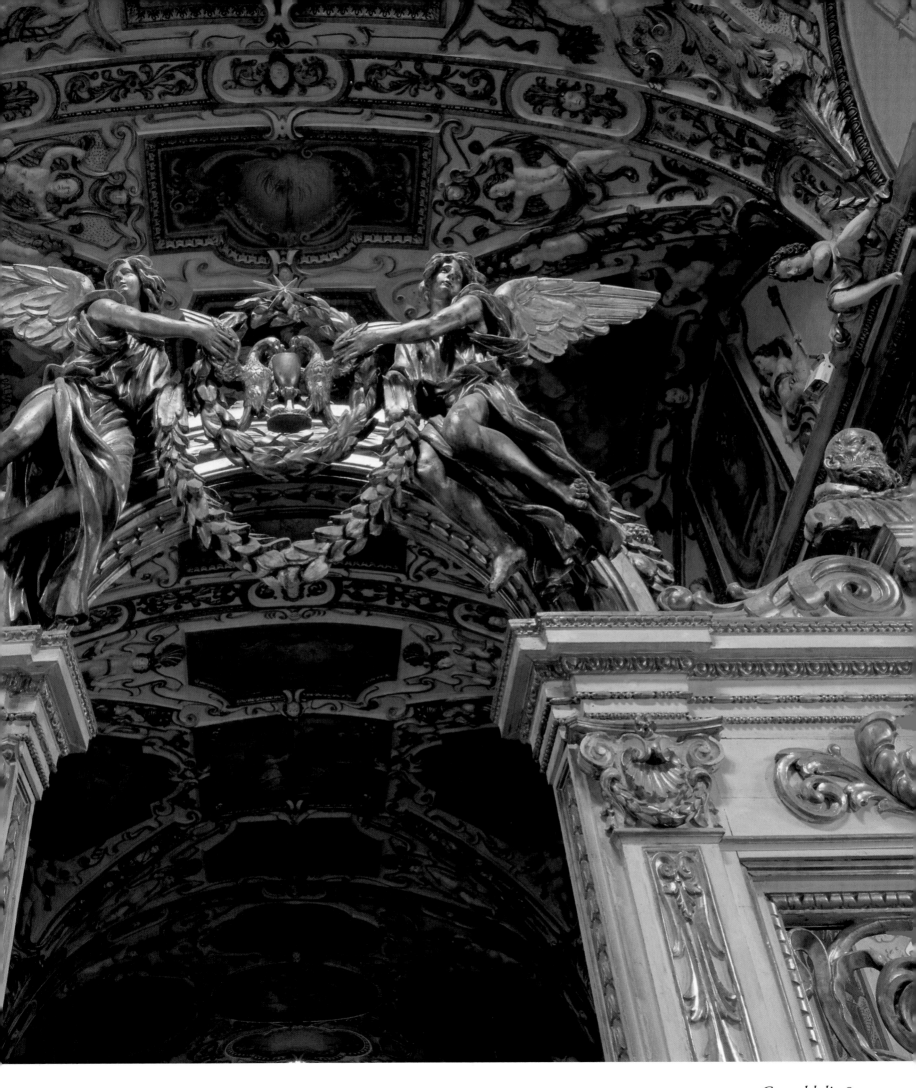

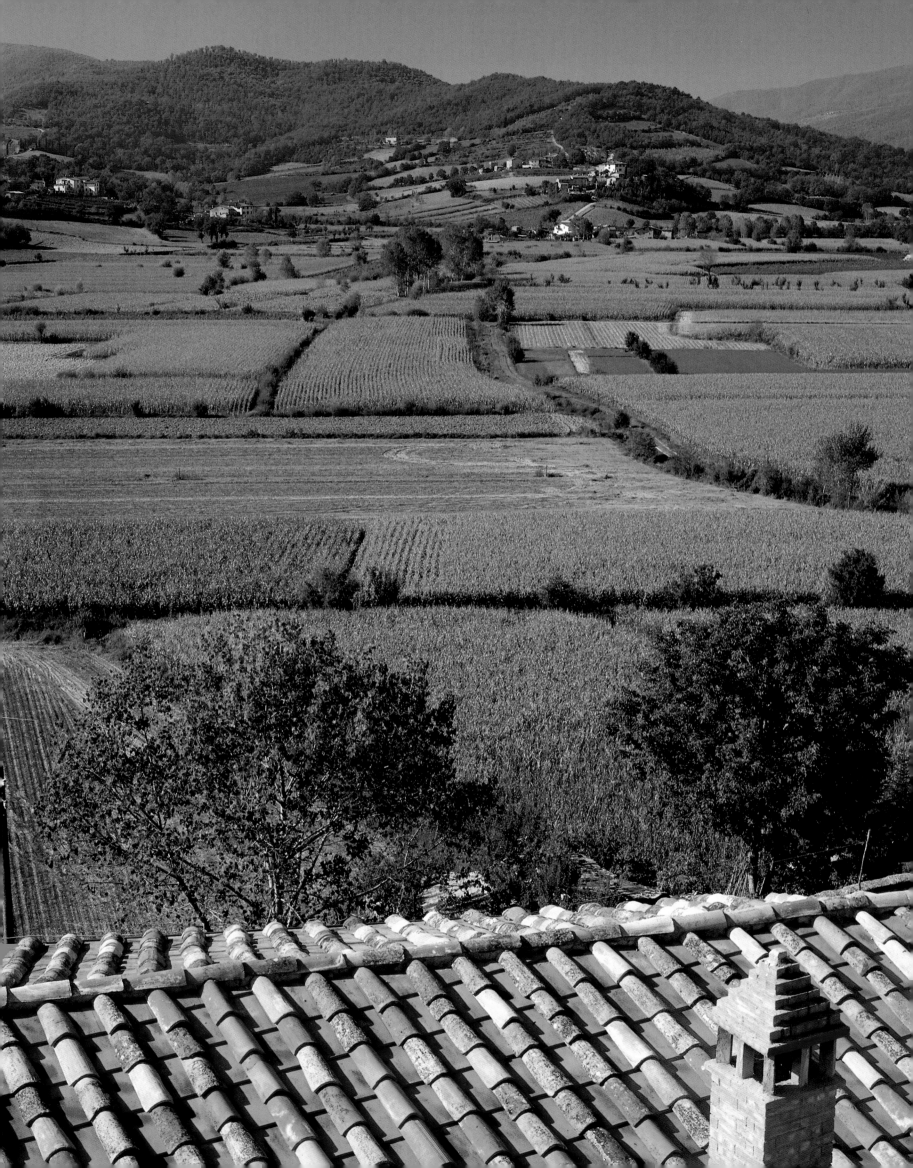

Around Siena and Arezzo

San Gimignano
Casole d'Elsa · Radda in Chianti
Castellina in Chianti · Monterchi · Monte San Savino
Foiana della Chiana · Lucignano · Pienza
Montalcino · San Quirico d'Orcia
Castiglione d'Orcia

Opposite
*The terracotta roof of a house on the outskirts of
Monterchi provides the foreground to this view over the
fertile Cerfone valley, east of Arezzo.*

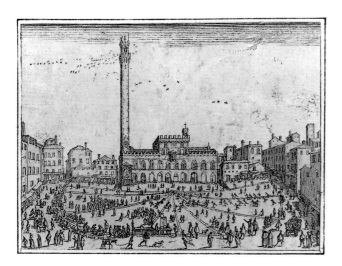

THIS corner of Tuscany is a land of rivers. To the east the Tiber cuts off a sliver of the territory; further inland the valley of the Arno brings its greenery to the countryside, south of which stretches the Chiana valley. The river Orcia runs west of the Val di Chiana, flowing past abbeys and more villages.

Beside the Orcia sit country villas, with their orchards and parks. Far from being 'natural', this countryside reveals the co-operation between man and nature at its best. In the late seventeenth and early eighteenth centuries the agricultural middle-class set up an Accademia dei Georgofili, an 'Academy of the Friends of Agriculture', to work out how best to exploit and conserve the land. We have reaped the benefit. Hedges, deliberately planted as windbreaks in the eighteenth century, enliven the territory, while black cypress groves and red oaks add their lustre to such thirteenth-century villages as Radicofani, which crown the neighbouring hilltops. Local aromatic plants are responsible for the slightly perfumed milk of the region, while sheep graze and eventually produce the lovely Pienza *pecorino* cheese.

These rivers are dynamic. At first the upper Tiber rushes pell-mell down rocky gorges, before slowing as it reaches its narrow plain. Predominantly mountainous, this region is wooded, with pasture-land fighting for survival and succeeding. Sheep and cattle graze on the hillsides, while in the villages traditional lace-makers ply their ancient trade alongside furniture-makers. The hides of the animals are used for hand-made shoes. Pasta is another staple product of the region, hence traditional dishes such as *tagliatini in brodo.* As for art, Caprese in the Tiber valley was the birthplace of Michelangelo, and his works and those of his fellow artists may be found in the most humble village.

The Val di Chiana is richer and more peaceful. The most extensive of all the Apennine valleys, it is dominated by the ancient city of Cortona and surrounded by some 500 square kilometres of long-cultivated farm land. Dry-stone walls, terraced groves of olives, pines, ilexes and cypresses mingle with walled villages and medieval castles, churches and abbeys, as well as remains of the Etruscans and the Romans.

At Arezzo the Arno abruptly changes course and flows north. This is wine and olive oil country. Old traditions, such as felt working

and glass-blowing survive here. Pine trees crown the ravines, while oaks grow in the deep gulleys. The Guelphs of Florence and the Ghibellines of Arezzo fought to control the river traffic and the region's castellated towns until the Florentine republic finally triumphed in 1384.

Geographically as well as historically, the superb city of Siena dominates the whole region. Especially influential between the eleventh to the fourteenth centuries (particularly so after defeating Florence at the battle of Montaperi in 1260), the city sits on three hills, with her three ancient gateways pointing towards Florence, Rome and the Maremma. For centuries it controlled the two main corridors of central Italy, which run along the Val di Chiana and the Val d'Orcia. Others built castles and strongholds along these routes, but, as a triumphant early fourteenth-century fresco painted by Simone Martini in Siena's Palazzo Pubblico depicts, one by one they capitulated to the forces of this powerful city.

Just outside San Quirico d'Orcia lies the eerily surreal landscape of the crete.

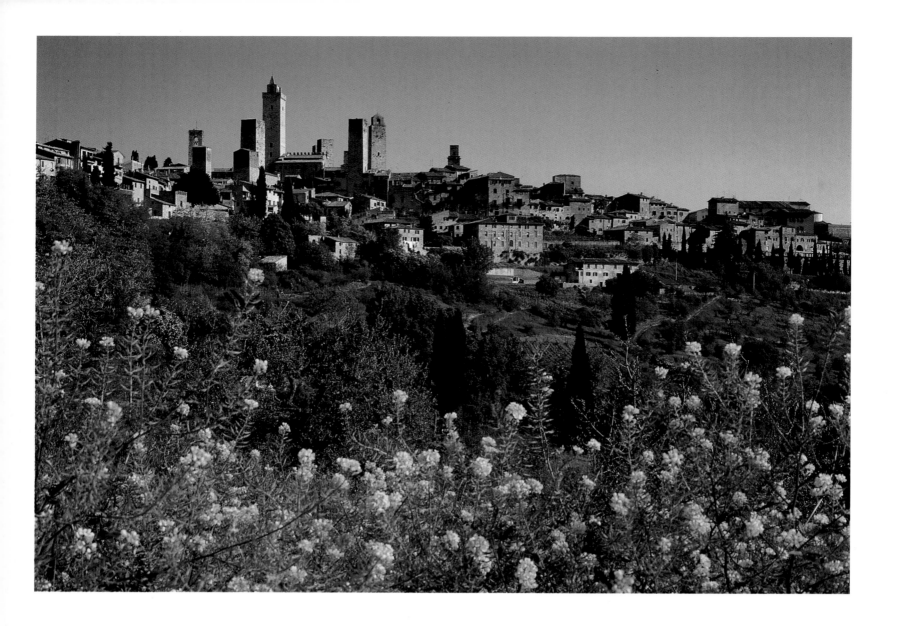

San Gimignano

*Towers and buildings of every
size and shape provide a
backdrop to the landscape on the
south side of the town* (above). *The
view east from the vantage point of
the tower of the Palazzo del Popolo
reveals a Renaissance landscape of
orderly cultivation* (opposite).

THIS most beguiling of Tuscan small towns is
centred on two piazzas: that of the Duomo, with
its twelfth-century Collegiate church, the towered
palace of the Podestà and the twin-towered house of the
Zalvucci; and the Piazza della Cisterna, irregular in
shape, shaded by the towers of surrounding houses, the
finest being the Torre del Diavolo and the twin
Ardhingelli towers. San Gimignano's town hall, the
former Palazzo del Popolo, now contains an art gallery
in its Torre Grossa. Once there were around seventy
such towers. Today only thirteen remain, still justifying
the description of the town as the 'Città delle belle
torri'. Beautiful they may be, but these towers were
built expressly for defence and aggression. The noble
families who lived in them were prepared for combat
whenever a rival great family, hidden in a neighbouring
tower, ventured out.

Two main streets, the Via San Giovanni and the
Via San Matteo, wind gently through the town, both
lined with thirteenth-century houses dating from San
Gimignano's years as a free city before it became a vassal
of Florence in 1353. The style of the town is Florentine,
Luccan, Pisan and Sienese, for the medieval elders of
San Gimignano decreed that any well-disposed immi-
grant could build in his own style within the triple ring
of defensive walls. Outside the walls grow cypresses and
vines, the latter's grapes producing, notably, the deli-
cious white Vernaccia di San Gimignano.

Of the religious buildings of San Gimignano, the
Collegiate church, Romanesque in style but enlarged by
the architect Giuliano da Maiano in 1466, has a Last
Judgment painted on its west wall by Taddeo di Bartolo
in 1393, as well as a cycle of mid fourteenth-century fres-
coes depicting scenes from the Old and New
Testaments. Easily missed is the lovely Renaissance
chapel of Santa Fina, built by Giuliano da Maiano and
his brother Benedetto, with frescoes of 1475 by
Domenico Ghirlandaio depicting the life of Fina who,
at the age of ten, decided to spend her life stretched out
on a wooden plank and died five years later.

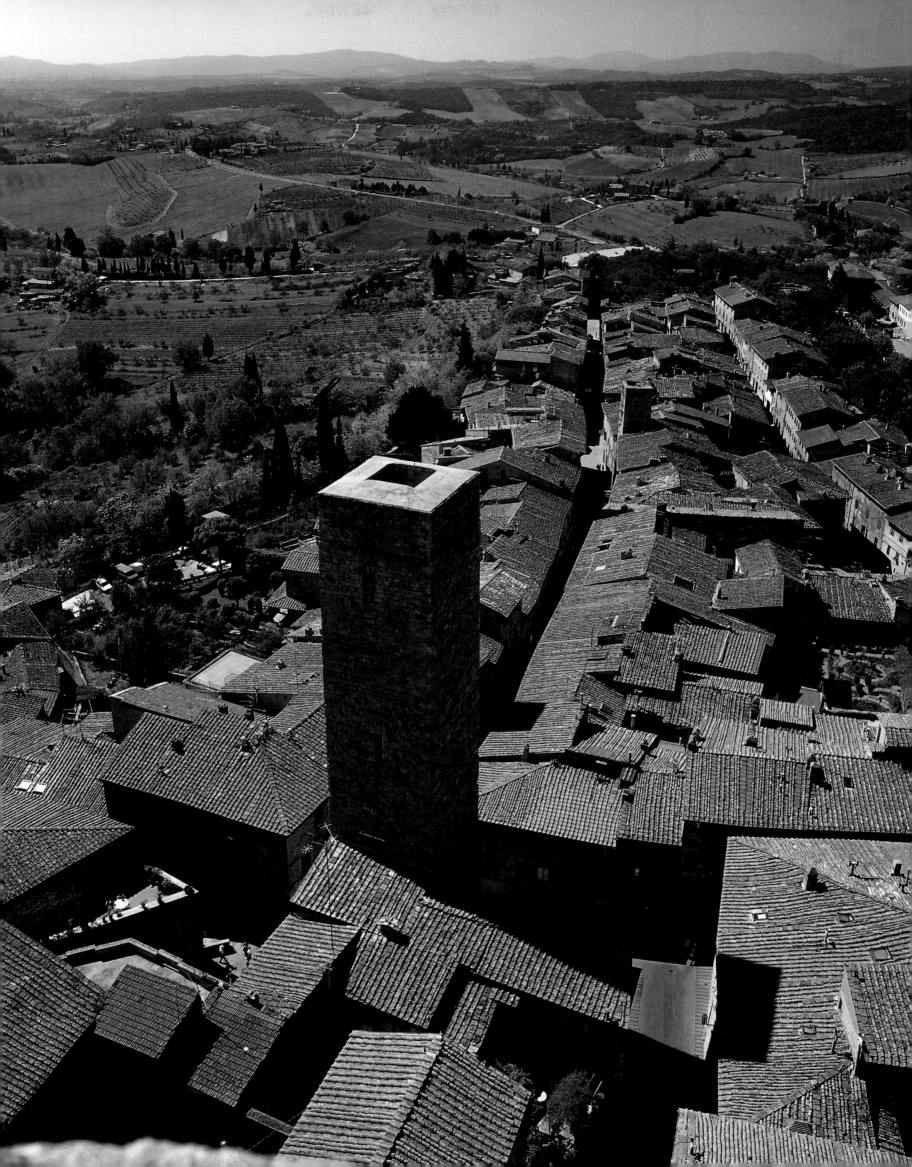

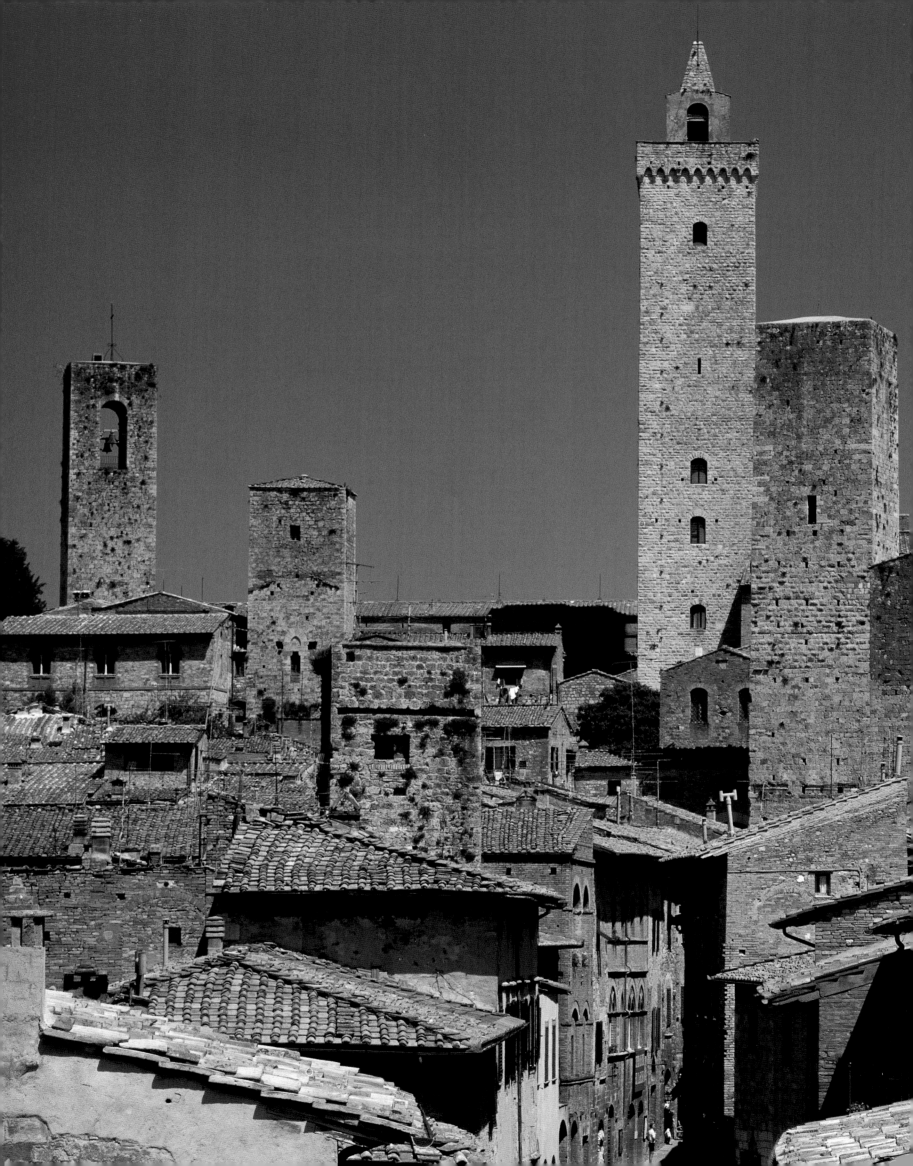

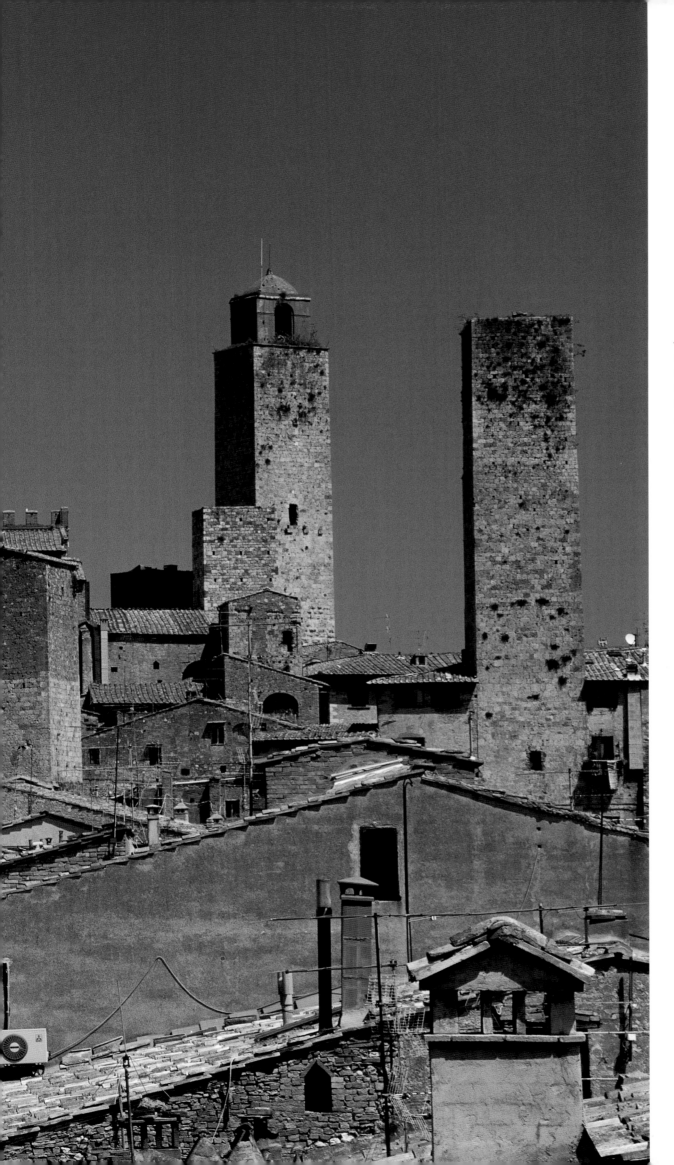

A *town built for internal strife: at one time there were about seventy defensive towers in San Gimignano; the thirteen which remain still lend a martial and medieval air to this view from the Porta San Giovanni.*

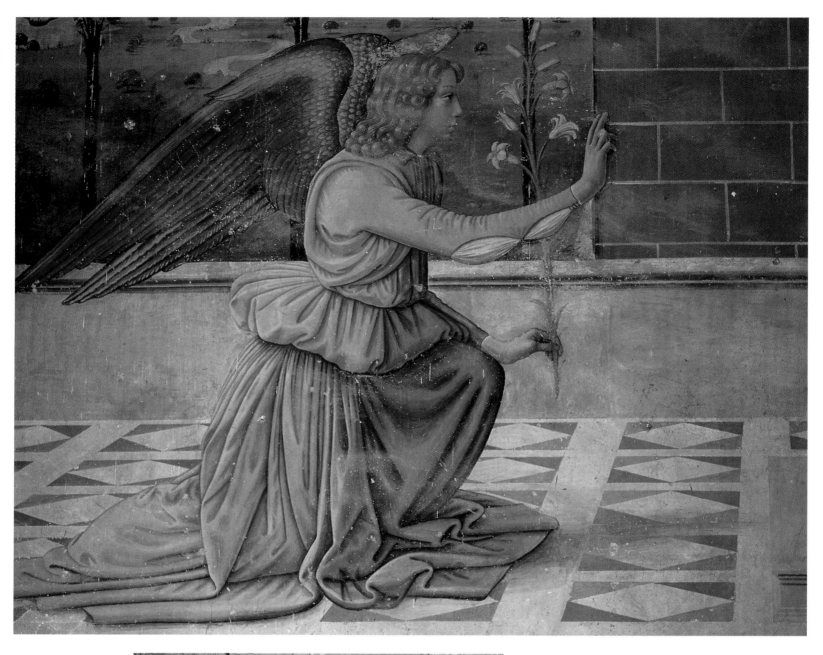

*The Angel Gabriel at the Annunciation (above)
brings news of the conception of Jesus to the Virgin
Mary (opposite): two details from the fresco painted by
Domenico Ghirlandaio in 1482 on the wall of the
baptistry adjoining the Collegiata. Traditional crafts still
flourish in Tuscany: a carpenter at work in a tranquil
side street beneath an image of the Madonna.*

Overleaf
*The towers of San Gimignano loom up eerily as
evening closes in, creating dramatic effects of light
and shade in squares and courtyards.*

LAVDATE DOMINVM
OMNES GENTES X AV

INITIVM SAPIENTIE
TIMOR DOMINI

RI FECIT · IVLIANVS QVONDAM AN
DE SCO GEMIN ANO · MCCCCLXXXI

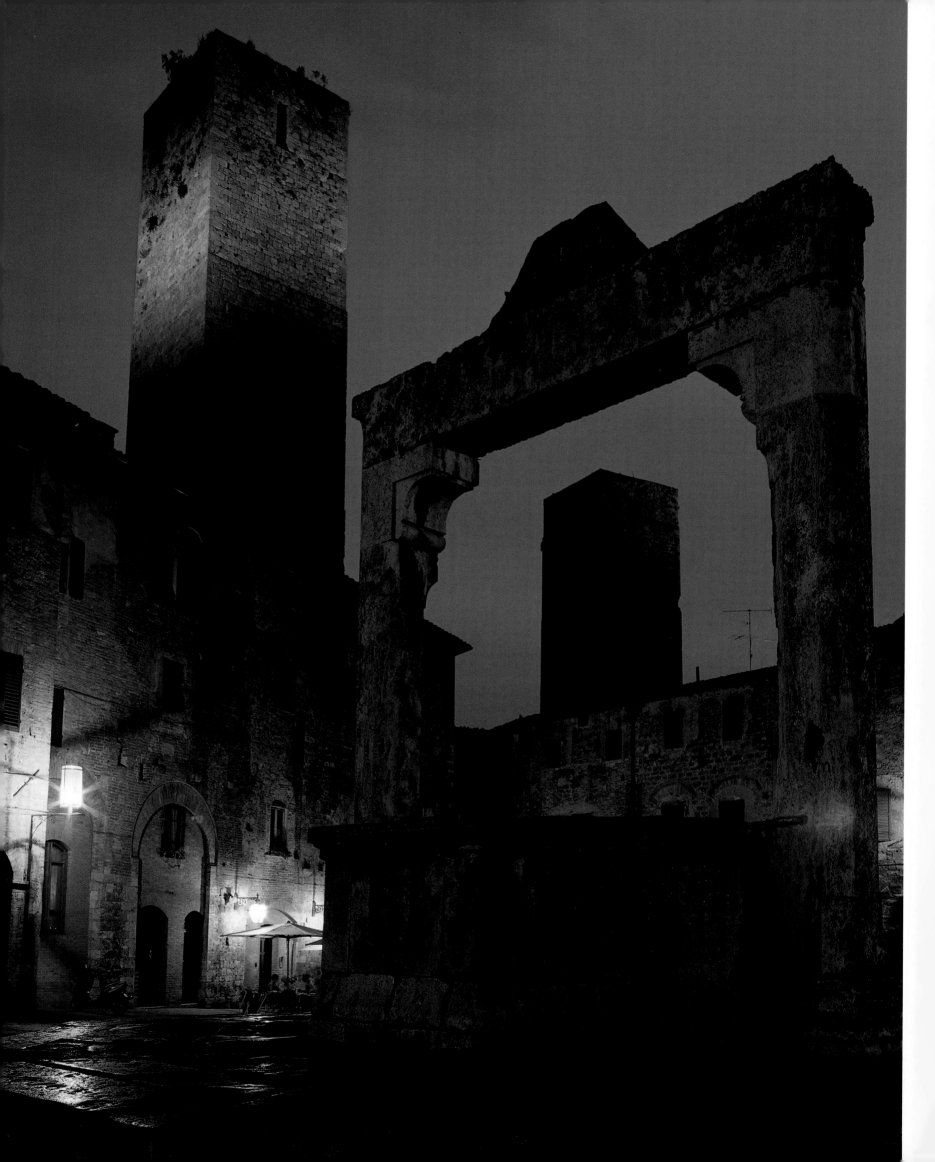

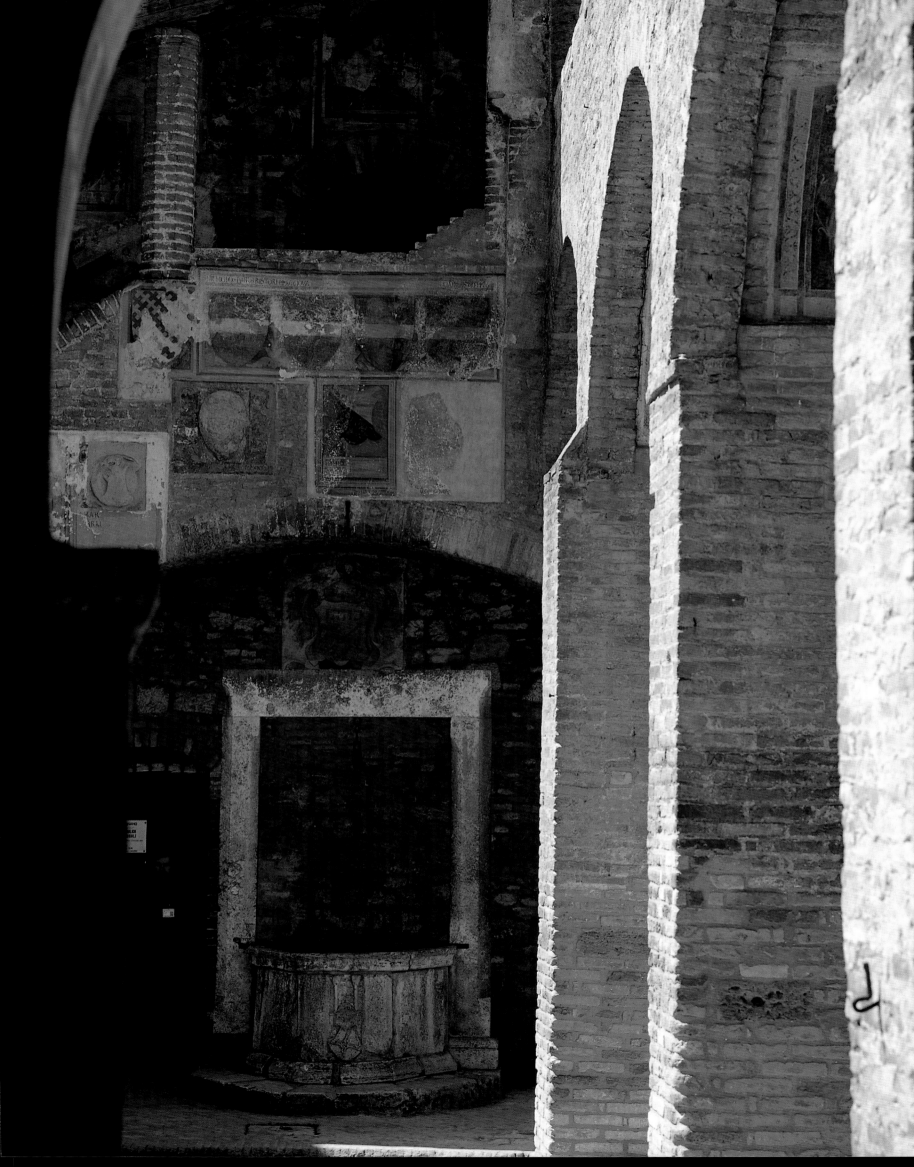

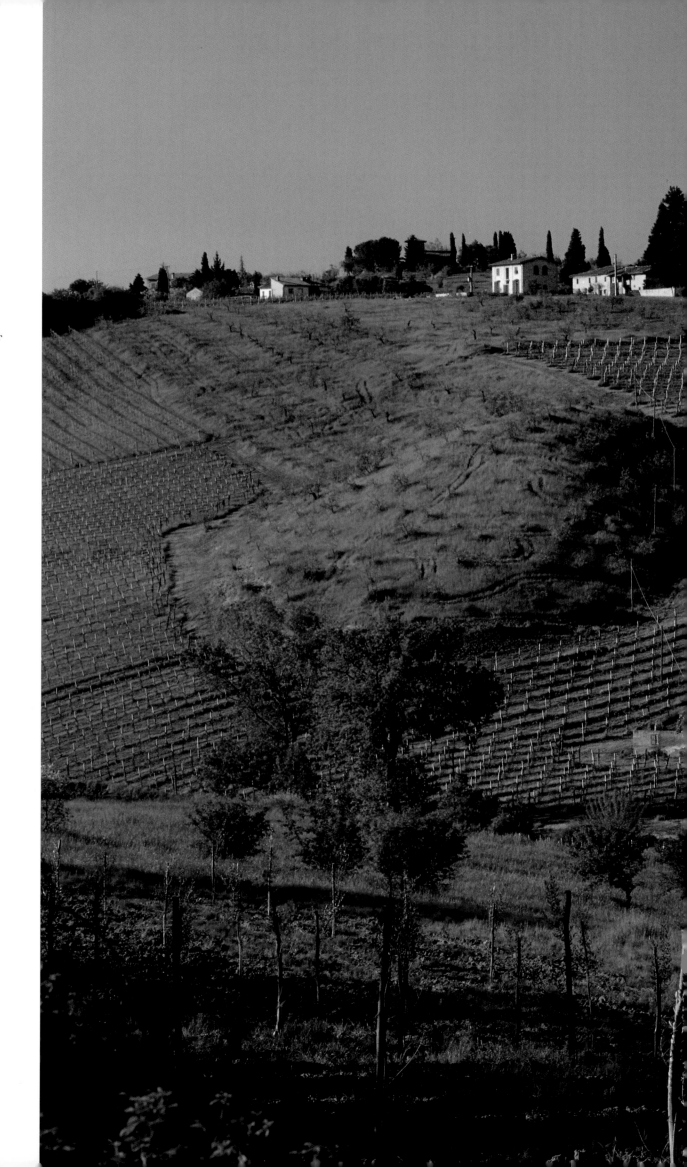

*T*he rich patterning of a wine-
producing landscape: south of
San Gimignano the hamlet and
church of Monte Olivero are
surrounded by vineyards.

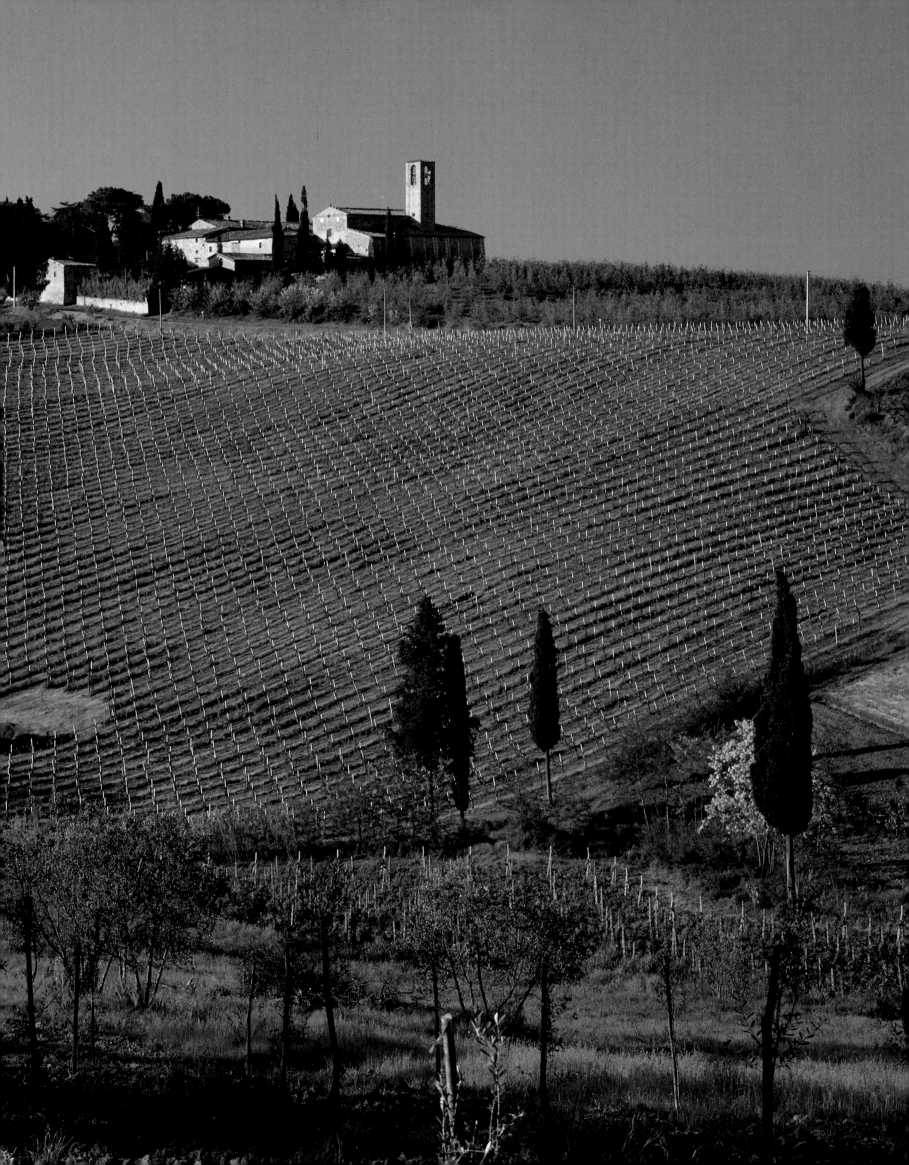

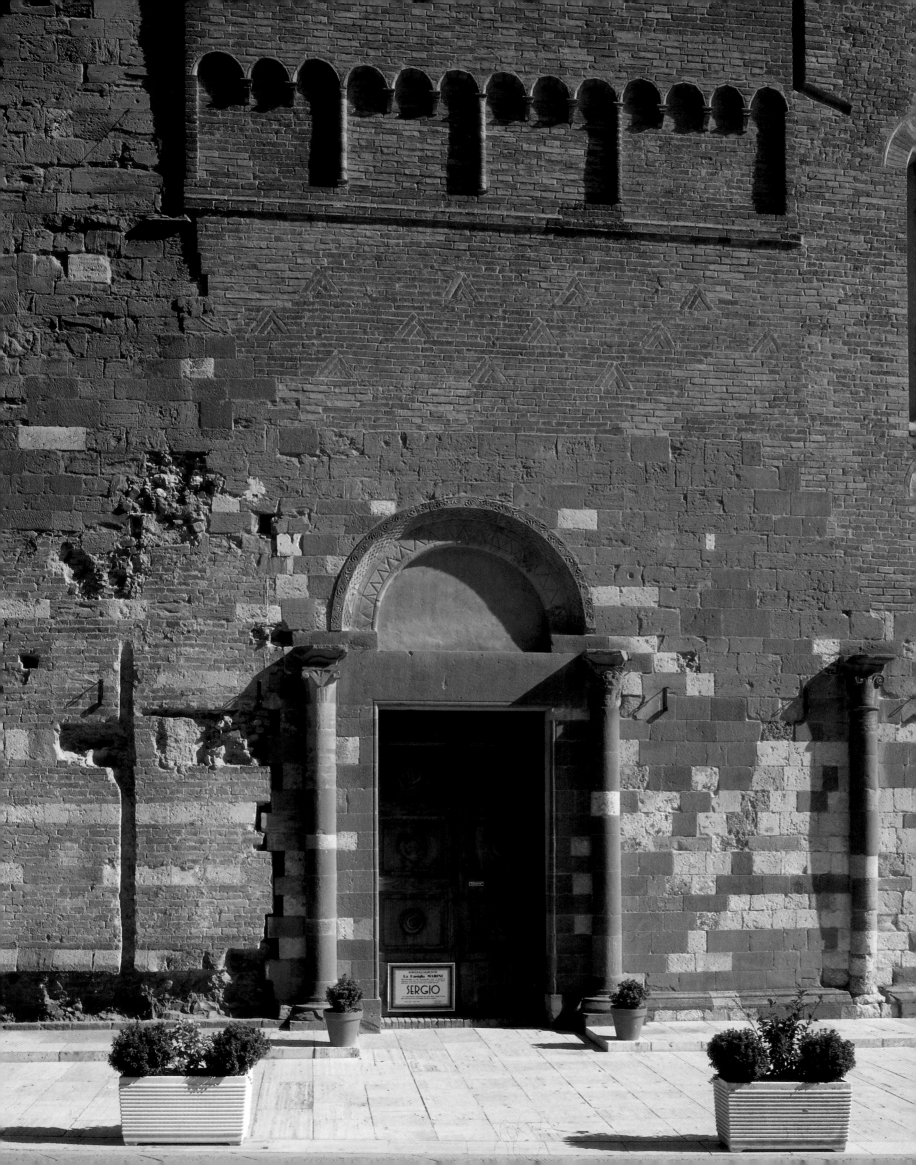

Casole d'Elsa

O N A picturesque hill, Casole d'Elsa is dominated by a fourteenth-century fortress and by the Palazzo Pretorio which Francesco di Giorgio Martini designed in 1487. The stern aspect of the fortress is softened by its internal frescoes, particularly a Madonna and Saints attributed to Giacomo Pacchiarotti, who was born in Siena in the fourteen-seventies.

Yet the village is much older than its present fourteenth-century aspect indicates, as the Etruscan remains on display in this palazzo reveal. Casole d'Elsa's Gothic Collegiate church also betrays its antiquity in its crypt, which is all that remains of an earlier building. Once Romanesque, the present church was transformed to the Gothic style in the fifteenth century. The arch which separates the five choir chapels from the rest of the church once again reveals the work of earlier artists; its frescoes of the Last Judgment date from the fourteenth century and were painted by Giacomo di Mino del Pellicciao. The two finest monuments inside this church commemorate Bishop Tommaso Andrei, who died in 1303, and Ranieri del Porrina, who died in 1315.

Next to the Collegiate church is the village's presbytery, attractively built from both stone and brick, and dating initially from the fourteenth century. The ruins of its neighbouring cloister date from the next century. Once again this building houses spectacular works of art, in particular a Madonna and Saints, painted in 1488 by Andrea di Niccolò of Siena, and a Madonna and Child by Duccio di Buoninsegna.

The medieval factions of Volterra, Siena and Florence all fought over this strategic site, though the depradations they caused were far less savage than those of the Second World War.

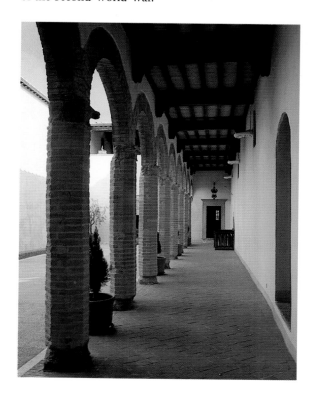

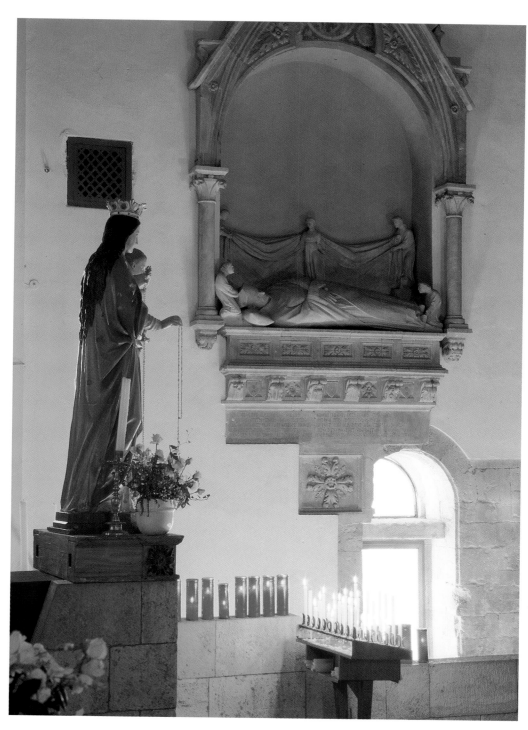

The forbidding aspect of the façade of its fortress (opposite) is only one side of Casole d'Elsa. The village has fine ecclesiastical buildings and monuments: the cloister of the Canonica (left); the early fourteenth-century tomb of Bishop Tommaso Andrei by Gano da Siena in the Romanesque Collegiate church (above).

*S*een from the south-east, Casole
d'Elsa lies comfortably on the
horizon of an easily rolling landscape.

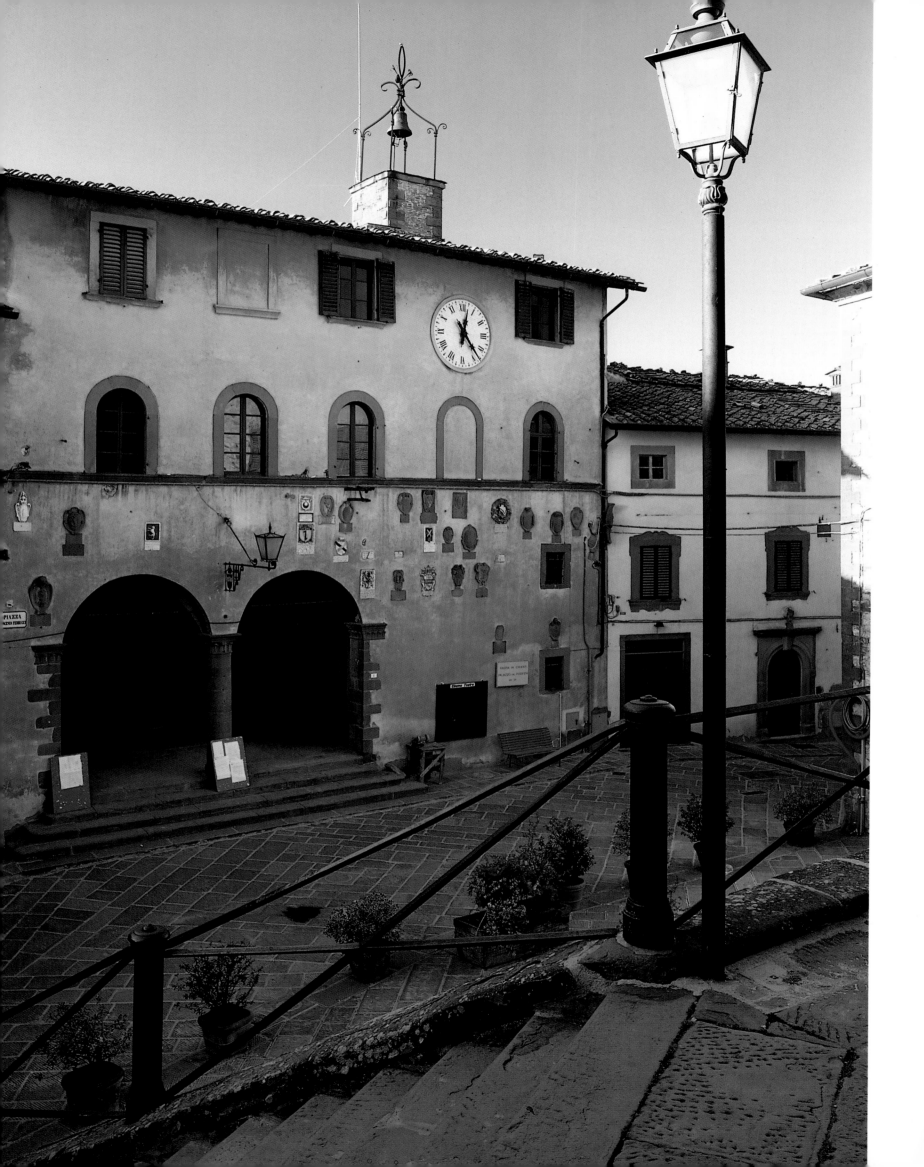

The steps of the church of San Niccolò provide the vantage point for this view of the Palazzo Pretorio (opposite); close by is a remarkable fountain from which this detail is taken (below). Radda did not escape the turbulence of the late Middle Ages; it is still encircled by massive fortifications (right).

Radda in Chianti

FORTIFIED Radda in Chianti rises on a hill which divides the valleys of the Pesa and the Arbia. This is one of Tuscany's most prolific wine centres, becoming the headquarters of the Chianti League in 1415. Here, now, is a centre for the historic study of Chianti wine, with an important regional wine museum.

Radda in Chianti's first mention in recorded history occurs in a charter of 1002, whereby Emperor Otto II gave the court of Radda to a Florentine abbey. The Guidi counts disputed this donation, and Radda became definitively a fief of Florence only in 1203. In that same year the Sienese besieged this tiny village; in 1268 it was occupied by the French. Radda in Chianti regained its own sovereignty only in the fourteenth century, when the citizens decided to build its walls. But more troubles followed, particularly when the Aragonese invaded Tuscany in 1478 and the Duke of Calabria became the local lord.

From that era dates the palace of the Podestà, which was completed in 1474. Around it straggle narrow streets, still following their medieval pattern, flanked by houses of the same era. The Palazzo Pretorio, built in the Florentine style in the fifteenth century, has a façade decorated with coats of arms and a graceful loggia. A couple of arches, set to the left of the palace, are topped by a second storey with a clock, and above the whole perches an incongruous bell. Opposite rises the church of San Niccolò, fronted by a flight of steps and the public well, with the Chapel of the Compassion at its side.

Today Radda in Chianti quietly slumbers. Houses have been built on the medieval walls. Citizens inhabit the towers of the old fortifications, one of which serves as the local belfry. Outside the walls the vegetation is rich, and the woodlands teem with game, in season the prey of local huntsmen.

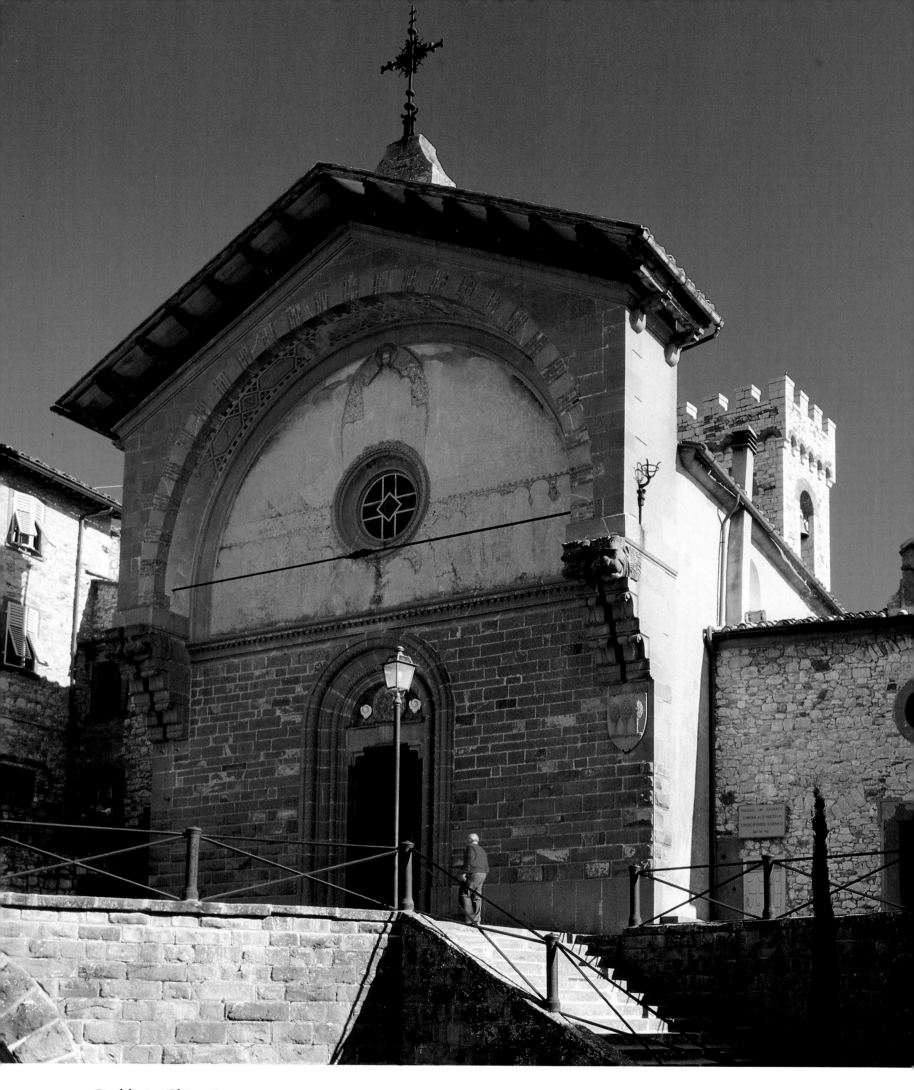

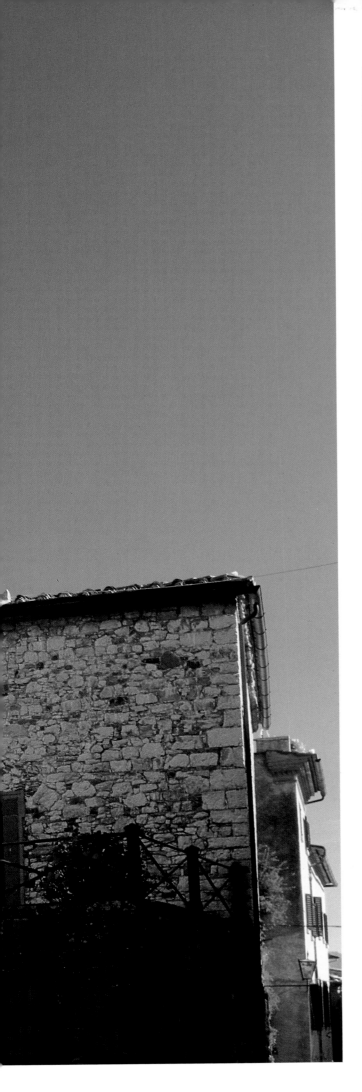

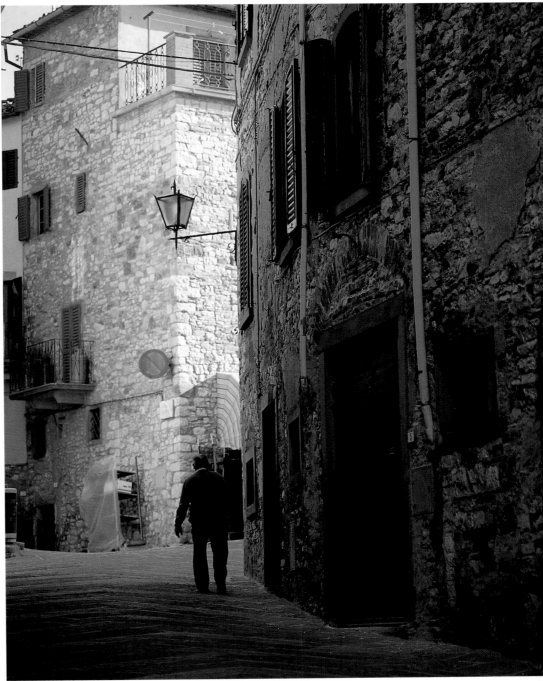

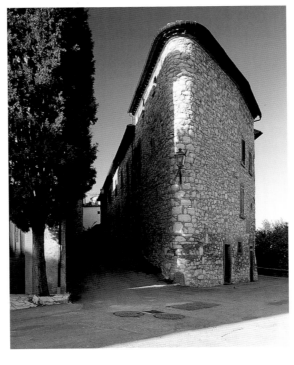

*T*he ecclesiastical buildings of Radda, such as the church of San Niccolò, flanked by the chapel of the Compassion (far left), share a robustness of construction with the medieval houses, which follow the encircling walls (left *and* above).

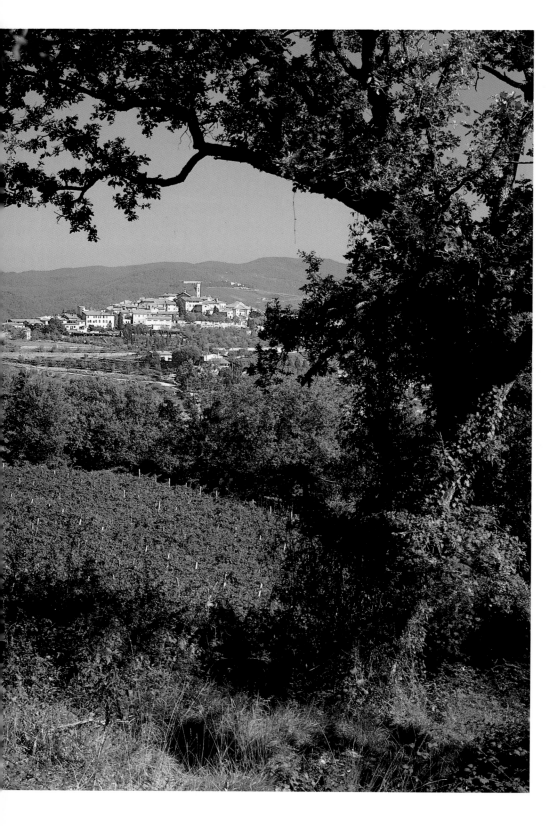

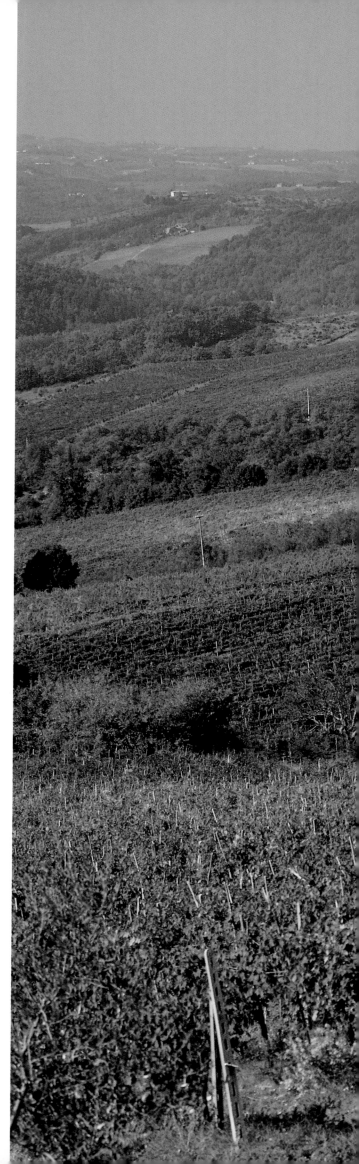

*F*ramed in foliage, Radda sits snugly in the intensely cultivated lands around it, here on the west side of the village (above). This is very much wine country and all around Radda stretch the famous vineyards of Chianti, like these at Panzano, to the north of the main village (right).

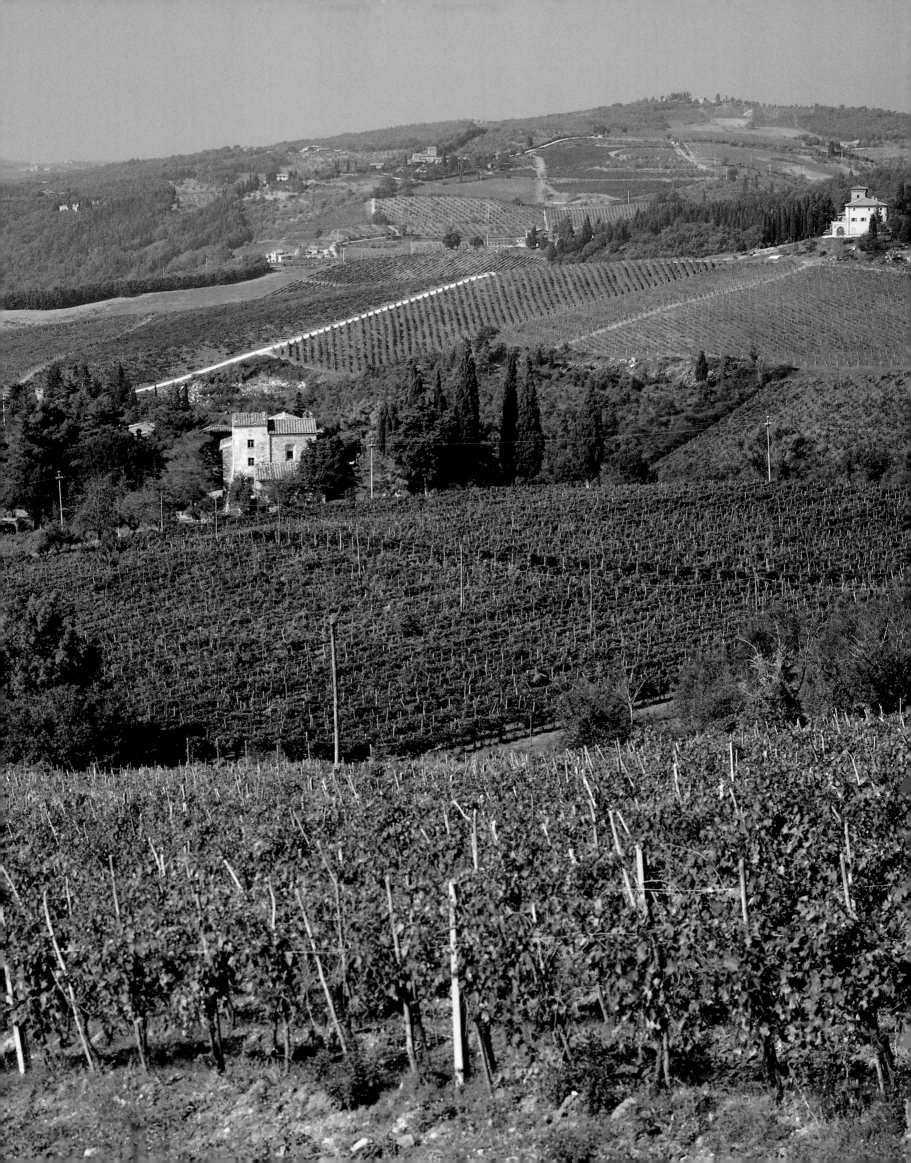

Castellina in Chianti

Some 600 metres above sea-level, Castellina in Chianti sits on a hill between the verdant valleys of the rivers Elsa, Arbia and Pesa. Long before its present aspect was formed, the village was an Etruscan settlement, remembered today in the necropolis of Montecalvario. Mindful of its strategic importance, the Florentines commissioned Filippo Brunelleschi to rebuild its walls, a project finished in 1451. Nowadays, houses stand atop them, and the former gateways have disappeared, one wantonly destroyed in the nineteenth century, the other bombed in the Second World War. But to the east and the west Castellina is still fortified.

Also destroyed in the Second World War was the parish church, so that today the villagers worship in a neo-Romanesque building. It contains several relics of bygone eras, in particular a fifteenth-century fresco of the enthroned Madonna by Lorenzo di Bicci and a Renaissance wood carving of St. Barnabas, who is one of the two patron saints of Castellina. The ashes of the other, St. Fausto (a saint who on request is reputed to bring rain), lie in an urn in the same church.

In summer the balconies above the medieval streets of this village are laden with geraniums, while coats of arms decorate the walls of the late Renaissance palaces of the Ugolini and Biancardi families, the former a fifteenth-century gem, the latter almost as seductive. Above the Biancardi palace look for the coat of arms of the Medici Pope Leo X. The Piazza Umberto I contains the town hall, which is graced with an external staircase and a fourteenth-century tower. The 'Salo del Capitano' on the first floor has a splendid fireplace, and from the next storey you can look out from four windows across the woods, olive groves and vineyards of the surrounding countryside.

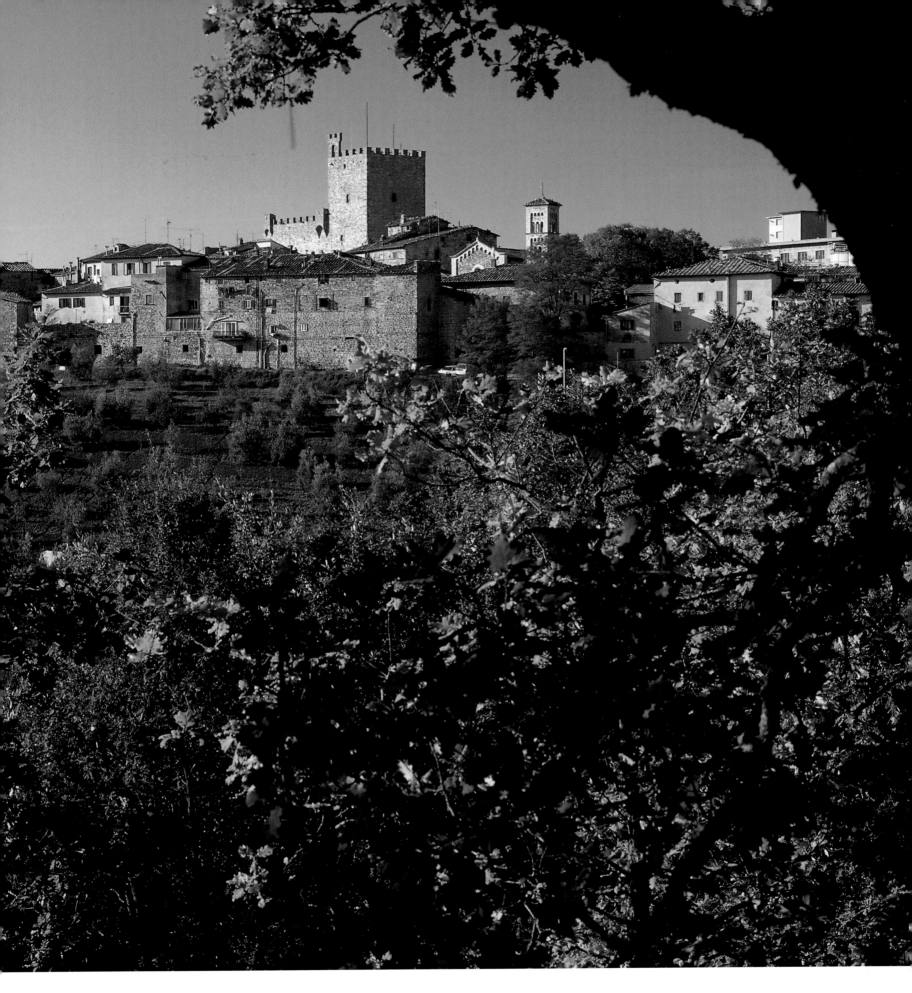

*T*he fearsomely fortified mass of Castellina's town hall
casts its shadow over the Piazza Umberto I (above
left) *and easily dominates any view of the village, here
seen from the east* (above).

*A*n animated statue of St. Barnabas embellishes the interior of Castellina's parish church (opposite).

*T*he characteristic detailing of village life in Chianti: floral decoration along a thoroughfare (left); local produce and the fine, robust wines of the region (above) may be sampled in one of the village's enjoyable restaurants (above left).

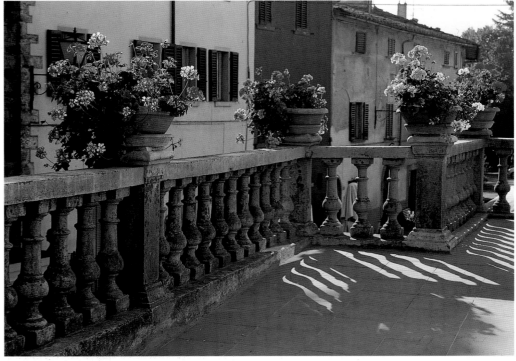

Castellina in Chianti · 109

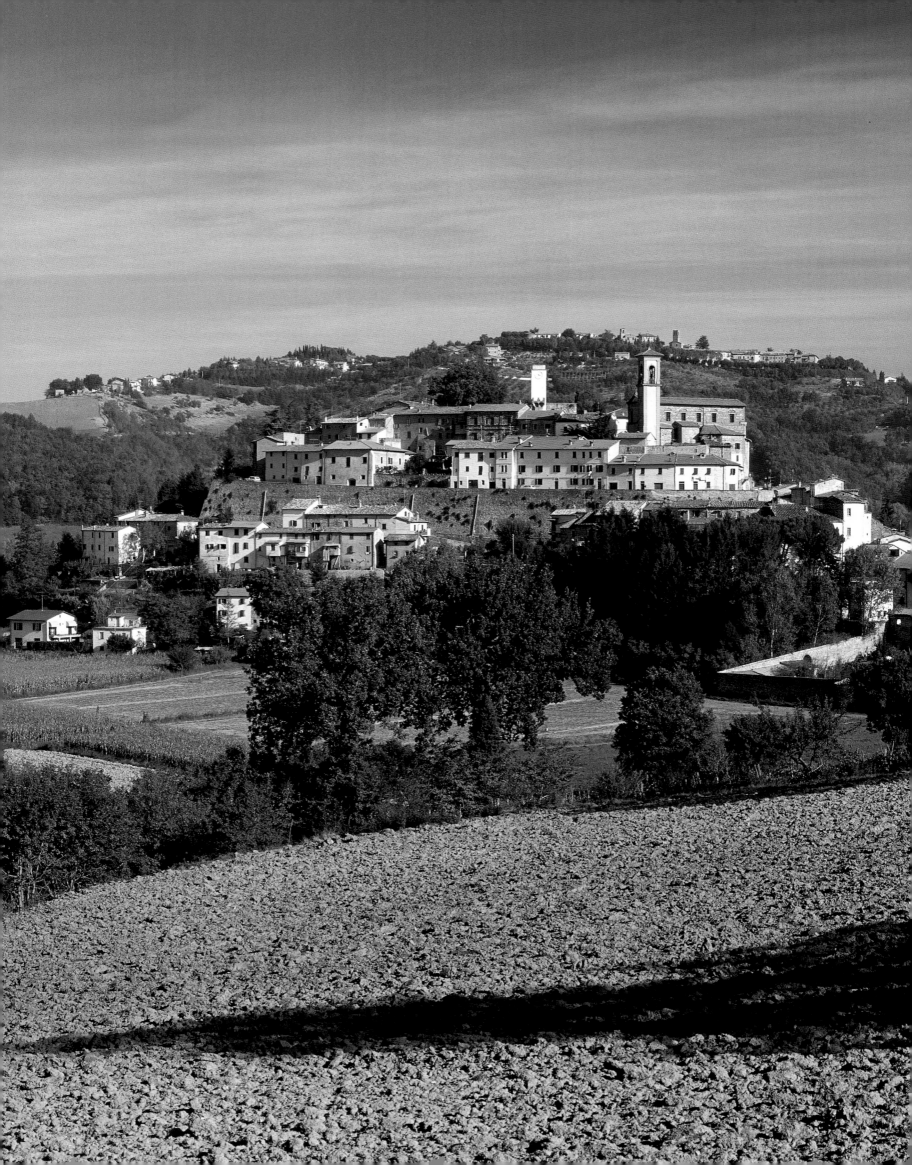

Monterchi

ON A HILL 356 metres above sea-level, overlooking the valley of the Cerfone, rises the medieval, walled village of Monterchi, its name derived from 'Mons Erculis', the hill of Hercules, whose cult was celebrated here in the Etruscan and Roman eras. Monterchi changed hands many times over the centuries, ruled first by the marquises of Santa Maria, then by the Tarlati family of Arezzo, then by Florence, next by the Papacy, until finally in 1860 it became part of the kingdom of Italy.

A picturesque arcaded medieval passage runs round the apse of Monterchi's Romanesque parish church. Dedicated to St. Simon, the church has fourteenth- and fifteenth-century frescoes, a sixteenth-century Della Robbia ciborium, a fifteenth-century Florentine crucifix and a painting of the Presentation in the Temple dating from the sixteenth century.

The mother of Piero della Francesca was born in Monterchi, and the village became famous in 1888 when a fresco painted by her son came to light in a small chapel in the local cemetery, which is just outside Monterchi on the road to Città di Castello. Known as the 'Madonna del Parto' (the Madonna of Childbirth) and probably executed in 1445, the painting may be in memory of the artist's mother. But the imagery may also have a further significance. In pagan times and probably still when Piero painted this Madonna, the waters of a local spring were considered beneficial for barren women longing for a child.

Sheltering under the south-west side of the hill from which it derives its name, the village of Monterchi sits snugly close to its neighbour Citerna, visible here on the skyline.

A significant stage on the 'Piero della Francesca Trail', Monterchi boasts one of the artist's finest works, the fresco of the Madonna del Parto (opposite), *in which two angels draw back curtains to reveal the pregnant Virgin Mary, who points proudly to her womb.*

L ight and shade in Monterchi: *inside the sixteenth-century baptistry of San Niccolò is this fresco of the Presentation in the Temple* (above); *an arch leads to a shady street* (above right), *while the medieval Via de' Medici, here lined with winter firewood, seems entirely composed of archways* (right).

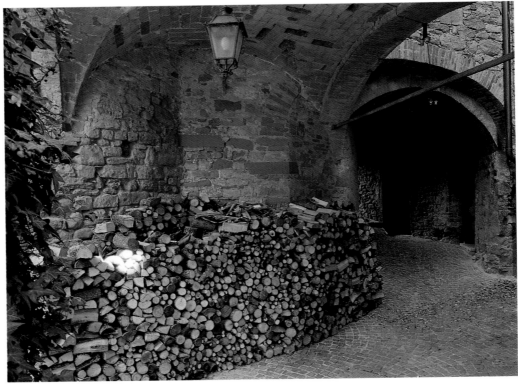

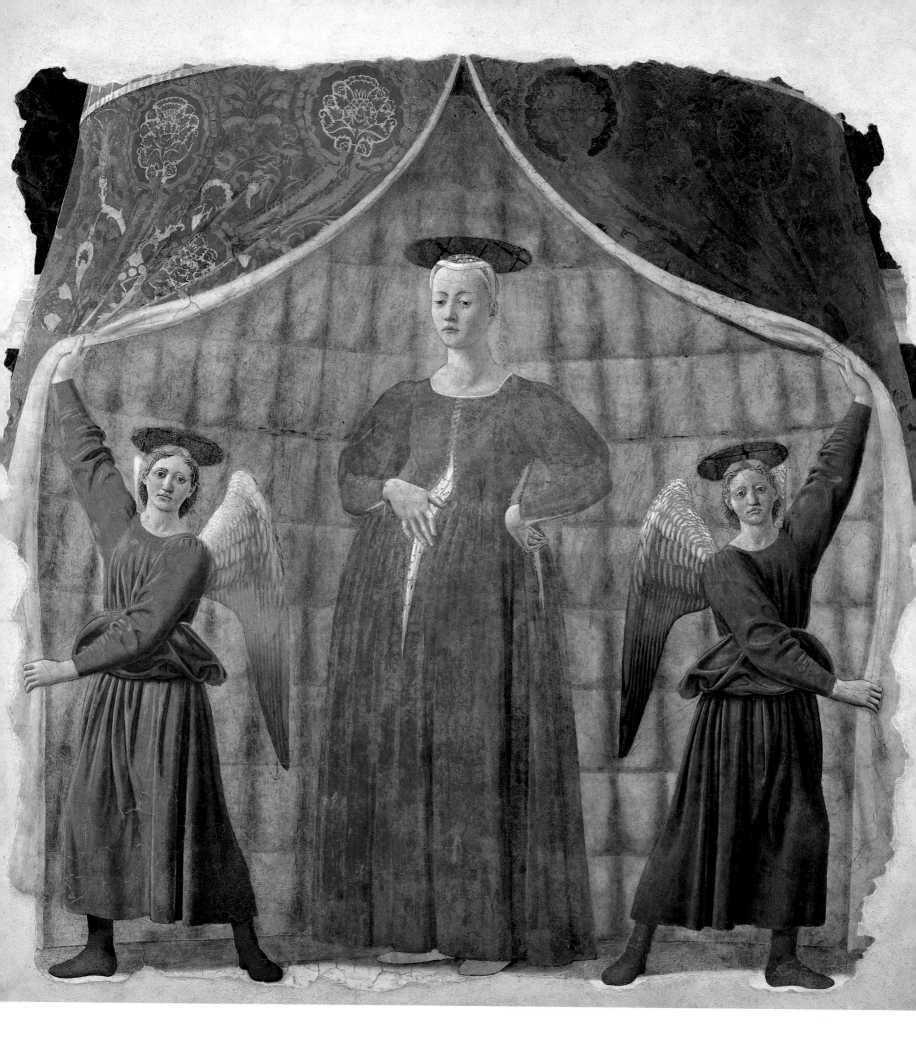

Monte San Savino

OVERLOOKING the undulating green fields of the Valdichiana, Monte San Savino's topmost features are three belfries, one pointed, one domed and the third square. With its defensive walls and *rocca* of 1386, its external aspect is threatening – not surprisingly, for the town suffered many vicissitudes, having allied itself with Florence and then been completely destroyed by the troops of the Aretine Bishop Guido Tarlati in 1326. Rebuilt by the Aretines, in subsequent years the town repeatedly changed hands, dominated in turn by Perugia, Siena, Arezzo and Florence. Cosimo de' Medici's coat of arms can be seen on the Porta Fiorentina, which Giorgio Vasari designed in 1550. At the entrance to the town the Cassero, built by Bartolo di Bartolo in 1383, has holes high in its battlements for dropping missiles on unwanted visitors. Opposite rises a gentler bulding, the simple and satisfying Renaissance Palazzo della Cancelleria.

The Corso Sangallo bisects the town, with impressive monuments to either side. Some of the finest are by Andrea Contucci, who was born at nearby Poggiolo in 1460, chose to live here till his death in 1529 and changed his name to Andrea Sansovino. The church of Santa Chiara houses two of his magical ceramics. Between 1518 and 1520 he built the Loggia dei Mercanti, with its five arcades supported on Corinthian columns.

Opposite rises an altogether more modulated building from the sixteenth century, the high Renaissance Palazzo di Monte, which Antonio da Sangallo the Elder built for the father of Pope Julius III, who was actually born here. Nanni di Baccio Bigio then embellished it with a threefold loggia. Walk through the palace to reach the town's little open-air theatre, on whose wall is mounted a bronze bust of Sansovino. Further along, the Corso is flanked by more palaces and churches: the parish church of Saints Egidio and Savino with a magnificent tomb designed by Sansovino in 1498; the fourteenth-century Palazzo Pretorio with its tall tower and coats of arms; Sant' Agostino, with its pretty façade, an Assumption by Vasari and a cloister by Sansovino, as well as his tomb; and, finally, the house where Sansovino died.

The skyline of Monte San Savino, with its three handsome belfries (below), *heralds its concentration of fine architecture, like the Porta Fiorentina* (opposite), *designed by Giorgio Vasari and crowned by the Medici coat of arms.*

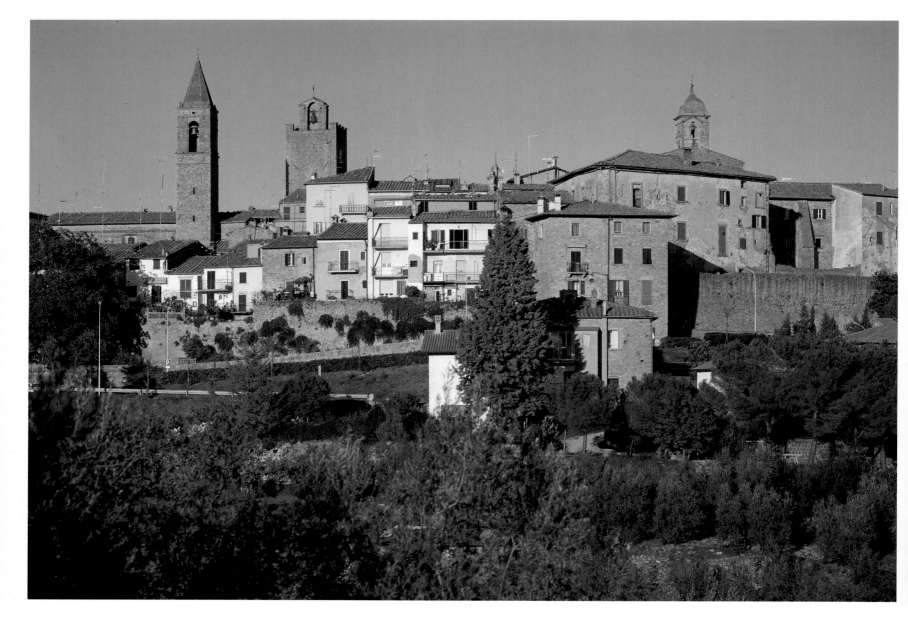

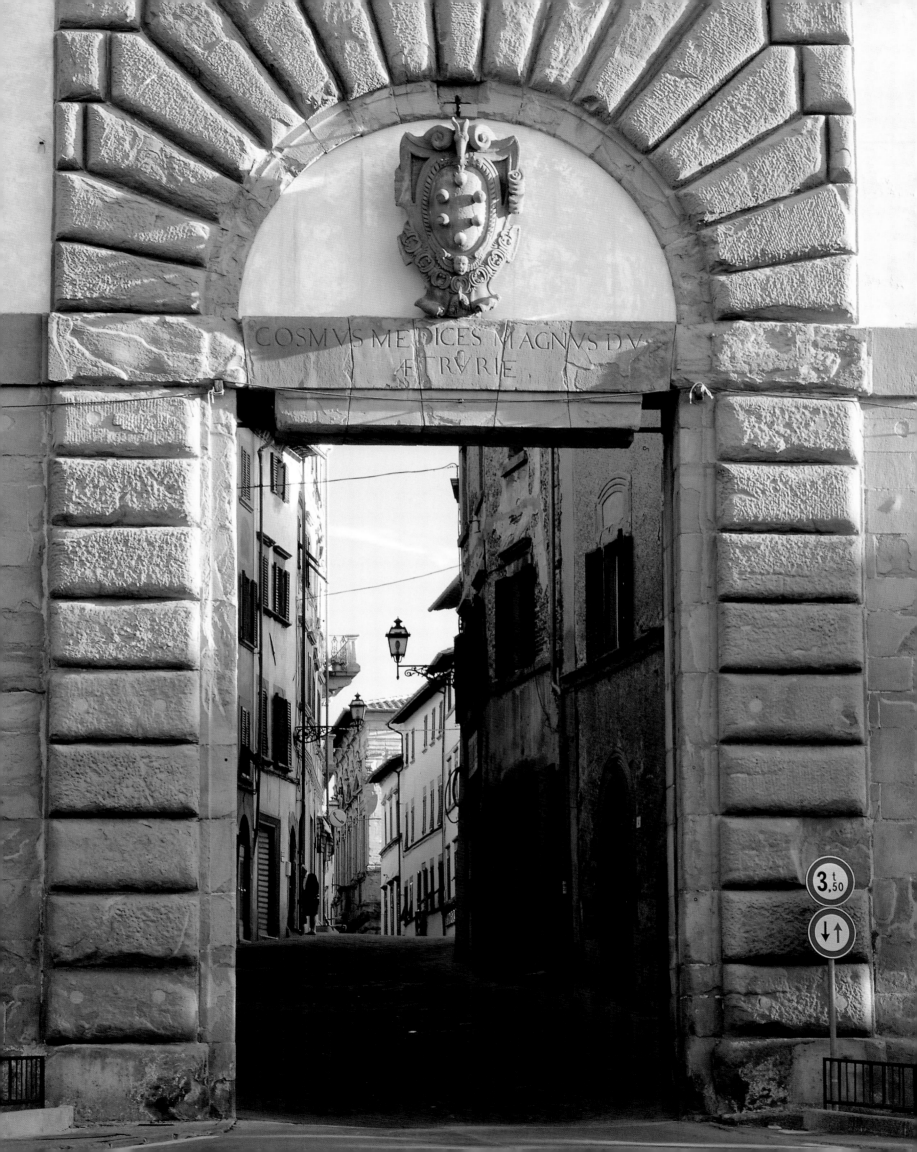

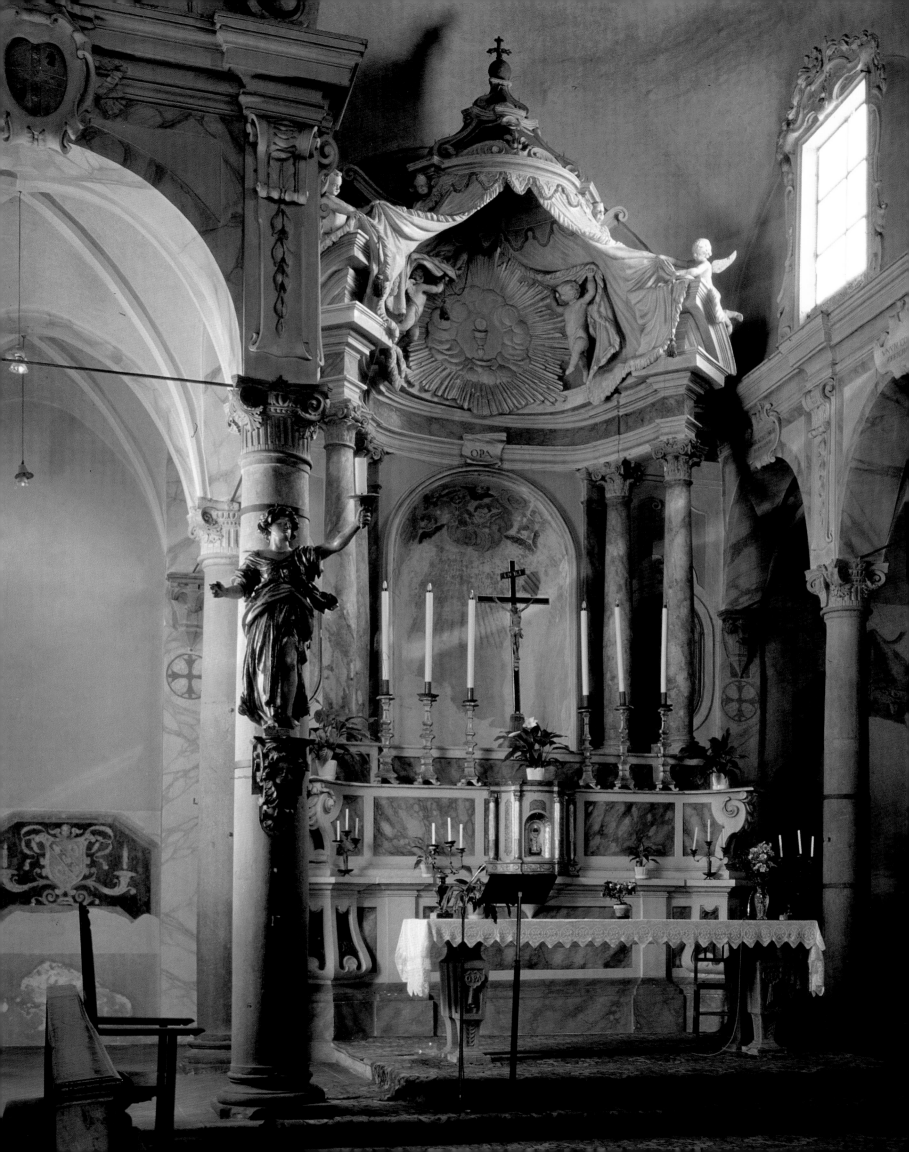

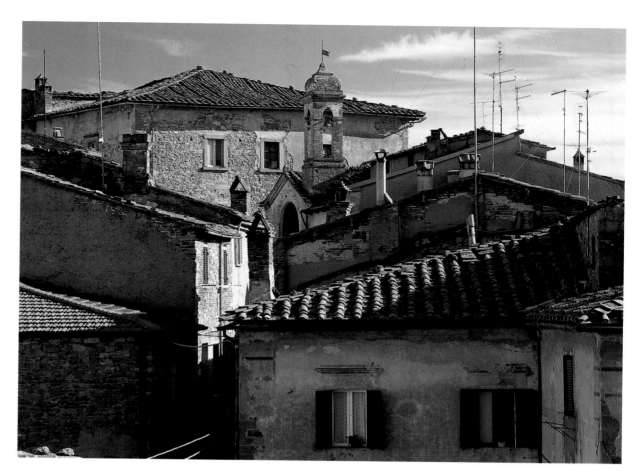

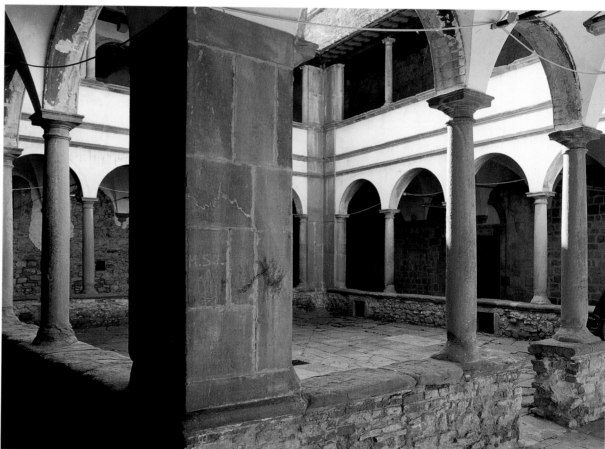

*T*he ecclesiastical buildings of Monte San Savino mix
grandeur and intimacy: the Baroque high altar of
the church of SS. Egidio and Savino (left); the belfry of
Sant' Agostino (top) amid the confusion of village roofs;
the cloister of the same church (above), designed by
Andrea Sansovino in 1528.

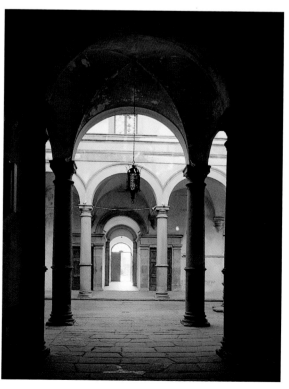

The streets of Monte San Savino are characterized by their fine houses (opposite) and contain many architectural gems, large and small: the Renaissance façade of the Palazzo Cancelleria (above); the threefold loggia of the Palazzo Comunale (left), designed by Antonio da Sangallo the Elder in 1515; coats of arms adorning the façade of a Renaissance palazzo on the Piazza della Conserva (far left).

Monte San Savino · 119

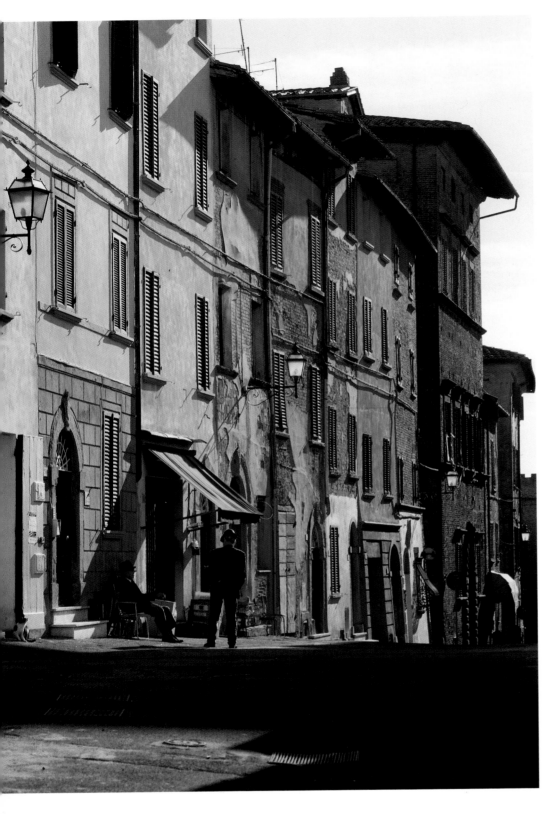

Foiano della Chiana

As 'Forum Jani', the etymology of its name suggests, Foiano della Chiana was once a Roman town. Today, its medieval heart, built mostly of brick and flaking plaster, is delightfully chaotic. Set on the hillocks between the valleys of the Chiana and the Esse, its streets run uphill and downhill and often turn into steps. Ancient archways give entrance to the town, that at the end of the Via Ricasoli being crowned by two dwellings, while the Porta Senese and the Porta del Castello are let into the fourteenth-century walls. Climb the steps through the latter to the late sixteenth-century church of Santa Maria della Fraternità, which has a classical façade.

Nearby is the brick Collegiate church of San Martino, a complex and impressive building which was begun in 1512 and finished only in 1796. The walls have blind arches, contrasting with the Baroque façade. The interior contains rich artistic treasures, notably a Madonna of 1502 by Andrea della Robbia and a 1523 Coronation of the Virgin, one of Luca Signorelli's last paintings.

The fifteenth-century church of St. Michael the Archangel was in part rebuilt in the seventeenth century but has a fifteenth-century campanile. As well as possessing fifteenth-century choir stalls and seventeenth-century confessionals, all exquisitely carved, it houses a Madonna of the Rosary painted by Lorenzo Lippi.

Foiano della Chiana has some equally monumental civic buildings, including the Torre Civica, which is surmounted by a belfry; this was begun in the fourteenth century but only finished in the eighteenth. The two finest buildings face each other in the Piazza Cavour. The Palazzo Granducale, with its grandiose classical arcades, was built for Grand Duke Ferdinand II de' Medici. Opposite are the rusticated doorways of the Palazzo Pretorio, begun in the fourteenth century and seat in 1341 of the short-lived 'free commune' of Foiano della Chiana. Three plaques, two tragic, one pompous, are on the palace wall. One bears the bust of Fra Benedetto da Foiano, friend of Savonarola, who died incarcerated in Castel Gandolfo after Pope Clement VIII refused him a pardon; the second of King Umberto I, who was assassinated in 1901; and the third of the smug-looking Luigi Diligenti, who represented the town in Italy's parliament for twenty-four years.

The streets of Foiano run chaotically up and down the hills of the village, providing extraordinary changes of light and texture: flaking house façades in the Via Ricasoli (above) and an elegant arcaded loggia near the Porta del Castello (opposite).

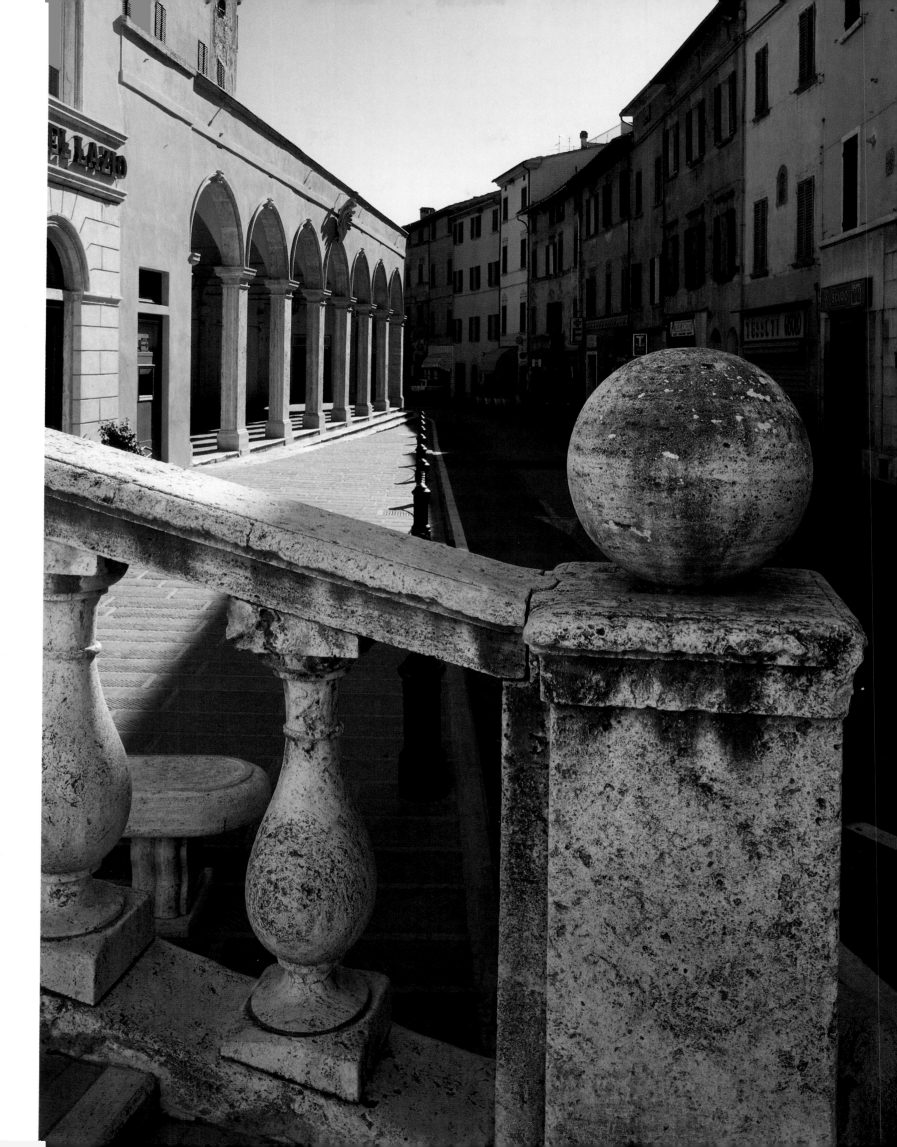

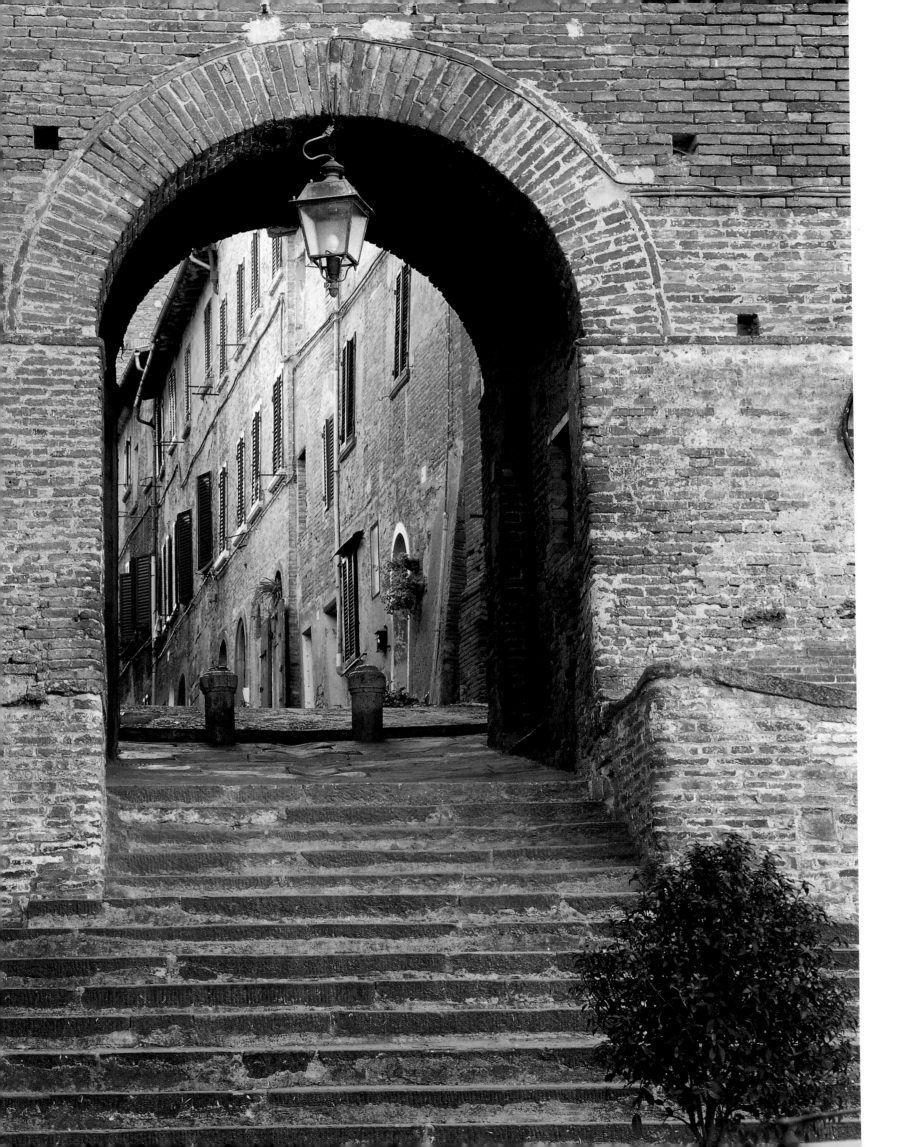

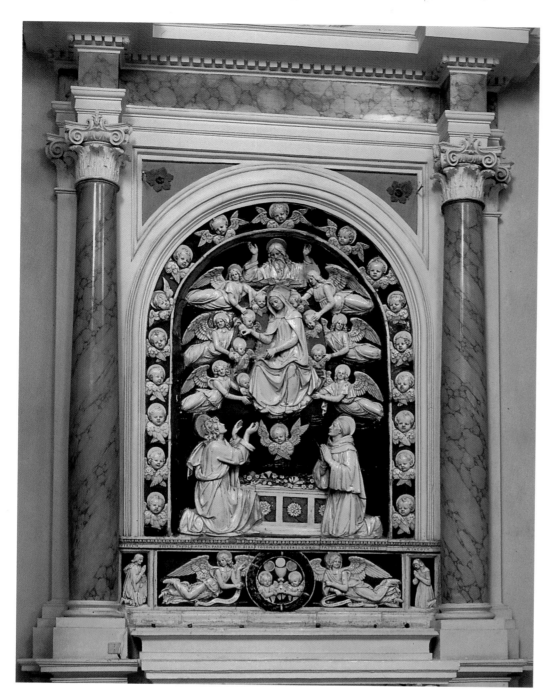

A place of sudden discoveries and *mystery (opposite) like this set of steps leading to the Porta Ricasoli, Foiano yields up its treasures to the truly curious (this page, clockwise): a Madonna by Andrea della Robbia in the Collegiate church of San Martino; the late sixteenth-century façade of Santa Maria della Fraternità; the rusticated doorway of the Palazzo Pretorio; steps leading through the Porta del Castello.*

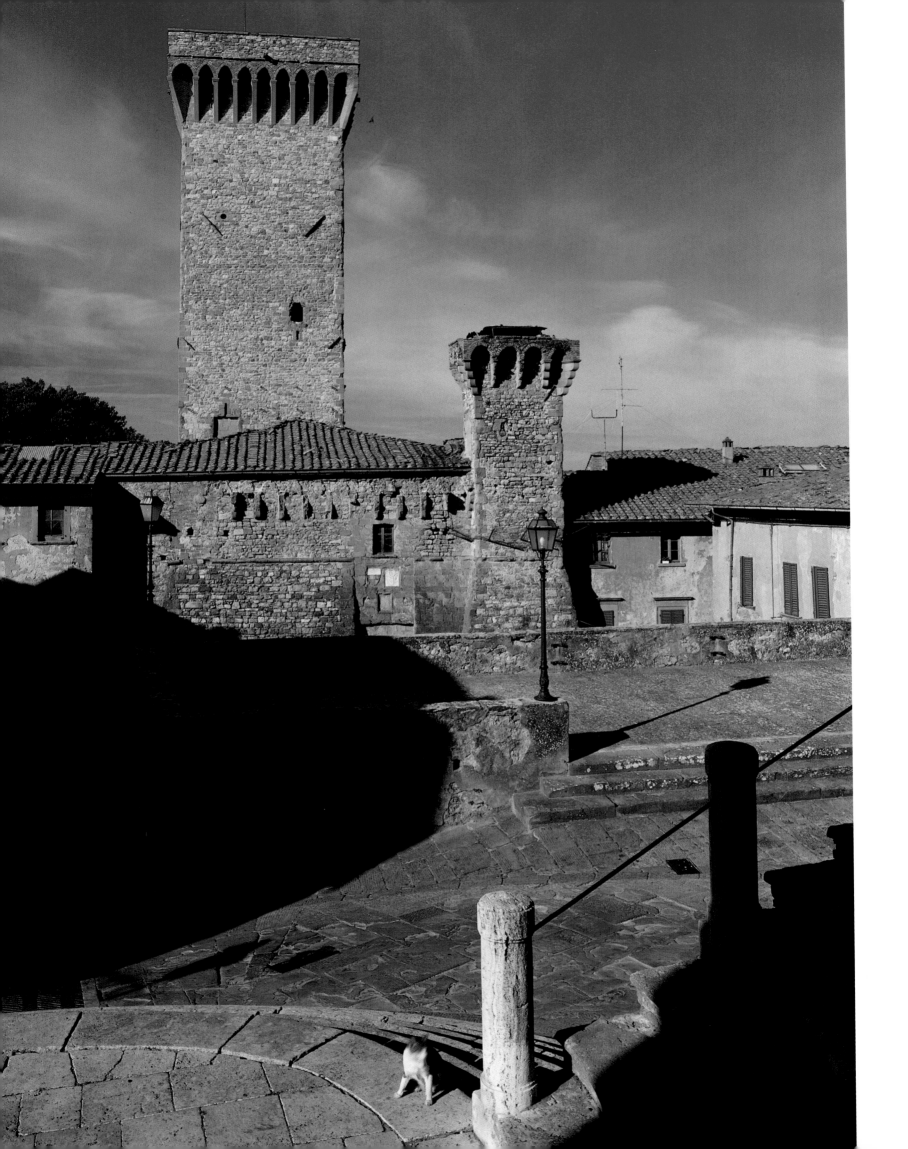

The bastion of the village's fourteenth-century fortress towers over the house roofs (opposite). Arches abound in Lucignano, like this ancient example spanning one of the village's elliptical streets (below), or the strictly classical forms which adorn the 1594 Collegiate church (right).

Lucignano

Rising on a hill, its fourteenth-century fortress set slightly to one side to protect the medieval Porta San Giusto, Lucignano is a perfectly elliptical medieval village, with nearly every building in exquisite condition. Houses, brown and white, rise from its encircling walls. Narrow, paved and curving streets lead to its centre, up stone steps and under arches.

An elegant, charming, double-curved flight of steps leads up to Lucignano's impressive Collegiate church, its lower storey brick and stone, its upper storey rough-hewn, still waiting for a marble façade. Dedicated to St. Michael the Archangel and designed by Orazio Porta, the church was finished in 1594. Then in 1709 Andrea Pozzo created its lavishly Baroque high altar, with a splendid gilded statue of Michael slaying the dragon, flanked by the relics of no fewer than six saints, each in a silver-gilt reliquary bust. Other gilded statues hold candelabra on either side of the church.

This village seems almost uniquely blessed by the quality of its churches: Neo-classical San Giuseppe, its doorway dated 1741; and Gothic San Francesco, which has a Romanesque façade and was begun in 1248. Inside San Francesco are precious frescoes, some of them by Bartolo di Fredi and Taddeo di Bartolo. And beside the church, higher up in the piazza, rises Lucignano's Palazzo Communale. Its interior is painted with delicate frescoes, with a sixteenth-century Pietà in the entrance hall and the vaulted Sala del Tribunale with mid fifteenth-century frescoes of classical and Biblical heroes. The *pièce de résistance* of the small museum in this palace is a massive golden Gothic reliquary, two-and-a-half metres high. Known as the 'Tree of Lucignano', it was created between 1350 and 1471. Its twenty-four branches sprout from a central shaft and are decorated with leaves; each of twelve branches terminate in a medallion of an Apostle.

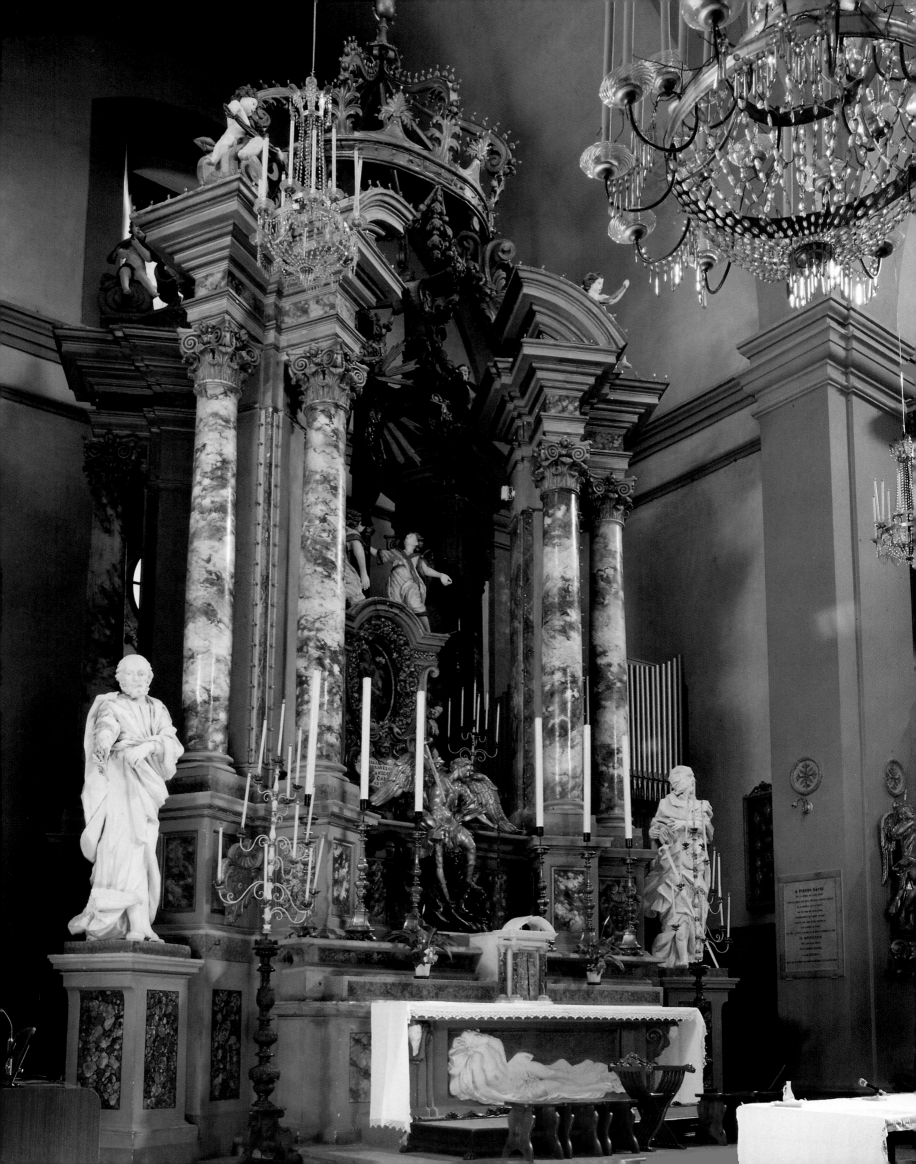

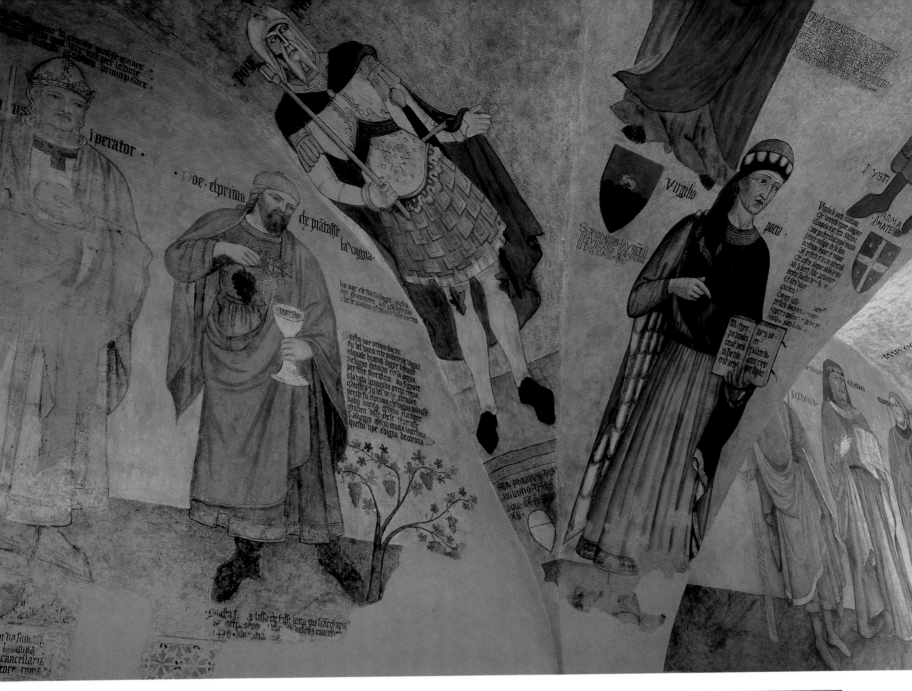

Preceding pages
*A*ndrea Pozzo's Baroque high
altar in the church of St.
Michael the Archangel and the coral-
decorated 'Tree of Lucignano'.

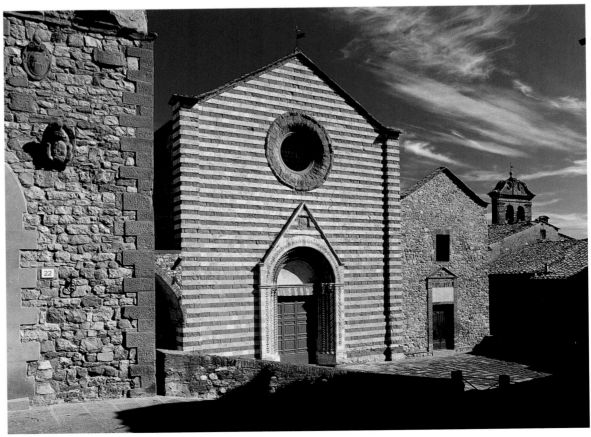

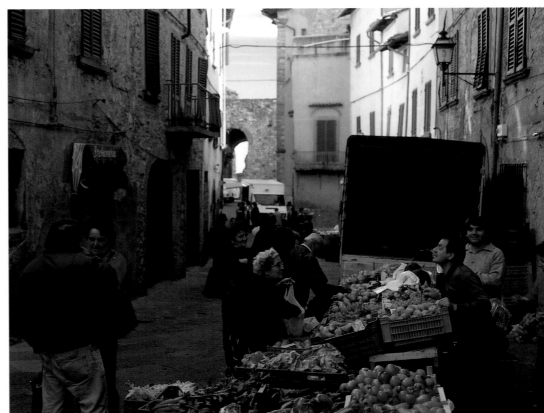

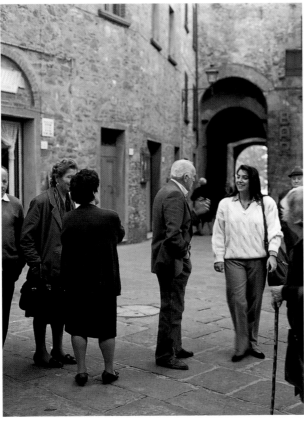

*T*he Renaissance and the twentieth century mix easily
in this bustling and animated place: mid fifteenth-
century frescoes of biblical and classical figures in the
Sala del Tribunale (opposite, above); the Romanesque
façade of the church of San Francesco (opposite, below);
street life and street detail (this page); the olive groves of
Lucignano (overleaf).

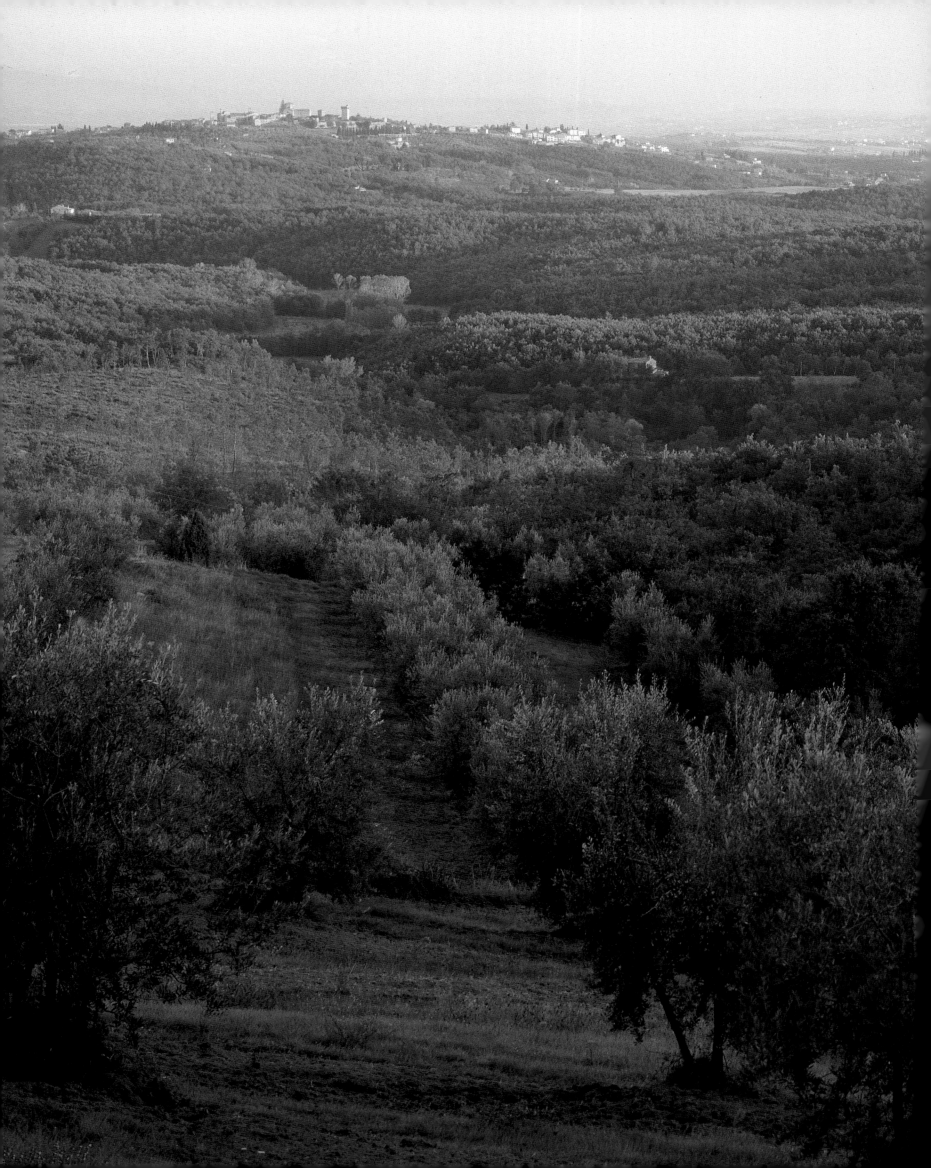

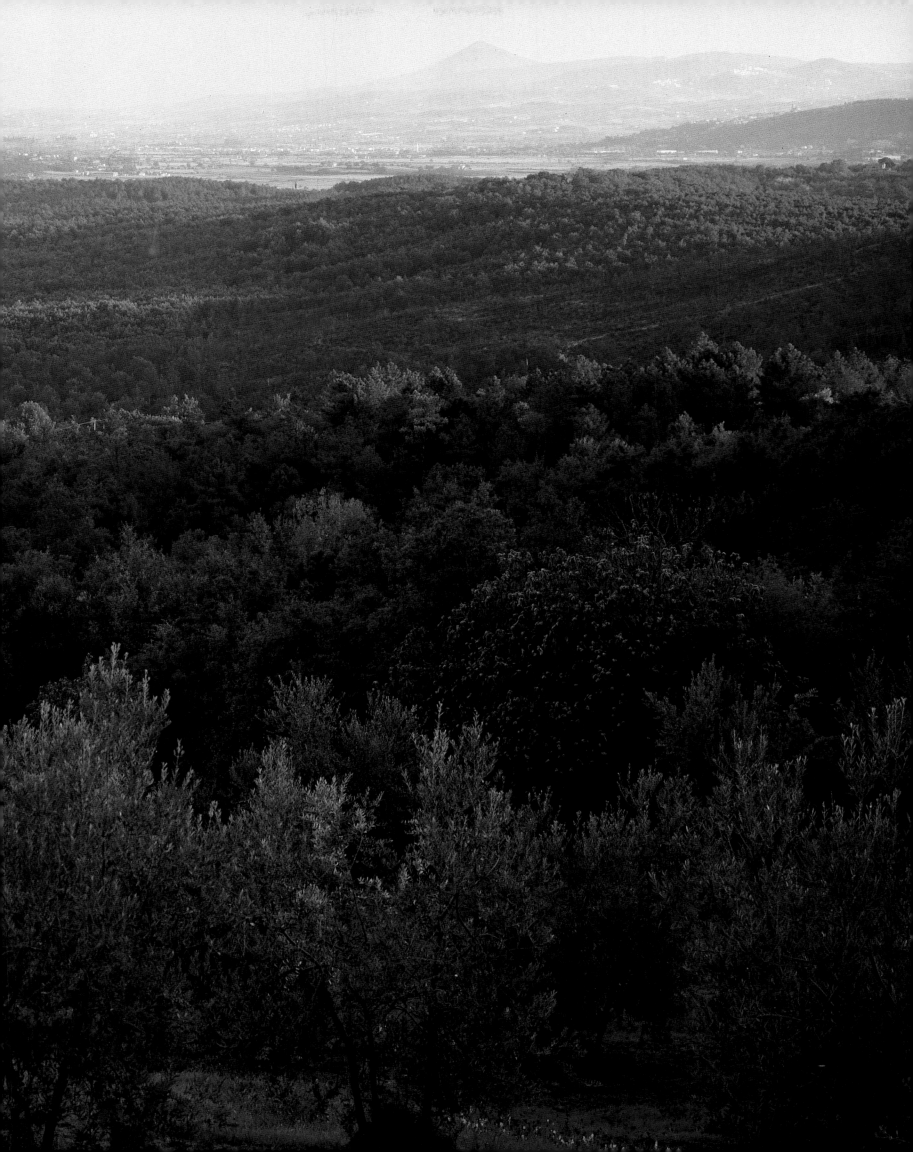

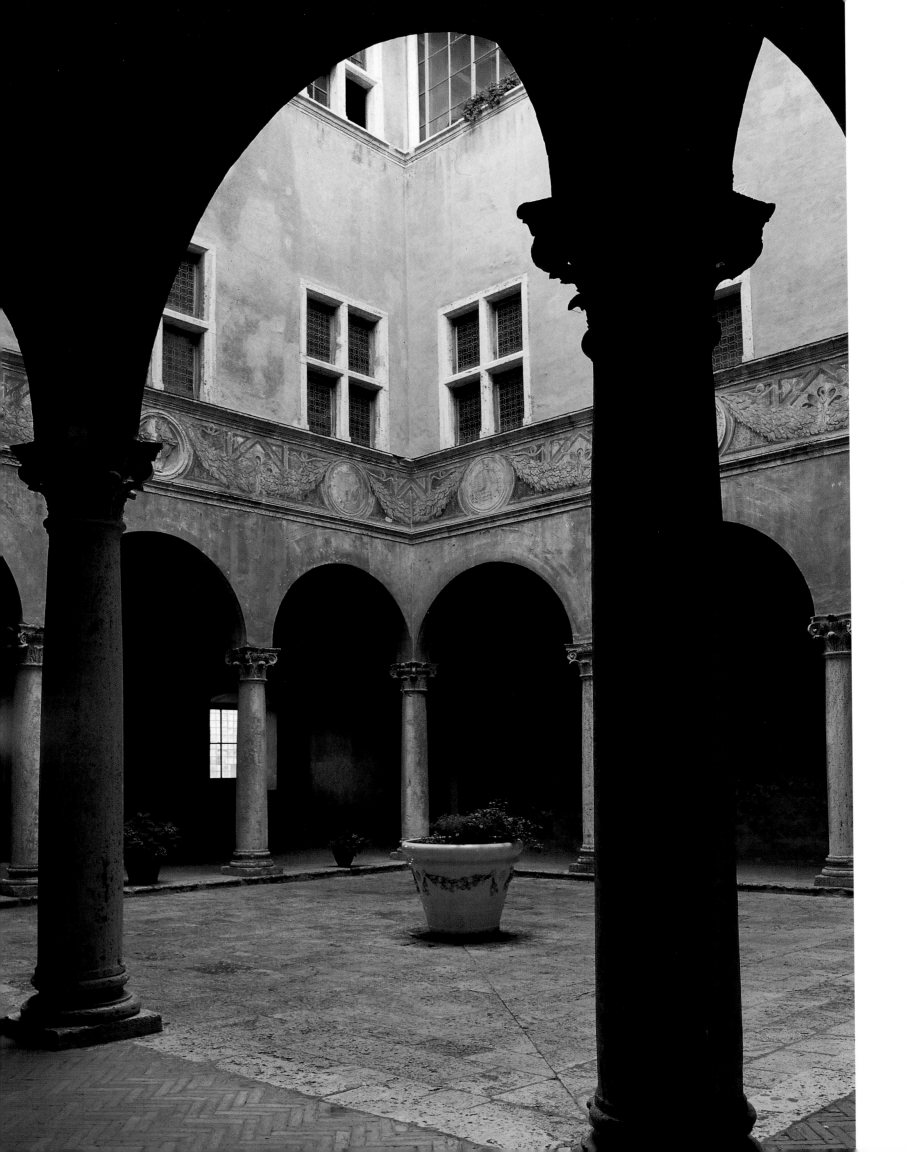

TUSCANS call this place 'Città d'autore', the town of its creator, for it is almost entirely the work of one man, the Florentine architect Bernardo Gamberelli, who preferred to be known as Rossellino. In the Middle Ages the town was known as Corsignano. Here in 1405 was born Enea Silvius Piccolomini, who in 1458 was consecrated Pope Pius II. By Papal Bull he changed the name of his birthplace to Pienza, and he commissioned Rossellino to rebuild it.

Rossellino based his whole concept on a piazza which, after his patron, he named Piazza Pio II. At its heart is an exquisite Renaissance well, for this is a hill-town, and hill-towns need ready access to water. His extensive and gracious cathedral was one of the first in Italy to be built in the Renaissance style. On its pediment is carved the coat of arms of Pius II. Inside are magical altarpieces painted by Vecchietta, Matteo di Giovanni, Giovanni di Paolo and Sano di Pietro. The crypt, which contains Romanesque sculpture, has a font designed by Rossellino, who also created the magnificently carved canons' stalls.

In the same square stands the Palazzo Piccolomini, which Rossellino based on the Palazzo Rucellai in his native Florence. In the Papal bedroom hangs a portrait of Pius II (who, incidentally, forgave Filippo Lippi for absconding with a nun). The hall of arms and the library are enchanting, as is the three-storeyed loggia. And the hanging garden of the palace looks out on to the Orcia valley and across to Monte Amiata. Behind the Palazzo stands the late-Gothic, thirteenth-century church of San Francesco, with its Madonna by Luca Signorelli, its cross from the workshop of Duccio and its fourteenth- and fifteenth-century frescoes.

On the north side of the piazza rises the Palazzo Communale, built in 1463 and incorporating arches and a crenellated bell tower. The east side is shaded by the Gothic Palazzo Vescovile, which Pius II commissioned and then gave to the future Borgia Pope Alexander VI.

Pienza is famous for its sheeps' cheese, 'Il Pecorino', and on the first Sunday in September holds an animated cheese fair. During the months of August and September the town invites a celebrated artist to reside in the Palazzo Communale to teach visiting students.

Pienza

This small town was virtually made by one man, Enea Silvius Piccolomini, commemorated in this monument in the cathedral (above)*; as Pope he took the name Pius II, not for religious reasons, but in memory of Virgil's 'Pius Aeneas'. He was also responsible for commissioning much of the architecture of the town, such as his own Palazzo Piccolomini* (opposite)*.

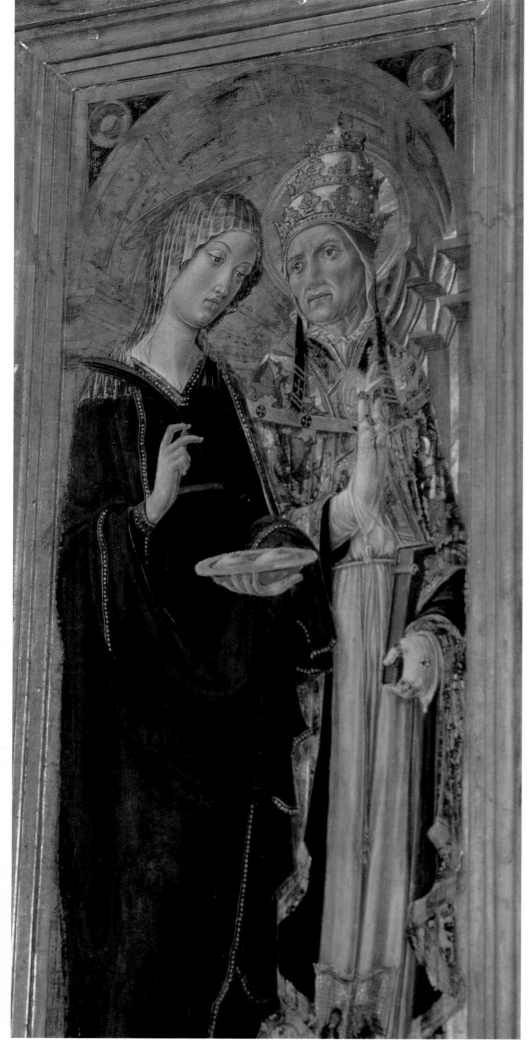

The Piccolomini influence spread wide around Pienza: here his arms adorn a wall in Montalcino. Pienza cathedral is especially notable for its art treasures: Vecchietta's painting of Pope Pius blessing the severed breasts of St. Agatha; a fifteenth-century Madonna and Saints by Sano di Pietro (opposite).

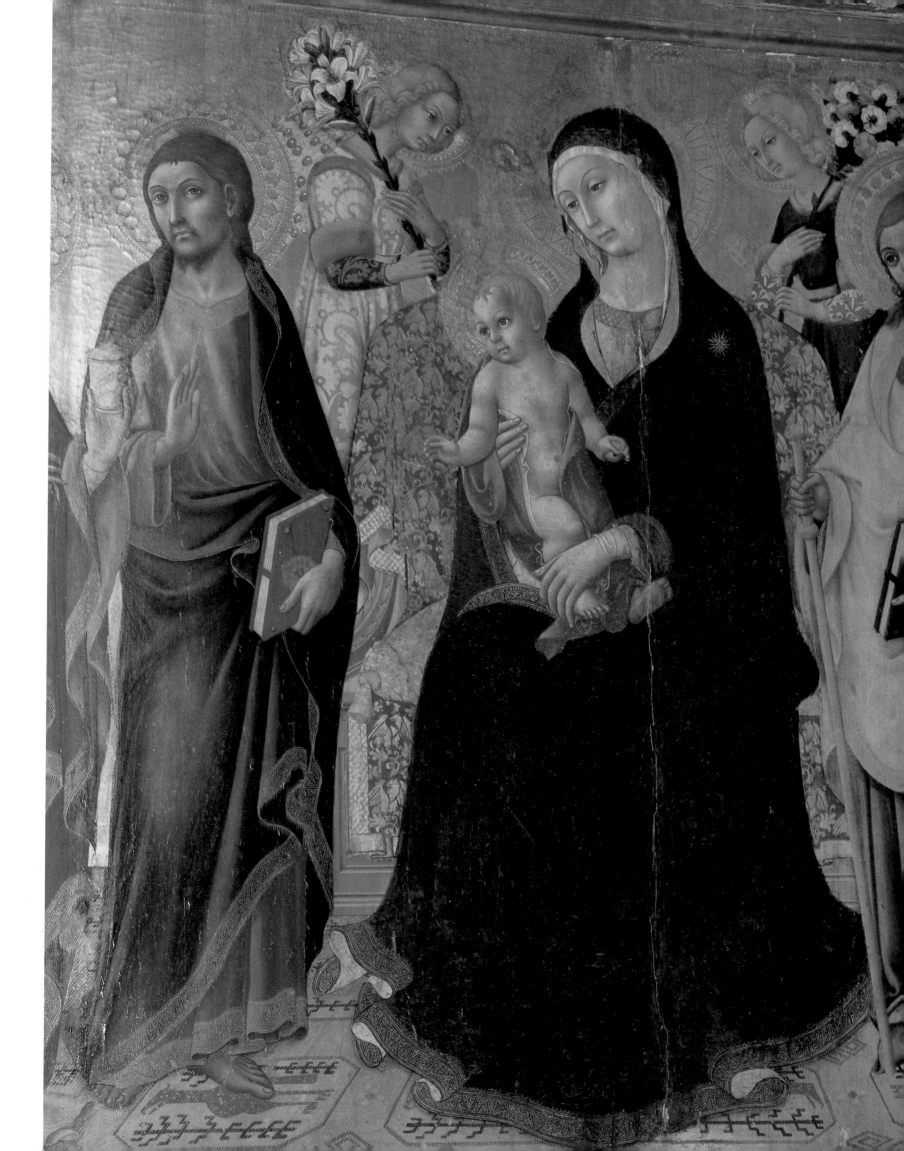

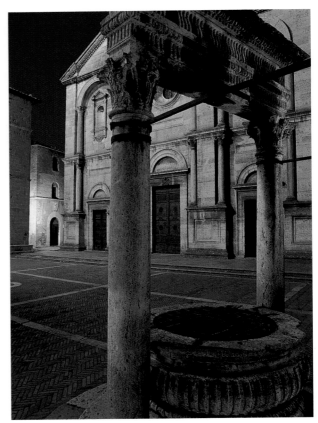

*E*vening falls on the fortified ramparts of Pienza
(above). *Their rugged aspect hardly prepares the
visitor for the sophisticated Renaissance architecture
within: three views of the façade of Pienza cathedral*
(right, above *and* below, *and* opposite).

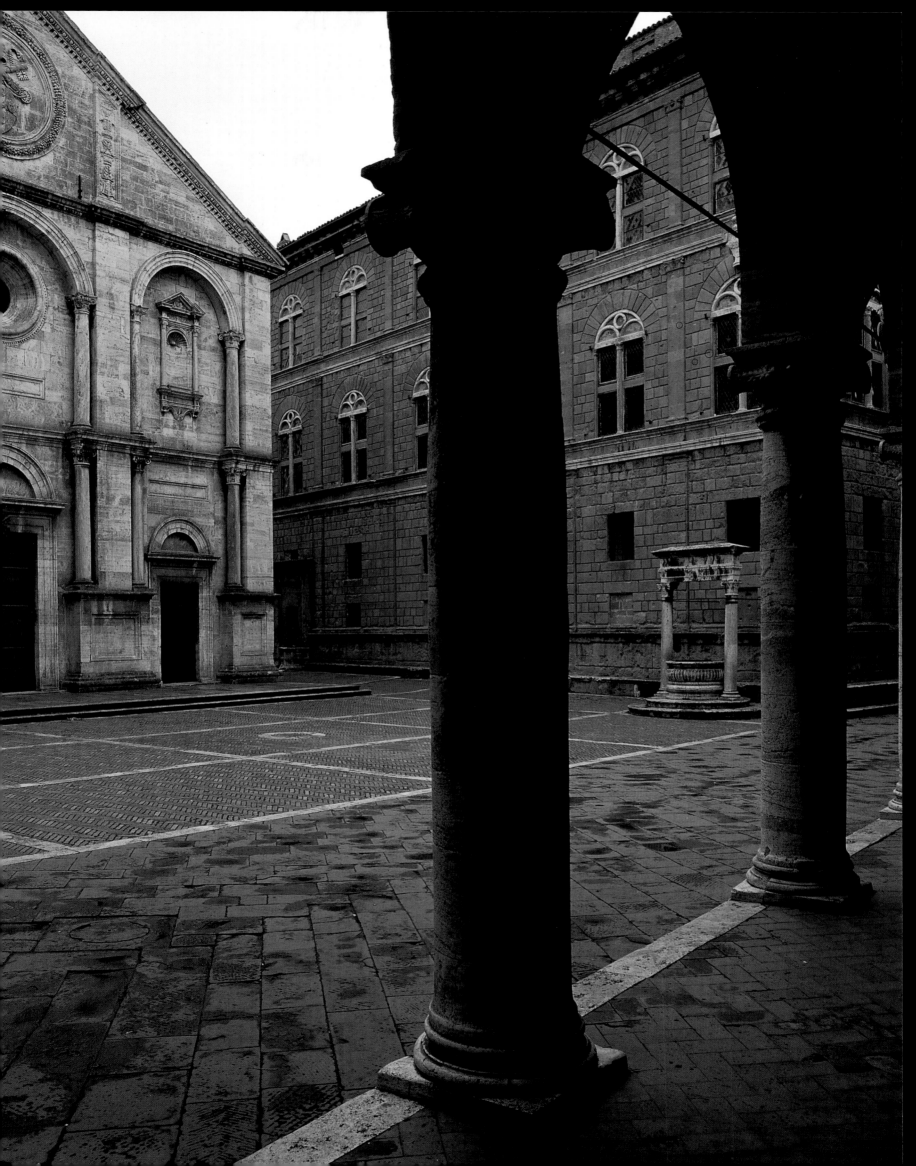

The majestic isolation of a tiny hamlet on a ridge between Pienza and San Quirico d'Orcia.

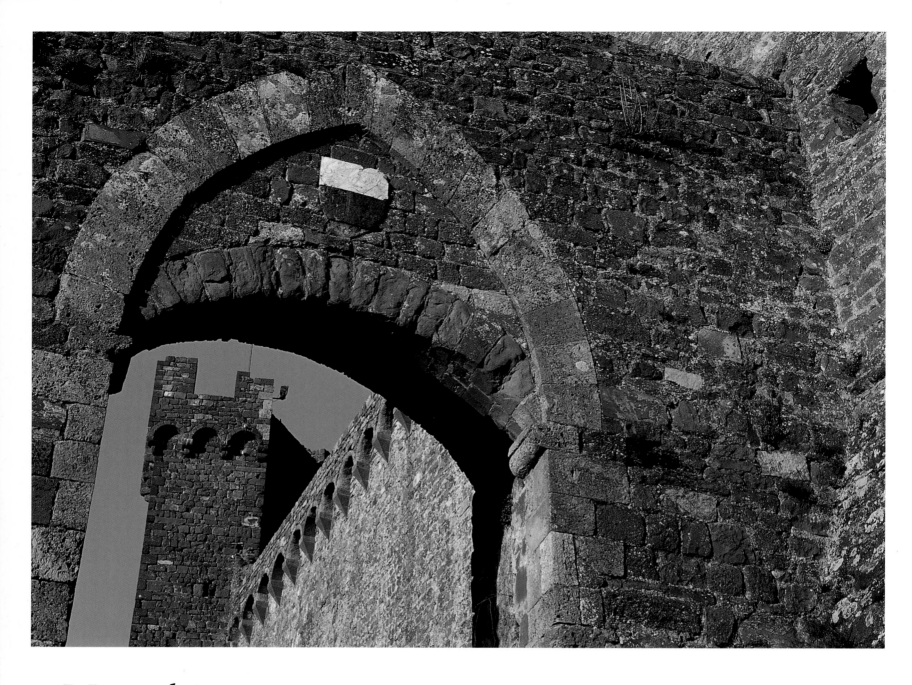

Montalcino

ANCIENT Montalcino clings to a dramatic hill-top site, which rises from olive trees and vines above the valleys of the Asso and the Ombrone. As if this situation were not enough to protect Montalcino from invaders, the little town has preserved sections of its former thirteenth-century ramparts. The town is also guarded by a medieval fortress, built in the thirteenth and fourteenth centuries, which today serves as a wine museum.

This is a thirteenth-century paradise which has survived virtually intact into the twentieth century. Over the years Montalcino has amassed an exquisite architectural inheritance. The thirteenth-century Palazzo del Commune in the Piazza del Populo adjoins a Renaissance loggia. The Civic and Diocesan Museum in the Via Ricasoli houses paintings by Sienese masters as well as polychrome wooden statues created by their contemporaries in the fourteenth and fifteenth centuries – artists of the standing of Sodoma, Beccalumi and Bartolo di Fredi. Its other treasures include a

twelfth-century painted crucifix, local ceramics and the illuminated Atlantica Bible.

Close by is the Romanesque-Gothic church of Sant'Agostino. There is also an Archaeological Museum displaying local prehistoric and Etruscan finds, set out in a lovely room decorated by one of the pupils of Sodoma.

Long ago this village was a fief of the Sienese republic. During the 1555 siege of Siena that city's leaders sought refuge at Montalcino, and in gratitude have ever since given the town pride of place at the Siena Palio, the traditional horse race held twice every summer in the main square of the city, which is by far the most important local event.

The vineyards outside the town produce a powerful wine, Brunello di Montalcino. In this same countryside, nine kilometres south-east, stands an abbey, dedicated to Sant'Antimo and founded by the Cistercians in the eleventh century, its crypt dating from that era, its basilica from the twelfth century.

Now housing a wine museum, Montalcino's fourteenth-century fortress (above) *formerly provided formidable protection to the profusion of churches, streets and houses which cluster on its steep hill site* (opposite).

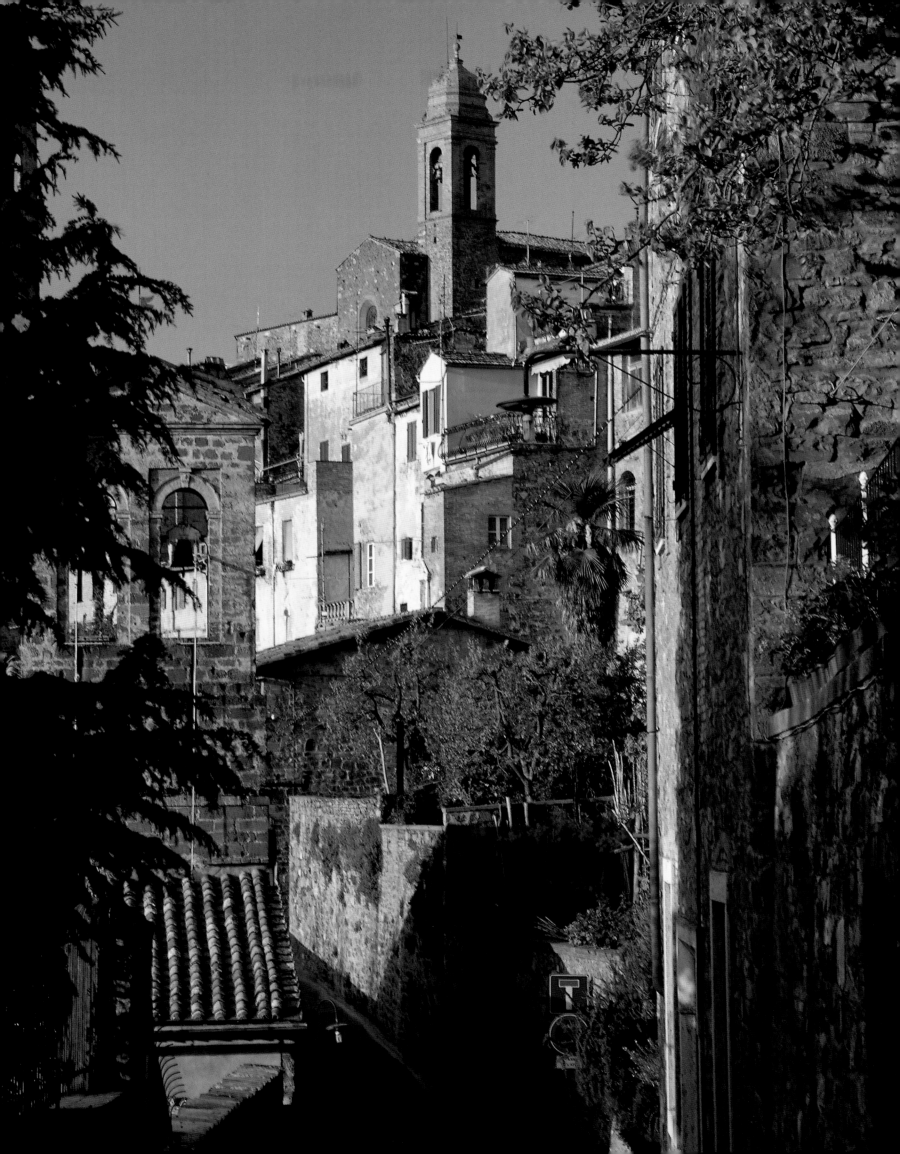

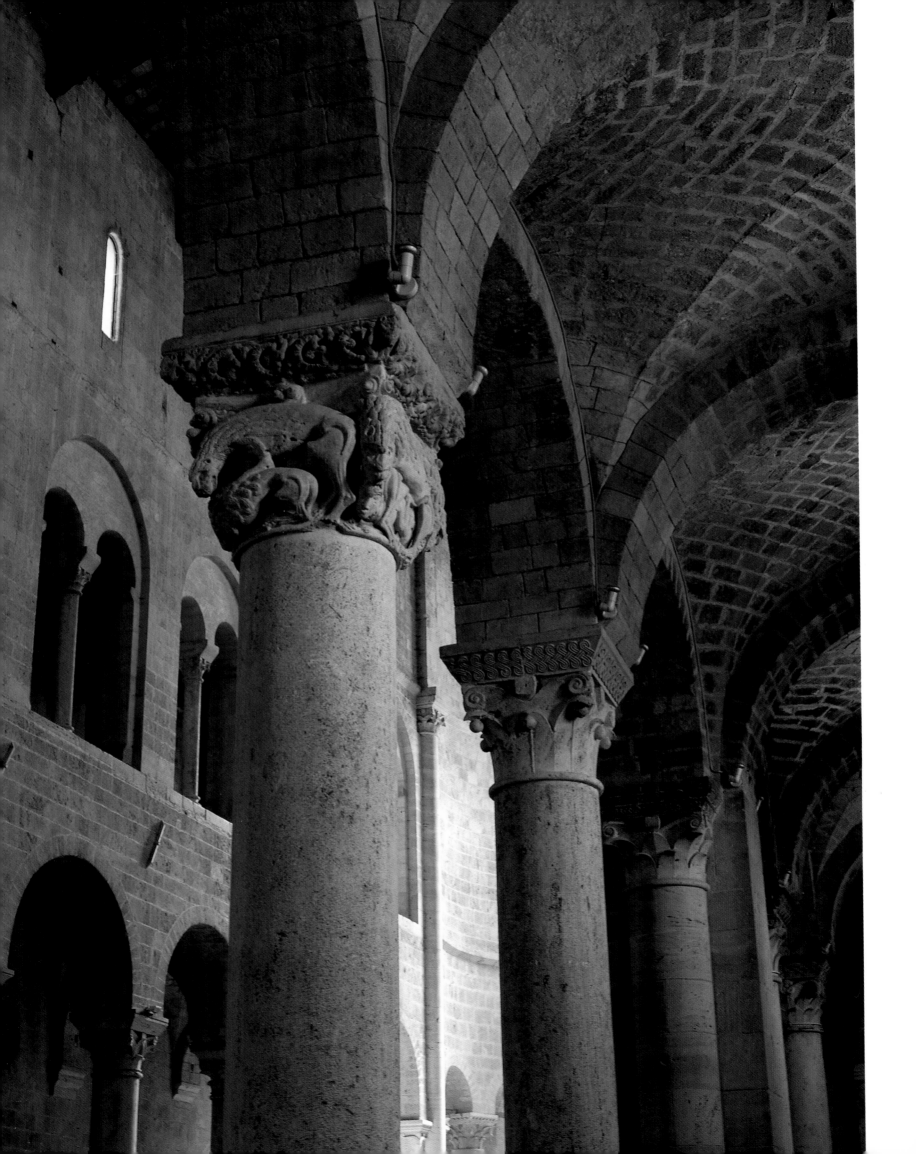

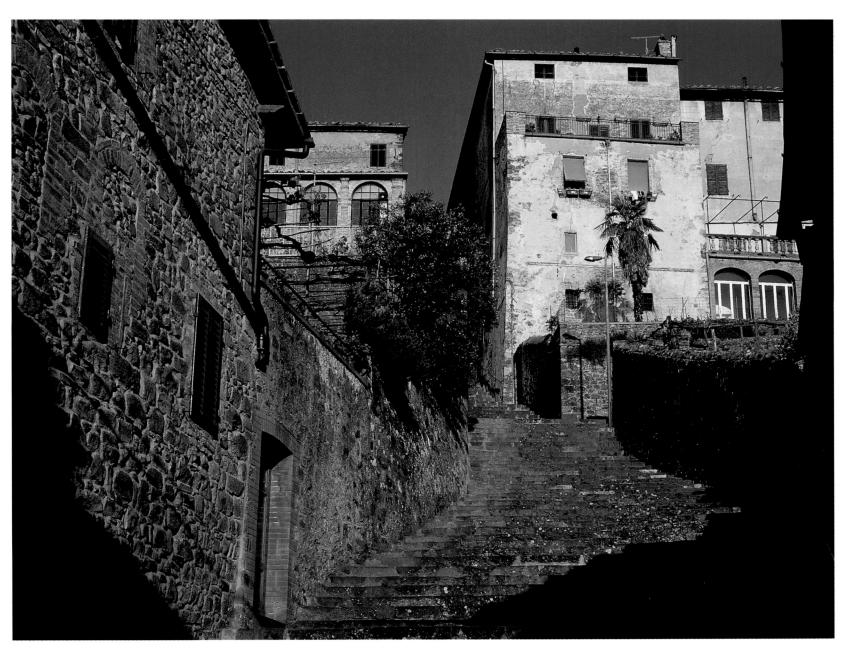

*T*he abbey church of Sant' Antimo (opposite), *famous for its decorated capitals which date from the twelfth century, stands to the south-east of Montalcino. In the town, steep streets may strain the muscles of visitors' legs* (above), *but the richness of architectural detailing makes all efforts worthwhile: here, the fourteenth-century marble porch and rose window of Sant' Agostino* (right).

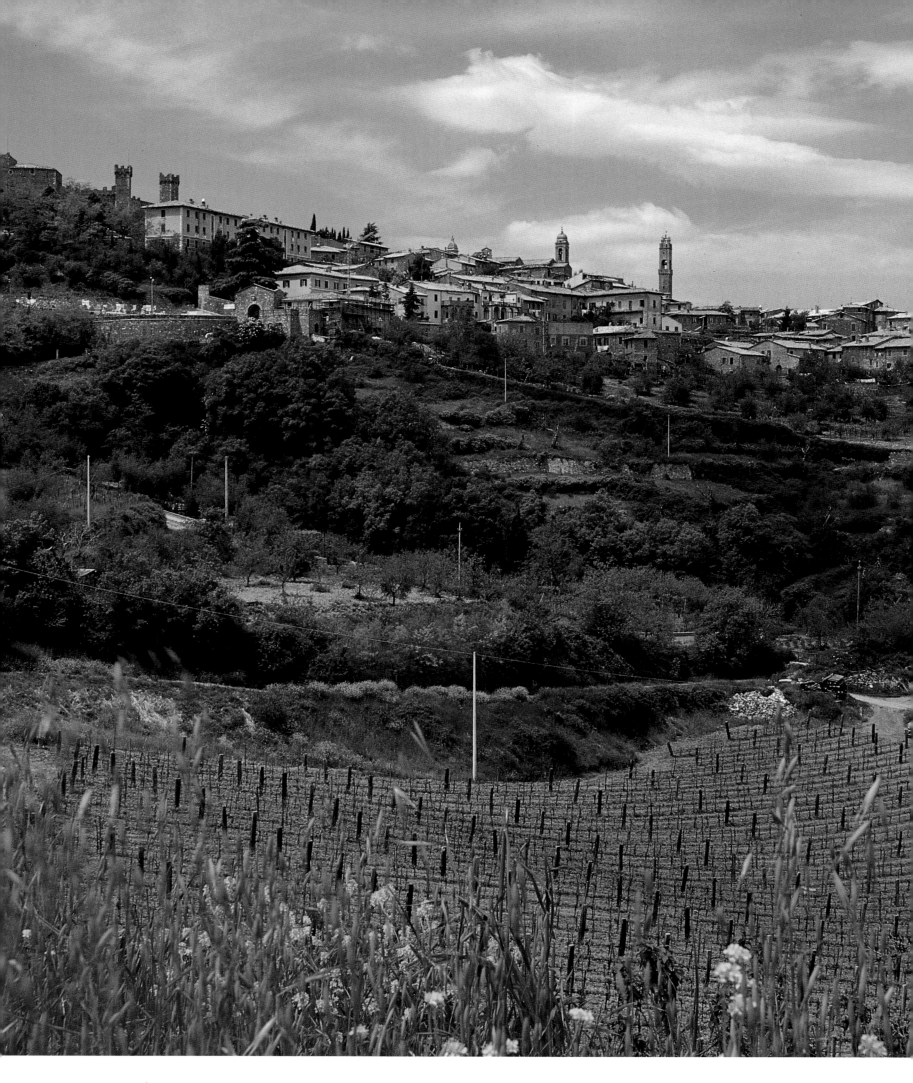

*M*ontalcino seems to spring fully grown from its hill site, set in a satisfyingly ordered landscape.

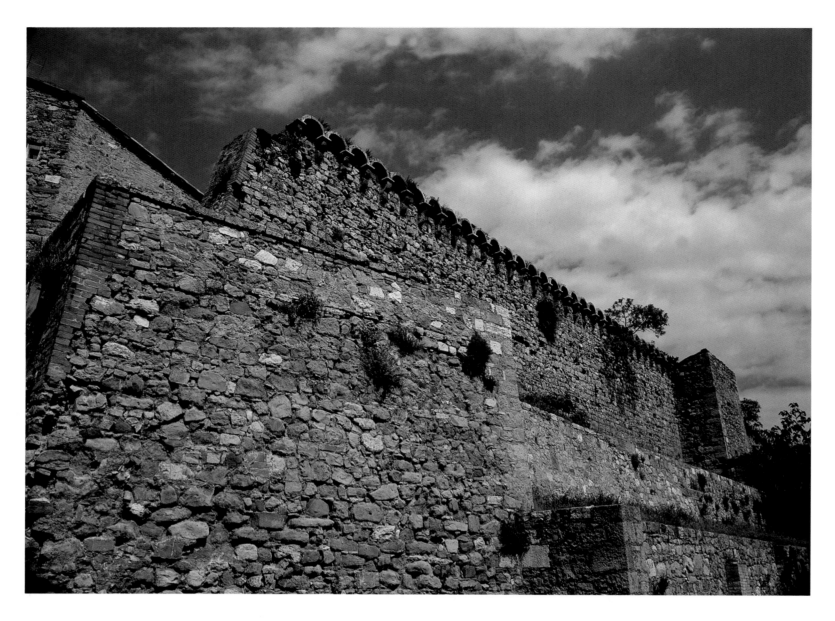

San Quirico d'Orcia

OVERLOOKING the valleys of the Orcia and Asso, San Quirico d'Orcia lost one medieval gateway during the Second World War but has happily preserved not only stretches of its thirteenth-century walls and towers but also the remarkable polygonal Porta Cappuccini. The Via Poliziana leads from this medieval gateway to both the stern-looking Palazzo Chigi, which Carlo Fontana built for Cardinal Flavio Chigi in 1679, and also to the twelfth- and thirteenth-century Romanesque Collegiate church, which is dedicated to Saints Quirico and Giulitta and is based on the site of a church founded here in the seventh century.

Three superb portals adorn it, the finest on the south side. Created by a disciple of Giovanni Pisano, or perhaps even by Pisano himself, it has sculpted lions and caryatids. The main doorway is a major example of the late twelfth-century Lombard style, with typical lions and bizarre animals' heads. And the sculpted doorway of the south transept dates from 1298. Inside,

the delicate marquetry of the stalls is the work of the Sienese woodworker Antonio Barelli, who made them in 1500 for Siena cathedral. They were brought to San Quirico two years later.

The village has other fine churches, including one – Santa Maria Assunta – dating from the eleventh century and the Gothic San Francesco with a Della Robbia Madonna. Opposite the former is the thirteenth-century Ospedale della Scala, with a loggia and courtyard.

The village has a Renaissance Palazzo Pretorio, flanked by medieval wings. But the most unusual and entrancing feature of San Quirico d'Orcia is its Renaissance garden, the Horta Leonini. The centrepiece is a statue of Cosimo III de' Medici, which came from the Palazzo Chigi, around which the garden was laid out by Diomede Leoni in the mid sixteenth century, with geometrically arranged box hedges and the formal, dark-green ilex.

Irregularity and order in the stonework of San Quirico: unevenly sized stones, intricately interlocking, make up the thirteenth-century walls (above); the south doorway of the elaborate Collegiate church (opposite), guarded by Lombardic lions.

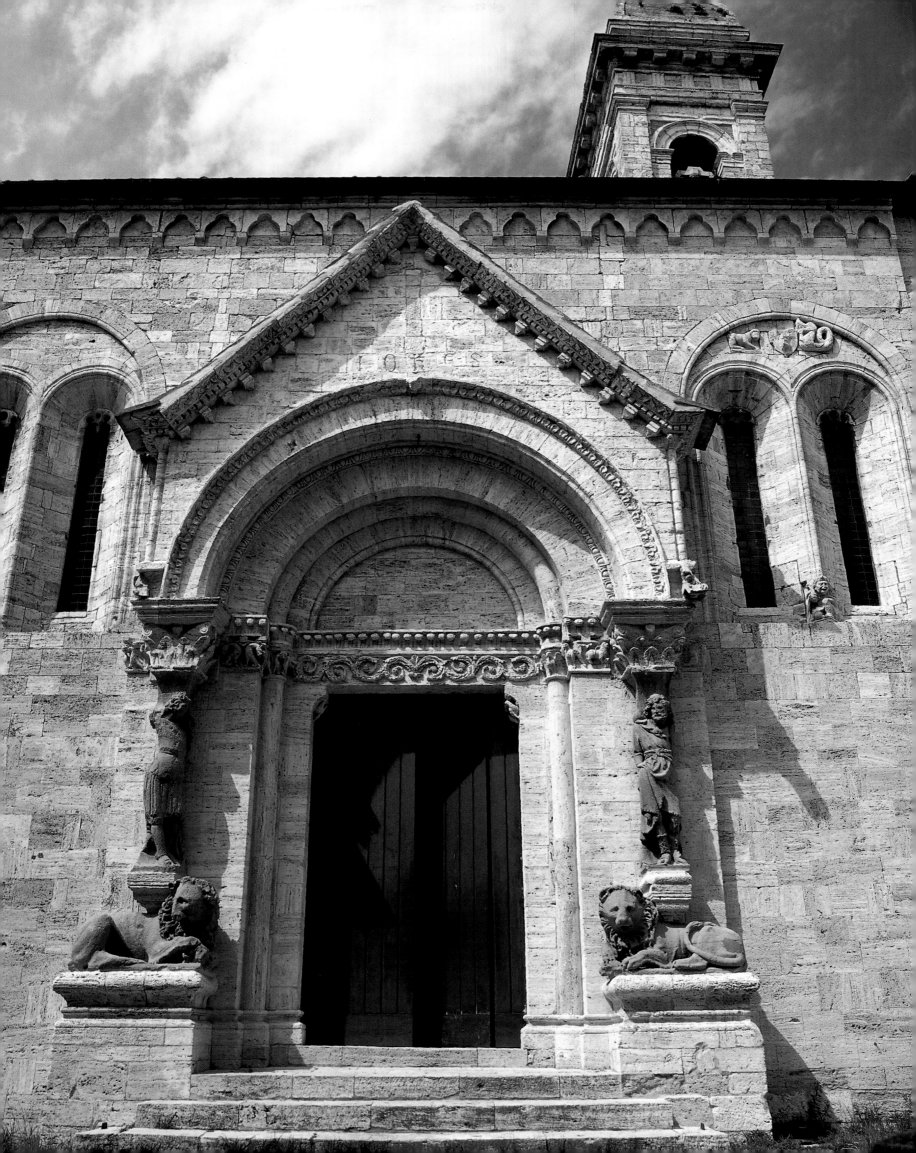

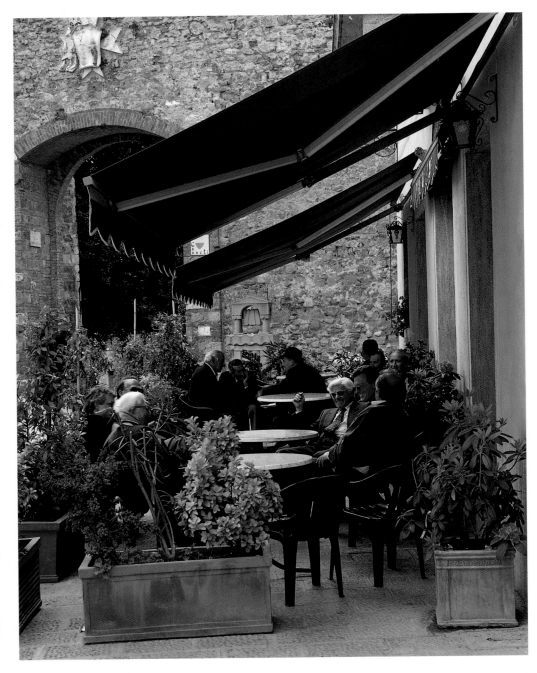

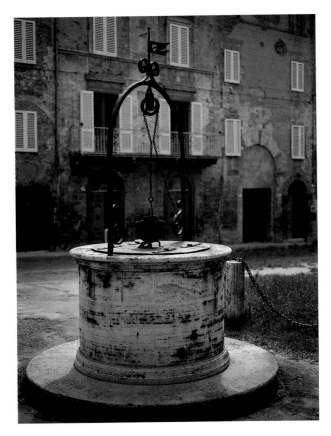

*O*ther secret pleasures of San Quirico include this well-head in the courtyard of the Palazzo Chigi (below) *and a mysteriously shadowy archway in the Via del Forno* (opposite).

*D*elights gastronomic and visual in San Quirico: Sunday afternoon in the Piazza della Libertà (above), *which gives on to the Horta Leonini and its statue of Cosimo III de' Medici* (right).

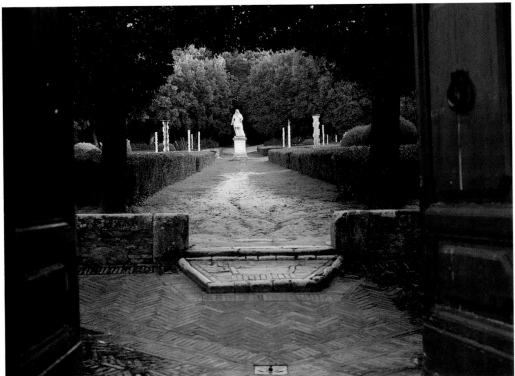

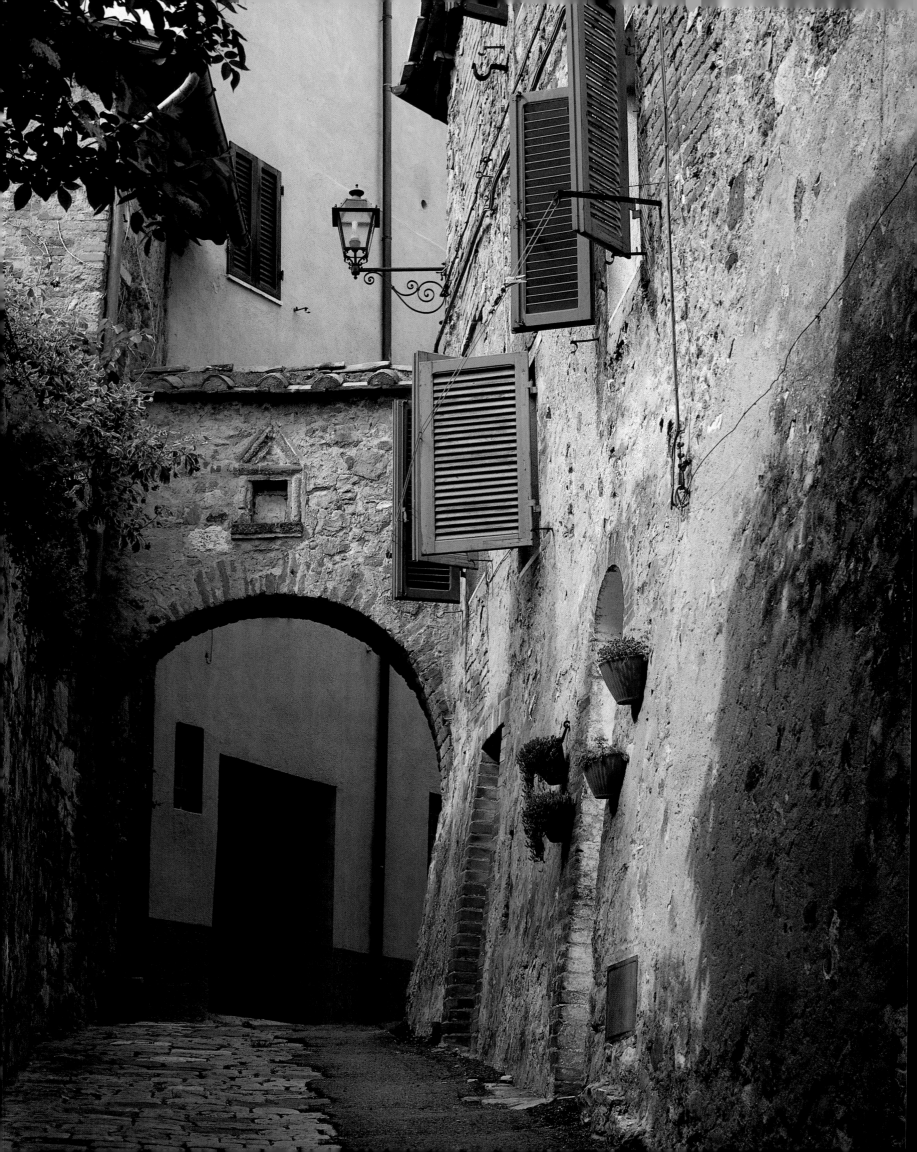

Castiglione d'Orcia

A village of slopes and sudden plunging views, Castiglione's rooftops, viewed from its rocca, lead the eye swiftly to the landscape beyond (below), while its awesomely angled streets make hard walking for this solitary figure (opposite).

THE HOUSES of Castiglione d'Orcia always seem only half plastered; their stones seem to cry out for a filling of mortar or cement. In the entrancingly sloping main piazza is a Renaissance fountain, however, sculpted in travertine in 1618. And in the same lively square, paved with bricks and cobblestones, the municipal palace houses Sienese frescoes, the finest a Madonna flanked by a couple of saints.

The sculpted façade of the village's Romanesque chapel of Santa Maria Maddalena dates back to the thirteenth century; its apse is certainly older, as is the simple belfry, in which hang two bells. Santa Maria Maddalena houses a Madonna by a pupil of Lippi Memmi. The fourteenth-century painting of Mary and Jesus in its semicircular apse is thought to be by Pietro Lorenzetti.

Another church graces the village. Dedicated to Saints Stephen and Degna and much altered by a nineteenth-century restoration, its façade dates from the sixteenth century. The treasures it once housed (particularly an early fourteenth-century Madonna and Child

by Simone Martini and another Madonna and Child painted in the same era by Pietro Lorenzetti) are now displayed in Siena; but they remind us that Castiglione d'Orcia was the birthplace of the celebrated Lorenzo di Pietro, who in the fifteenth century painted, sculpted and practised as an architect under the pseudonym 'Il Vecchietta' and is here commemorated in the name of the village's main piazza. This church also claims that another Madonna, enthroned, with the infant Jesus and Angels, is by the village's most famous son. The church also contains an early seventeenth-century crucifixion by Fabrizio Boschi.

Castiglione d'Orcia rises to 540 metres above sea-level and is dominated by the ruins of its formidable fortress, whose walls are surrounded by cypresses. In part restored in the mid nineteen-seventies, the castle welcomes visitors in summertime and offers a splendid view of the Orcia valley and Monte Amiata from its high vantage point, from which the landscape drops vertiginously away towards the real south of Tuscany.

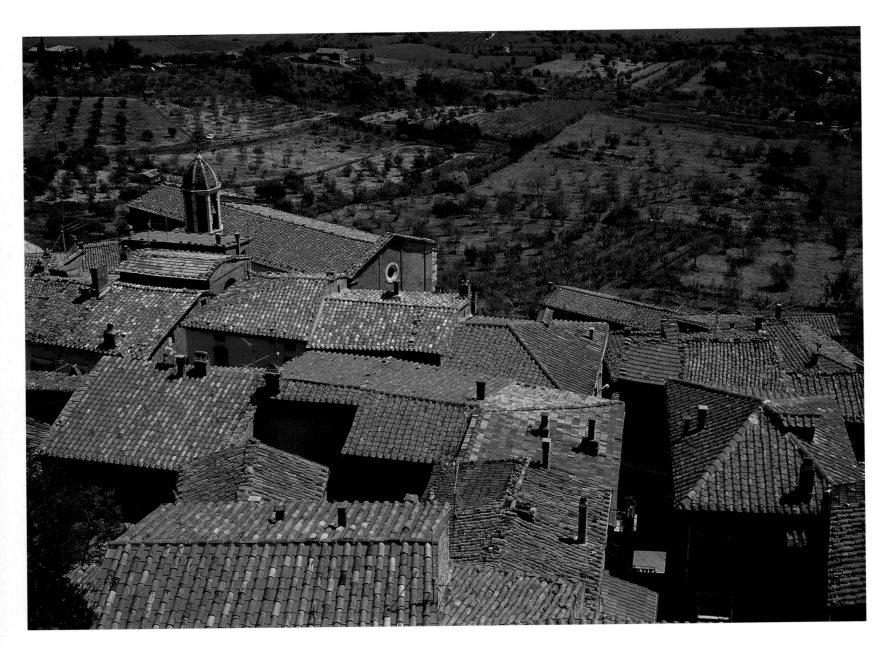

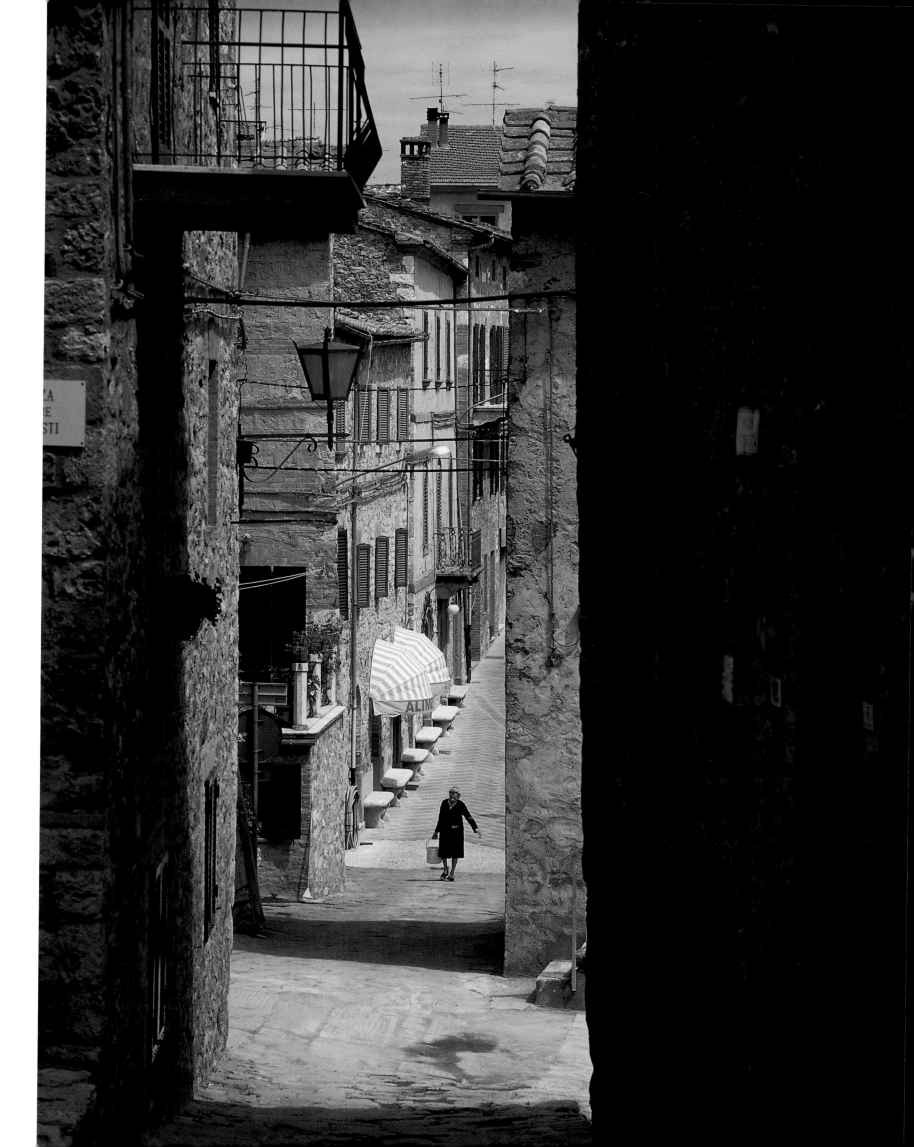

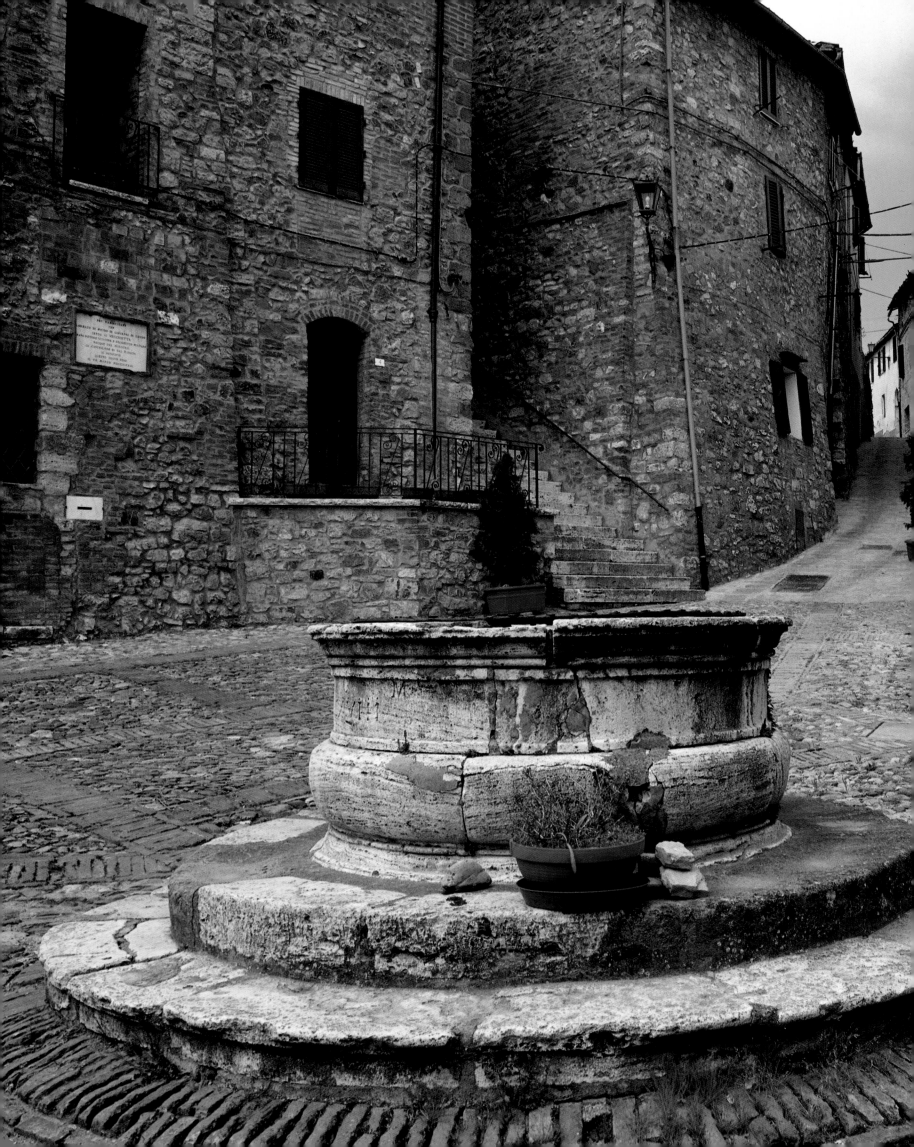

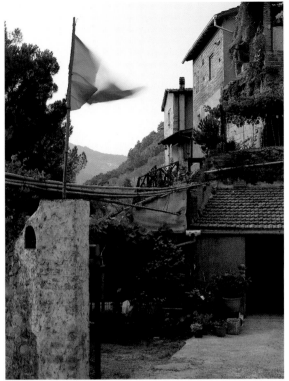

*T*he true texture of a Tuscan village is created by the constant interplay of light and shade with stonework and masonry: the unsurfaced houses and streets of Castiglione, relieved only by the wood of shutters and a little graceful ironwork (above *and* left).

Castiglione d'Orcia · 153

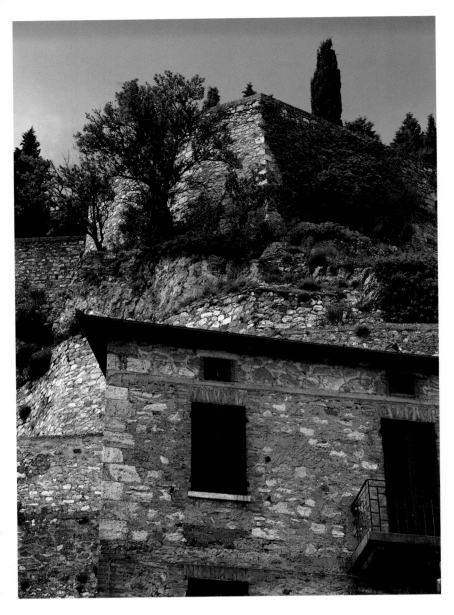

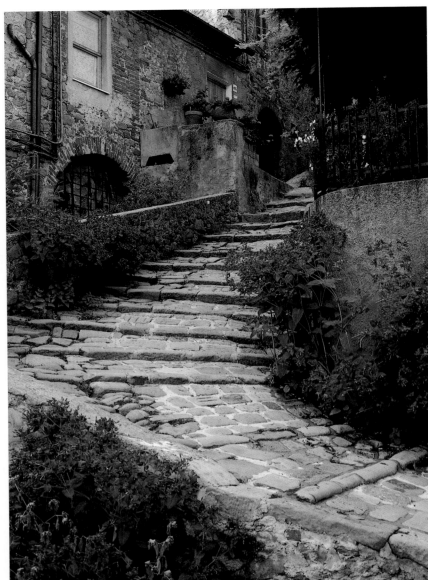

Castiglione seems dominated by high places: another vertiginously steep street (above right); the stronghold of Rocca d'Orcia viewed from the fortress of Castiglione (above); the ruins of eleventh-century San Bruzio (right). Some relief to the constant rise and fall of the village's streets is provided by the Piazza, with its striking Renaissance fountain (opposite).

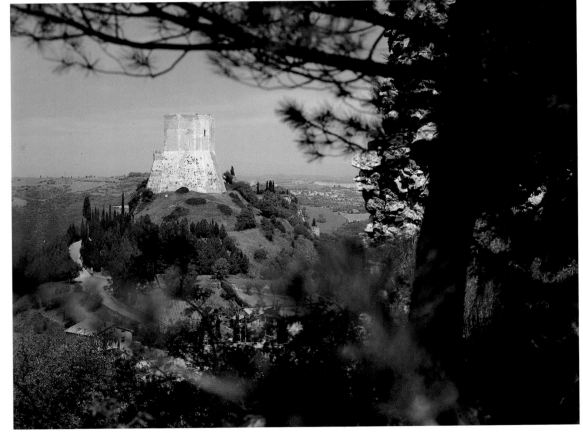

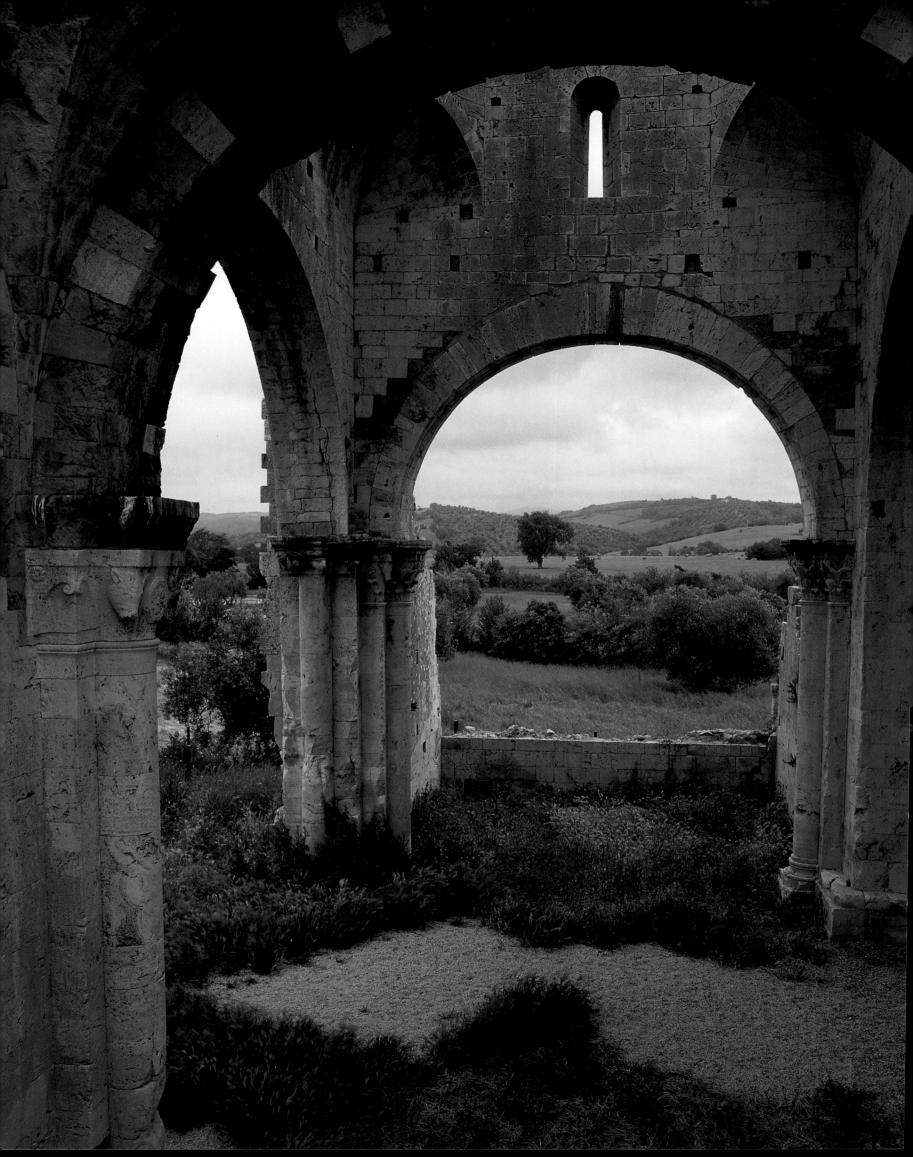

The South

Cetona · Radicofani · Sovana
Arcidosso · Abbadia San Salvatore · Saturnia
Pitigliano · Montemerano · Magliano in Toscana
Populonia · Ansedonia

Opposite
*Romanesque arches frame a green panorama at
Magliano in Toscana.*

*M*ore evidence of the all-pervading influence of the Medici: this relief of their arms appears above a doorway in Arcidosso.

THE south-western part of Tuscany, roughly corresponding to the province of Grosseto, is characterized above all by the fascinating region known as the Maremma and by Monte Amiata and Monte Argentario – the latter virtually an island, connected to the mainland by a narrow neck of land that runs through the Orbetello lagoon. Long inhospitable to travellers, with its recurrent outbreaks of malaria and its numerous brigands and pirates, the Maremma was systematically reclaimed only from the nineteen-thirties. Today it fronts a long strip of coastland, with beaches and rocky headlands offering splendid tourist facilities.

Parts of the region are now protected areas, in particular the Maremma natural park and Lake Burano, which is now a wildlife reserve. Set up in 1975, the Maremma natural park covers more than seventeen thousand hectares, stretching from Principia a Mare as far as Talamone. It includes dunes and pine forests (with many varieties of pine), mastic trees, heather, ilex groves, myrtle and rosemary. The wildlife is of astounding variety: wild boar, wild cats, pheasants, bustards, weasels, rabbits, foxes, herons and long-horned cattle. Mankind has contributed such delights as Palaeolithic caves, with remarkable fossils, and the ruined Benedictine abbey of San Rabano, which was founded around A.D.1000 as a tentative, ultimately unsuccessful attempt to colonize Monte Uccellina. Folk traditions here die hard, because many of them are extremely practical. The 'butteri', for instance, are horse-riding herdsmen, able to follow their flocks into areas which would be otherwise impassable.

The park is threaded by canals. Further east, the woodlands become denser, even on the slopes of Monte Amiata where, in winter, the climate allows fifteen kilometres of ski slopes. Amiata also has a wildlife park, protecting the Apennine wolf, foxes, buzzards, hawks, deer, stone-martens and weasels. In the Middle Ages it was remote enough for the monks of Abbadia San Salvatore to retreat from the world almost to its summit. The contours of this part of southern Tuscany mean that many of its most beautiful villages are much improved by being sited on the tops of hills. Sarteano and Cetona further north-east are another couple of villages strategically set on hills, whose lower slopes nurture broom, olive trees, evergreen oaks – and a whole profusion of vigorous vegetation.

This part of Tuscany possesses a cultural heritage dating back to the Etruscans; two of the most beautiful villages, Sovana and Ansedonia, are rich in their remains. Further north the whole litteral of the Tyrrhenian Sea is today known as the Etruscan Coast, and at the village of Populonia on the Baratti gulf is a major Etruscan necropolis. As for the Romans, they relished thermal baths, and their legacy to this part of Tuscany includes those at the village of Saturnia, bubbling enthusiastically outside the old village.

Later ages left a similarly rich heritage, much of it also revealed in the region's loveliest villages. Just outside Magliano in Toscana, for instance, the Romanesque church of the Annunciata was later decorated by the Sienese, who also built the defensive walls around the village. Inside these walls rises a Gothic Palazzo dei Priori. Other great Tuscan cities lent their finest architects to this region, so that you find at Pitigliano a Renaissance palazzo which the Florentine Giuliano da Sangallo modified in 1500.

Strategically, too, many of the most exquisite villages of southern Tuscany were of unexpected importance. The Via Cassia, the Roman road which brought travellers from northern Europe to Rome, crosses this land, and is paralleled by a medieval route, the Via Francigena, which served the same purpose for pilgrims in the Middle Ages and later. In 994 Archbishop Sigeric of Canterbury followed this route and found it fascinating enough to leave us a description of its path, which crossed the Alps at Great St. Bernard, passed through Parma, crossed the Apennines, skirted Florence on the way south towards Siena and then went on to Monte Amiata.

The cultural heritage of southern Tuscany is rich indeed: medieval walls in the ancient settlement of Cetona (above) and the Torre della Tagliata (left) overlooking the sea at Ansedonia, the residence of Puccini during the composition of Tosca.

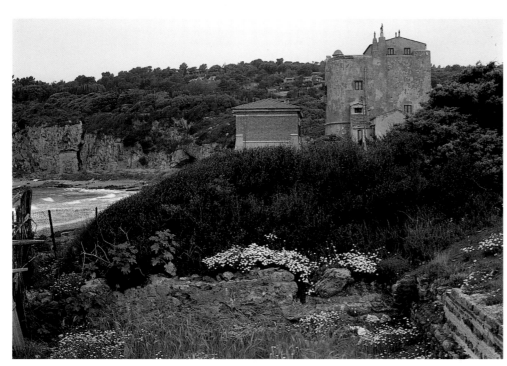

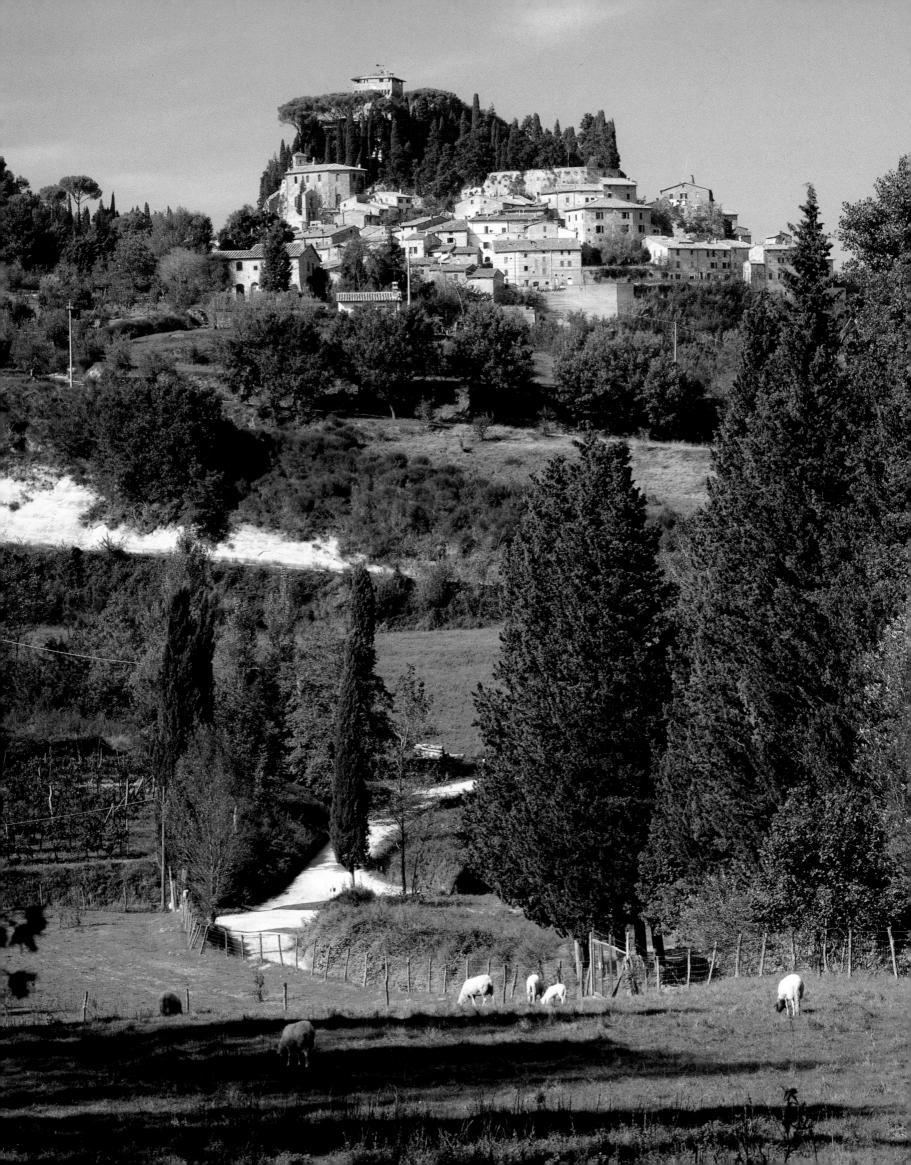

Cetona

CONE-SHAPED, its ancient houses seemingly piled on top of each other, Cetona rises a third of the way up the slopes of the 1147-metres-high mountain named after it, with the fortress crowning the village. Pines and cypresses shade the buildings of this place, which has been inhabited since the Palaeolithic Age. Prehistoric settlements have been opened up in the archaeological nature park in the Belverde-Bianchetto area. The travertine rock is pierced with caves, many once inhabited, some of which (the Grotto of Saint Francis, the Poggetto and the Antro della Noce) can be visited.

Traces of the sturdy double ring of walls which once protected Cetona can still be discerned. The main square, Piazza Garibaldi, which was laid out in the sixteenth century, is overlooked by churches and stately houses with, at the far end, the Torre del Rivellino, a tower which was once part of the village's outermost fortifications. The prettiest church is that of Sant'Angelo, notable for a twelfth-century Madonna and Child, carved from wood.

The Via Roma leads to Cetona's thirteenth-century Collegiate church, which is well worth a visit, if only for a lovely late fifteenth-century fresco of the Assumption of the Blessed Virgin Mary attributed to Pinturrichio. Those who relish such treasures will find the convent of San Francesco, two kilometres from Cetona on the way to Sarteano, in whose church is a fifteenth-century Madonna by Sano di Pietro (on the high altar) as well as an early sixteenth-century Madonna and Child by Girolamo di Benvenuto. And two kilometres south of the village is the former hermitage of Santa Maria a Belverde, founded in 1367 by a nobleman who had joined the Franciscans, with superb frescoes dating from the same century by Cola Petruccioli of Orvieto.

The village, seen here from the south (opposite)*, climbs in confusion up its hill, shaded by pines and cypresses. Its streets are illuminated with many delightful details, like this flowery balcony* (below) *in the Via Frontone.*

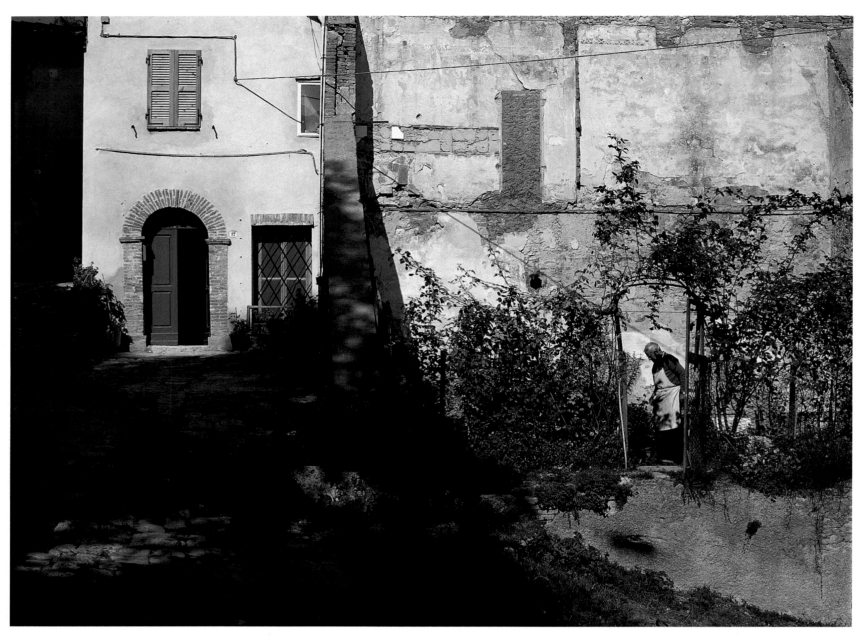

The tranquil streets of Cetona: a profusion of flowers in the Via San Domenico (above) *and the Via della Fortezza* (opposite), *washing in the Via Guglielmo Marconi* (right), *and a contemplative cat in the sunlit Via de Laura* (far right).

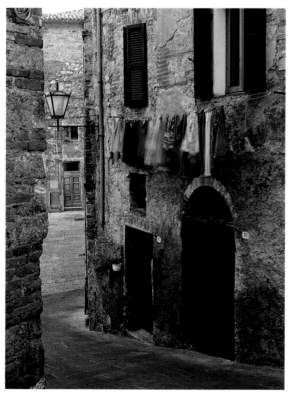

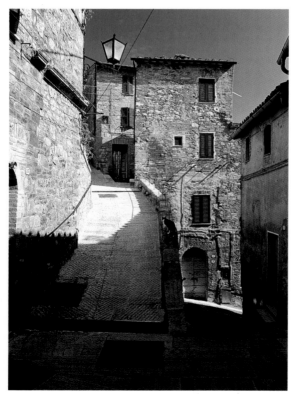

The land falls away steeply outside the walls of Cetona to a landscape of idyllic perfection, contemplated by a solitary painter.

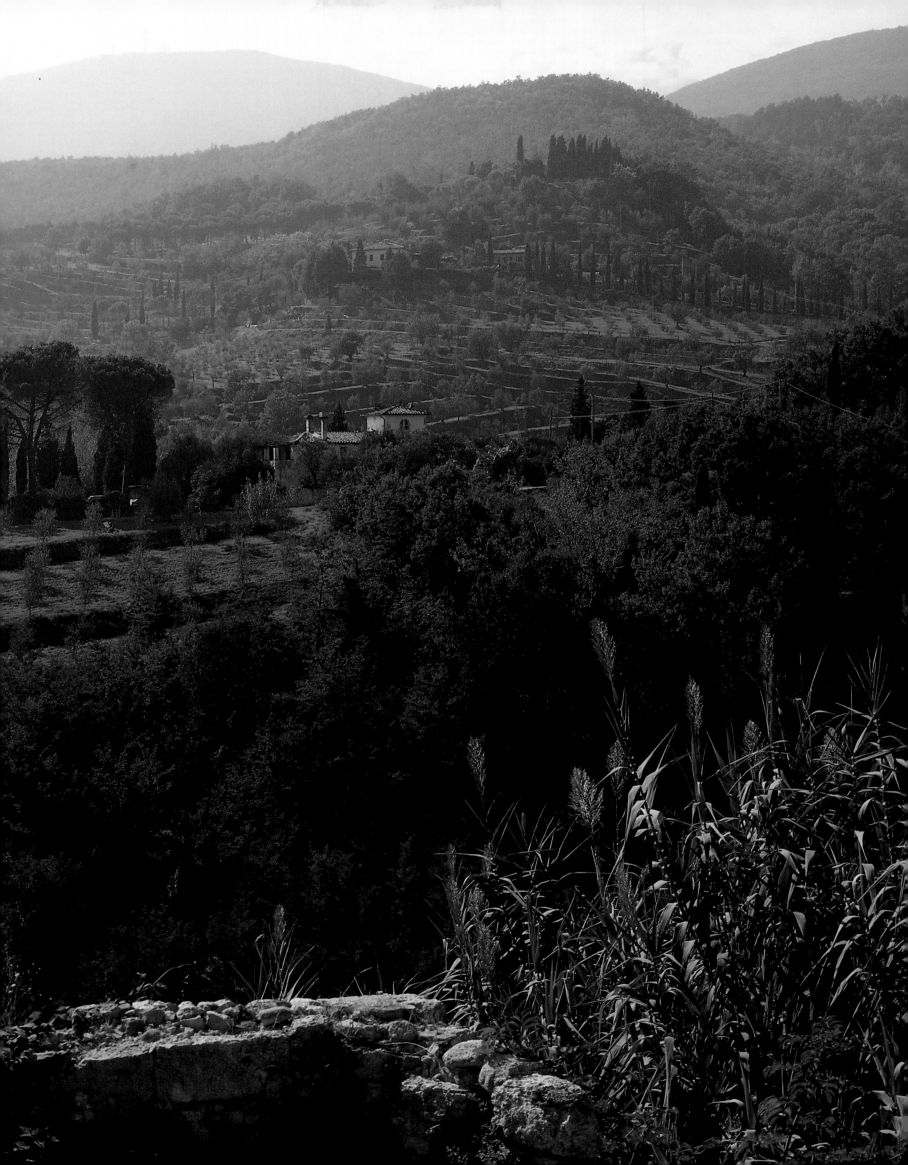

Radicofani

The sturdy walls and houses of Radicofani are crowned in this view (above) by the campanile of the church of San Pietro. As in many another Tuscan village, the ubiquitous influence of the Medici made itself felt here, expressed (opposite) in this relief of their arms on the fountain in the Via Cassia.

CHARLES DICKENS once stayed at what he described as 'a ghostly, goblin inn' at Radicofani. Much earlier than the Italian travels of the English novelist, Radicofani was in thrall to the brigand Ghino di Tacco, who imprisoned the Abbot of Cluny in a fortress built in 1154 for the sole English pope, Hadrian IV, on a formerly volcanic, basalt hill, 766 metres above sea level, which divides the Orcia valley from that of the river Paglia.

Today, the village offers a gentler aspect and better lodgings; its medieval alleyways are narrow and shady; its external staircases quaint; its grey, basalt houses crumbling. Pope Hadrian's fortress is now partly in ruins. Captured by a *condottiere* in the mid fifteenth century, it was bought from him by the Sienese, who rebuilt it. A century later, the Medici took the fortress and further enlarged it. The building was, however, destroyed by an explosion in the eighteenth century. Now partly restored, its walls offer a vast panorama of the surrounding Tuscan countryside.

A late-Renaissance fountain in the Via Cassia was paid for by Duke Ferdinando I in 1603. Its carvings depict Justice, Abundance and the Medici coat of arms. This fountain stands in front of the Palazzo La Posta, a Renaissance villa which the Medici Grand Dukes of Tuscany used as their customs house, levying tolls on travellers to Siena, Florence or Rome. Built in 1584 by Simone Genga and Bernardo Buontalenti, this customs house was later transformed into the inn which Dickens so much abhorred and went on to describe as having 'a winding, creaking, wormy, rustling, door-opening, foot-on-stair-case-falling character . . . such as I never saw anywhere else.'

Radicofani's main square is dominated by the campanile of the thirteenth-century Romanesque church of San Pietro, whose three-aisled Gothic interior is filled with artistic treasures, including works by the Della Robbia family. A second splendid church, the Gothic Sant'Agata in the Via Roma, is dedicated to the patron saint of Radicofani and has works by the Della Robbias.

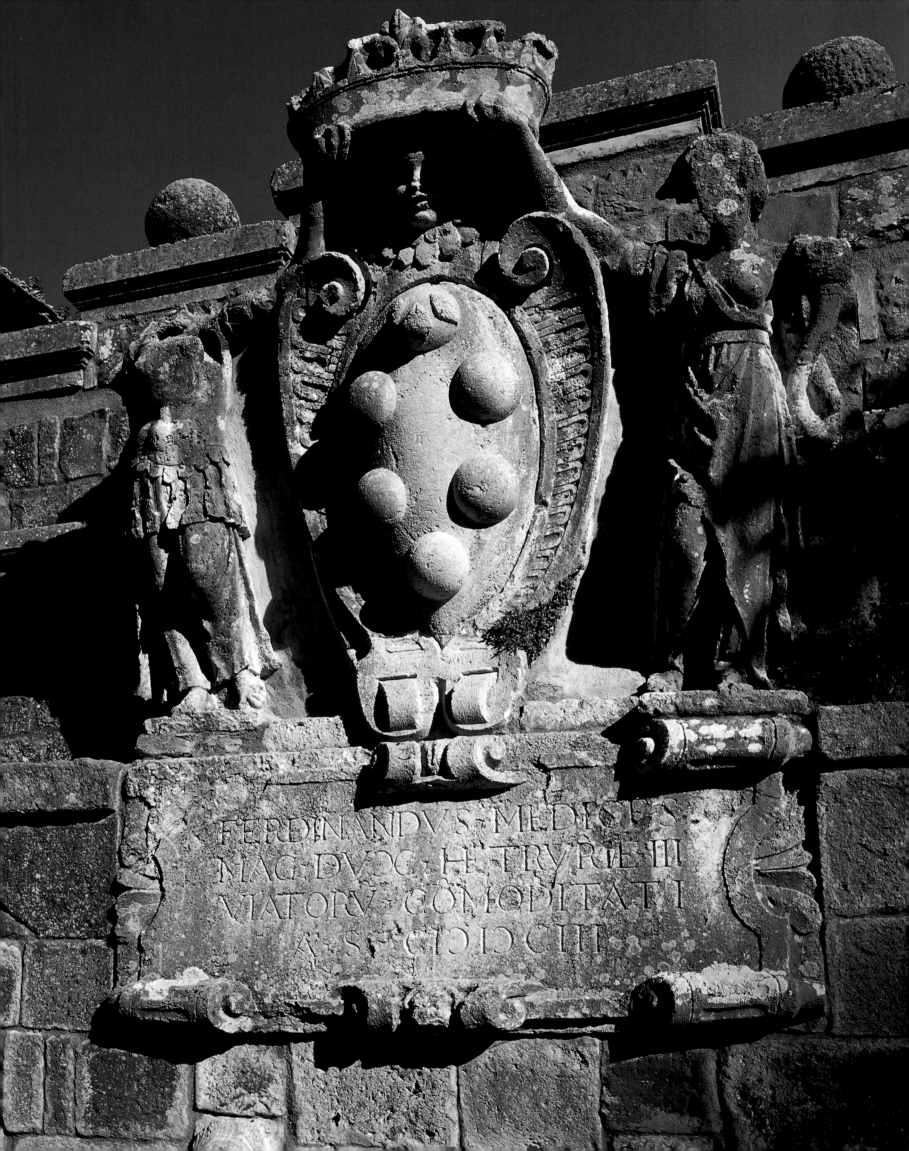

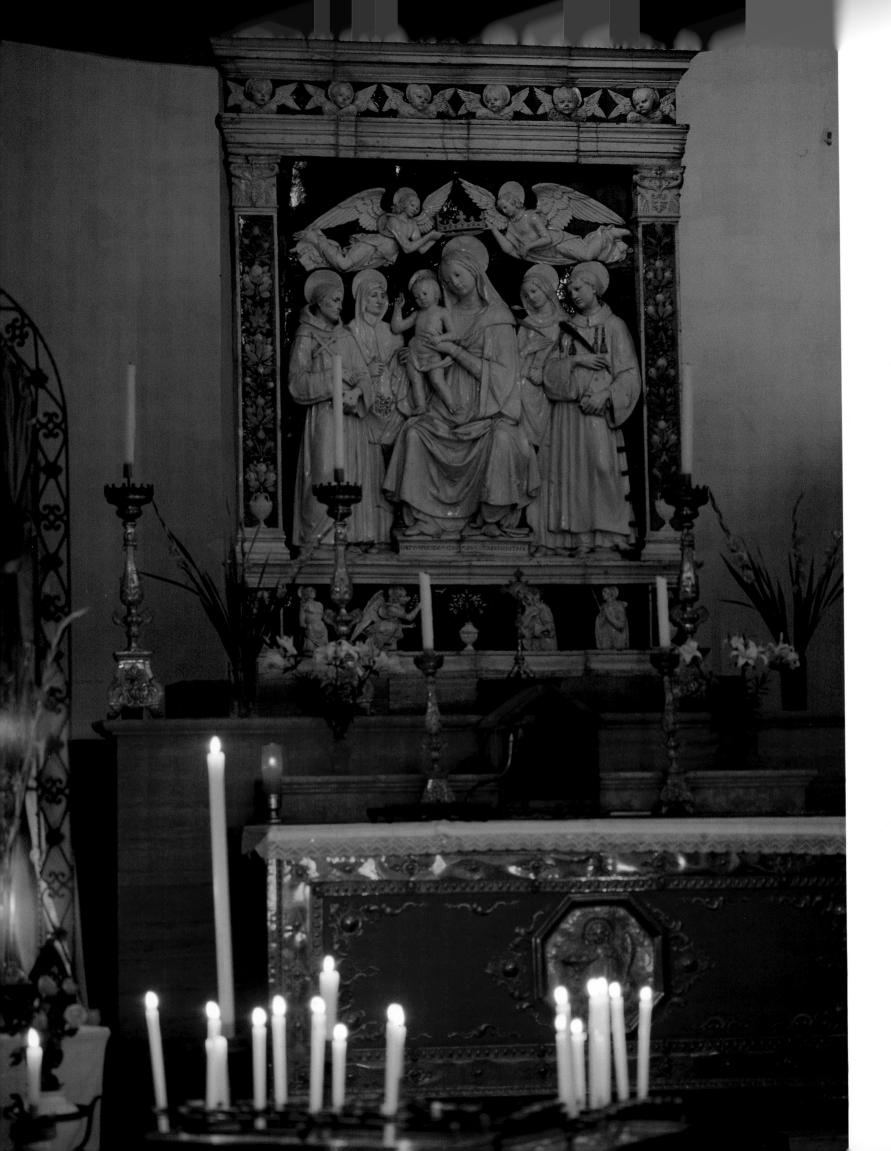

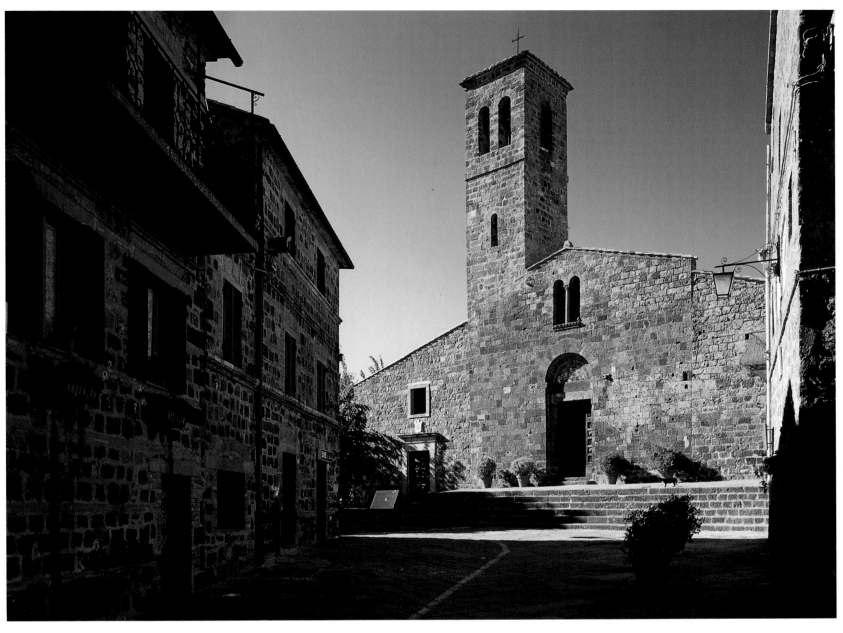

*T*he church of San Pietro in Radicofani (above) possesses a fine altarpiece by Andrea della Robbia (opposite), showing the Virgin and Child with saints. The Medici stables of the Palazzo La Posta still bear many original details: here, a relief of a horse motif (right) and a hitching ring (far right).

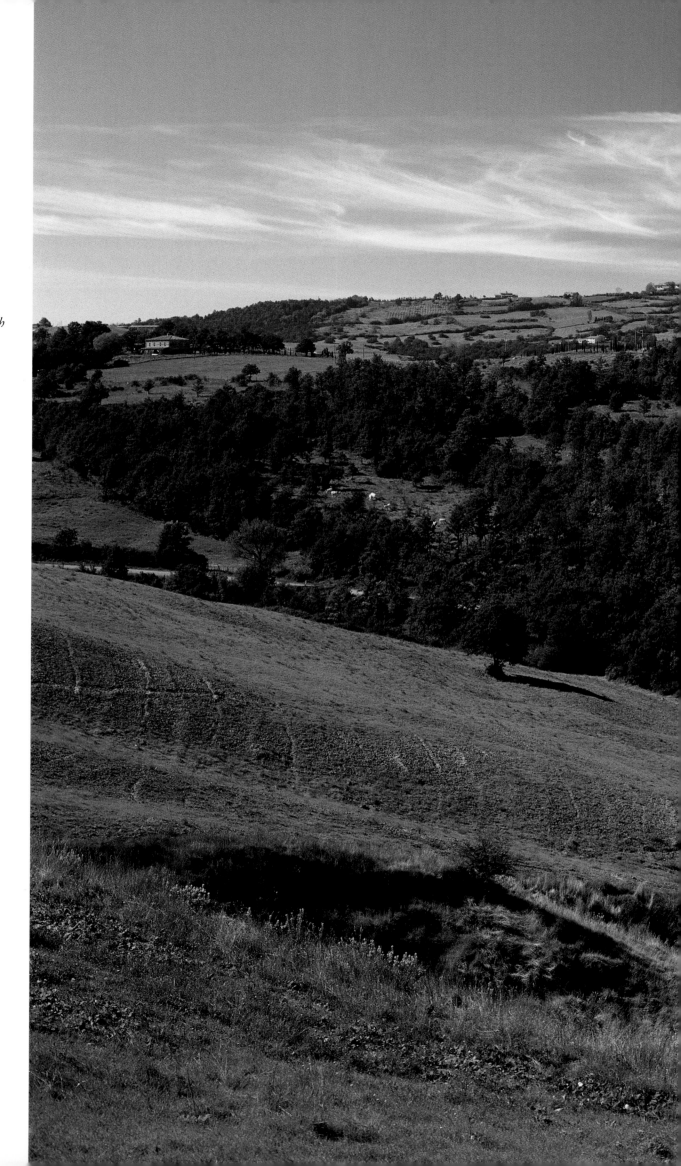

The classic Tuscan landscape with village: Radicofani's hill is crowned by the tower of San Pietro, while Monte Amiata looms darkly in the background.

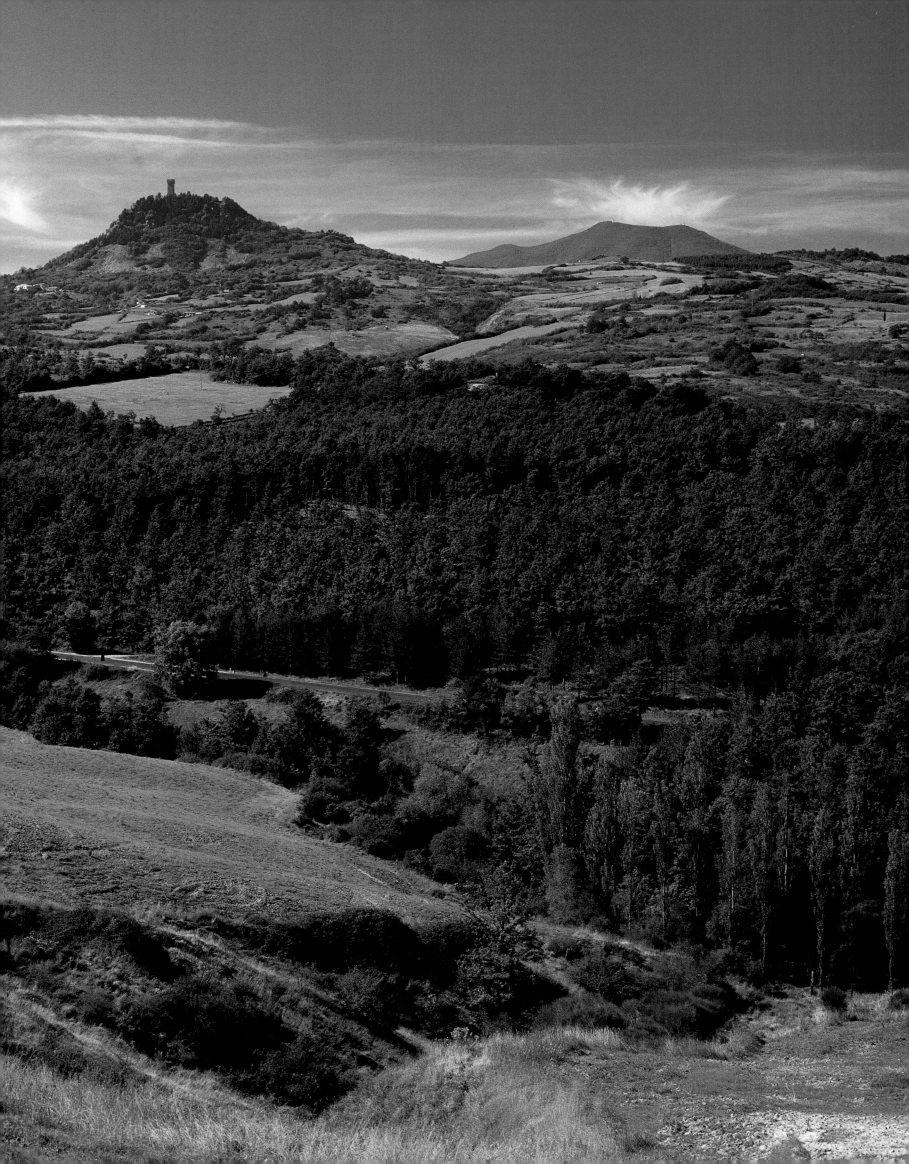

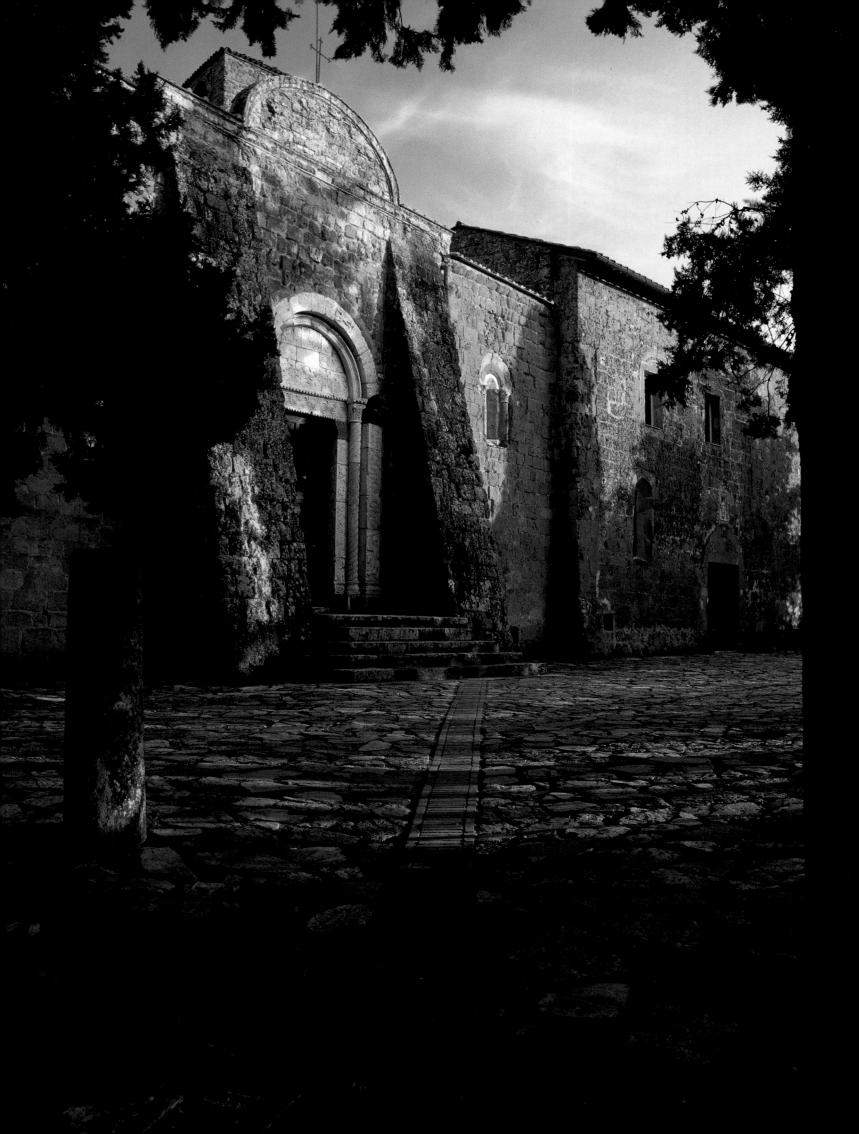

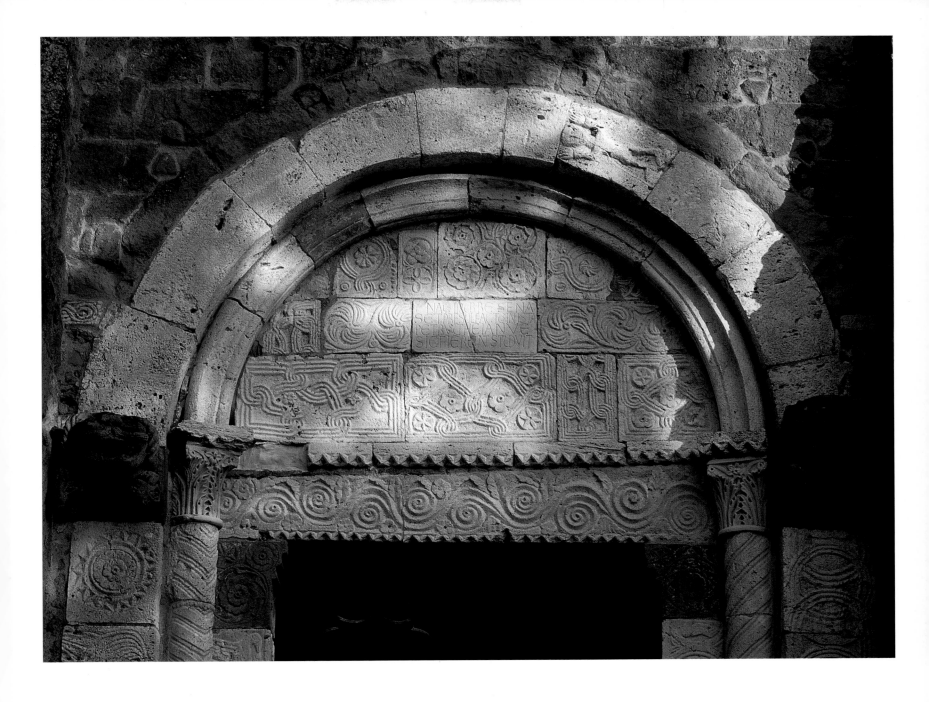

Sovana

The Duomo of Sovana (opposite), dedicated to Saints Peter and Paul, is a sturdy Romanesque structure. Its doorway (above) is notable for its curious interlaced decoration, thought to have been pieced together from pre-Romanesque stonework. Another oddity is the human figure in relief on one of the outer stones of the arch.

Its ancient, ochre-coloured houses rising from a plateau, the village of Sovana, partly abandoned, still preserves the ruins of its medieval fortress, a building we owe to the family which also produced the reforming Pope Gregory VII, who was born here in 1073. This tiny spot was once the seat of a Christian bishop, as well as being a stronghold of the Lombards. Its decline, and preservation in its medieval state, was due to malaria and the need of its surviving population to take refuge in nearby Pitigliano, which took over Sovana's bishopric in 1660.

The façades of the twelfth-century Romanesque church of Santa Maria and of several medieval palaces cast their shadows over Sovana's delightful Piazza del Pretorio. The thirteenth-century Palazzo Pretorio, which was in part rebuilt two hundred years later, and the late-Renaissance, sixteenth-century Palazzo Bourbon del Monte are only the most important of the village's many impressive buildings. The high altar of

Santa Maria includes an eighth-century ciborium, one of Tuscany's most important remains. Nor should a more humble embellishment of this impressive square, the Palazzo dell'Archivio, be neglected; it was founded in the twelfth century and has a sweet, unpretentious campanile.

From the square runs a street of medieval houses, the Via del Duomo, which includes the house in which Gregory VII was born. Curiously, Sovana's most important church, the Romanesque and Gothic Duomo of Saints Peter and Paul is situated at the end of the village, in isolated and tree-shaded splendour. First built in the ninth century, it was rebuilt again and again until the end of the fourteenth century; in spite of its Gothic vaulting, this remains essentially a Romanesque gem.

One and a half kilometres away is a yet more venerable site, an Etruscan burial ground dating from the fourth century B.C., with the façades of tombs carved from the rock.

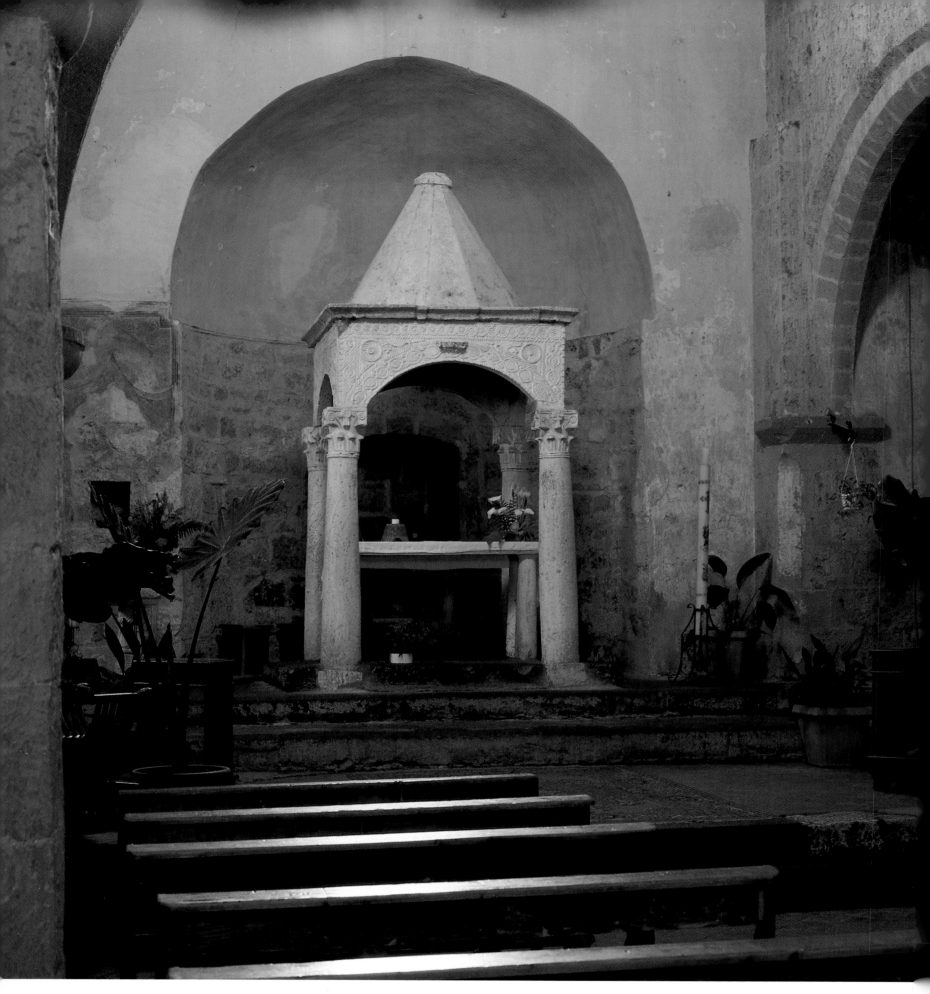

Virtually every detail of Sovana testifies to its great antiquity as a centre of civilization and worship: the high altar of Santa Maria is sheltered by an eighth-century marble baldacchino; *in the Piazza del Pretorio,* the Taverna Etrusca (opposite, above *and* below left) *recalls Sovana's Etruscan origins, for which even more direct evidence exists in the form of burial chambers just outside the village* (opposite, below right).

Arcidosso

Sited on the western slopes of Monte Amiata and protected further west by Monte Labbro, Arcidosso is embraced by a forest of beeches and chestnuts and still overlooked by the remains of the Rocca Aldobrandesca, a medieval fortress built by the Aldobrandeschi family. Two lovely churches stand outside the old village. On the road to Montelaterone rises the Romanesque edifice of Santa Maria ad Lamula, with its exquisitely carved capitals, while to the southwest, and beside a fountain, stands the Madonna Incoronata. Inside the latter are Sienese works of art, including a fresco from the workshop of Taddeo di Bartolo, a legacy of the city which successfully besieged Arcidosso in 1332 and took it from the Aldobrandeschi. Though today Renaissance in style, owing to a fifteenth-century reconstruction, the Madonna Incoronata was built as a thanks offering for those who survived the Black Death of 1348.

This is a village of arches, passageways and quiet piazzas, with ancient houses flanking steep streets and ramps, one of which leads up to a glowering, battlemented medieval gateway which defends the old quarter. The gateway's bleak aspect is softened by the prominent coat of arms of the Medici family, chiselled in stone and added after Arcidosso became a vassal of Florence in 1559. The old lanes wander to other, equally venerable churches, so that by way of the Gothic Porta dell' Orologio you find the church of San Leonardo, which was founded in the twelfth century, enlarged in 1300 and derives its present aspect from the sixteenth century. Beyond the Talassese gate is the little church of Sant'Andrea, which first appears in records in 1118.

Nestling amid the chestnuts of the densely wooded slopes of Monte Amiata, Arcidosso is the quintessence of rural Tuscany. The massive tower of its rocca, *however, reminds us that this region has not always been so apparently peaceful.*

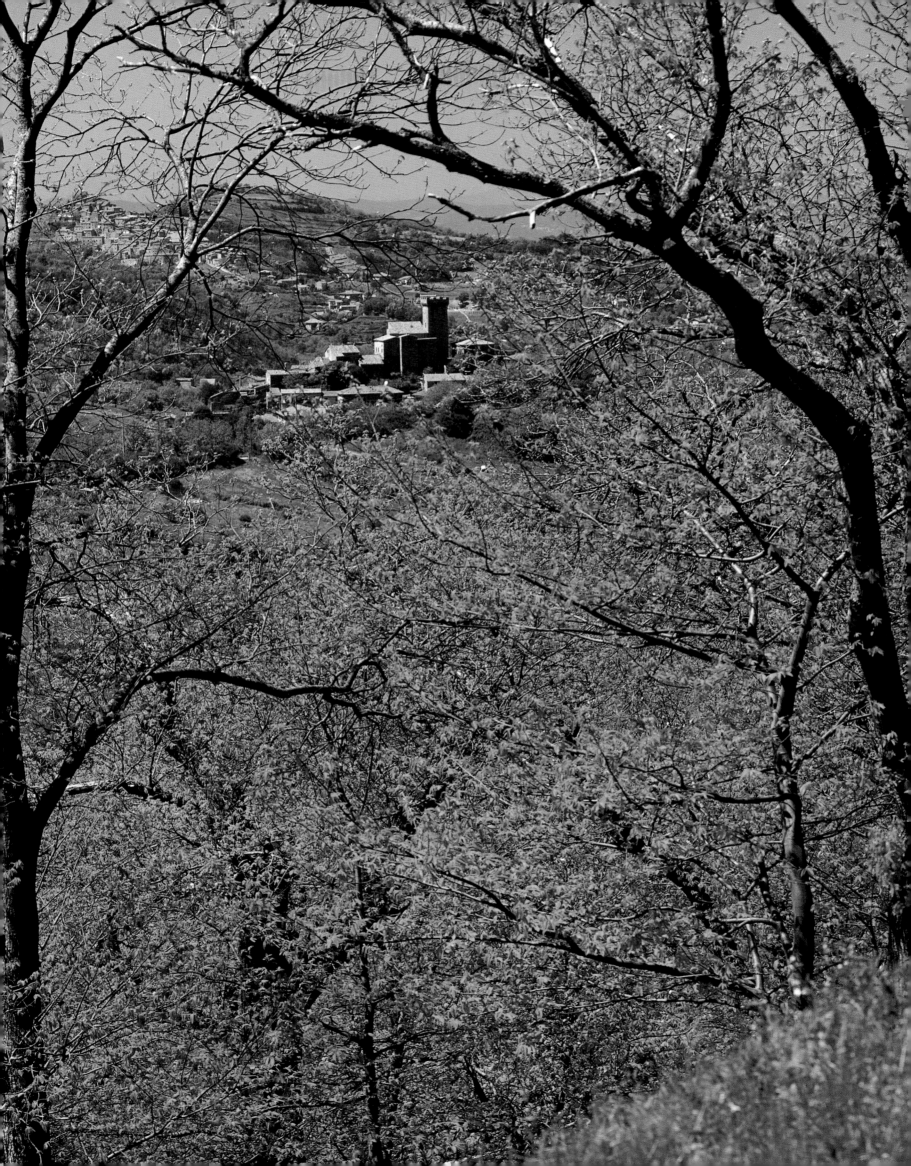

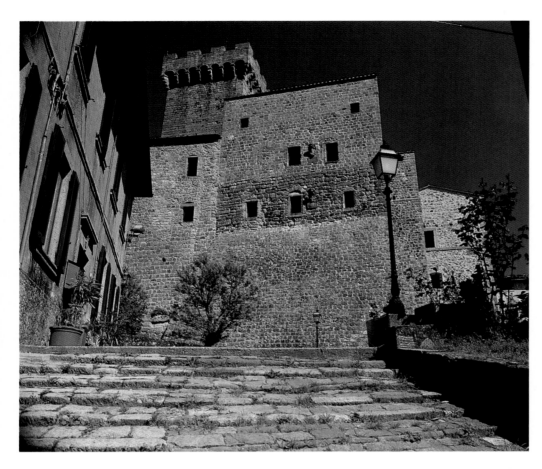

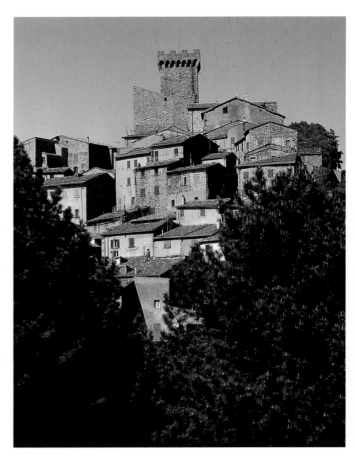

*A*rcidosso boasts much fine architecture and decorative treasure, notably the massive Rocca Aldobrandesca (above, above right and opposite), *which completely dominates the village and, indeed, the countryside around. Architecture of a less aggressive kind is provided by such features as this gargoyle-decorated cistern* (right) *by the sanctuary of the Madonna delle Grazie, the same church's carved Renaissance pulpit* (overleaf) *and this splendidly weathered house with its delicate balcony.*

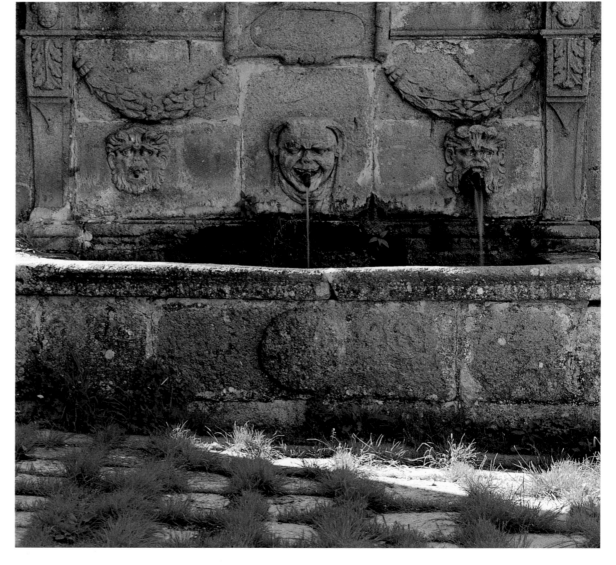

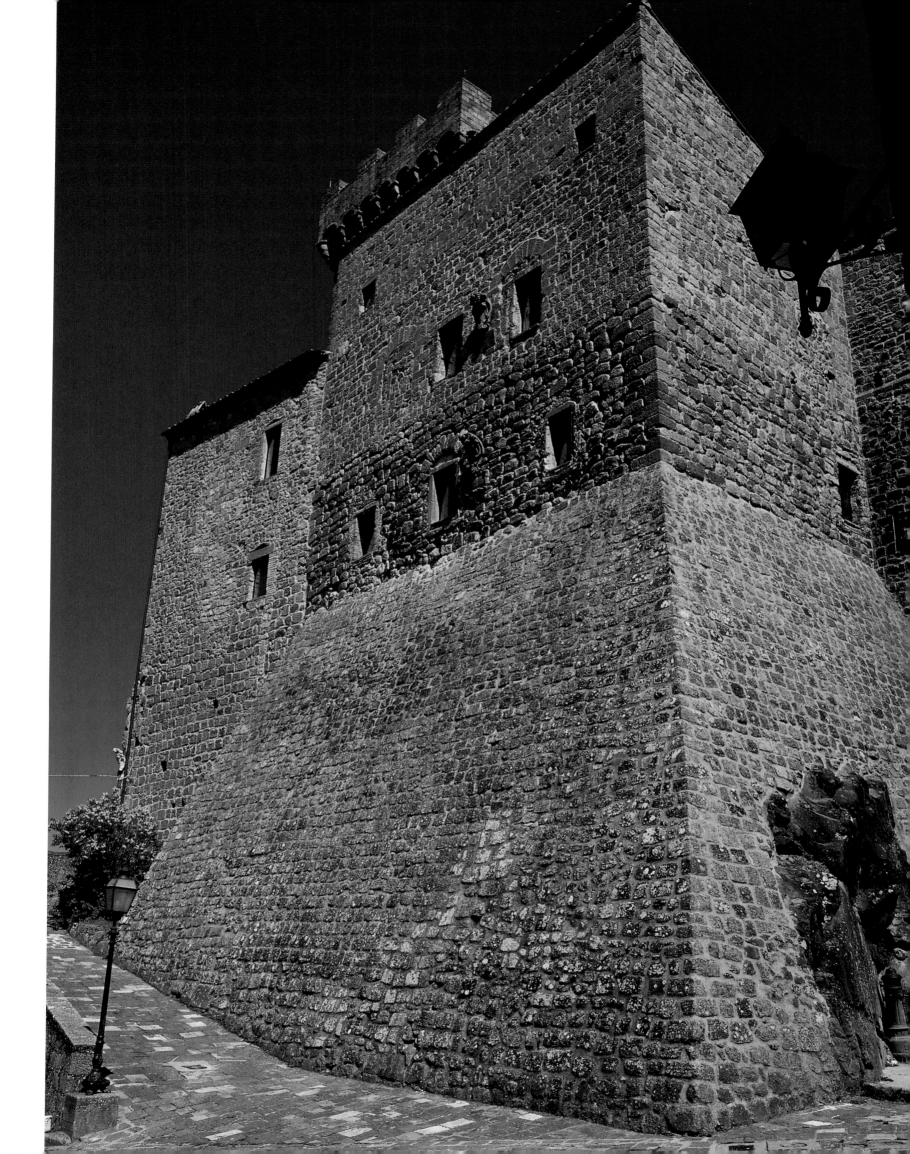

Abbadia San Salvatore

ANOTHER village high on the slopes of Monte Amiata, Abbadia San Salvatore is known today as a winter sports centre. In the Middle Ages, however, it derived most of its wealth from the richest abbey in Tuscany, which catered for the medieval equivalent of tourists, namely pilgrims on the way from northern Europe to Rome.

Founded by the Lombard King Rachis in 743, the abbey reached the height of its wealth and influence in the eleventh century. Abbot Winizzo inaugurated a sumptuous rebuilding of its church, which he reconsecrated in 1035. Apart from leaving later frescoes intact, subsequent restoration has taken the building back to its Romanesque form (though the apse was destroyed in an earthquake of 1287). Of the two towers, one was never finished, while the second is crenellated and used as a belfry. Inside, a timber roof arches over such gems of religious art as a late twelfth-century wooden crucifix, hanging on the right-hand wall, and a fresco of the martyrdom of St. Bartholomew painted by Francesco Nasini in 1694. He and his brother Antonio Annibale also painted the frescoes in the choir, raised above the crypt and reached by steps, and some of the chapels. The eighth-century crypt is cool and exquisite, divided into three naves by thirty-six slender columns, some of them incised, all different and decorated with carved capitals.

Next to the church the monastery buildings include a sixteenth-century cloister and a treasury which still houses an eighth-century silk cope and a reliquary of roughly the same date, the latter brought here by Irish monks. As for the village which sprang up around the abbey, its walls and four gates still protect its historic centre (the Castellina), south of which rises the walled Castello. Its fifteenth-century Palazzo Pubblico stands close by the church of Santa Croce, which was built in the thirteenth century, if not before, and enlarged in the first half of the sixteenth. Another fine church, Santa Maria, has a Renaissance façade, while San Leonardo is Gothic. The houses of this well-preserved village, both medieval and Renaissance, are built of dark grey stone.

Abbadia sits in its boulder-strewn setting, beneath the powerful presence of Monte Amiata.

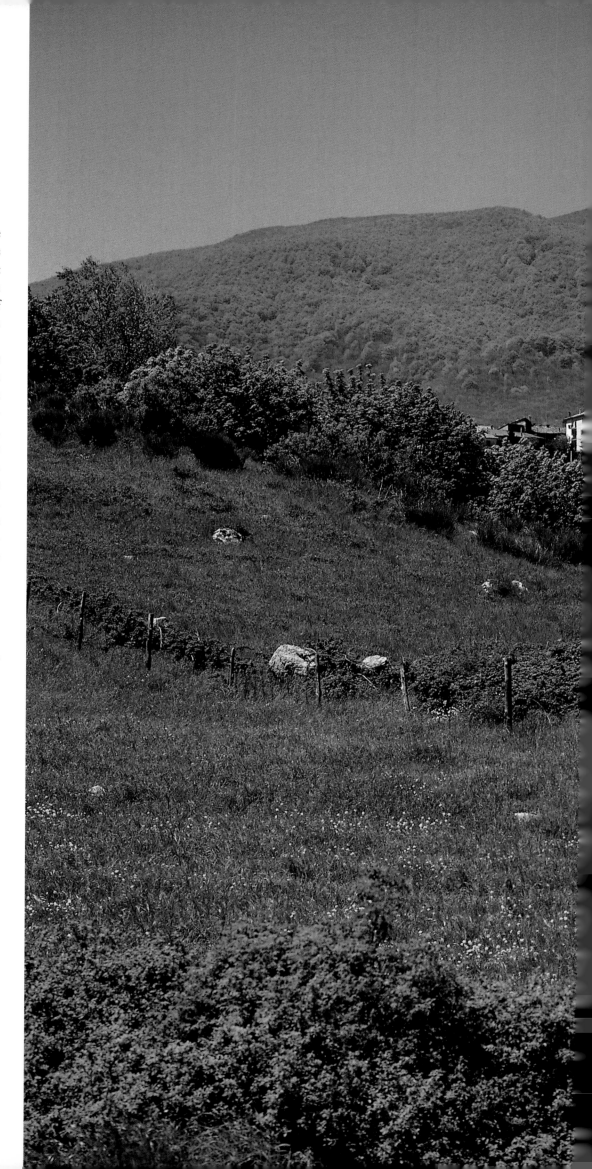

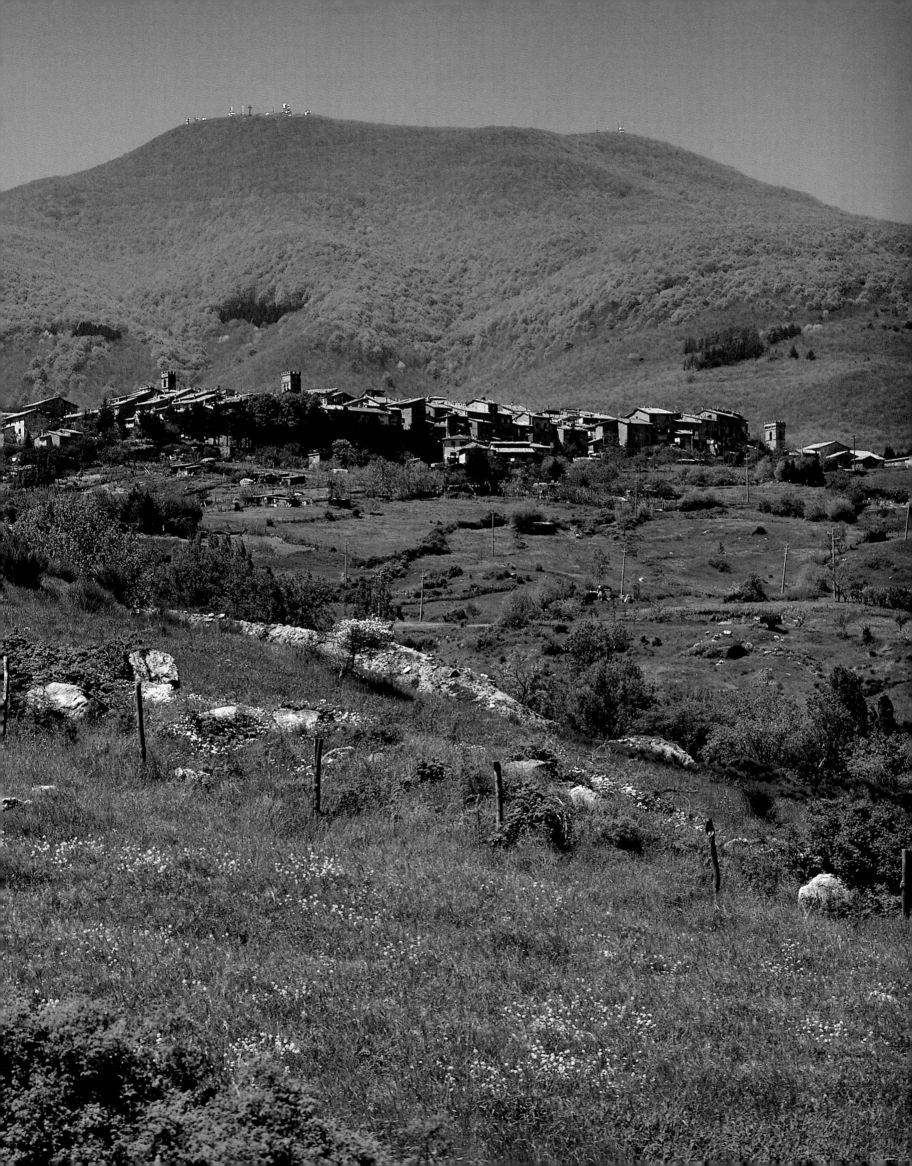

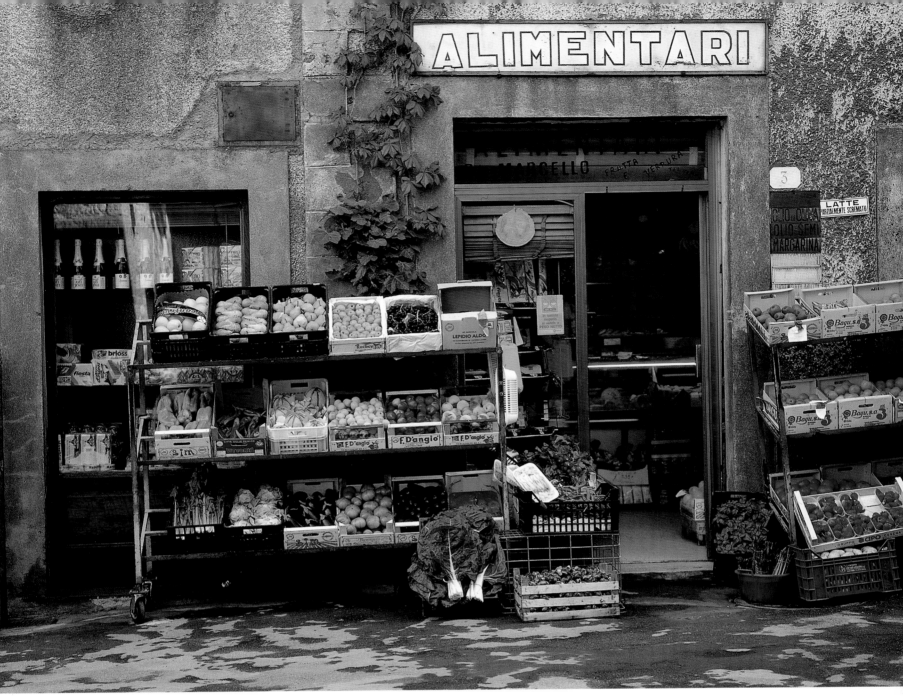

*C*hange and tradition in
Abbadia: the modern packaging
of local produce in the Via Mazzini
forms a contrast to the time-
honoured signs for blacksmith and
tailor in the same street (right). In
the old town, the tower of Santa
Croce looms over narrow streets,
crossed by arches and harbouring tiny
traditional workshops (opposite).

Abbadia San Salvatore · 185

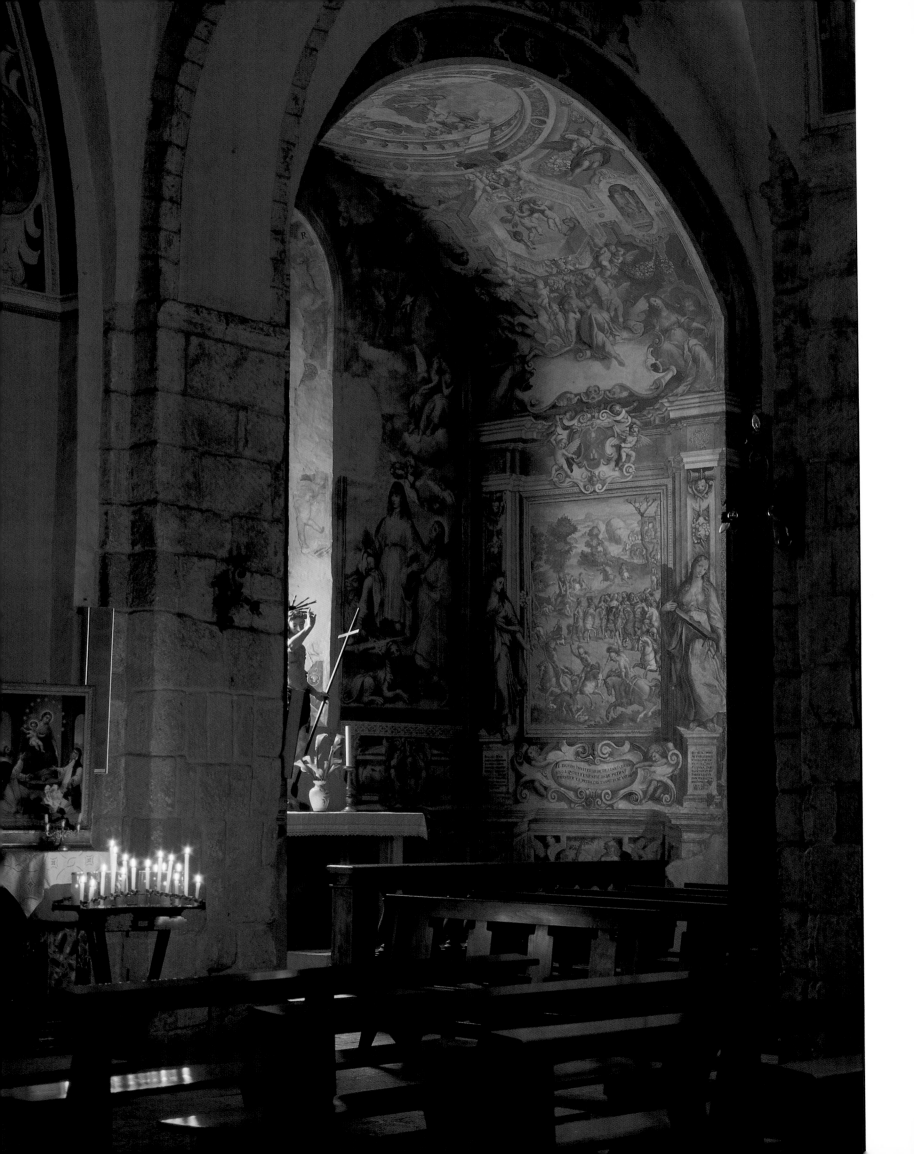

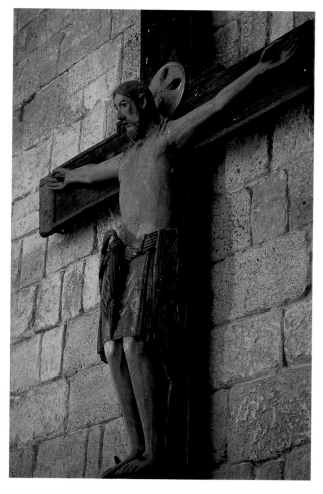

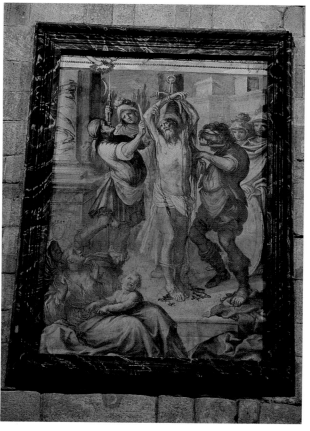

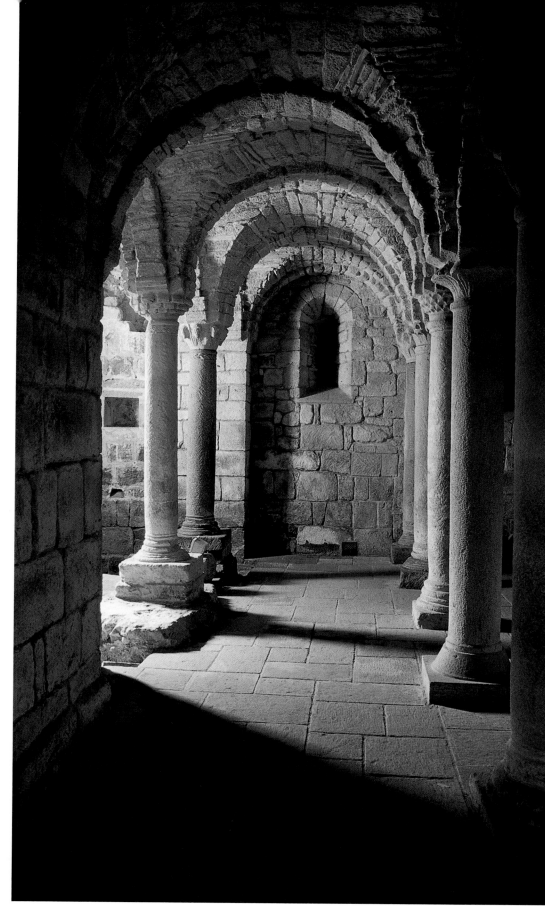

The frescoes in the apse of the abbey church (opposite) were painted in the early eighteenth century by Giuseppe Nasini. Other treasures there include a twelfth-century crucifix (top), a 1674 painting of the martyrdom of St. Bartholomew by Francesco Nasini (left), and an ancient crypt supported by thirty-six columns (above).

Saturnia

Of very ancient occupation, a fact proclaimed by the presence of Etruscan tombs (below right), Saturnia is entered by the medieval arch of the Porta Romana (below). Further evidence of the village's importance in the Middle Ages is suggested by the frescoes of the parish church (opposite, below right), one of which shows the patron who paid for them kneeling respectfully at the feet of St. Peter. Yet Saturnia remains a living place, where washing is hung out to dry and tyres are repaired in a local fountain (opposite).

ON an isolated promontory of travertine rock in the upper valley of the Albegna, at its confluence with the Stellata, stands Saturnia, formerly the ancient Etruscan settlement of Aurinia. The Romans changed its name to Saturnia in the belief that it had been founded by the father of Jupiter. Still defended by Roman-Etruscan walls, whose square and polygonal stones intersect miraculously, the village may even be pre-Etruscan in origin. Nearby, at Puntone and Pian di Palma, are Etruscan tombs, the finest the tomb of the Pellegrina at Pian di Palma, dating from the sixth and fifth centuries B.C.

A tiny village but nevertheless celebrated, the praises of Saturnia were sung by Livy, Pliny, Herodotus and Dionysius of Halicarnassus. Over the subsequent centuries, though, its fortunes rose and fell. Attacked by Saracens, invested by the Aldobrandeschi family, sacked by the Sienese, given a fortress by Luca di Bagnacavallo

in 1419, Saturnia came under the sway of the Medici and eventually of Ximenes of Aragon.

Today, the village is entered by the Porta Romana, whose medieval arch sits amid the white walls of the village. The ancient Roman pattern of streets, the *cardo* and *decumano*, still dominate the plan of the village. Walk along the Via Clodia to reach the vast Piazza Vittorio Veneto. To the left is Saturnia's Romanesque parish church, notable for a Madonna and Child by Benvenuto di Giovanni, who flourished in the fifteenth century. Nearby are the remains of the fortress and the Villa Ciacci, a pastiche of a medieval castle built just before the First World War, but fitting convincingly into the overall pattern of the village.

Three kilometres to the south run the sulphurous waters of the Terme di Saturnia, with an even heat of 37.5 degrees centigrade, bubbling through a series of gentle falls beside a tumbledown mill.

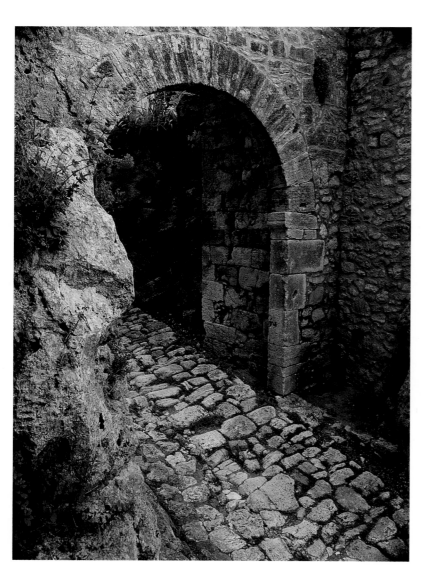

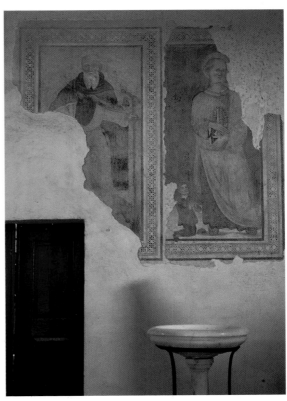

Pitigliano

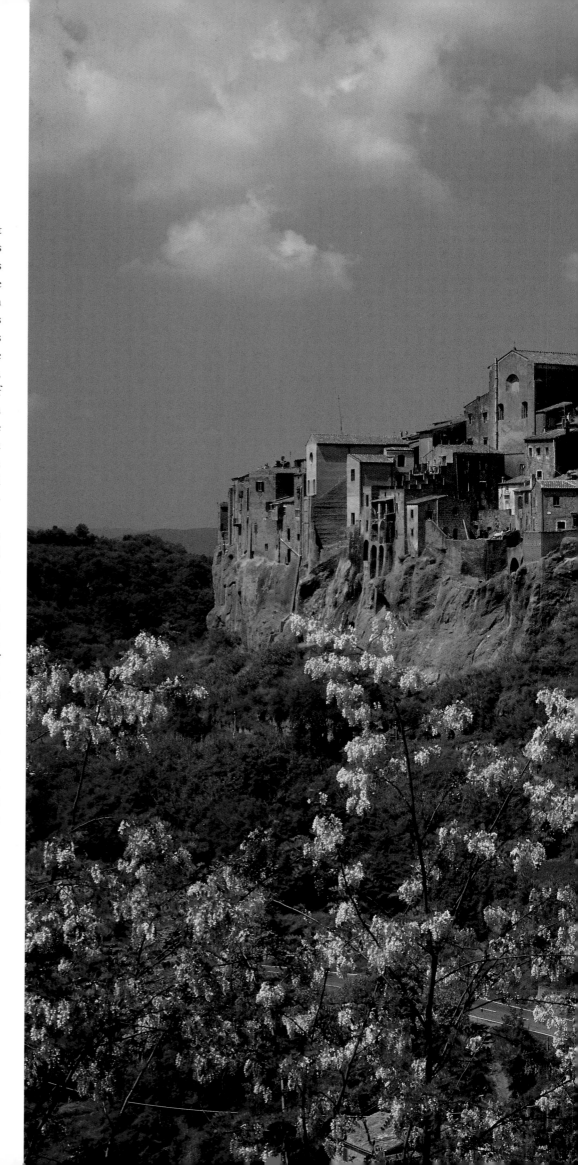

RISING proudly on its volcanic, tufa peak to a height of 313 metres above sea level, Pitigliano overlooks three ravines. This sleepy little town has numerous Etruscan graves to bear witness to its antiquity. The tombs lie in cavities lower down the cliffside, which today often serve as stables or storerooms. The Romans as well as the Etruscans recognized Pitigliano's value as a defensive site, as did the Aldobrandeschi family in the Middle Ages. In later times, under the Orsini family, who in 1293 succeeded the Aldobrandeschi as lords of the region, Pitigliano was a stronghold of the Guelph party, which supported the Papacy against the Ghibelline faction of the Emperor. A citadel, built in 1545, reinforced the village's defenses. In the same year, to guarantee the water supply, Gian Francesco Orsini built an aqueduct, of which two huge arches and thirteen smaller ones still stand.

Today the medieval sector of Pitigliano remains unspoilt, traversed by the picturesque Via Roma and embellished by numerous external staircases. Its architectural treasures include the thirteenth-century cathedral of Peter and Paul, whose splendid campanile once served as the local watchtower. Much of the church's original décor was transformed in the Baroque period. Inside are paintings by an eighteenth-century son of Pitigliano, Francesco Zuccarelli, who emigrated to England in 1752 and was one of the founders of the Royal Academy.

The village also boasts the late-Renaissance church of Santa Maria, built in 1509. Its finest secular building, however, is the huge Palazzo Orsini, originally the main seat of the Orsini family. Begun in the thirteenth century, it was enlarged in the next and finished in the sixteenth by the architect Giuliano da Sangallo. Its most delightful feature is the richly decorated fifteenth-century portal.

Pitigliano is also famous for its wine, made from the *sangiovese* grape which is also used in the more famous Chianti.

*P*itigliano seems almost to grow directly from the rugged outcrops of its remarkable volcanic site.

190

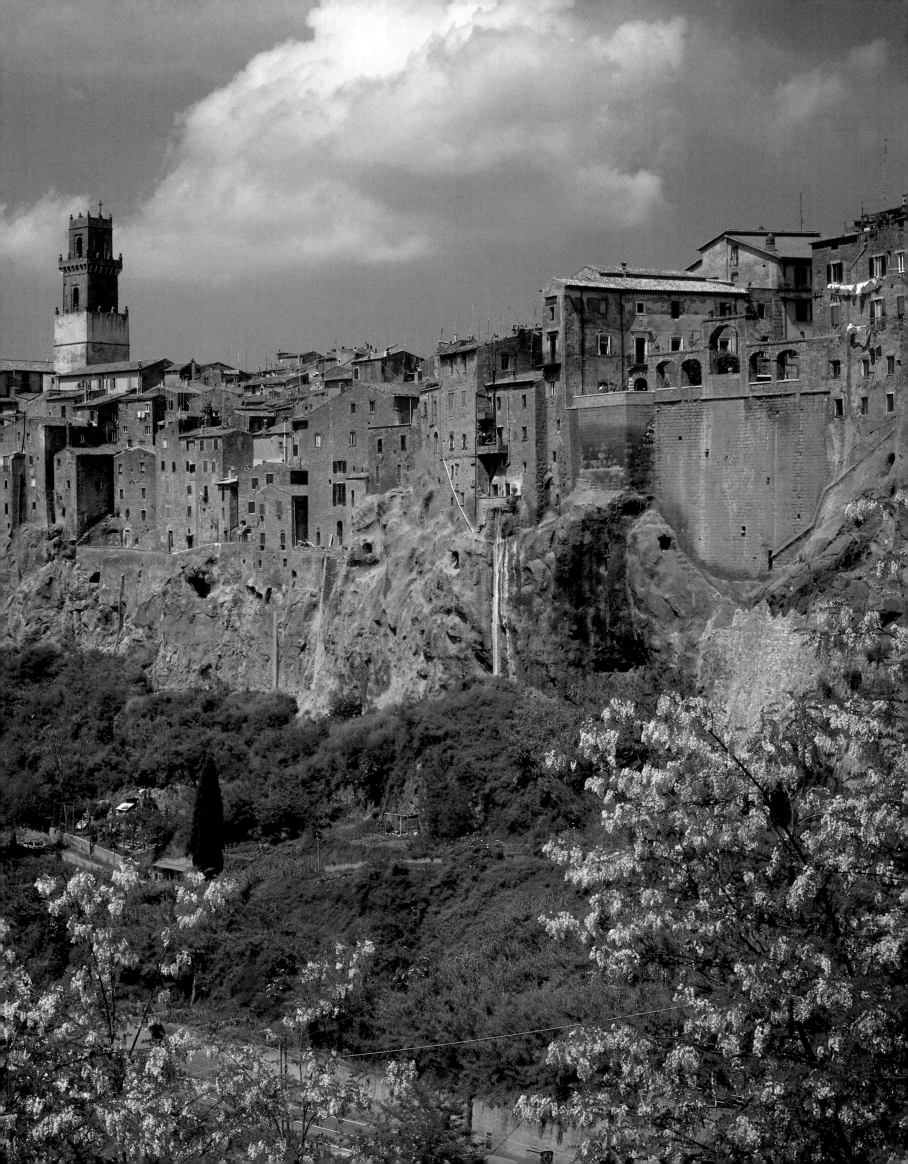

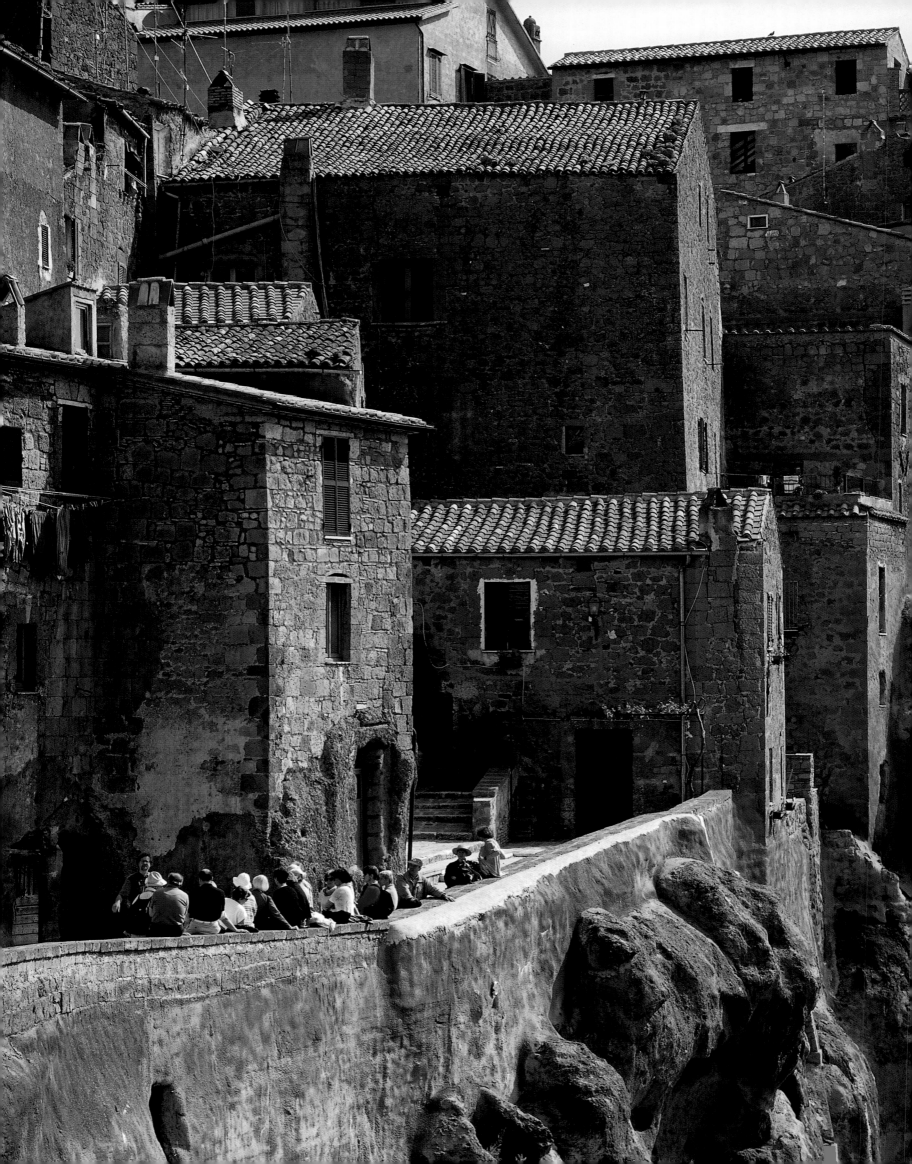

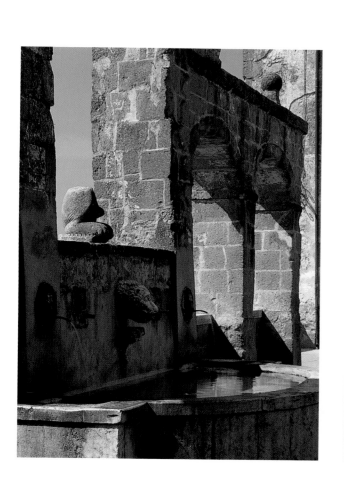

A place of substance, Pitigliano attracts many visitors to its confusion of streets, houses and ramparts. The town also boasts a fine citadel (above) and an aqueduct, but its greatest treasure is undoubtedly the Palazzo Orsini, of which we see here a detail of the elaborately sculpted portal (left).

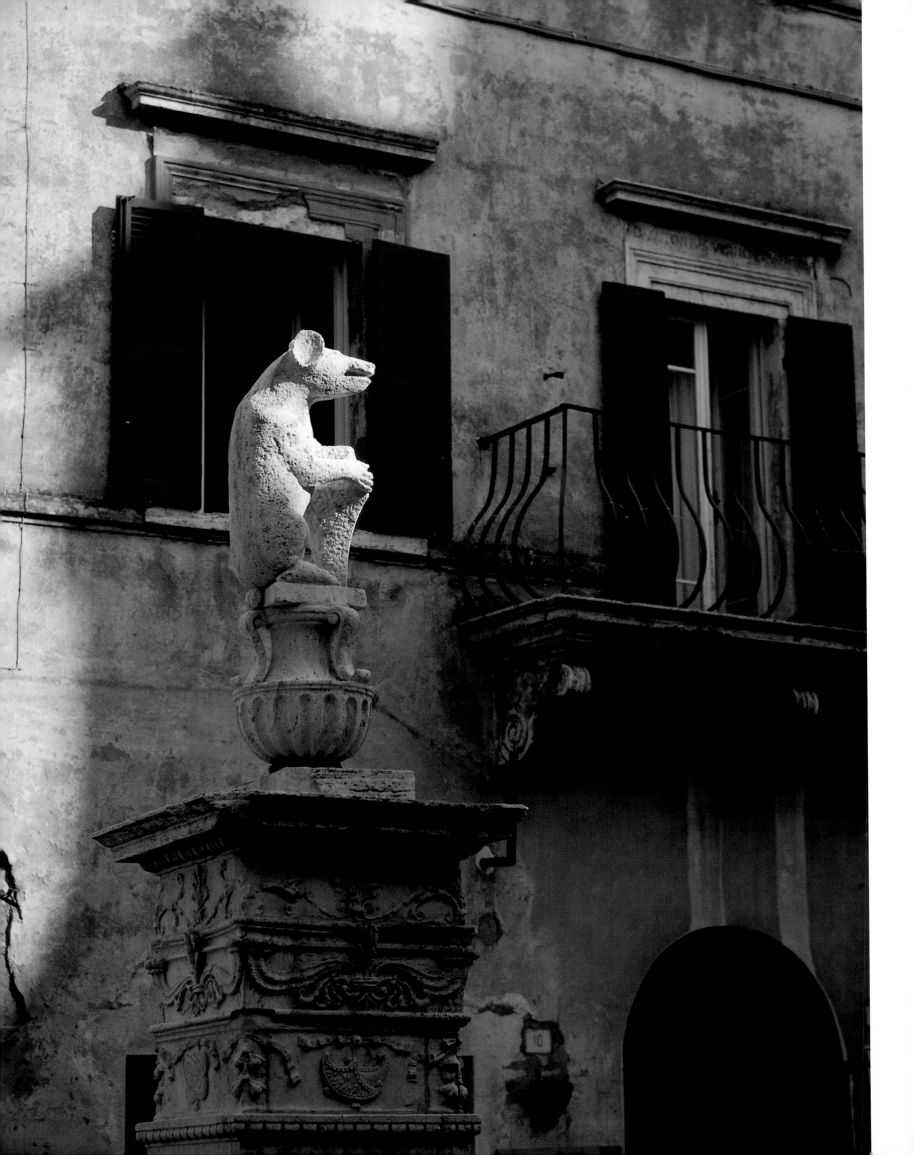

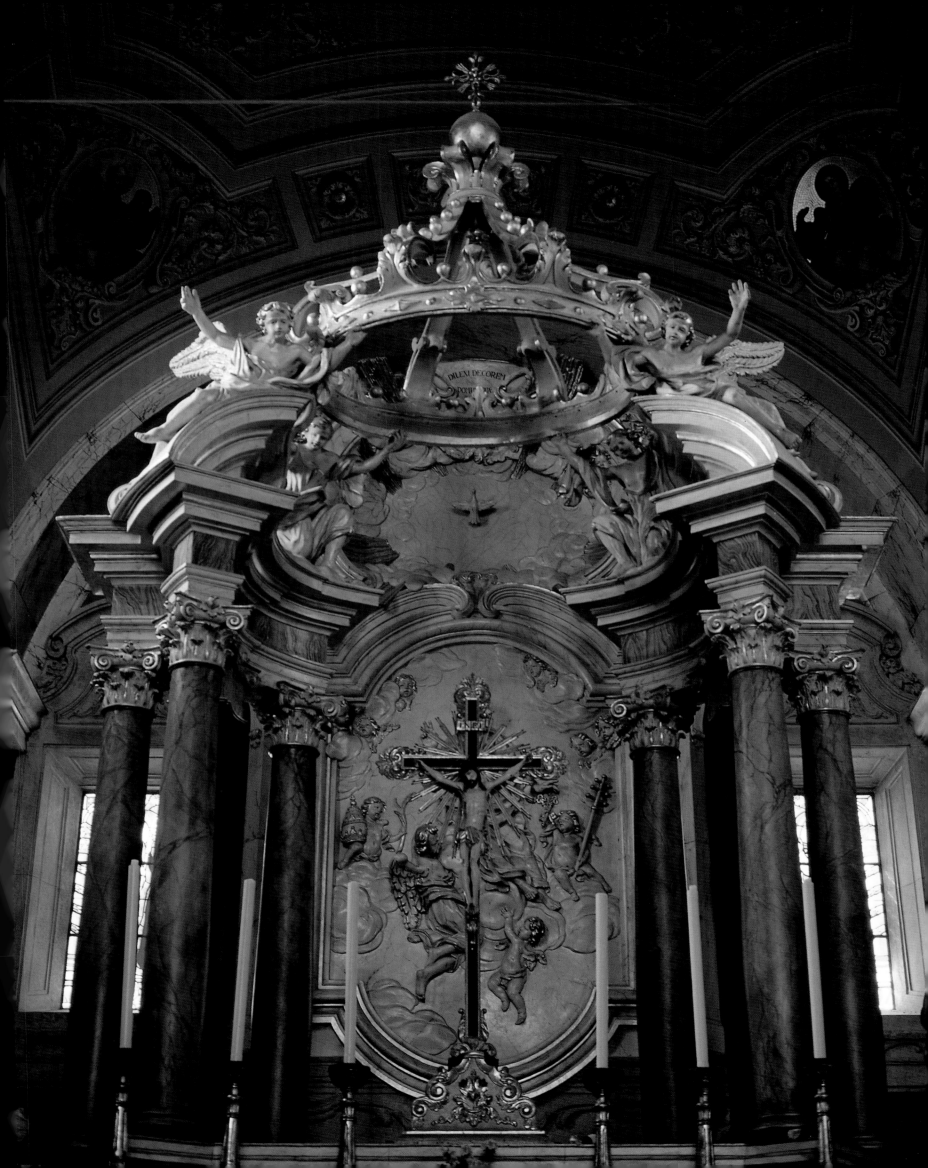

*T*he religious and secular splendours of Pitigliano are plentiful: the figure of the bear (preceding pages), emblem of the Orsini family, erected in the Piazza del Duomo in 1490; the massive high altar of the Duomo.
The aqueduct, here passing before the Palazzo Orsini, was built by Gian Francesco Orsini in 1545 to assure a water supply for Pitigliano; two large arches and thirteen smaller ones of the original structure still stand.

Montemerano

The view south through olive groves reveals the village of Montemerano on the skyline, dominated by the tower of its church (above). One of the treasures of this latter building is a carving by Vecchietta of St. Peter holding the keys to Heaven (opposite).

MONTEMERANO seems like a segment of the fifteenth century transported into our own. Olive groves surround this delicious village, whose hilltop situation offers splendid panoramas of the surrounding countryside. Medieval walls, well restored in the fifteenth century, provide more susbstantial protection than the belt of olive trees. The parish church of San Giorgio, built in the fifteenth century, stands just inside the gates.

Inside are some remarkable examples of religious art, including a statue of St. Peter, carved from wood and painted in the fifteenth century by Lorenzo di Pietro, known as Il Vecchietta, a fifteenth-century polyptych by the Sienese Sano di Pietro, a bas-relief of the Assumption by Pellegrino di Mariano, sculpted in the same century, and a superb Annunciata, another fifteenth-century work, by an unknown artist who is therefore simply called the Maestro di Montemerano. The apse is completely decorated with frescoes. Again painted in the fifteenth century by a pupil of the Sienese artist Andrea di Niccolò, they depict the Epiphany, the Birth of Jesus, the Eternal Father with his angels, the Madonna and Child, the Slaughter of the Innocents and Evangelists and Saints. It is now known that Andrea's pupil painted his frecoes over earlier, thirteenth-century ones.

These works are not the only artistic store of Montemerano. A chapel to the right of the church has been transformed into a museum of art. Here are more works by Sano di Pietro, including portraits of St. Antony of Padua, St. George, St. Peter and St. Laurence. Il Vecchietta is represented here by a ravishing statue of St. Peter, carved in wood. The early fifteenth-century Sienese painter Stefano di Giovanni di Sassetta is represented by an Annunciation.

Further riches in the village include the thirteenth-century church of the Madonna del Cavalluccio and a leaning medieval tower.

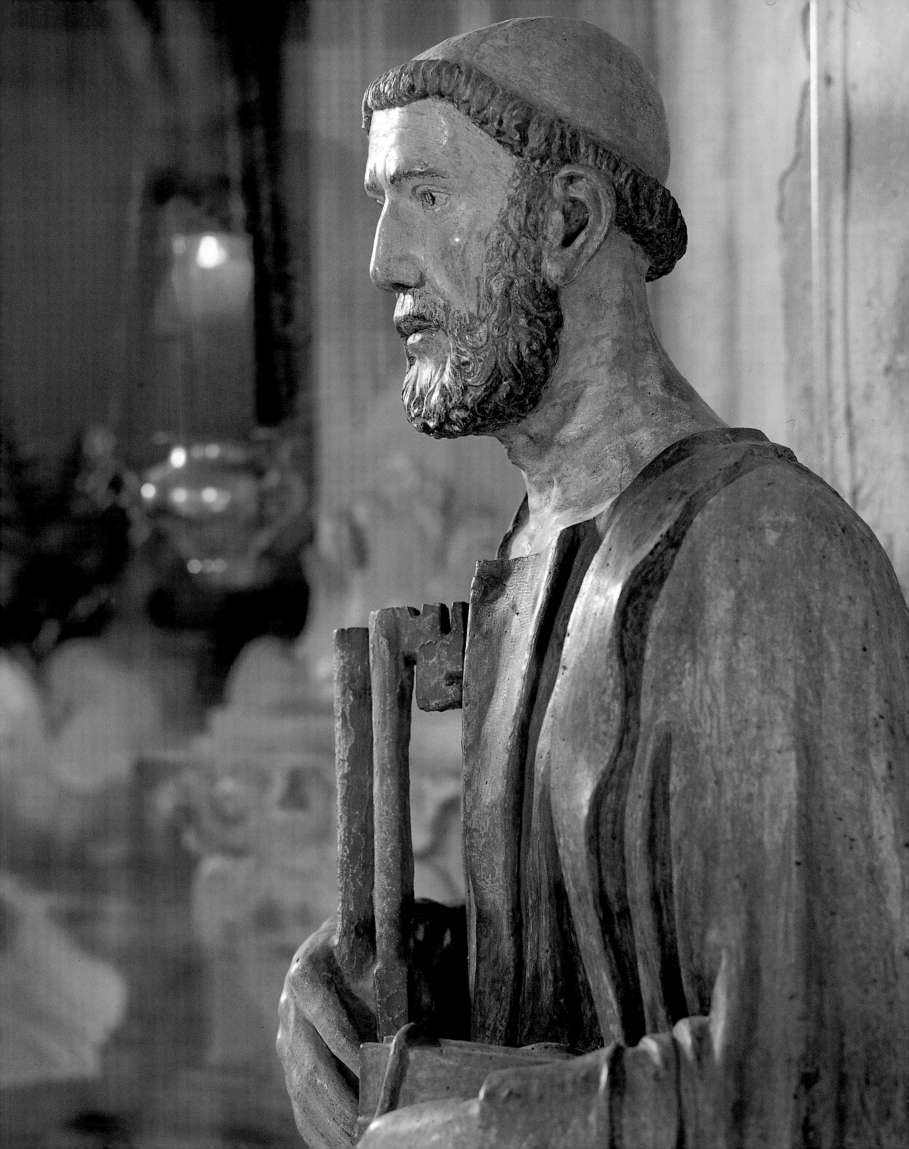

The streets, façades and gardens of Montemerano are a colourful testimony to the fertility of Tuscany. Every sunlit corner offers a profusion of floral delights, while the home production of wool (right) bears witness to the region's continuing craft traditions.

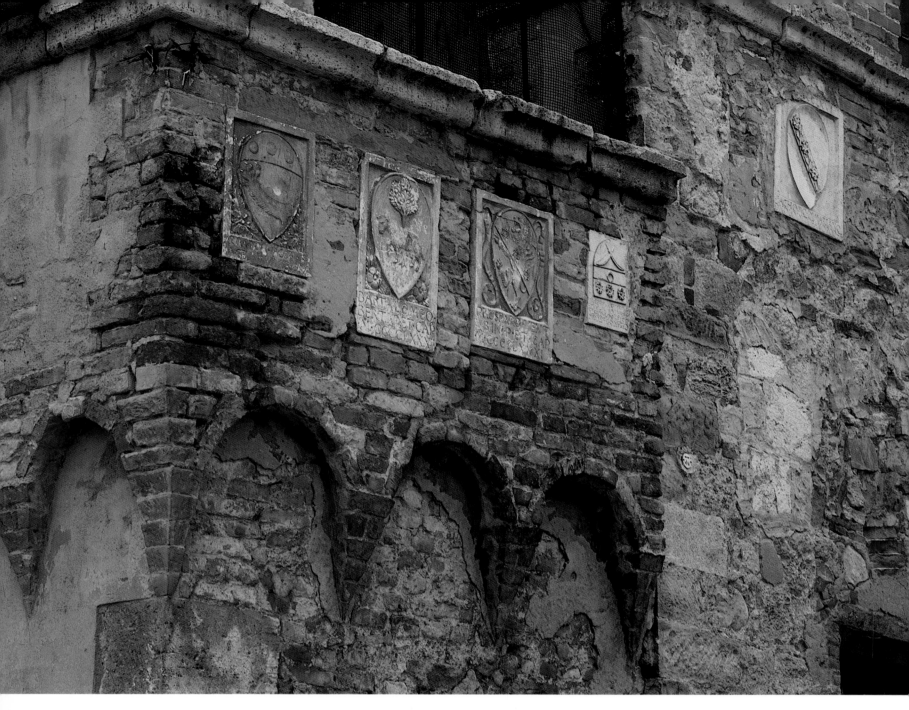

*T*hough much of the architecture of Magliano is in the style of the Renaissance period, there are some examples of Sienese Late Gothic; the crumbling Palazzo dei Priori (above), for instance, with its façade encrusted with coats of arms, dates from 1430. San Martino which houses these frescoes (right) presents an interesting mixture of eleventh-, fourteenth- and fifteenth-century building.

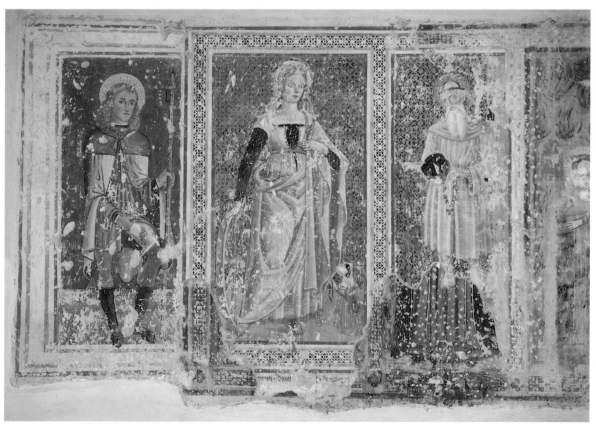

Magliano in Toscana

THE hill-top village of Magliano in Toscana was founded by the Etruscans and now straddles the Via Aurelia. To find the best preserved Etruscan remains you must explore first the ruined yet still impressive eleventh-century church of San Bruzio, which rises among olive groves two-and-a-half kilometres south-east of Magliano, close to the ancient Etruscan necropolis.

The complex fortifications of this village, unusually for Tuscany, date from the Renaissance (though their arches still bear traces of Sienese Gothic). They were built by Sienese military architects, except for the thirteenth-century parts to the south-east, which date from the time the Aldobrandeschi family was dominant. Three gates pierce them: the Porta Nuova, the Porta San Martino and the Porta San Giovanni.

Another example of Renaissance building in the village is the church of San Giovanni Battista, with its stately façade dating from 1471. Originally this had been a Romanesque building of the early eleventh century, to which were added later Gothic and Renaissance features. The church of San Martino has an equally chequered architectural history. First built in the eleventh century, it was rebuilt in both the fourteenth and the fifteenth.

Magliano in Toscana also has some splendid secular buildings, in particular the 1430 Gothic Palazzo dei Priori and the Palazzo di Checco il Bello. Coats of arms of the Podestas of Magliano enliven the façade of the former, which is also embellished with an ogival doorway.

Just outside the walls of the village stands the church of the Annunciata. Built in the Romanesque era and considerably enlarged subsequently, it houses frescoes and an early fifteenth-century Sienese painting of the Madonna and Child by Neroccio. Beside it grows the celebrated 'Ulivo della Strega' (the witch's olive tree), around which in pagan times, legend has it, orgies and lascivious rituals were performed.

A glimpse of the countryside beyond through Magliano's stout fortifications is granted by the Porta San Martino (right, below). Within the encircling walls are many fine town houses, often with engagingly crumbling façades, like this example (right, above), embellished with delicate balustrades.

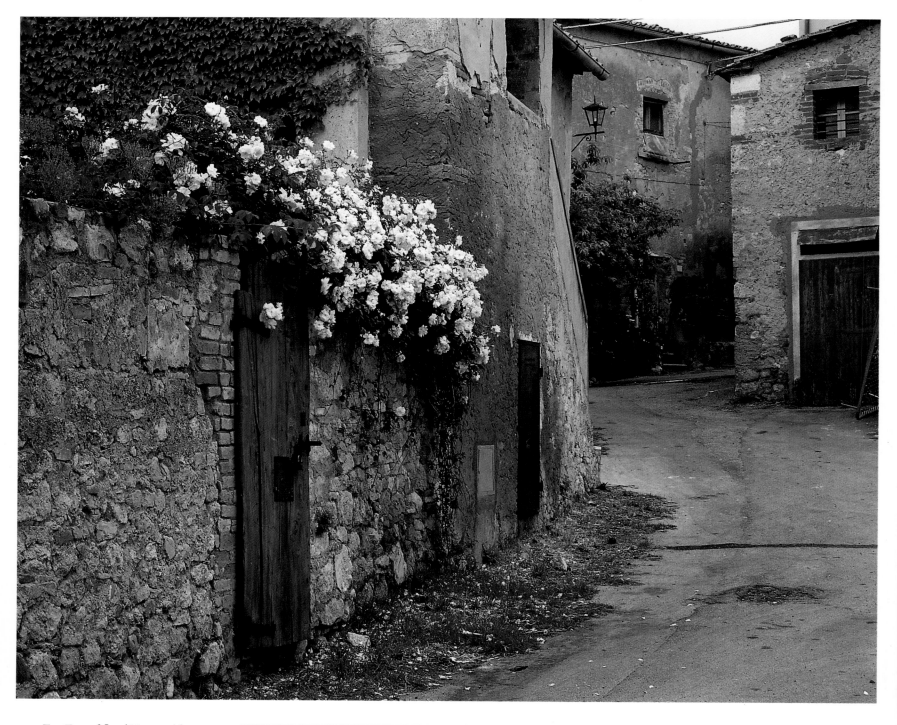

M ore of floral Tuscany (these
pages): the roses and
geraniums seem to be relished equally
by the citizens and the ubiquitous
cats of Magliano.

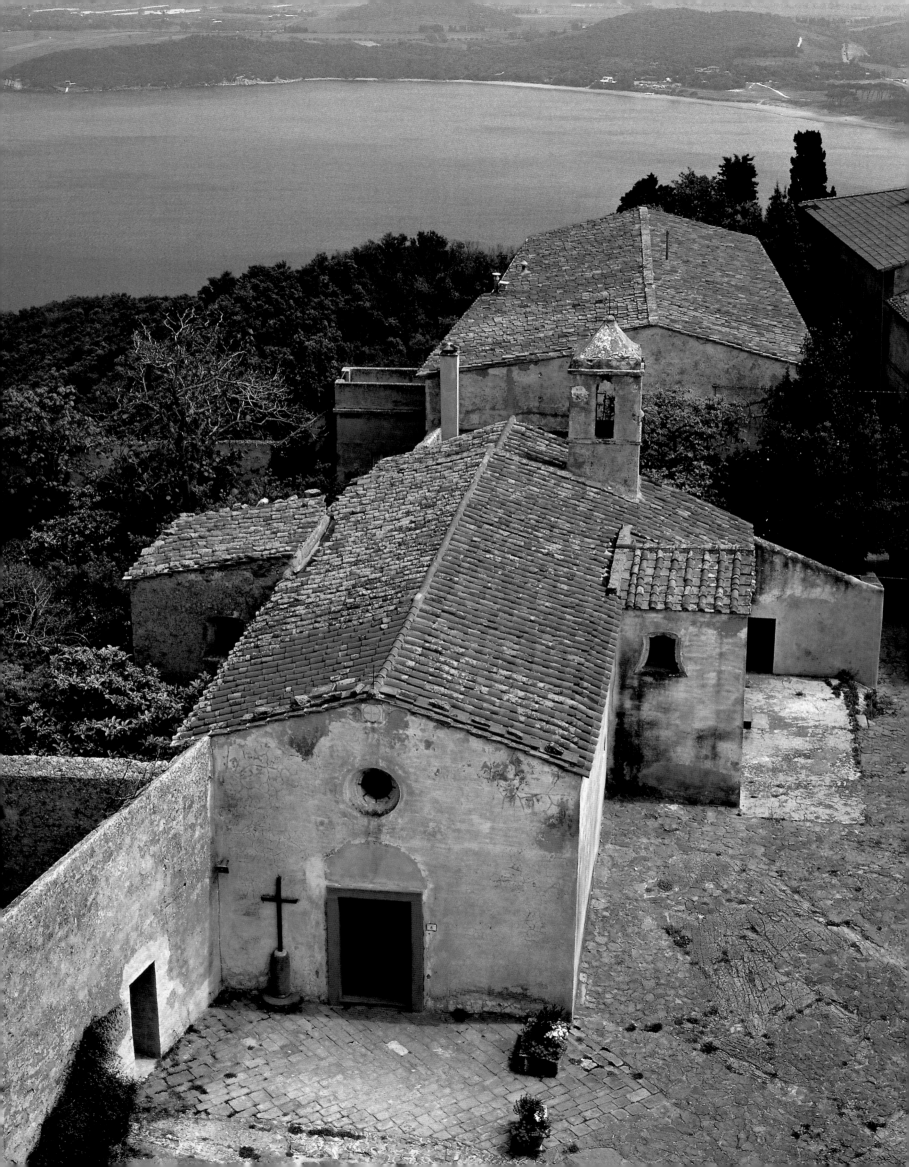

A SMALL, essentially medieval village, laid out as a quadrilateral, Populonia is the sole Tuscan port originally founded by the Etruscans. Part of its charm derives from being in the natural park of Rimigliano, which is a protected coastland region of some 350 hectares, with pinewoods sloping down to sandy beaches.

The Etruscans called it Popluna. Here they smelted iron ore from the island of Elba (as did the Romans later), and here they built a necropolis which served them for six centuries from the eighth century B.C. Today their last resting places, most of them tumuli, are subjected to the curious gaze of tourists, who admire the tombs and later can see the chariots and bronze figurines, now removed to the local museum, which were buried with them. In the same place are displayed their iron and bronze candelabra, statues of Dionysus with satyrs and proud women's heads, deco-

rated vases, funeral stele, and beautifully sculpted sarcophagi with recumbent figures.

The village itself has battlemented, mainly fourteenth-century walls, though the legacy of the Etruscans is recognizable in the massive blocks of stone. Once Christianized, Populonia became a fief of Charlemagne, who then gave it to Pope Hadrian I. Soon it had become the seat of a bishop, but suddenly it lost all importance when the bishops transferred their seat to Massa Marittima in 835. Nothing then happened in Populonia, and the spot was thus magically preserved for posterity.

Apart from the Etruscan remains, its chief monument today is the medieval fortress, the Torre di Populonia, with its pair of crenellated towers, one of them cylindrical, the other square. From this *rocca* on fine days there is a magnificent view up the coast as far as Livorno.

Populonia

One of the oldest ports in Italy, Populonia overlooks a secluded bay (opposite), *here making a striking background to the venerable roofs and walls of the parish church and nearby houses which cluster under the watchful presence of the medieval fortress* (above).

*T*he oldest part of Populonia stands on the crest of a
 thickly wooded hill (above), *its profile made
distinctive by the one round tower and one square tower
of its medieval* rocca (opposite, above). *Beneath this
bastion of military might, quiet streets open out on to the
agreeably humble piazza* (opposite, below).

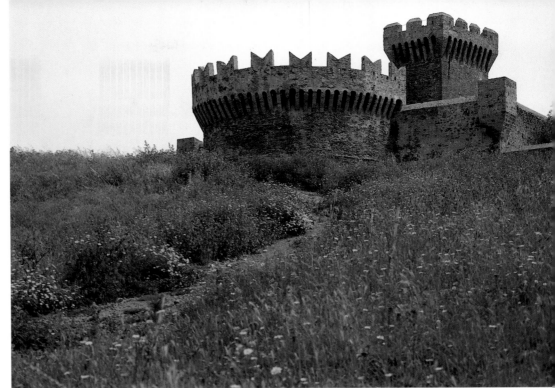

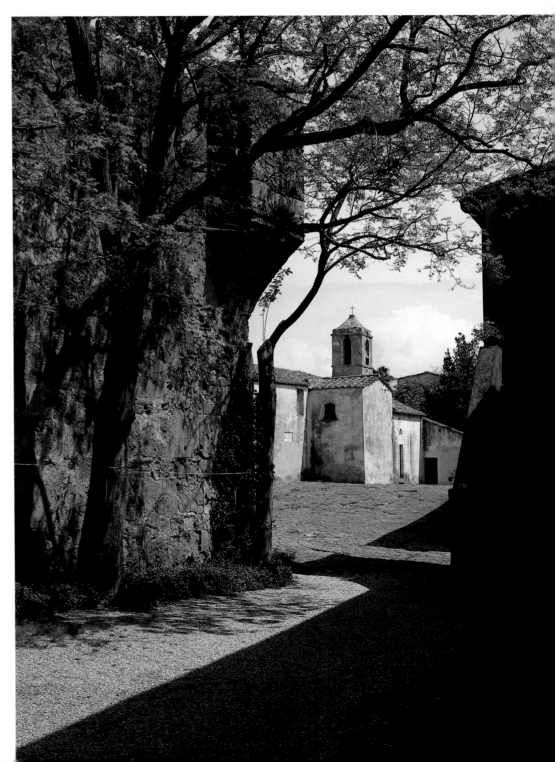

Viewed through coastal pines on the other side of the bay, the old town of Populonia looks down on the tiny modern port below (right). The Etruscan tombs (below), in their massive solemnity, indicate the long history of this place, once known as Popluna.

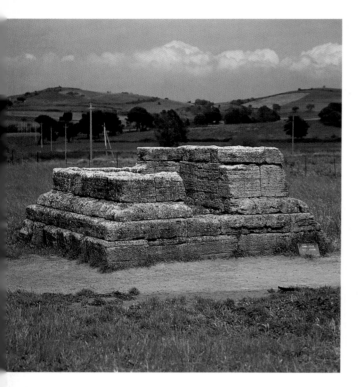

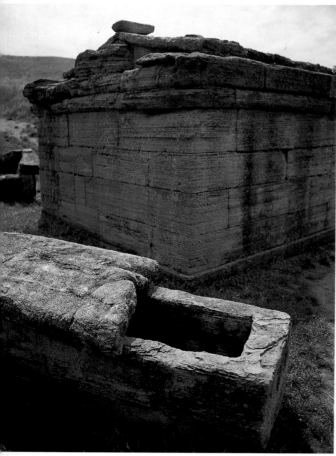

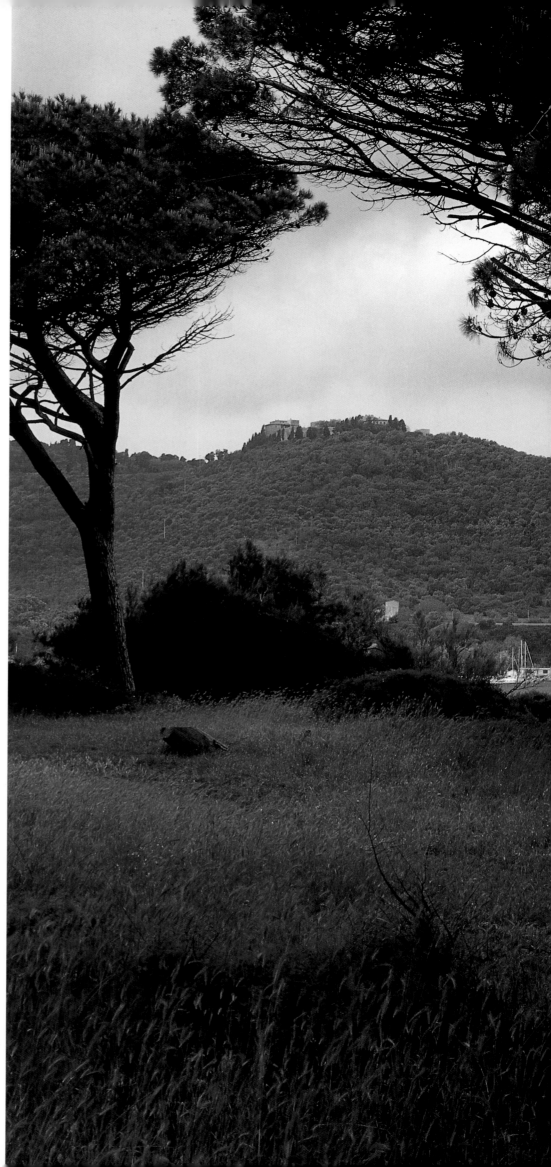

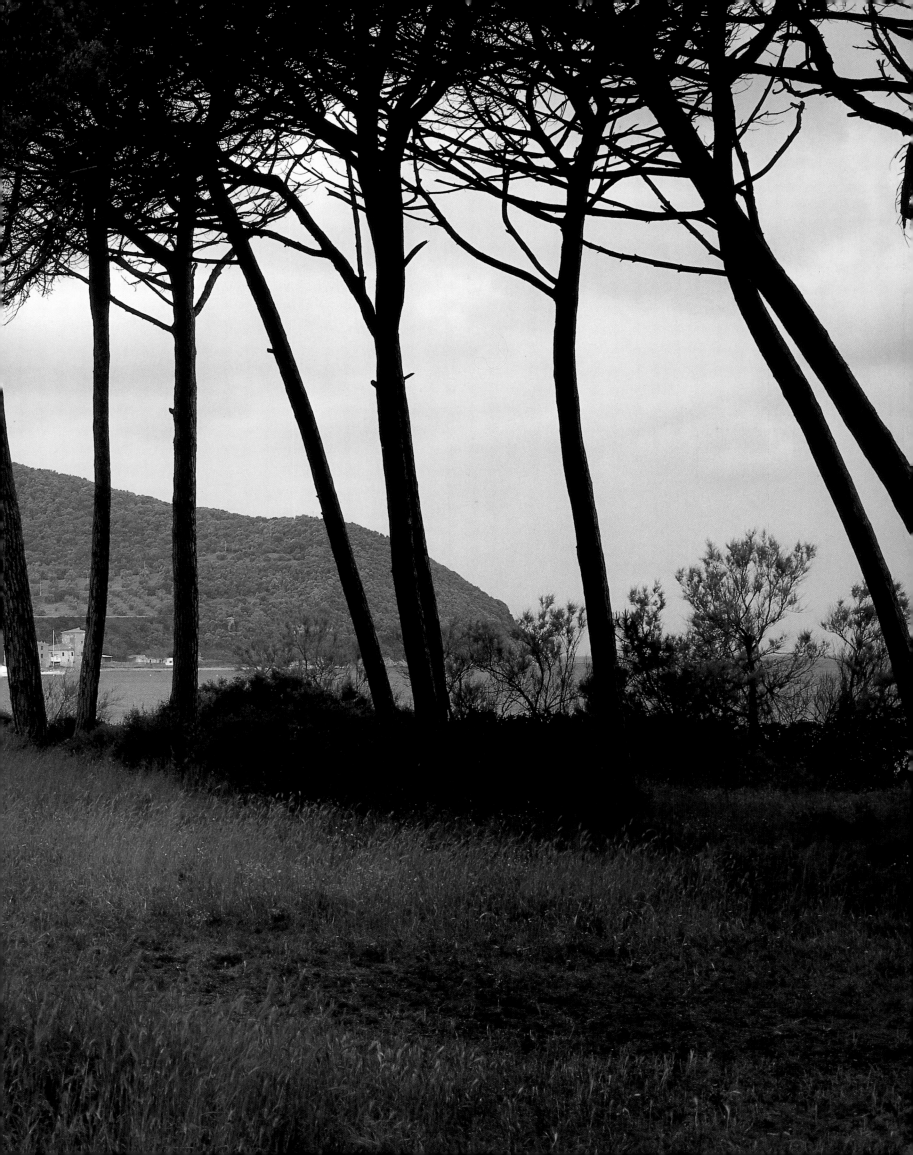

Ansedonia

ANSEDONIA, on the Tuscan coast just south of Orbetello, was once the Roman city of Cosa, founded nearly three hundred years before the birth of Christ. Here the Romans chose a site with a superb view over the lagoon of Busano (which is now a bird sanctuary). Reached by the Aurelian Way, the village became a Roman *municipio* during the time of the civil wars, when its walls were built with no fewer than eighteen towers which still stand largely intact. The Visigoths, the Saracens and the Sienese all failed to destroy the village and its fortifications.

Enter these walls by way of the Porta Romana, the best conserved of the ancient gateways, and you reach the Roman forum, close by which a former citizen's house has been excavated and in part restored. Archaeologists have uncovered fine mosaic pavements and wall-paintings. Ansedonia's two Roman temples no longer exist (apart from the remains of one dedicated to Juno, Jupiter and Minerva), but you can still climb to the Capitolium, the highest point of the former Acropolis, and gaze out to sea towards the island of Giannutri, Orbetello, the Argentario mountain and the lagoon.

Later significant sites include the fifteenth-century chapel of San Biago, constructed over a Roman tomb (possibly that of a saint). This is the southernmost village in the province of Grosseto, a port in a countryside of rich green vegetation. Today, its surroundings are copiously dotted with holiday villas, but in a mainly unobtrusive fashion. But it is the Etruscan and Roman remains which give Ansedonia its special cachet. The Romans dug a canal to connect their port with Lake Burano, though nowadays this is oddly called the Tagliata Etrusca. Puccini lived in Ansedonia's Torre della Tagliata while composing *Tosca*. And just outside this village, at Settefinestre, is another excavated Roman villa, this one dating from the first century B.C. and surrounded by its Roman farm.

Excavations at Ansedonia have yielded many treasures from its predominantly Roman past, like this torso (left). A more modern achievement is evoked by the isolated Torre della Tagliata (opposite).

USEFUL
INFORMATION

Map · Hotels and Restaurants
Market days and Festivals
Select Bibliography

Opposite
A relief of the panoply of Minerva, excavated from the
ruins of the Roman city of Cosa, the forerunner
of Ansedonia.

Above
The arms of a member of the Nelli family,
1713, in Radda in Chianti; a distinguished group
among the Florentine upper class, the Nelli family were
artists, architects, writers and politicians. One ancestor
had even been a friend of Petrarch in the
fourteenth century.

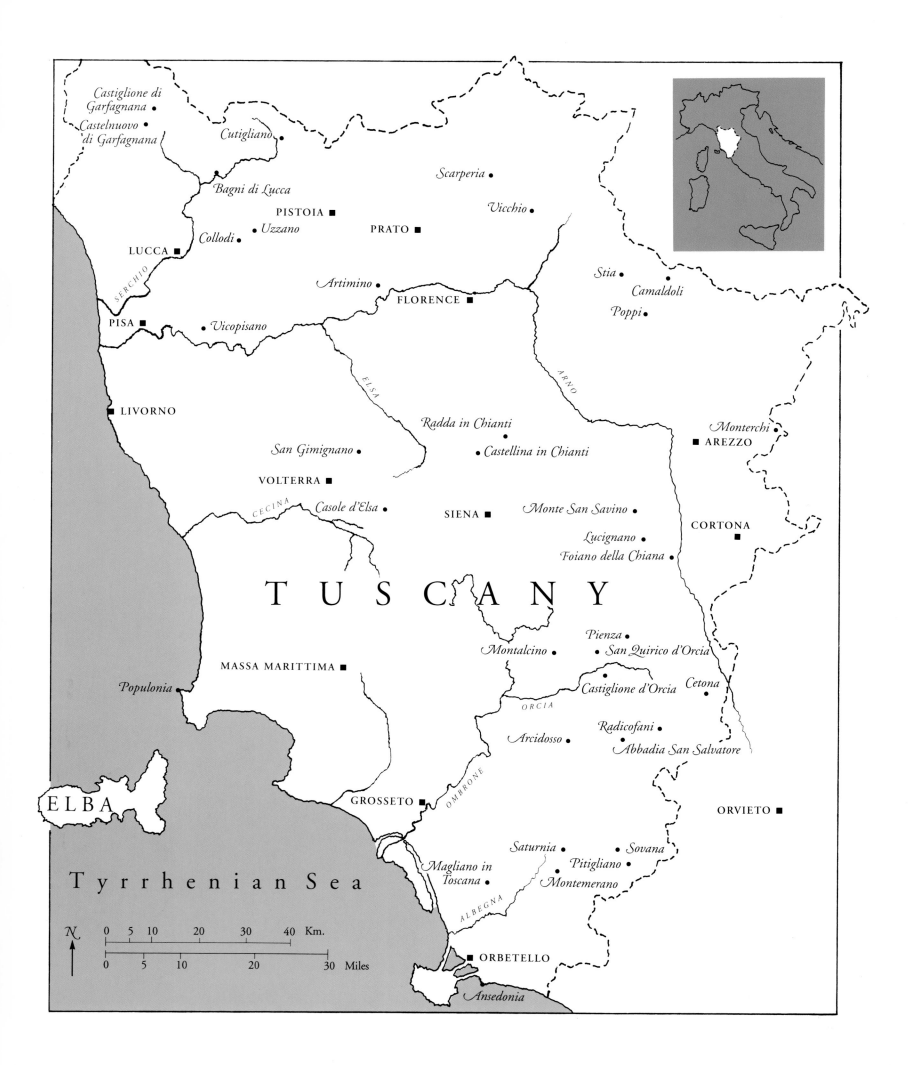

Castiglione di Garfagnana

Castelnuovo di Garfagnana

Cutigliano

Scarperia

Bagni di Lucca

PISTOIA ■

Vicchio

PRATO ■

Collodi • Uzzano

LUCCA ■

Artimino

Stia

Camaldoli

FLORENCE ■

Poppi

PISA ■

Vicopisano

ARNO

SERCHIO

LIVORNO ■

Radda in Chianti

Monterchi

ELSA

 AREZZO ■

San Gimignano •

Castellina in Chianti

VOLTERRA ■

CECINA

Casole d'Elsa •

Monte San Savino

SIENA ■

CORTONA ■

Lucignano

Foiano della Chiana

T U S C A N Y

Pienza

Montalcino •

San Quirico d'Orcia

MASSA MARITTIMA ■

Cetona

Castiglione d'Orcia

Populonia

ORCIA

Radicofani

Arcidosso •

Abbadia San Salvatore

GROSSETO ■

OMBRONE

ORVIETO ■

E L B A

Saturnia •

Sovana

Magliano in Toscana •

Pitigliano

Montemerano

T y r r h e n i a n S e a

ALBEGNA

N

0 5 10 20 30 40 Km.

0 5 10 20 30 Miles

ORBETELLO ■

Ansedonia

216

Useful Information

Details are given in the order in which places appear in the main part of the book.

While every effort has been made to ensure that the information given below is correct, the author and publisher cannot be held responsible for any inadvertent inaccuracies. The grading of hotels and restaurants is very much the author's own, ranging from traditional luxury to simple comfort.

AROUND FLORENCE AND LUCCA

Natural Park of Migliarino, San Rossore and Massaiuccoli

Information
Consorzio del Parco, Via C. Battista 12, 56100 Pisa; tel. 050/4 35 12.

The Mugello

Information
For trekking in the Mugello, apply at Via Togliatti 4, 50032 Borgo San Lorenzo; tel. 055/845 65 51.

Bagni di Lucca (p.24)

Hotel
The Bridge. At Ponte a Serraglio; tel. 0583/80 53 24.
Restaurant
** *Ruoto*. Via Giovanni XXIII, Fornoli; tel. 0583/8 60 71.
Information
For canoeing consult Fuori Rotta, Fabbriche di Carregine, 55021 Bagni di Lucca; tel. 0583/8 58 02.

Castelnuovo di Garfagnana (p.30)

Festivals and Fêtes
Corpus Christi procession; local festivals (*maggi*) in September.
Market
Thursdays.
Sights
ARCHAEOLOGICAL EXHIBITION
 Via Vallisineri 5; tel. 0583/92 81 14.
NATURAL PARK OF THE APUAN ALPS
 Park Hospitality Centre, Piazza Erbe 1; tel. 0583/6 51 69.
Hotel-Restaurants
** *Il Casone*. In an elegant, late eighteenth-century building; tel. 0583/64 90 90.
** *Filippe*; tel. 0583/64 90 81.
* *Ristorante da Carlino*; tel. 0583/64 92 70.
Filippi Francesco ('agriturismo'); tel. 0583/6 85 76.
Fabbiani; tel. 0583/6 56 54.
Restaurants
Ristorante la Lanterna; tel. 0583/6 33 64.
La Vecchia Lanterna; tel. 0573/6 33 31.
Triti; tel. 0583/6 21 56.
Information
Tel. 0583/6 22 68.
For trekking information, consult the Club Alpino Italiano, Via Vittorio Emanuele, 55023 Castelnuovo di Garfagnana; for speleology, the Gruppo Speleogico Garfagnana, Via Vittorio Emanuele, 55023 Castelnuovo di Garfagnana.

Castiglione di Garfagnana (p.34)

Sight
LOCAL HISTORY MUSEUM AT SAN PELLEGRINO IN ALPE
 Just south of the village; daily, except Mondays, 9.30–13.00 and 14.30–19.00 in summer, and 9.00–12.00 and 14.00–17.00 from October to May.

Cutigliano (p.40)

Festivals and Fêtes
Crafts and mid-year festival in August; mushroom market in season; nearby Abetone hosts international ski competitions in February and March.

Sight
ETHNOLOGICAL MUSEUM OF THE MOUNTAIN
 Weekends, 9.30–12.30 and 15.30–17.30; daily in August, 9.30–12.30 and 16.00–18.00.
Hotel-Restaurants
*** *Hotel Italia*; tel. 0573/6 80 08.
*** *Villa Patrizia*; tel. 0573/6 80 24.
** *Roma*; tel. 0573/6 81 21.
** *Casina delle Rose*; tel. 0573/6 80 56.
*** *Piandinovello*. North of the village; tel. 0573/67 30 76.
Albergo Ristorante Alpino; tel. 0573/67 30 62.
Hotel Ristorante La Valle; tel. 0573/6 80 35.
Bacci V; tel. 0573/67 30 70.
Restaurants
Trattoria da Fagioliono; tel. 0573/6 80 14.
Information
Via Tigri; tel. 0573/6 80 29.

Uzzano (p.44)

Hotel
Da Grazia Gambarini ('agriturismo'); tel. 0572/47 63 68.
Restaurants
Da Giordano; tel. 0572/45 13 94.
Trattoria di Magrini e Pagano; tel. 0572/49 01 57.
Pizzeria Paoletti; tel. 0572/47 85 86.
Pizzeria Tocci; tel. 0572/44 40 72.

Collodi (p.46)

Sights
ARCHAEOLOGICAL MUSEUM
 Via Papa Giovanni XXIII. Daily, except Mondays, 9.00–13.00; Saturdays, also 15.00–19.00; Sundays, 9.00–12.30.
PARCO DI PINOCCHIO
 Daily till sunset.
VILLA GARZONI GARDENS
 Daily till sunset.
Hotel-Restaurant
* *Osteria del Gambero Rosso*. Built by Giovanni Michelucci in 1963 (and a listed national monument); tel. 0572/42 93 64.

Vicopisano (p.50)

Hotel-Restaurant
* *Da Mauro*. At Cascina, to the south;
tel. 050/74 06 18.
Hotel
Pensione Mariotti; tel. 050/78 80 93.
Restaurants
Alderigi e Ciramini; tel. 050/79 87 89.
D'Antonio di Vallini Stefano; tel. 050/70 20 01.
Trattoria la Baracchina; tel. 050/70 20 49.
Information
Lungarno Mediceo 42, Pisa; tel. 050/4 02 02.

Artimino (p.54)

Sights
ETRUSCAN MUSEUM
In the Villa di Artimino. Daily, except
Wednesdays, 9.00–13.00; Saturdays, also
15.00–19.00; Sundays, closes at 12.30.
MEDICI VILLA
At nearby Poggio a Caiano; guided tours daily,
except Mondays, 9.00–13.30; Sundays, closes
at 12.30; gardens open March to April,
9.00–17.30, May to August, 9.00–18.30 and
November to February, 9.00–16.30.
ETRUSCAN TUMULUS OF MONTEFORTINI
Also at Poggio a Caiano; daily, except
Mondays, 9.00–13.00.
VILLA MEDICEA ('La Ferdinanda')
Tuesdays, 8.00–12.00 and 14.00–18.00; book
in advance; tel. 055/871 80 92.
ARCHAEOLOGICAL MUSEUM
Daily, except Tuesdays, 9.00–13.00; Saturdays,
also 15.00–19.00 and Sundays, 9.00–12.30;
tel. 055/871 81 24.
Hotel-Restaurant
**** *Paggeria Medicea*. Specializes in hunting
and fishing holidays; tel. 055/871 80 81.
** *Da Delfina*; tel. 053/871 80 74.
Restaurant
Biagio Pignatta. At Poggio a Caiano, five
kilometres north-east; tel. 055/871 80 86.
Information
At Carmignano; tel. 055/871 21 66.

Scarperia (p.58)

Festivals and Fêtes
Mid-June flower festival; edible mushroom
festival, end of July; Festival of Santa Maria a
Fagna, 13–15 August; antiques and artisan
market, first Sundays, June to October;
gastronomy festival, end of August; lantern
festival, with allegorical floats, first week in
September.
Sights
MUSEUM OF SCARPERIA

Sant'Agata; tel. 055/84 06 750.
Hotel-Restaurants
Scarperia-Ristora; tel. 055/84 30 346.
Azienda Agricola Domenico Scelsi ('agriturismo');
tel. 055/840 68 01.
Hotel
Pensione Teresa; tel. 055/84 60 65.
Restaurant
Osteria Nandone; tel. 055/84 61 98.

Vicchio (p.64)

Festivals and Fêtes
Palm Sunday, traditional processions; 24 June,
the Feast of St. John the Baptist, with a fair and
fireworks; summer festival in July; saddle-horses
and livestock fair, 30–31 August; traditional
crafts show, end of August-beginning of
September, with folklore displays.
Sights
CASA DI GIOTTO
Tel. 055/84 47 82.
MUSEO COMMUNALE BEATO ANGELICO
Tel. 055/84 97 026.
Hotels and Restaurants
** *Villa Campestri*; tel. 055/849 01 08.
Tenuta Casole di Berretini Alberto;
tel. 055/84 40 98.
Azienda Agricola G. Bacciotti; tel. 055/84 07 944.
Azienda Agricola G. Trotta; tel. 055/84 49 904.
Both these 'agriturismo' homes offer lodgings
and country food at the family table.

Stia (p.68)

Festivals and Fêtes
Carnival (pre-Lent festival); the Feast of the
Little Angels, 20 May, when children dressed as
angels lead a procession from the central square
four kilometres to the sanctuary of Santa Maria
delle Grazie.
Sights
PORCIANO, MUSEO DEL CASTELLO
Sundays, from mid May to mid October;
tel. 0575/5 85 33.
Hotel-Restaurants
** *La Buca*; tel. 0575/5 87 97.
* *Falterona*; tel. 0575/5 87 97.
Croce al Mori di Brunelli Franc ('agriturismo');
tel. 0575/5 86 04.
Restaurant
La Fattoria; tel. 0575/5 84 81.
Information
Piazza Tanucci Bernardo 5; tel. 0575/50 41 06.

Around Florence and Lucca

Poppi (p.72)

Sight
PRIMO PARCO ZOO
 Daily, 8.00 till sunset.
Hotel-Restaurants
*** *Parc Hotel*; tel. 0575/52 99 94.
*** *Albergo Ristorante Campaldino*;
tel. 0575/52 90 08.
** *Casentino*; tel. 0575/52 90 90.
Hotels
* *Francioni*; tel. 0575/55 01 38.
Pensione Bellavista; tel. 0575/55 90 11.
Pensione Bosco Verde; tel. 0575/55 90 17.
Azienda Cipriani ('agriturismo');
tel. 0575/55 60 93.
Azienda Corsignano ('agriturismo');
tel. 0575/55 02 79.
Restaurants
Ristorante La Loggia. Specializes in mushroom
dishes; tel. 0575/52 03 65.
Meme Gastronomia. For pizzas;
tel. 0575/52 02 40.
Information
Piazza Risorgimento 116, Arrezzo;
tel. 0575/2 39 52.

Camaldoli (p.76)

Hotel-Restaurants
*** *Hotel Ristorante Il Rustichello*;
tel. 0575/55 60 20.
* *Albergo Camaldoli*; tel. 0575/55 60 19.
* *Pensione La Foresta*; tel. 0575/55 60 15.
The Hermitage; tel. 0575/55 60 13.
It is also possible to make a retreat at the
monastery; tel. 0575/55 60 21 and 0575/55 60 44.
Information
Piazza Risorgimento 116, Arrezzo;
tel. 0575/2 39 52.

AROUND AREZZO AND SIENA

San Gimignano (p.86)

Festivals and Fêtes
Concerts, art exhibitions and open-air opera
during summer.
Market
Thursdays, in the Piazza Duomo, Piazza delle
Erbe and the Piazza della Cisterna.
Sights
PALAZZO DEL POPOLO
 Civic Museum and Torre Grossa. Daily,
 except Mondays, February to March,
 9.30–18.00; April to September, 9.30–19.30;
 October to February, 9.30–13.30 and
 14.30–16.30.
MUSEUM OF SACRED ART AND ETRUSCAN
MUSEUM
 Daily, except Mondays, April to September,
 9.30–19.30; October to March, 9.30–12.30 and
 14.30–17.30.
ORNITHOLOGICAL MUSEUM (Oratorio di San
 Francesco)
 Daily, except Mondays, April to September,
 9.30–12.30 and 15.00–18.00; October to
 March, 9.30–12.30 and 14.30–17.30.
Hotel-Restaurants
*** *Hotel Bel Soggiorno*. Fourteenth-century inn;
tel. 0577/94 03 75.
*** *Cisterna*; tel. 0577/94 03 28.
*** *Leon Bianco*; tel. 0577/94 12 94.
*** *L'Antico Pozzo*; tel. 0577/94 20 14.
* *Albergo il Pino*. Relatively inexpensive;
tel. 0577/94 04 15.
Restaurants
La Mangiatoia; tel. 0577/94 15 28.
La Stella. In a relatively quiet corner of San
Gimignano; tel. 0577/94 04 44.
Rosticceria Pizzeria Chiribiri; tel. 0577/94 19 48.
Information
Via di Citta' 43, Siena; tel. 0577/4 22 09.

Casole D'Elsa (p.96)

Market
First and third Monday of the month.
Hotel-Restaurants
**** *Relais La Suvera*; tel. 0577/96 03 00.
*** *Ristorante Hotel Gemini*; tel. 0577/94 86 22.
*** *Albergo Pietralata*; tel. 0577/94 86 57.
Torre Doganiera di Vara Giovanni ('agriturismo');
tel. 0577/96 00 71.
Il Poggiarelo ('agriturismo'); tel. 0577/96 02 25.
La Pergola ('agriturismo'); tel. 0577/96 31 83.
Restaurant
Il Merlo; tel. 0577/94 87 51.
Information
Piazza Luchetti 1; tel. 0577/94 87 16.

Radda in Chianti (p.100)

Market
Fourth Monday of the month.
Hotel-Restaurants
**** *Relais Fattoria Vignale*. Stately eighteenth-
century house; tel. 0577/73 80 94.
** *Albergo Ristorante La Villa Miranda*;
tel. 0577/73 80 21.
* *Albergo Il Girarrosto*; tel. 0577/73 80 10.
*** *Albergo Vescine*. Four kilometres west and
especially picturesque; tel. 0577/74 11 44.
Several farms in the neighbourhood also offer
excellent lodgings, particularly the Fattoria di
Monte Vertine; tel. 0577/4 40 41; and the
Fattoria Castelvecchi; tel. 0577/73 80 50.

Restaurants
La Vigna. Just outside the village;
tel. 0577/73 86 40.
Antica Casa Domine; tel. 0577/73 82 40.
Information
Piazza Ferrucci 1; tel. 0577/73 80 03 – 73 83 11.

Castellina in Chianti (p.106)

Sight
ETRUSCAN MUSEUM
 Piazza del Commune 1. Daily, except Sundays,
 9.00–12.00.
Hotel-Restaurants
**** *Pensione Tenuta di Ricavo.* Medieval village
transformed into an hotel; tel. 0577/74 02 21.
**** *Villa Casalecchi.* Set amid pine trees;
tel. 057/74 02 40.
**** *Albergo Fattoria Casafrassi*;
tel. 057/74 06 21.
*** *Hotel Salivolpi.* One kilometre from
Castellina in Chianti on the way to San
Donato; an old farmhouse transformed into a
luxury hotel; tel. 0577/74 04 84.
Restaurants
Antica Trattoria La Torre. Offering fine wines
and country-style food; tel. 0577/74 02 36.
Albergaccio di Castellina. Offering typical local
cuisine; tel. 0577/74 10 42.
Osteria della Piazza; tel. 0577/73 35 80.

Monterchi (p.110)

Festivals and Fêtes
Polenta festival, third Sunday of September;
numerous annual meetings and conventions on
the work of Piero della Francesca.
Sight
Piero della Francesca's *Madonna del Parto* can be
seen in the Museo delle Madonna del Parto, Via
Reglia, tel. 0575/703131; daily, except Mondays,
9.00–13.00 and 14.00–18.00.
Information
Piazza Risorgimento 116, Arrezzo;
tel. 0575/2 39 52.

Monte San Savino (p.114)

Festivals and Fêtes
Presentation of the Giulio Salvadori Poetry
Prize, end of May; youth festival (*Festival dei
Ragazzi*) in June (theatre, plastic arts,
photography and music by the young people of
the province of Arezzo); ceramics exhibition,
June–July; open-air theatre, mid July to mid
September; suckling-pig festival (*Sagra della
Porchetta*), first weekend in September; St.
Catherine's Fair, end of November.

Hotel-Restaurants
*** *Domenico*; tel. 0575/84 93 73.
*** *Il Sangallo*; tel. 0575/81 00 49.
** *Verniana*; tel. 0575/84 93 95.
* *Il Monte*; tel. 0575/84 44 44.
Paturzo Fulgero ('agriturismo');
tel. 0575/84 40 94.
Castello di Gargonza. Medieval castle in the
nearby walled hamlet of Gargonza;
tel. 0575/84 70 21.
Restaurants
La Terazza; tel. 0575/84 41 11.
Pizzeria Mirage; tel. 0575/84 95 61.
Information
Piazza Risorgimento 116, Arezzo;
tel. 0575/2 39 52.

Foiano della Chiana (p.120)

Festivals and Fêtes
Carnival procession of allegorical floats,
Sundays at the beginning of Lent; flower and
antiques fair, mid April.
Hotel-Restaurants
* *Ristorante Locanda La Luna*;
tel. 0575/64 82 47.
Poggiarello Alto di Menchetta Carla
('agriturismo'); tel. 0575/64 90 15.

Lucignano (p.124)

Festivals and Fêtes
Maggiolata Lucignanese, processions of carts
decorated allegorically with flowers, with folk-
singing, last two Sundays in May.
Sight
CIVIC MUSEUM
 Summer, 9.30–13.00 and 15.00–19.30; winter,
 9.30–15.00 and 15.00–18.30.
Hotel-Restaurants
*** *Ristorante-Hosteria da Totò*;
tel. 0575/83 67 63.
* *Nuovo Lady Godiva*; tel. 0575/83 63 36.
*** *La Locanda dell'Amorosa.* Sixteenth-century
villa twelve kilometres south at Sinalunga;
tel. 0577/67 94 97.
La Rocca. Apartments in a medieval village;
tel. 0577/83 61 75.
Santa Maria di Benata Cornelia ('agriturismo');
tel. 055/96 70 90.
Information
Piazza Risorgimento 116, Arrezzo;
tel. 0575/2 39 52.

Pienza (p.132)

Festivals and Fêtes
Pienza e i Fiori, a plant and flower show, with
exhibits of flower arrangements, dating back to

the Renaissance, mid May; theatre festival (*Teatro Povero*) in which the whole community participates, last two weeks of July; summer concerts in the cathedral; concert in the Palazzo Piccolomini, 15 August; meetings with a master artist, with an exhibition of painting and graphic art in the Palazzo Communale, August and September; cheese fair, first weekend of September, including a competition between the four medieval districts of the town and traditional music and singing in the 'Pienza Serenade'; exhibition of traditional crafts (metalwork, woodwork, terra-cotta, embroidery and leather work), October, in the cloister of San Francesco.

Sights

CATHEDRAL MUSEUM
Daily, except Tuesdays, 10.00–13.00 and 14.00–17.00, November to March, only by prior arrangement; tel. 0578 74 80 72.

PALAZZO PICCOLOMINI
Daily, June to September, 10.00–12.00 and 16.00–19.00; otherwise, 10.00–12.30 and 15.00–17.00.

Hotel-Restaurants

*** *Il Chiostro di Pienza.* Fine wine cellar and panoramic view from the garden; tel. 0578/74 84 00.
** *Albergo Corsignano*; tel. 0578/74 85 01.
Podere Fonte Bertusi ('agriturismo'); tel. 0578/78 80 77.

Restaurants

Trattoria La Moranda. Regional cuisine; tel. 0578/75 50 50.
Il Falco. Regional cuisine; tel. 0578/74 85 51.

Information

Via di Citta' 43, Siena; tel. 0577/4 22 09.

Montalcino (p.140)

Festivals and Fêtes

Classical music in the Fortezza Medicea and in the abbey of Sant'Antimo, July and August; national honey fair, early September; thrush festival, late October.

Sights

ABBEY OF S. ANTIMO
Daily, April to September, 10.30–12.30; October to March, 11.00–12.30 and 15.00–17.00.

PALAZZO ARCIVESCOVILE
Civic, Diocesan and Archaeological Museum. Daily, except Mondays, May to September, 9.30–13.00 and 15.30–19.00; October to April, 10.00–13.00 and 15.00–17.00.

FORTEZZA
Daily, except Mondays, summer, 9.00–13.00 and 14.30–20.00; winter, 9.00–13.00 and 14.00–18.00.

PALAZZO COMMUNALE
Daily, except Mondays, May to September, 10.00–13.00 and 15.30–18.30; October to April,

9.30–13.00 and 15.00–17.30.

CASTELLO DI POGGIO ALLE MURA
Saturday and Sunday, summer, 11.00–13.00 and 15.30–19.30; winter, 11.00–13.00 and 14.30–17.30; groups by request on Fridays.

Hotel-Restaurants

*** *Albergo al Brunello*; tel. 0577/84 93 04.
*** *Albergo Il Giglio*; tel. 0577/84 81 67.
** *Albergo Giardino*; tel. 0577/84 82 57.
** *Fattoria del Barbi.* Celebrated for its wine cellars as well as its food; tel. 0577/84 82 77.
** *Il Giglio*; tel. 0577/84 81 67.
Albergo il Coco ('agriturismo'); tel. 0577/84 86 50.
Albergo Podere Brizio; tel. 0577/84 94 19.

Restaurants

Cucina di Edgardo; tel. 0577/84 82 32.
Taverna dei Barbi; tel. 0577/84 93 57.
Il Pozzo (at Sant'Angelo in Colle); tel. 0577/86 41 15.

Information

Costa del Municipio 8; tel. 0577/84 93 31.

San Quirico D'Orcia (p.146)

Festivals and Fêtes

The costumed Barbarossa festival in June celebrates the taking of the village by Emperor Frederick Barbarossa in the twelfth century.

Market

Second and fourth Tuesday of the month.

Hotel-Restaurants

**** *Albergo Posta Marcucci*; tel. 0577/88 71 12.
*** *Albergo Le Terme*; tel. 0577/88 71 50.
*** *Hotel Palazzuolo*; tel. 0577/89 70 80.
** *Motel Patrizia*; tel. 0577/89 77 15.
Residenze Casanova; tel. 0577/89 81 77.
Albergo il Colle San Alfredo ('agriturismo'); tel. 0577/89 75 62.

Restaurants

Osteria del Leone; tel. 0577/88 73 00.
Pizzeria Spaghetteria le Contrade; tel. 0577/89 80 98.

Information

Via Dante Alighieri 1; tel. 0577/89 72 11.

Castiglione d'Orcia (p.150)

Market

Thursdays.

Sight

The medieval village of Rocca d'Orcia (north-west of Castiglione d'Orcia), with its fourteenth-century ruined castle.

Hotel-Restaurants

** *Albergo Ristorante le Rocche*; tel. 0577/88 70 31.
* *Il Borgo* (at Rocca d'Orcia); tel. 0577/88 72 80.

Information

Via di Citta' 43, Siena; tel. 0577/4 22 09.

Maremma Natural Park

Open 9.00 till dusk Wednesdays, weekends and bank holidays; guided tours only mid June to the end of September; hospitality centre, the Casa del Pinottolaio, has limited sleeping facilities.

Information
Parco della Maremma, 58010 Alberese; tel. 0564/40 70 98.

Cetona (p.160)

Festivals and Fêtes
Carnevale Cetonese, with a procession of floats and people in fancy dress, Sunday before Ash Wednesday; flower festival (*Cetona in Fiore*) with an annual market; *Cetona Cabaret*, national competition with performances by would-be cabaret artists, August; amateur photography competition, September; Christmas in Cetona, activities reflecting the community's traditional customs.

Sight
MUSEUM OF THE PREHISTORY OF MONTE AMIATA
 Daily, except Mondays and Saturdays, July to September, 9.00–13.00 and 17.00–19.00; October to June, 15.00–17.00.

Hotel-Restaurant
*** *Belvedere Hotel*; tel. 0578/23 90 83.

Restaurants
Botega delle Piazze; tel. 0578/24 42 95.
Posteria Vecchia; tel. 0578/23 90 40.

Information
Via di Citta' 43, Siena; tel. 0577/4 22 09.

Radicofani (p.166)

Festivals and Fêtes
Feast of St. Antony Abbot and blessing of the animals, 17 January; patronal festival, feast of St. Agatha, 5 February, with Mass and processions; carnival, Thursday before Lent; Good Friday processions; Feast of the Assumption, with Mass, procession, bonfires and fireworks, streets decked with flowers, 15 August.

Hotel-Restaurants
** *Albergo Eni*; tel. 0578/5 20 25.
** *Albergo La Torre*; tel. 0528/5 59 43.
Cantanino di Castrini Biancamaria ('agriturismo'); tel. 0578/5 57 71.
Il Pero di Pasqualucci Diana ('agriturismo'); tel. 0578/5 20 16.

Restaurant
La Grotta; tel. 0578/5 58 66.

Sovana (p.172)

Sight
ETRUSCAN NECROPOLIS
 Guided tours arranged at the *Taverna Etrusca* (see below).

Hotel-Restaurant
** *Taverna Etrusca*. Traditional local food; tel. 0564/61 55 39.

Restaurant
La Tavernetta; tel. 0564/61 62 77.

Arcidosso (p.176)

Festivals and Fêtes
Twelfth Night, 5 and 6 January, processions, with presents from the kindly witch (*La Befanata*) and celebratory bonfires; Good Friday processions; Spring Festival, first Sunday after Easter; *Maggiolata*, traditional folk-singing and processions, 30 April–1 May; Feast of the Assumption, with fireworks, 15 August; patronal festival, Feast of St. Nicholas, 6 December.

Sights
AMIATA ANIMAL PARK
 Guided tours; tel. 0564/96 68 67.

Hotel-Restaurants
*** *Albergo Ristorante Aiole*. Serves regional cuisine; tel. 0564/96 73 00.
*** *Toscana*; tel. 0564/96 74 88.
** *Albergo Ristorante da Lorena*. Offers dishes of the locality; tel. 0564/96 71 62.

Restaurants
Ristorante da Ghino. Offers characteristic dishes of the Amiata region; tel. 0564/96 72 62.
Zi' Emilio; tel. 0564/96 69 24.
Ristorante Le Pergole; tel. 0564/96 42 27.
Pizzeria Giardino; tel. 0564/96 60 62.

Information
Via Monterosa 206, Grosseto; tel. 0564/45 45 27.

Abbadia San Salvatore (p.182)

Festivals and Fêtes
Feast of St. Antony Abbot and blessing of the animals, 17 January; Carnival, when men drive decorated carts pulled by garlanded donkeys through the locality; Good Friday, procession of penitents, bearing a heavy crucifix; patronal festival, Feast of St. Mark, with Mass and procession, 19 September; Christmas Eve bonfire (*Fiaccole di Natale*).

Hotel-Restaurants
*** *Albergo Adriana*. Close to sports centre; tel. 0577/77 81 16.
*** *Parco Erosa*. Tranquil, with a piano-bar; tel. 0577/77 63 26.

*** *Albergo Ristorante Italia.* Private garden; tel. 0577/77 80 07.
* *Albergo Alessandra;* tel. 0577/77 81 71.
Albergo Roma; tel. 0577/77 80 15.
Albergo Sella. Stands in a beech forest; tel. 0577/78 97 42.
Pensione Ristorante Cesaretti. Serves regional dishes; tel. 0577/77 91 98.
Albergo La Croce. On the mountainside, convenient for skiing, and with terrace and private garden; tel. 0577/78 97 48.
Albergo Ristorante La Baita. Sheltered by woodlands and situated 1450 metres above sea-level, good for skiers; tel. 0577/78 97 06.
Restaurants
Fonte Magria il Trotaio. Serves fish and local cuisine; tel. 0577/77 85 39.
Ristorante Sala Carli. Situated on the first floor of a medieval palace; tel. 0577/7 94 44.
Information
Via Mentana 97; tel. 0577/77 86 08.

Saturnia (p.188)

Hotel-Restaurant
Hotel Terme di Saturnia. Sumptuous and expensive lodgings for those taking the waters; tel. 0564/60 10 61.
La Cascata; tel. 0564/60 29 78.
Hotel Saturnia; tel. 0564/60 10 07.
*** *Villa Clodia;* tel. 0564/60 12 12.
Restaurant
I Due Cippi da Michele; tel. 0564/60 10 64.

Pitigliano (p.190)

Festivals and Fêtes
Grape festival, 12–14 September.
Sight
BOTANICAL GARDEN
Daily, except Saturdays; tel. 0564/61 60 39.
Hotel-Restaurants
** *Hotel Guastini;* tel. 0564/61 60 65.
** *Hotel Corano;* tel. 0564/61 61 12.
** *Valle Orientina;* tel. 0564/61 66 11.
Poggio del Castagno ('agriturismo'); tel. 0564 61 55 45.
Restaurant
Trattoria del Corso; tel. 0564/61 68 27.
Information
Via Roma; tel. 0564/61 52 43.

Montemerano (p.198)

Hotel-Restaurant
*** *Villa Acquaviva;* tel. 0564/60 28 90.
** *Laudomia.* In nearby Podere di Motemerano, with superb views of the valley; tel. 0564/62 00 62.

Restaurant
Da Caino; tel. 0564/60 28 17.

Magliano in Toscana (p.202)

Hotel-Restaurant
* *I Butteri;* tel. 0564/58 98 24.
Molino ('agriturismo'); tel. 0564/58 97 37.
Podere S. Antonio ('agriturismo'); tel. 0564/58 99 40.
D'Ubaldo Fabio e Formichi Eliane ('agriturismo'); tel. 0564/58 97 58.
Restaurants
Antica Trattoria Aurora. Specializes in game and regional cookery; tel. 0564/59 20 30.
Da Guido; tel. 0564/59 24 47.
Information
Via Garibaldi; tel. 0564/59 20 47.

Populonia (p.206)

Sights
THE NECROPOLIS
Three kilometres east of Populonia, containing tombs dating from the 8th to the 3rd century BC; conducted tours, 9.30–12.30 and 15.30–19.00; 9.00 till dusk, September to April.
TORRE DI POPULONIA
Tuesday to Sunday, 9.30–12.30 and 14.30–17.30.
Hotel-Restaurants (all at San Vicenzo)
**** *Park Hotel I Lecci;* tel. 0565/7041 11.
*** *Albergo Nazionale;* tel. 0565/70 15 67.
** *Riva degli Etruschi;* tel. 0565/70 23 51.
Leonardo Malfatti ('agriturismo'); tel. 0565/79 80 19.
Restaurant (also at San Vicenzo)
Gambero Rosso; tel. 0565/70 15 84.
Information
Via B. Alliata 2, San Vicenzo; tel. 0565/70 15 53.

Ansedonia (p.212)

Sight
RUINS OF ROMAN CITY OF COSA
Hotels
* *Le Rocce;* tel. 0564/88 12 75.
* *Vinicio;* tel. 0564/88 12 20.
Restaurants
Ad Ansedonia; tel. 0546/88 12 11.
Il Pescatore; tel. 0564/88 12 01.
Information
Via Monterosa 206, Grosseto; tel. 0564/45 45 27.

Select Bibliography

ACTON, Harold, *Tuscan Villas*, London, 1973.

ANDERSON, Burton, *Vino*, London, 1980.

ARDITO, Stefano, *A Happy Arrival: A Guide to the History, Nature and Secrets of Monte Amiata*, Abbadia San Salvatore, 1994.

BAZZONI, Ennio (ed.), *Firenze e dintorno: Mugello, Pratomagno, Casentino, Val di Chiana*, Florence, 1992.

BENTLEY, James, *A Guide to Tuscany*, London and New York, 1987.

CHAMBERLIN, Russell, *Florence and Tuscany*, Basingstoke, 1994.

DEL BECCARO, F., *La provincia di Lucca*, Lucca, 1964.

DICKENS, Charles, *Pictures from Italy*, London, 1848.

GATTESCHI, R., *Toscana in festa*, Florence, 1971.

HALE, Sheila, *Florence and Tuscany*, 4th edition, London and New York, 1992.

IMBERCIADORI, Jole Vichi (tr. Peter Rackham), *San Gimignano of the Beautiful Towers*, San Gimignano, n.d.

KEATES, Jonathan, *Tuscany*, London, 1988.

La provincia di Grosseto, Guida turistica, Rome, 1965.

LAWRENCE, D. H., *Etruscan Places*, London, 1932.

LAWRENCE, D. H., 'Flowery Tuscany', *Selected Essays*, Harmondsworth, 1950.

MACADAM, Alta, *Blue Guide to Tuscany*, London, 1993.

MASSON, Georgina, *Italian Villas and Palaces*, London, 1959.

PETRI, I., *Pienza, storia breve di una simbolica città*, Genoa, 1965.

PIAZZA, Luciano (ed.), *Amiata: il territorio, la storia, la cultura*, Florence, 1991.

RAISON, Laura, *Tuscany: an Anthology*, London, 1983.

TIRONE, Piero, *Maremma*, Novara, 1992.

VASARI, Giorgio (tr. George Bull), *Lives of the Most Eminent Italian Architects, Painters and Sculptors*, revised edition, Harmondsworth, 1975.

WHITNEY, P., *The Visitor's Guide to Florence and Tuscany*, London, n.d.

TOSCANA, 4th edition, Touring Club Italiano, Milan 1974.

ZEPPEGNO, L. and Vacchi, L., *Guida alla civiltà sepolte d'Italia*, Milan, 1972.